Digital Photography Composition

FOR

DUMMIES®

by Tom Clark

WILEY

Wiley Publishing, Inc.

Digital Photography Composition For Dummies®

Published by
Wiley Publishing, Inc.
111 River St.
Hoboken, NJ 07030-5774
www.wiley.com

WILEY

About the Author

Tom Clark is a successful commercial photographer in Miami. After receiving a Bachelor of Arts in Commercial Photography, he moved to Miami and began his career by assisting local photographers on fashion, editorial, and portrait assignments. Tom also assisted some of the city's top architectural and interior photographers and worked on set with many of the top photographers in New York, Los Angeles, and Europe for fashion, editorial, and celebrity portraiture. With the combination of his experience on set and his education, Tom successfully made the move from photo assistant to photographer. Today he shoots for a number of local and international publications on a freelance basis, and he provides commercial advertising services to clients of all sizes.

What aren't discussed in Tom's commercial success but are possibly the root of his inspiration are the long trips into the wilderness, up mountains, and to the seas where getting the perfect shot is an exploration and nights are filled with campfires, starry skies, and long exposures. To check out Tom's work and see his *Photo of the Week* (which highlights his most interesting recent captures), visit his Web site at www.tomclarkphoto.com.

Dedication

For my dad.

Author's Acknowledgments

Thank you to Traci Cumbay for working so closely on this project and helping to keep the work consistent with the *For Dummies* style. It was great to have someone to share ideas with. More thanks to Project Editor Sarah Faulkner and Copy Editor Jessica Smith for keeping the flow and organization of this book in check.

I am delighted that Erin Calligan Mooney contacted me for this project and presented such a great opportunity to me. Thank you Stacy Kennedy for managing this project, and thank you Craig Denis for contributing architectural and interior photographs that worked so well to validate my points on the topic.

The models I would like to thank for appearing in this book include the following: Fania Castro, Gillian Richardson, Alejandro Nuñez, Omar Bain, Niurka Zamora, Amy Larue, Autumn Suna, Emily Jo Burton, Joe Kydd, Diego Alberto, Clarissa Hempel, Josh Noe, Eduard Kotysh, Lauren Koenig, Ivonne Padilla, Melissa Gil, Greg Norman, Jr, Francisco Stanzione, Oleg Dankovtsev, and Alejandra Pinzón.

Last but not least, thank you Emily Noe for assisting with the production of the photos for this book and for being a wonderful muse.

Publisher's Acknowledgments

We're proud of this book; please send us your comments at http://dummies.custhelp.com. For other comments, please contact our Customer Care Department within the U.S. at 877-762-2974, outside the U.S. at 317-572-3993, or fax 317-572-4002.

Some of the people who helped bring this book to market include the following:

Acquisitions, Editorial, and Media Development

Project Editor: Sarah Faulkner

Acquisitions Editor: Stacy Kennedy

Copy Editor: Jessica Smith

Assistant Editor: Erin Calligan Mooney

Senior Editorial Assistant: David Lutton

Technical Editor: Susan B. Fleck

Editorial Manager: Christine Meloy Beck

Editorial Assistants: Jennette ElNaggar, Rachelle S. Amick

Cover Photos: Tom Clark

Cartoons: Rich Tennant (www.the5thwave.com)

Composition Services

Project Coordinator: Sheree Montgomery

Layout and Graphics: Carl Byers, Carrie A. Cesavice, Samantha K. Cherolis

Proofreaders: Laura Albert, John Greenough, Nancy L. Reinhardt

Indexer: Sharon Shock

Special Help Traci Cumbay, Christine Pingleton

Publishing and Editorial for Consumer Dummies

 Diane Graves Steele, Vice President and Publisher, Consumer Dummies

 Kristin Ferguson-Wagstaffe, Product Development Director, Consumer Dummies

 Ensley Eikenburg, Associate Publisher, Travel

 Kelly Regan, Editorial Director, Travel

Publishing for Technology Dummies

 Andy Cummings, Vice President and Publisher, Dummies Technology/General User

Composition Services

 Debbie Stailey, Director of Composition Services

Contents at a Glance

Table of Contents

Introduction

*I*f you want to create interesting and aesthetically pleasing photographs, you need to understand great composition. You have rules (which can, of course, be broken) to guide you, decisions to make, and techniques and tools to get the job done. Put all these together, and you give purpose and meaning to your photographs.

After you realize why some photographs look better than others and more successfully tell their stories, you can create amazing images wherever you are and in any conditions. You can approach any scene in many ways, and each photographer will do so differently. You want to be sure that you approach a scene with the confidence of a person who understands how to compose great images — and has fun doing so.

Whether you're an amateur, pro, semipro, hobbyist, scrapbooker, traveler, artist, or someone who just received a camera as a gift, knowing more about composition will make your photographs better. Besides, if you're going to take pictures, they may as well be good ones.

About This Book

Photographic composition is a complex topic that covers a wide range of theories and competing schools of thought. Many photographers carry separate opinions when it comes to defining what's most important in creating great compositions. Some feel that following the rules is essential, and others feel that to be unique you need to break the rules. In this book, I provide a thorough coverage of the rules (because in order to break the rules successfully, it helps to know what they are). I also do my best to give you the information necessary to determine when to go with the rule book and when to go with your gut.

In this book, you find information that covers composition from all angles. I designed each chapter to present valuable information that can improve your ability to see potential in what you're photographing and to capture that potential with your camera. Combining ideas from multiple chapters makes you a more dynamic photographer, but you certainly can take one chapter at a time, focusing on one skill or technique until you're moved to expand your compositional repertoire.

Ultimately, you make the decisions about what good composition is. Use this book to introduce new ideas to your creative thought process, to enhance your decision-making skills, and to understand the technical information you need to achieve the results you want.

And remember that this book isn't designed to be read from cover to cover. You can jump in wherever you need the most help without feeling like you've skipped a beat. No chapter relies on your knowledge of any preceding chapter to make sense. You may want to practice the ideas in one chapter before you move on to the next, but you're going to find everything you need (or directions to further information) anywhere you start reading.

Conventions Used in This Book

In this book, I use the following conventions to make sure the text is consistent and easy to understand:

- For each photograph, I include the following information:

 - **Focal length:** This number shows the angle of view provided by the particular lens used. It determines how much of your scene is captured when composing a shot.

 - **Shutter speed:** This number indicates how long it took to complete the exposure (usually measured in fractions of a second). It determines how precise the moment of capture is, and it's particularly important when photographing subjects in motion.

 - **Aperture:** This number shows how much light the lens let in at the time of exposure (measured by an f-stop). It helps to regulate your depth of field, which determines how much of your scene is sharp or blurry.

 - **ISO:** This number displays how sensitive the digital sensor is to light during the time of the exposure. A sensitive ISO rating (determined by a higher number) can produce a properly exposed image more quickly and with less light than a less sensitive rating (determined by a lower number).

 You can find this info beneath each photo. To save space, I give you just the numbers — no labels. So when you see "35mm, 1/250 sec., f/11, 320," you'll know that I'm referring to the focal length, shutter speed, aperture, and ISO. The specs are always in this order.

- All Web addresses appear in `monofont`.

- New terms appear in *italic* and are closely followed by an easy-to-understand definition.

- **Bold** highlights the action parts of numbered steps and the key words in bulleted lists.

When this book was printed, some Web addresses may have needed to break across two lines of text. If that happened, rest assured that I've added no extra characters, such as hyphens, to indicate the break. So when using one of these Web addresses, simply type in exactly what you see in the book as though the line break doesn't exist.

What You're Not to Read

If you're in a hurry to start taking amazing photographs, you may want to skip around this book to areas that most appeal to you. No problem. If you are in a big hurry, here's a tip: You can skip the sidebars (those gray-shaded boxes) and any text marked with the Technical Stuff icon. The information you find in these places may interest you and add something to your work, but it isn't necessary for understanding how to compose beautiful photographs.

Foolish Assumptions

Before I could write this book, I had to make some assumptions about you, its reader. For example, I assume that you

- Want to get a reaction from the people who view your images
- Are familiar with the basic functions of your camera and have some experiences using them

How This Book Is Organized

Photographic composition is all about organization: The way you organize elements in a frame determines how people view the image. Similarly, writing a book requires you to stay organized as well. So, each part in this book gives you valuable information related to a specific topic. Each part works on its own or can be combined with information from another part. The following sections give you an overview of what parts this book contains.

Part I: The Basics of Composition

This part introduces you to photographic composition and explains why it's a necessary skill in producing interesting and aesthetically pleasing images.

It covers the topic of training your eyes to see things from a compositional standpoint and discusses the abilities and equipment you need to consistently create beautiful photographs.

Part II: Elements of Photographic Design

Certain key elements are the building blocks of composition. This part shows you ways to put these elements together when composing an image. I tell you about critical factors like lines, shapes, patterns, and color, and I introduce you to the "rules" that have arisen from the blood, sweat, and tears of photographers who came before you.

Part III: Arranging the Key Elements to Compose a Successful Shot

A well-composed photo has various parts — or elements — that work together to create a cohesive message. I provide you with an overview of these elements in Part II, but in this part, I delve into each in more detail. You find out how to use focus, perspective, background, and lighting to tell your story. I also show you ways to use framing techniques to keep viewers' eyes on your image. I round out the part with a chapter on the other compositional ideas you can use to make sure your subject headlines the show.

Part IV: Composition in Action

Your subject matter typically determines how you compose an image. For instance, you compose images of people differently from images of architecture or landscapes. Each chapter in this part discusses how to handle a common subject by combining the elements of design and the photographic techniques you find in Parts II and III. And after you've taken your photos — whether they're portraits, still-life images, or abstracts — you can polish them using the postproduction improvements I tell you about in this part.

Part V: The Part of Tens

This part provides three short chapters in which I share important aspects of my experience as a photographer to help better your understanding and execution of interesting photo compositions. You discover ways to give yourself assignments that will enhance your photographic composition skills, find inspiration, and compose one scene in various ways.

Icons Used in This Book

Icons are a beloved tradition in the *For Dummies* series, so why buck tradition now? I use the following icons to direct your eye to specific types of information within the book:

The text that appears next to this icon presents the information that you'll rely on again and again when photographing. This is the stuff that experienced photographers know cold.

In some instances, I dive a little further into a technical topic to give you greater detail that you may find interesting. You're welcome to skip these divergences; you won't miss anything crucial.

Whenever I give you information that saves you time, money, or photographic frustration, I mark the text with this icon.

Some practices send your composition into a tailspin that even postproduction editing can't fix. Whenever I tell you about possible errors or missteps, I highlight the information with this dangerous-looking icon.

Where to Go from Here

As I mention earlier, you don't have to read this book in any particular order — the way you proceed is totally up to you. You can simply pick a topic that you're interested in and dig in. For instance, if you're antsy to start applying your photographic skills to shooting landscapes or another specific subject, flip right to Part IV. If color has you baffled, Chapter 6 has the information you need. Need an introduction to or refresher on camera settings? Head for Chapter 3. And if you're a beginner, an overachiever, or someone who just can't stand the thought of missing something, turn the page and keep reading until you hit the index. Whatever you do, don't delay. Get started on your journey toward successfully composed images.

Part I
The Basics of Composition

In this part . . .

The difference between good photography and mediocre photography is composition. Until you grasp the ideas behind successful compositions, your photography can go only so far. This part alerts you to exactly what composition is, why it's so critical for making images, and what skills and equipment you need to begin creating knockout compositions.

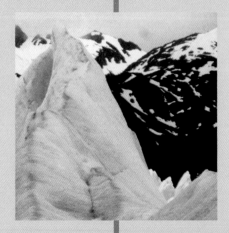

1

Photographic Composition: The Overview

In This Chapter

▷ Reviewing photographic composition

▷ Developing the skills that lead to great compositions

*T*he world is full of beauty, and the world of photography is full of limitless potential to reveal that beauty. Any particular scene or scenario can be conveyed in countless ways that are equally compelling, and each photographer chooses a composition based on her own unique values and ideas. What a viewer takes from your photographs — how he understands your message — depends mainly on your ability to compose clear and interesting images. Every time you take a photograph, you're communicating with whoever looks at it, and getting your message across has a lot to do with your fluency in the language of photography.

Some people say that great photographs can be captured with even the cheapest point-and-shoot cameras and that photography is all about the photographer's eye, not the equipment or technique used. This thought is true on certain levels of standards, but why would you stop at just having a good eye? Photography and composition is about more than just pointing your camera at something that looks interesting. Discovering how to take your good eye to the next level and back it up with a thorough understanding of the equipment and techniques available advances the quality of your photography to much more impressive levels.

In this chapter, I give you an overview of what role composition takes in photography and show you what techniques you can use to improve your images' compositions.

Getting a Grasp on Good Composition

Artists of all types (photographers, painters, architects, musicians, and so on) know that a noticeable difference exists between good composition and poor composition. A viewer may not be educated in photographic composition, but she knows a good photo when she sees it. Similarly, you don't need to understand music theory to differentiate between a good song and a bad song. However, you're more likely to compose a good song if you understand the theory behind the music.

Understanding what photographic composition is and how it conveys a message to viewers changes the way you take pictures and increases your enjoyment in viewing the work of other photographers.

Defining photographic composition

In general, the term *composition* refers to how various parts come together to create a harmonious whole. When something — whether it's a photograph, a painting, a room, or any other object — contains multiple elements, those elements automatically develop relationships to one another. For example, where you position the sofa and chairs determines how those items work together (and whether your guests can talk to each other).

More specifically, *photographic composition* represents the decisions you make when creating an image. It includes everything that's in your *frame* — the rectangular space that's represented by your camera's viewfinder or your photograph. In a photograph, the way you reveal the relationships between the different elements in your scene makes up your composition.

The following terms are essential to understanding what makes up a scene and what your selected composition represents:

- **Frame:** Your *frame* is the rectangle or square (depending on your camera's format) that contains the scene you're shooting. You can't always manipulate a scene, but you can control how the scene is represented in your frame if you're properly prepared. Being prepared means knowing which camera angles provide the best results in a given scenario (Chapter 8) and knowing how to use your equipment to get the best results with regard to focus (Chapter 7), exposure (Chapter 3), and arrangement (Chapter 5).

- **Elements:** The *elements* of a composition are the people, places, and things that make up a scene. Everything included in your frame is an element, including the subject, the details that make up the foreground and background, and any objects, props, or details that surround the subject. In fact, compositional elements consist of anything that can be

defined in an image: shapes, forms, lines, textures, colors, tonalities, light (or the absence of light), and space. The arrangement of a scene's elements in your frame determines your composition.

✔ **Subject:** The *subject* is a person, place, thing, or essence (in abstract images) that gives a photograph purpose. Because an image tells a story about its subject, the goal of a good composition is to showcase the subject. Keep in mind that one photograph can include multiple subjects.

Notice the elements that make up the scene in Figure 1-1 — the snowcapped mountains, the valley with a river running through it, the body of water that the river feeds into, and the cloudy and hazy sky. The mountain on the left side of the frame is the subject in this image.

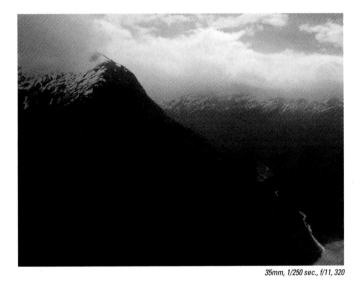

35mm, 1/250 sec., f/11, 320

Figure 1-1: Consider what each element in your frame says about your subject when deciding to incorporate it or eliminate it.

Because of the composition I chose for Figure 1-1, the mountain on the left-hand side dominates all the other elements in the scene; those elements exist in the frame to tell you more about the mountain itself — that it's in a cold climate, it's massive, and it exists in dramatic weather conditions. The various elements in this scene relate to the subject as follows:

✔ **The river running through the valley gives a sense of scale.** Because the river appears so small in comparison to the mountain, you can assume that the mountain is massive. By positioning the river in the bottom corner of my frame, I allowed space for the mountain to dominate the frame. (See Chapter 12 for more on scale.)

✔ **The background is dramatic and ominous.** The background gives a sense of depth because of the way it fades in contrast and is consumed by the haze. (You can read more about choosing an effective background for your image in Chapter 9.)

✔ **The clouds in the sky give you an idea of the mountain's elevation.** The mountain reaches the clouds and almost seems to divide the sky into two sections. To the left of the mountain, the clouds are much thicker than they are to the immediate right of it.

✔ **The body of water that the river feeds into tells you that this mountain begins at sea level.** If you started at the base and hiked to the summit, you would experience many shifts in weather. I only had to show a small amount of the body of water to relay its part of the message. Minimizing its presence in the frame gives more drama to the mountain.

Leading the eye to important elements

After years of reading, your mind is trained to automatically respond to the words on this page. You start at the top left corner of a page and scan the printed letters from left to right, working your way down. The large, bold fonts in the headings capture your attention and give you an idea of what information is on the page. You probably read those headings first and then decide whether you want to read the normal print under them. Advertisements often include fine print used to reveal information that's necessary for legal reasons without encouraging you to read it.

A photograph works much like printed text, but it can be much more complex. Your job as a photographer is to tell a story, so the way a viewer reads into an image will have a major effect on the message. Having an idea of how people look at images helps create successful compositions.

You can use any of a long list of techniques to direct a viewer's eyes through a photograph. Here's a list of ways to draw attention to important elements:

✔ **Pay attention to your contrast.** The area with the highest *contrast* (the most drastic transition from light to dark) usually is the first place viewers look in an image. You also can use color to create contrast. Chapter 6 gives you more information on contrast.

✔ **Keep your focus on the subject.** Your *focal point* is the area in the scene that you focus on with your lens. Usually this point is the subject itself. When you look at something, your eyes focus on it. And the point in an image that's in focus is most similar to how you see things in real life. So, you'll probably pay most attention to that area when viewing an image. For more information on how to focus on a subject, read Chapters 3 and 7.

✔ **Provide leading lines.** Leading lines get the attention of a viewer's subconscious and direct his eyes from one element in the frame to another. Photographers use leading lines as a way to keep your eyes in the frame and to tell a story in a certain order. Picture, for example, railroad tracks that lead your eyes to a vanishing point on the horizon. For more on lines, head to Chapter 4.

✔ **Direct viewers through the frame with tonal gradations.** *Tonal gradations* are areas that go from lightness to darkness or vice versa. These gradations help direct a viewer through a frame because if your eye starts at the point with the highest contrast, perhaps it will next go to the point with the second highest contrast.

✔ **Draw attention in a photograph using color.** An outstanding color can help viewers determine the subject of a photo. If, for example, a photograph includes a crowd of people wearing white hats and one person wearing a red hat, viewers' eyes naturally go to the person with the red hat, which is likely your subject. Chapter 6 covers various methods of using color to draw a viewer's eye or create a specific mood.

✔ **Include patterns and repeating elements.** These elements tend to catch a viewer's eye — perhaps because humans have the natural ability to recognize similarities in things. A mirrored image (like the reflection of mountains in the water) adds interest to a composition. Natural and manmade patterns add interest as well. For more about repetition and patterns in composition, see Chapter 12.

✔ **Create a visual frame within your frame using the compositional framing technique.** Your frame refers to the edges of your viewfinder or photograph, but a *compositional frame* is something you create that occupies the area inside the edges of your frame. Its purpose is to keep viewers' eyes from wandering away from the photograph. If a leading line goes to the edge of the frame, a viewer's eyes follow it, leading him directly out of the image. A compositional frame creates lines that go along the edges to direct eyes back toward the elements of the scene. For examples and more information on framing, flip to Chapter 11.

These techniques don't exist in a vacuum; you often mix and match them according to the effect you want to create. If, for example, you arrange your composition so the subject is in focus and is positioned in the area with the highest contrast, you pretty much guarantee that a viewer's eyes will go directly to the subject. If your subject is in focus but another element in the scene creates higher contrast, the two elements compete for attention.

Achieving balance

When photographers create *compositional balance,* they create a space that's easy for viewers to look at — one in which the various elements are evenly distributed throughout the frame. If too many elements are bunched together

in one area of the frame, the other areas become empty and uninteresting. Viewers generally spend more time looking at images that contain points of interest throughout the frame.

Figure 1-2 shows compositional balance in one of its simpler forms. You can see how the eagle provides a counterweight to the mountains. If the eagle weren't flying through the sky, your eyes would only be drawn to the mountains — and, as a result, you probably wouldn't spend too much time viewing the image. Chapter 12 provides more detailed descriptions of balance and techniques on how to achieve it.

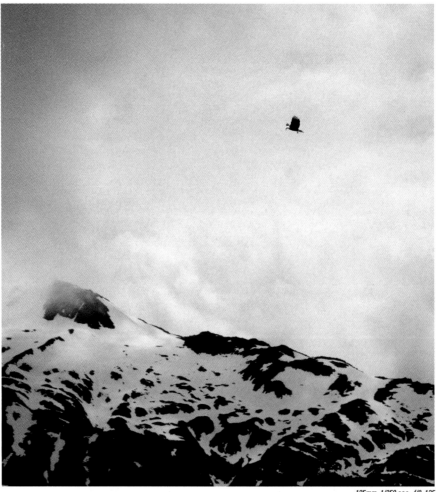

135mm, 1/250 sec., f/8, 125

Figure 1-2: Balance is achieved by positioning elements evenly throughout the frame.

Gaining Control of Your Compositions

You can't create great compositions without making some important decisions — from how to set up your camera and choose which angle you shoot from to what elements make it into your shot. Many — if not most — of these decisions become second nature to you as you gain experience with your camera. However, as you dip your toes into the compositional waters, you have a lot to consider, so this section alerts you to the kinds of decisions you need to make when you compose a photograph.

Working your basic camera settings

The best photographers can pay attention to their scenes and concentrate on creating the finest compositions possible without having to worry about their cameras producing bad technical results. In other words, they're familiar and comfortable with the settings and technicalities of their cameras. To improve your own compositions, you too need to know what your equipment is capable of and how to use it.

Most digital cameras offer various automatic and manual settings. Each of these can be used to produce great images; often it's up to the discretion of the photographer as to which one works the best. The automatic setting is fine in some situations, but you also need to be comfortable manually controlling your aperture, shutter speed, and ISO. (If you're in the dark on these terms, they're explained in Chapter 3, which also gives you information on your camera's automatic settings.)

Regardless of whether you use automatic or manual controls, you should always check the results of your image quality by referring to your camera's histogram. The histogram warns you if your highlights are blown out or if your shadows are underexposed. See Chapter 3 for more on using histograms.

Confidence is key, especially when you photograph people. Get as familiar with your equipment as possible so you can achieve appropriate exposures the first time. This way you can spend more time communicating with your subjects or taking in the beautiful scene you're photographing. Having your face constantly buried in the camera's LCD display screen causes you to miss photographic opportunities.

Choosing the lens that fits your message

Your lens determines what information is available to the camera's digital sensor. With digital SLR cameras, lenses are interchangeable so you can choose the appropriate one for the scene you're photographing. Most digital point-and-shoot cameras are equipped with a zoom lens that enables you to zoom in for tight shots and zoom out for a wider angle of view.

You can choose from the following three main types of fixed lenses:

- **Wide-angle:** These lenses reveal a more peripheral view and allow you to capture a large area of your scene. Using this type of lens is ideal when you want to fit as much information as possible into your frame. Elements that are closest to your camera will appear much larger than those that are farther away when using this lens type.

- **Normal:** These lenses reveal an angle of view that's similar to what you see with your eyes. They don't capture as much peripheral information as a wide-angle, but they do produce an image that's most true to the way something looks in real life.

- **Telephoto:** These lenses have a narrow angle of view that captures a smaller portion of your scene. This type of lens causes elements to appear larger in your frame than the other two lens types. Telephoto lenses are ideal when you're far from your subject but want to get a tight shot of it.

Chapter 3 tells you more about lenses.

Using perspective to enhance your message

Your *perspective* is determined by your camera position in relation to the elements of your scene. It's how you see your subject and everything else in your frame. In a three-dimensional world, the way you see things changes when you move up, down, and side to side. Changing your perspective enables you to position everything in your frame in the way you see most visually pleasing or appropriate for your message.

The elements in a scene and the relationship of those elements to each other within the frame determine the message that a photograph conveys.

If you're on a road trip with your family and come across a national landmark, you'll probably take a photograph to prove you were there. The message of that photograph is "Hey, look at us; we were there." In this situation, your perspective is critical for revealing and manipulating the relationships of a scene's elements in your frame.

Say you get everybody out of the station wagon to have a look at the Grand Canyon. While your family is looking over the edge, you ask them to turn around for a picture. You have three elements to consider, the subject (your family), the background (the Grand Canyon), and the foreground (the parking lot). Your perspective is going to determine how much of each of these is going to be included in the composition and what relationships they have with each other. I describe the details of perspective in Chapter 8; however, the following list introduces you to some of your options in the Grand Canyon situation:

- ✔ **Step close to your family.** This perspective shows more detail of who they are and less detail of the environment around them.

- ✔ **Back away from the family.** By backing up, you make your family smaller in the frame and show more of their surroundings.

- ✔ **Use a wide-angle lens.** With this lens, you can include as much of the scene as possible — your family, the background, the station wagon, and even some other tourists in the area.

- ✔ **Use a long lens.** When you use this type of lens, you can crop in specifically on the family and their immediate surroundings.

- ✔ **Choose a high angle.** If you choose to shoot from a high angle — maybe by standing on top of the station wagon — you show the family and a view that looks down into the canyon.

Figure 1-3 shows a scene that I photographed with two separate perspectives. Each image in the example reveals different aspects of the environment. The perspective on the left approaches the subject from far away and has an emphasis on the surrounding environment, thus distributing compositional importance to all the elements in the scene. The perspective on the right approaches the subject from a nearer vantage point and distributes more importance to the subject. This perspective is more descriptive with regard to the subject and is great for isolating the star of your photograph.

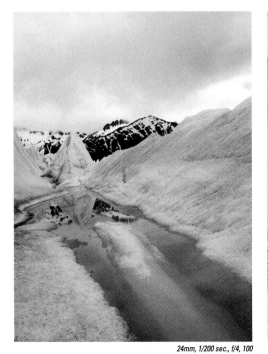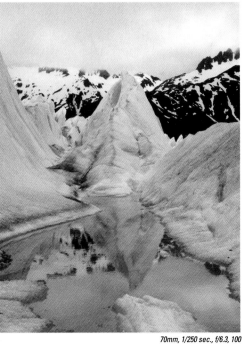

24mm, 1/200 sec., f/4, 100 *70mm, 1/250 sec., f/6.3, 100*

Figure 1-3: Because of the differing perspectives, the messages in these images also are different.

Pulling together the elements of composition

Your composition for a particular scene is basically a recipe. You consider certain factors automatically — what you focus on, how wide your angle of view is, and which perspective best represents the scene, to name a few. But other variables are unique to each situation, such as how many subjects to include, what mood the scene's color scheme and lighting create, whether your subject is still or in motion, and so on.

In order to best determine these variables, you simply have to practice and build your skills. Most photographers go through phases as they build their compositional skill level. Doing so enables you to really master one area before moving on to the next. You can pay special attention to any specific compositional element, but here's the order I suggest:

1. **Keep an eye on your focal point.**

 By using the techniques in this book and your camera's owner's manual, ensure that your subject is always your focal point. Don't settle for results in which your subject is blurry (unless you're using your artistic

license to do so, which is discussed in Chapter 12).

2. **Concentrate on creating compositions that have depth.**

To create depth, include foreground elements, a subject, and a background. Your subject is in focus (you mastered that in the first step), and you have foreground and background elements to create a supporting scene that enables viewers to work their way through the image.

Figure 1-4 shows an image with foreground, middle ground, and background elements. Your eyes are drawn into a photograph that displays this technique.

3. **Pay attention to color in your scene.**

Color plays a major role in determining how people feel about images. Being in tune with color is essential to relaying messages in a photograph. Pay attention to color in your scenes, and you'll eventually notice it without trying. Look for scenes that predominantly reveal a single color, or seek out scenes with complimentary color elements.

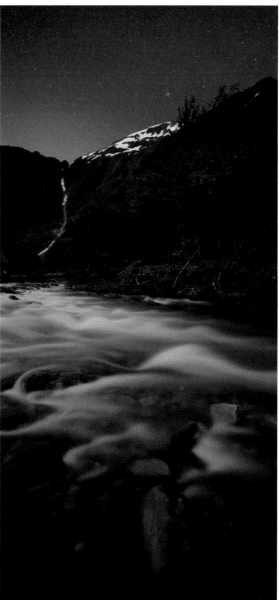

24mm, 15 sec., f/5.6, 800

Figure 1-4: Depth helps to draw a viewer's eyes into a photograph.

In other words, find a scene in which the colors contrast by existing on opposite sides of the color wheel. I talk about color in more detail in Chapter 6.

4. **Start paying attention to the design elements you find in Chapter 4, including the following:**

 • **Lines:** Elements that lead a viewer's eyes from one area of the composition to another

 • **Shapes and forms:** Elements that take up a specific space in the frame in a particular way

 • **Scale:** The size and weight relationships of photographic elements

 • **Patterns:** The repeating elements and mirror images

You have many elements to consider when you compose an image. You don't have to include each one in every image, but do consider them. You'll eventually develop the ability to analyze a scene and determine which elements are appropriate for telling the story of the scene through your eyes. The elements that you use to create an image should be only the ones that are necessary to support your message.

2

Developing an Eye for Composition

*N*o doubt you've come across photographs that have caught your attention and caused you to stop and stare. Images like these can have a haunting quality that draws you in and brings you to a certain place. They can alter your mood or clarify your thoughts. The ultimate goal of a photographer is to create these types of images — the ones that speak to people.

The ability to combine a subject that's relevant to your intended message, a mood that drives the message, and an image that's overall aesthetically pleasing makes you a better photographer. Composition is the key to unlocking this ability. So, in this chapter, I show you how to develop your photographic eye and recognize (and later apply) effective compositions when you see them.

You know something good when you see it, so how do you translate that same effectiveness onto your digital sensor to share with other people? You start by observing your surroundings with a watchful eye and a sharp memory. When something looks good or interesting to you, take some time to ask why you're drawn to it. If you can figure out what attracts you to a particular scene, you may have a chance to translate that attractiveness through one of your own photographs.

Studying What the Eye Sees

Your eyes are extremely sophisticated lenses that have the ability to refract light focused onto your retina and interpret it into image-forming signals. Understanding how the eye works and how people see helps you create compositions that show a scene in the way you want people to see it. Your camera and lens were designed to work in a similar way to your eyes, so understanding one helps to understand the other.

You have the option to limit what viewers see or you can reveal everything — it simply depends on your message. When approaching a scene, your eyes scan the area and find certain elements that stand out to you. By noticing these elements, you can figure out what's significant about a scene and why it's worth photographing, and then you can determine how to relay those important elements to other people.

When you look at an object, it's the only thing you see clearly; everything else is out of focus and lacks detail because your eyes set a focus point based on distance. If two objects are at separate distances, you can focus on only one at a time. Figure 2-1 shows how your eye sees and why only one thing can be in focus at a time.

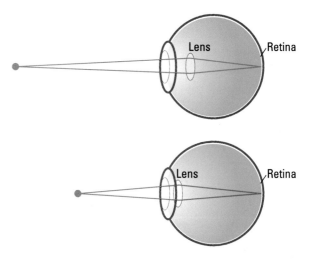

Figure 2-1: The human eye focused at different distances.

Your eyes are easily distracted because they have to constantly focus on the various elements of a scene in order to take in the whole picture. So once an element is recorded and understood visually, your eyes move on to the next element. When you've looked at all the elements in an area, you have a general idea of what the entire scene looks like even though you only can focus on one element at a time.

The following sections outline the different things your eye focuses on when you look at a scene.

Contrast

When you first glance at a particular scene, the first thing you notice is whatever sparkles or stands out the most. *Contrast* is what causes something to stand out to your eye; it's the difference in visual properties among objects that are close to each other in proximity. In the visual sense, contrast is created by tonal differences (blacks and whites, shadows and highlights, darkness and lightness, and so on) and complementary colors that reside on opposite sides of the spectrum. For more about contrast, check out Chapters 6 and 10.

The area in a scene with the most contrast most likely grabs your eye's attention first. The same concept applies to composition. A viewer of a photograph is naturally and instinctively drawn to the area of the image with the most contrast. When that area also happens to contain your subject or other information relevant to your message, your composition begins to make sense.

Distance

The eyes can focus on only one particular distance at a time. So, in order to take in all the information surrounding you, your eyes scan the area and your brain puts the information together. This way, even though you can see only one element at any given time, you still know what other elements exist, so you have a good idea of where you are and what's going on.

A person views your photographs in a similar way. Her eyes go to the area that stands out as having the most contrast, and then she scans the rest of the image to see what the whole story is about, examining everything in the frame. Creating a good composition means leading the viewer to specific areas that support and complement your message.

Patterns

Patterns stand out to your eyes as visual elements. Even in chaotic scenes, you can spot a pattern if it exists. Because they contain repetitive elements, patterns tend to have a visual significance and draw attention. A pattern's visual significance can be used to your advantage when composing a photograph. It has the ability to draw a viewer's attention or to lead his eyes to your subject.

For example, as you look down the hallway in a hotel, the doors all look the same, but they gradually appear smaller in the distance until they lead your eyes to the end of the hallway. (You can find more information on using patterns in your compositions in Chapter 4.)

Relationships between subjects and supporting elements

When you come across a scene, you determine what your subject will be by deciding what *you* think is the most important or visually striking element present. Some photographers see things differently from one another and may create images with different messages. For instance, when you see a family eating Thanksgiving dinner, you may think the person who's carving the turkey is the subject. Another photographer may think the turkey itself is the subject. A third photographer may think the empty bottles of wine in the background should become the subject.

Because the subject is your main focus in a composition, you place your lens's focal point on the subject when you take an image. By placing your focal point on your subject, you're instructing viewers to look at that area primarily. (For information on how to manipulate your focal point, head to Chapter 3, and for more on using focus as a compositional tool, see Chapter 7.)

Other areas in your composition may contain details that reveal important information about your subject based on your message. These are known as *supporting elements* in a scene. After you know what your subject is, you can determine what your supporting elements are based on what you see to help tell the story of your subject. Say, for example, you're photographing a leaf falling from a tree. If your viewers can see other leaves lying on the ground, they know this isn't the first leaf to fall from the tree. And if they see other leaves still on the tree, they know this one leaf won't be the last to fall. However, if the ground were covered with leaves and the tree was bare, this falling leaf would produce a different story. You determine what your supporting elements are (and what you will include in your photograph) based on what you want to say about your subject.

You don't want the supporting elements to stand out more than your subject, but you do want them to be apparent enough to draw attention on a secondary level. A good composition draws a viewer in to the subject and then leads her to the supporting elements in the most visually appealing way. Attention to this type of detail is important for making your message as effective as possible.

I took Figure 2-2 during a fashion editorial shoot based on urban camping in Miami. The model, who's the subject, is shown as if she's trekking through the city like a hiker would hike through the wilderness. She wears a hiker's pack, so you get the idea that she's hiking; however, the supporting elements tell you where she's hiking. One look at this image and you know that she isn't in the wilderness. The texture of the ground in the foreground and the bridge overhead confirm that the hiker is in an urban environment. The river, a supporting element, is important in this image because it makes a connection to hiking in the backwoods (hikers typically stay near a water source when going on long journeys through the wilderness).

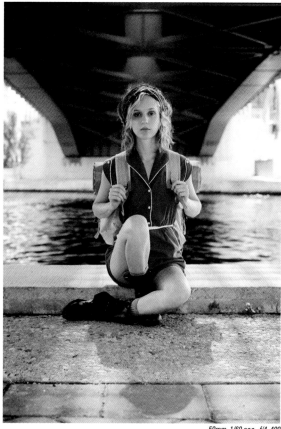

50mm, 1/60 sec., f/4, 400

Figure 2-2: A subject surrounded by elements that support her story.

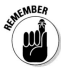

The relationships, both physical and suggested, between your subject and the supporting elements in a scene help clarify your message. Here are some examples:

- ✔ Two elements side by side appear to be equals in a composition; one element in front of another appears to be more important in the composition than the element behind it.

- ✔ Sometimes taking out one element makes another element unnecessary to your message.

✔ An element that stands out (such as a red umbrella in a sea of blue ones), becomes more significant and changes your message.

Figure 2-3 shows a nontraditional composition. The subject (the tree) is split in half by the edge of the frame. Because you can see only a portion of the tree, the most you glean is that the tree has certain shapes, textures, and colors. However, the relationship it has with its own shadow shows you the tree's full shape and gives you an idea of how much distance exists between it and the rock wall.

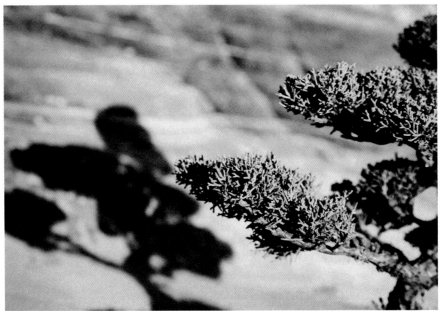

135mm, 1/100 sec., f/8, 100

Figure 2-3: The relationship between the tree and its shadow gives the viewer a complete sense of place and identity regarding the tree.

Seeing What the Camera Sees

A camera and lens see and record light much like your eyes do. For example, like your eye lenses, a camera lens refracts light and focuses it onto the digital sensor. And just like your retina, the digital sensor uses the light information to form images and record them. The distance from the lens

to the sensor deter-
mines the distance at
which your focal point
will be. Figure 2-4 shows
how the lens moves to
and from the sensor to
achieve focus at differ-
ent distances.

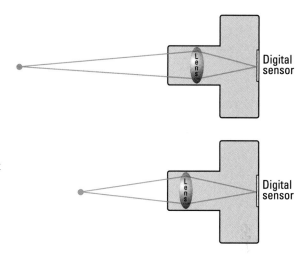

 You can change the dis-
tance of your focal point
by rotating the focusing
ring on your digital
SLR's lens or by using
your camera's autofo-
cus feature. Chapter 3
tells you much more
about how to use your
equipment.

Figure 2-4: The camera lens focused at different distances.

In the following sections, I show you how to create an illusion of three-
dimensional space in a two-dimensional photograph. In other words, I explain
how to give viewers a sense of space similar to what they would get from the
scene in real life. I also discuss how to control what viewers look at in your
photographs.

Revealing three dimensions in a two-dimensional medium

Having a pair of eyes rather than just one eye gives you the capability of
depth perception, the ability to recognize three dimensions. Depth percep-
tion helps you understand distance relationships even when you have
minimal information to work with. Because it has only one lens, a camera
perceives depth differently than your eyes do — it can only perceive two
dimensions.

 Although your camera produces two-dimensional images, it can recognize
three-dimensional space because its lens can focus at different distances. A
camera image with one element in focus while another is blurry represents
the way your eyes observe a scene. You can use this technique in conjunc-
tion with certain compositional techniques to maximize the representation

of three-dimensionality (or depth) in a photograph. The following clues in a composition can tip off a viewer about how much distance is between different elements:

- ✔ **Merging elements:** You experience merging when two or more elements intersect based on your viewing position. When one element physically blocks your line of sight to another element, you can assume that the position of the element that you see is closer to you than that of the blocked element. Figure 2-5 shows an example in which mountains merge in front of other mountains that are farther from the camera.

- ✔ **Size relationships:** When you know the typical size of something in a photograph, you can use it to reveal spatial information. If two adults are in a scene, you can assume that they're of similar size (give or take a foot). If one of the people appears to be much larger in the frame than the other, the viewer recognizes that the larger person is closer to him.

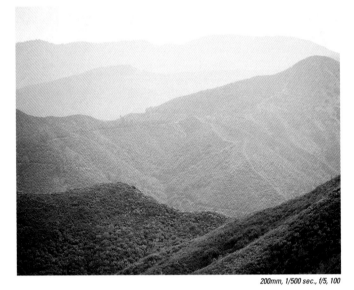

200mm, 1/500 sec., f/5, 100

Figure 2-5: Showing merging elements to establish a sense of distance between them.

✔ **Tonal gradation:** You use shadows, highlights, and tonal gradations to reveal three-dimensional surfaces in a photograph. *Tonal gradation* takes place when you see a gradual change from brightness to darkness. When you look down a well, for instance, the light reveals details at the top, but the light falls off as you look deeper into the well. The darker it gets, the deeper you're looking into the well.

Paying attention to everything in the frame

You're responsible for everything that appears in your chosen frame. So only those items that affect your message should be included in your frame. In other words, if something causes a viewer to ask, "Why is this here?" you know you should have either found a way to exclude it from your photograph or have an explanation as to why it's there.

When you look at a scene, ask yourself which elements convey your message and which ones may distract from it. Remove the distractions whenever possible. The most basic method for eliminating something from your frame is to crop it out as you're taking the photo. You can do so by zooming your lens, by moving closer to your subject to include less of the scene, or by moving your camera to the left or right or up or down. (Chapter 8 gives you tips about revealing and hiding items in a scene.) You also can remove some distracting elements during postproduction editing, but you should only use this method as a last resort (refer to Chapter 18).

In Figure 2-6, you see two scenes. The top image includes distracting elements; the bottom one shows an improved version of the image that I created by cropping at the time of the photograph. The original image, which shows a young woman doing yoga in an urban setting, was designed to appeal to young professional types who would be drawn to the idea of living in a modern condo building in downtown Miami. The scene was fairly cheap and artificial-looking, so I wanted to create a more natural look that included some of the surrounding city. These two images provide the same subject and environment, but the message was idealized by minimizing the details in the final image.

Both photos: 50mm, 1/320 sec., f/3.2, 50

Figure 2-6: Cropping into the scene eliminated distracting elements, creating a stronger message.

Finding and Creating Effective Compositions

The more you pay attention to and look for beauty in your surroundings, the more motivation you have to create photographs. After you take the images, go through them and determine what was successful and what wasn't — and why. Experience is the key to being good at anything, especially at creating excellent photographic compositions.

Here are a few ideas that you can use to enhance your skills as an observer and photographer:

- ✔ **Corner yourself.** Choose a place or specific scene and force yourself to take as many pictures of it as you can think of. Change your camera angles and your distances to the different elements. Focus on different things in the scene and pay attention to the qualities of light, color, and textures in the area. By sticking to that one scene, you may start to notice things about it that you would normally overlook. Starting to notice those things is how you develop your eye. You could probably create an entire body of work just from shooting in your own backyard. You just haven't *seen* the potential there yet.

- ✔ **Limit your shots.** Approach a scene and allow yourself to take only one photo. Before you take the shot, make sure you've observed the entire scene and know that you've found the composition that best suits your outlook at that time. Pay attention to how the light is affecting your scene. If it seems like things will get better as the sun moves through the sky to the west, wait to take the shot. If clouds are rolling in, and you feel that you may lose your good light, take the shot before the clouds set in. Be aware of all compositional elements present in a scene so you can make wise decisions. Later, if you revisit the same scene, take another single image and compare the differences between how you felt about the scene the first time and how you felt the second time.

- ✔ **Limit your time.** Approach a scene and allow yourself only a specific amount of time to get as many great shots as you can. This exercise helps you think on your toes and waste little time in getting the shot you want.

Look for inspiration in the work of other photographers. Sometimes looking at another artist's work helps you realize a brand-new approach to photography and better equips you to see the potential of elements all around you. Most professional photographers have Web sites that display their best works. If you like a particular photographer's style and know his

name, you can perform an online search to find his portfolios. Otherwise, you can search for nature photographers, portrait photographers, fashion photographers, travel photographers, and so on based on what kind of inspiration you're looking for.

3

Getting to Know Your Equipment

Composing beautiful photographs and understanding your photographic equipment go hand in hand. Composition, like any task, is easier and more effective when you have the right tools and use them correctly. You wouldn't choose a screwdriver over a hammer when you wanted to drive a nail, and in the same way, certain lenses and camera settings make more sense for certain compositions.

Camera equipment may seem overwhelmingly technical to you at first, but after you get to know your gear, it likely will become as familiar as using a hammer or screwdriver. So be sure to read the manuals that come with your camera and lenses in order to better understand all the settings and what they control. This chapter guides you to the parts of the manual that help you take better photos right off the bat.

The more time you spend getting to know your gear, the more natural your understanding of it becomes. A photographer who constantly fidgets with his camera controls is one who misses many great photographic opportunities. You want to develop an understanding that frees you and allows you to notice your surroundings, compose images, and communicate with your subjects.

Making the All-Important Lens Choice

A good camera lens can cost almost as much as (or in some cases more than) your digital SLR camera body. You may purchase a new body every few years based on the upgrades in technology, but your lenses will stick with you through time. So, before purchasing a specific lens, make sure it will be useful to your style of photography. Each type of lens is useful for different purposes, and knowing the benefits of specific lenses can help you choose the right tool for the job. The lenses you add to your camera bag should be based on the style of photography you mainly are involved in.

A lens can allow your camera to see an entire scene (including what's in your peripheral vision), or it can magnify a scene to provide a narrower angle of view. It also can provide a view that's similar to what you see with your eyes.

A lens's *focal length* (the distance in millimeters from the optical center of the lens to the digital sensor) determines how much the camera can see. A lens's curvature determines its focal length. More curvature causes the light to focus at a shorter distance and produces a wide angle of view. Less curvature causes light to focus at a greater distance and produces a narrower angle of view. (For more information on focal length and how it affects your composition, read Chapters 8 and 9.)

When choosing a lens, you can select a fixed lens or a zoom lens. Both can be helpful in certain situations. I introduce each in the following sections.

Working with a fixed lens

A *fixed lens* is one that contains only one focal length. Fixed lenses are designed to work perfectly at a specific focal length, and all their scientific and technological qualities are directed toward doing so. They're lighter than zoom lenses because they require fewer moving parts, and they tend to shoot faster — that is, they have a larger maximum aperture, which allows more light to come in and creates a faster shutter speed.

When I shoot fashion shots or portraits, I use only fixed lenses. I have time to study my scenes and compose my images, so I don't need to zoom in and out while shooting.

Here are the different types of fixed lenses you can choose from with regard to 35mm digital SLR photography:

- **Normal lenses:** These lenses have a focal length of 40mm to 85mm. The lens's curvature is normal, and it produces an angle of view that's similar to the one seen by the human eye. You can use this type of lens for shooting portraits, street photography, and still-life photos.

- **Telephoto lenses:** These lenses have a focal length that's greater than 90mm. They have minimum curvature, which produces a narrow angle of view and causes a scene to be magnified. The greater your focal length, the more magnification you have. Telephoto lenses are great for getting close to the action when you're actually far away. This effect can be useful in photojournalism and sports and wildlife photography.

- **Wide-angle lenses:** These lenses have a focal length of 17mm to 35mm. They have a great deal of curvature and produce very wide angles of view. Your camera can see more of a scene through a wide-angle lens. Try using this type of lens to photograph landscapes, architecture, interiors, and large groups of people.

- **Fisheye lenses:** These lenses have a focal length that's less than 16mm, and they produce an extremely wide angle of view. Fisheye lenses typically are used to create a fun or dramatic look, because elements that are close to the lens appear much larger than elements that are slightly farther from the lens. This look is commonly used in sports photography (skating, climbing, and so on) and in dramatic commercial advertising and high-fashion campaigns.

Saving time with a zoom lens

Some lenses contain a range of focal lengths so you can shift among them to find the right length for a specific shooting situation. These lenses, which are called *zoom lenses,* are convenient for scenarios that require you to shoot a variety of subjects from varying distances without wasting any time. After all, changing from one lens to another for one shot and then back again for another is time consuming and a pain.

The drawbacks to zoom lenses are that they're heavy and don't always provide the sharpest quality in an image. Most zoom lenses work better at certain focal lengths than at others. Because they can accommodate so many focal lengths, they drop the ball when it comes to perfecting just one.

I took the three images in Figure 3-1 within a matter of seconds using my 28mm–135mm zoom lens. The zoom lens enabled me to display one scene three different ways and to change my message without moving my camera or changing lenses.

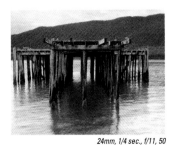 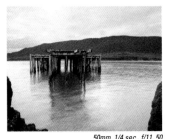 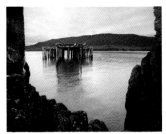

24mm, 1/4 sec., f/11, 50 50mm, 1/4 sec., f/11, 50 135mm, 1/4 sec., f/11, 50

Figure 3-1: Three angles of view of one scene taken with a zoom lens.

If you find that you require multiple focal lengths to get the job done, you're wise to purchase a couple zoom lenses. If you have a 24mm–70mm zoom lens and a 70mm–200mm zoom lens, you can cover the wide, normal, and telephoto ranges with just two lenses. Having this variety in two lenses would be much more convenient than carrying 24mm, 35mm, 50mm, 85mm, 135mm, and 200mm lenses and having to constantly change them as you were shooting.

Exposing Your Images Properly

Without exposure, you have no image. And without a well-balanced, thoughtful exposure that takes advantage of the tools you have, your image is less likely to be successful. Digital photography is a recording of light received by your camera's digital sensor. The amount of light that's recorded determines how dark or bright the elements in the image appear.

In an overexposed image, *highlights* — the brightest areas in the image — are *blown out* (meaning they provided more light to the sensor than was necessary and the sensor recorded them as white) and lack detail. In an underexposed image, shadow areas are *dense* (meaning they didn't provide enough light to the sensor and appear to blend together in a dark matter) and lack detail. The best exposure for a scene is one that maintains detail in the highlights without underexposing the shadow areas.

In the following sections, I walk you through the information you need to achieve great exposure for your images. I start off with the basics on aperture, shutter speed, and ISO, and then I move on and show you how to use histograms and light meters to determine exposure.

Taking a closer look at aperture, shutter speed, and ISO

Your camera's digital sensor exposes images based on the following factors:

- ✔ **Aperture:** The lens's opening, which you can widen to let in more light or close down to limit the amount of light
- ✔ **Shutter speed:** The length of time a camera's shutter is open, which determines the length of an exposure
- ✔ **ISO:** The sensitivity level that your digital sensor has to light

Understanding how each of these settings works individually and how they work together maximizes your control over any composition. Even though these factors help control your exposure, each controls other specific aspects of your images as well. So by comprehending what each one is used for, you gain the ability to selectively manipulate your exposure while maintaining control of the other effects that are vital to your message.

Aperture, shutter speed, and ISO are represented in *stops* — units of light used to measure and control exposure. If you increase your exposure by 1 stop, you're brightening your image and the information on your histogram shifts to the right uniformly in the amount of 1 stop. (Refer to the later section "Using a histogram to check exposure" for more on how a histogram can help you.)

The typical *range* (ability to capture detail) of a digital sensor is about 6 to 8 stops from black to white. Properly exposing a picture of a gray wall produces an image in which the wall appears gray. If you overexpose a gray wall by 3 stops, it appears white. If you underexpose it by 3 stops, it appears black.

I delve into more detail about aperture, shutter speed, and ISO in the following sections.

Controlling light with your aperture

Your camera's aperture controls your exposure by determining how much light enters the lens during a given exposure. You set your aperture first when the *depth of field* (the area of a scene that appears sharp in an image) in your scene is important to your message. Then you can adjust the shutter speed and ISO according to your chosen aperture to get the exposure you're looking for in your image. (For more on depth of field, head to Chapter 7.)

A number known as an *f-stop* signifies what aperture setting you're using. The higher the number is, the smaller your aperture is and the less light it lets in. Figure 3-2 shows aperture values in 1-stop increments. Each f-stop is roughly

50 percent greater than the one before it. The value doubles every 2 stops. If your camera is set to f/8 and you want to increase your exposure by 1 stop, open the aperture to f/5.6.

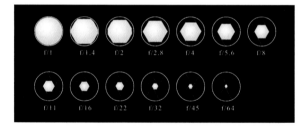

Figure 3-2: Aperture values in 1-stop increments.

In addition to exposure, aperture also controls your depth of field. A wider aperture produces a shallow depth of field, meaning that less of your image is sharp. A smaller aperture produces more depth of field and shows a greater area of the scene in focus. Setting your aperture to f/5.6 gives you a somewhat shallow depth of field, and shooting at f/2.8 gives you a very shallow depth of field. An f-stop of f/8 gets you closer to a great depth of field, and f/22 is usually good enough to make a whole landscape appear sharp.

Figure 3-3 shows a scene photographed at two different apertures (but otherwise exposed the same). I shot the image on the left with an aperture of f/2. The subject stands out because the background is blurry and the image has an overall softer feeling than the one on the right. I photographed the image on the right at f/16, giving sharp detail throughout the scene and drawing more attention to the background and away from the subject itself.

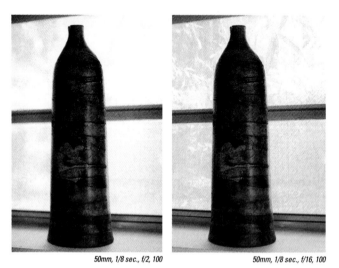

50mm, 1/8 sec., f/2, 100 *50mm, 1/8 sec., f/16, 100*

Figure 3-3: Two images exposed the same but taken with different apertures.

Setting your shutter speed

Your *shutter* is a curtain that sits in front of the digital sensor. When it's closed, no light enters your camera. When the shutter opens, the digital sensor is exposed to light. The shutter speed controls the length of an exposure by determining how long the shutter remains open: The slower the shutter speed, the longer the exposure. For normal, sunny-day shooting, shutter speeds typically are measured in fractions of a second, such as 1/125 or 1/60.

When you slow down your shutter speed by 50 percent (from 1/60 to 1/30), you increase your exposure by 1 stop. If you speed up your shutter speed by 100 percent (1/60 to 1/125), you decrease your exposure by 1 stop. In normal lighting conditions, your shutter speed typically is a fraction of a second. A shutter speed of 1/125 second is a fairly common speed because it's fast enough that you don't get motion blur from the movement of elements in a scene or the shaking of your hand. Motion blur is pleasant in photographs only when used appropriately and for a purpose. (Chapter 16 tells you more about motion blur.)

In low-light situations, you may have to slow down your shutter speed in order to expose an image. If you need to use a shutter speed slower than 1/125 second, place your camera on a tripod to eliminate any camera shake during the exposure.

Shutter speed controls movement in your scene, so setting your exposure with a priority to shutter speed (rather than aperture or ISO) is essential when you need to freeze or reveal motion in an image. Generally, you shoot as fast as possible in order to reveal your subject with as much sharp detail as possible. But you also can reveal motion by using a slow shutter speed (see Chapters 10 and 16 for more information).

Figure 3-4 shows a scene that was photographed using two different shutter speeds. The figure on the left was taken with a fast shutter speed of 1/30, and the figure on the right was taken with a slow shutter speed of 4 seconds. Notice how much movement was captured with the slower shutter speed compared with the faster one.

Adjusting your ISO

The ISO setting on your camera determines how sensitive your digital sensor is to light. The higher the rating, the less time and light you need to achieve a proper exposure. On most digital cameras, the ISO ranges from 50 to 6400. Every time an ISO rating doubles, light sensitivity increases by 1 stop. Here's a list of the ISO ratings to choose from in 1-stop increments: 50, 100, 200, 400, 800, 1600, 3200, 6400.

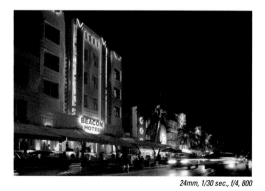 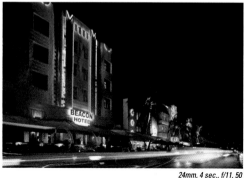

24mm, 1/30 sec., f/4, 800 *24mm, 4 sec., f/11, 50*

Figure 3-4: Changing your shutter speed can have a drastic effect on the way your scene is depicted.

With most digital cameras, you can shoot anywhere with an ISO of 50 to 400 without getting a great deal of *digital noise* (random speckles of red, green, and blue in an image that appear similar to film grain). Noise usually is undesirable because it makes an image difficult for viewers to read.

ISO settings higher than 400 can cause a photograph to have a noticeable amount of digital noise, so avoid shooting at those settings if you want a smooth quality to your images. The level of noise produced at a given ISO is dependent on your camera. It's a wise choice to do some testing to find out how high you can go before you begin to lose image quality from noise.

I recommend shooting with a very high ISO only when you

✔ Are in a low-light situation and have already determined that you can't further open up your aperture or slow down your shutter speed

✔ Want an artistic look in which noise would work to your advantage

Figure 3-5 shows a cropped-in detail of an image I photographed with my camera's minimum ISO and its maximum ISO. I took the image on the left with an ISO rating of 50, and it appears smooth and without flaws. I took the image on the right with an ISO of 3200, and it contains a lot of noise.

Using a histogram to check exposure

A *histogram* is a graph that displays the brightness distribution in an image. You can use your camera's histogram to determine how your total scene is being exposed. When photographing a scene, you use the histogram to determine whether you need to increase or decrease your exposure. (Check out your owner's manual to find out how to use your camera's histogram.) Figure 3-6 shows what a properly exposed image may look like in the histogram.

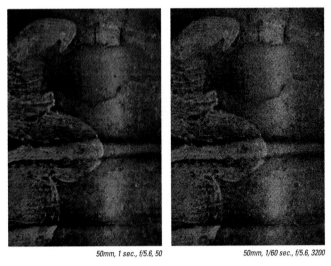

50mm, 1 sec., f/5.6, 50 50mm, 1/60 sec., f/5.6, 3200

Figure 3-5: The appearance (and lack) of digital noise in an image.

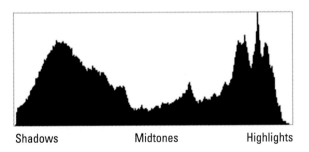

Shadows Midtones Highlights

Figure 3-6: A histogram for a properly exposed image.

The far left of the histogram in the figure represents black without detail, and the far right of the graph represents white without detail. A *full-scale exposure* (one that contains a full range of tonalities) has tonalities that range from black to white with everything in between. A full-scale exposure is the ideal in most situations. Some exceptions exist, however. For example, consider a scene that's supposed to be light, such as a snowy scene. In this case, most of the information would be skewed to the right. The opposite is true for a particularly dark scene.

If your scene's tonality is weighted heavily toward the left and is bunched up specifically at the very edge of the histogram, your image is underexposed. If the scene's tonality is bunched up on the right side of the histogram, your image is overexposed.

In digital photography, detail in your highlights is vital. If you overexpose your image, the detail in your highlights is gone for good. You can't recover highlight information in postproduction if it wasn't there to begin with. So, the best way to expose a scene is to capture detail in the highlights and to brighten the shadow areas (if necessary) in postproduction. For more on postproduction editing, see Chapter 18.

Discovering your camera's light meter

Your digital camera has a built-in light meter that determines how much light is available in a scene and helps you properly expose your image. The meter reads light that's reflecting off an element in a scene, and determines (based on your chosen ISO) how the level of light affects your digital sensor. Your camera then tells you whether you're underexposed or overexposed. You can compensate accordingly by altering your aperture, shutter speed, or ISO. (Read more about aperture, shutter speed, and ISO in the earlier section "Taking a closer look at aperture, shutter speed, and ISO.") Check out your camera's manual to discover where to see its meter readings and how to change your exposure settings.

You often can choose from four different metering modes, which you can read about in your camera's owner's manual. Each mode is useful for different subjects. Here are the modes and their uses:

- **Evaluative metering:** This mode detects the subject's position based on where you place your focal point. (For more on focal point, turn to Chapters 2 and 7.) It reads the value of light all around the subject and compares its brightness to the rest of the scene to determine a proper exposure. Evaluative metering usually is the standard or default mode, because it's suited for most subjects and situations.

- **Partial metering:** This mode reads the light information that exists in the center area of your frame. So, you must make sure your subject is in the center when you take your exposure reading. After that you can adjust your composition to position your subject somewhere else in the frame. Partial metering is most effective when your background is much brighter than your subject. This situation happens in backlit situations — when your subject is in front of the setting sun, for example.

- **Spot metering:** This mode meters a particular element or area, so if you want to set your exposure based on one specific element in your scene, it's the best mode to use. Black-and-white film photographers mostly used spot metering to determine the various intensities of light in a scene. It isn't as commonly used in digital photography, however.

- **Center-weighted average metering:** This mode uses the center of your frame to get a meter reading, and then it creates an average reading for the rest of the scene. Center-weighted average metering is sort of a mix

between evaluative and partial metering. ***Warning:*** This method isn't the most accurate, so I recommend that you not focus too much attention on it.

Using your camera's meter is a good way to get a general start to exposing an image, but I suggest that you look at your histogram for any particular scene after taking an image. If the histogram is bunched toward the left, increase your exposure (regardless of what your meter reading says), and if it's bunched toward the right, decrease your exposure. (Check out the earlier section "Using a histogram to check exposure" for more on histograms.)

Relying on your camera's automatic modes

Digital SLRs provide you with different types of automatic modes to work with based on your priorities. The following three modes are the ones you need to know about:

- ✔ **Full automatic:** With this mode, you don't have to think about any of your settings. You don't have control over your aperture, shutter speed, or ISO settings, so you're free to concentrate fully on your compositions and communications with your subjects. Results may vary when using this mode.

- ✔ **Tv shutter priority:** This mode gives you control over your shutter speed but handles aperture settings for you. If you want a fast shutter speed to freeze motion or a slow shutter speed to capture motion blur in a waterfall or a scene with cars driving down the street, this mode allows your camera's meter to determine your aperture settings. This mode comes in handy when shooting fast-paced sporting events. (Read more about photographing moving subjects in Chapter 16.)

- ✔ **Av aperture priority:** This mode enables you to select your aperture, but it chooses the appropriate shutter speed for you. You'll find Av aperture priority mode handy when you desire a specific depth of field but aren't concerned with the speed of your shutter. You'll most likely use this mode on still subjects and when you have a well-lit scene or when your camera is on a tripod.

Check your owner's manual to find out more about the modes your camera includes and how to set them.

I recommend that you get into the habit of shooting manually. It's a lot like driving: A person who can drive a manual transmission can always drive an automatic in a jam, but a person who only drives automatic usually can't drive a stick if they ever have to. In other words, you want to be comfortable with your camera and its settings at all times just in case.

I sometimes switch my camera to automatic shooting modes based on convenience or necessity. One of those situations is when I'm shooting an event or wedding in conditions where the light intensity keeps changing. Rather than manually switching my settings back and forth, I let the camera do the work for me. I also use an automatic mode if I'm shooting in extremely low light and relying on an on-camera flash to light my scenes. Shooting in auto allows the camera and flash to work together in creating the most appropriate exposures based on the situation at hand.

Putting Together an Effective Toolkit

In photography, having the right tools is often as important as both having a good eye and being in the right place at the right time. However, having too many tools can be overwhelming and can cloud your judgment. So start off by compiling a toolkit that covers the basics and gets you headed in the right direction. Through time you'll naturally acquire all the extras — and the expertise to use them.

Before heading out to photograph, always think about whether you can actually record light with the gear you've packed. Ask yourself whether you have the following essentials in your basic toolkit:

- **A camera:** Don't laugh — I'm sure some photographers have forgotten their cameras in the past.

- **Lenses:** Make sure you have the right lenses for the specific photos you want to capture.

- **Compact memory cards:** You need these cards to record the images. I have forgotten to take these to a shoot, and it was embarrassing. Without them, you can only pretend to take pictures.

- **An artificial light source:** You can choose from a battery-operated external flash, a strobe kit, and so on. Whether you need a light source depends on what you're shooting and what the lighting is going to be like. (For more about lighting, flip to Chapter 10.) For instance, if you're shooting indoors at nighttime, you'll probably want to bring a flash.

- **A tripod:** You never know when you'll end up in a low-light situation, or when you'll want to take multiple shots with your camera in one position. Bring your tripod to be prepared.

This list covers most situations and enables you to take photos (which is, after all, the whole point). But in order to pack the gear, you have to acquire it first. The following sections help guide you in the right direction.

When purchasing camera gear on the Internet, avoid online stores that don't appear trustworthy. They may offer a better deal, but you don't want to risk getting ripped off. In general, I shop at the B&H Web site (`www.bhphoto video.com`). The company carries pretty much everything and is trusted by most photographers.

Finding a camera that fits your photography style and budget

When looking for a camera, consider what type of photographer you are and what you need in a camera. You have many cameras to choose from, and each is slightly or drastically different depending on how much you want to spend. Here are the most common camera levels to choose from:

- ✔ **The basic consumer level:** This level offers the most variety and targets everyone, including children, artists, trendsetters, travelers, family portrait enthusiasts, memory makers, and Internet social networkers. Consumer-level cameras try to sell you on ideas like simplicity, looks, and convenience. The quality ranges from bad to decent, and the prices range from $200 to $1,200.

 These cameras are great for snapshot photography and for the photographer who enjoys composing images but doesn't necessarily want to develop a deeper understanding of the process.

- ✔ **The semipro and hobby level:** This level offers high-quality cameras that fit into a smaller range than consumer-level products and still include a variety of features and a high level of quality. Semipro- and hobby-level cameras usually range from $1,200 to $3,500. You can create beautiful, high-quality images with these cameras, and you can choose from plenty of options that cover all types of photography.

 Most photographers never need to upgrade from this level. The image quality is outstanding and useful in most artistic and commercial applications. I shoot exclusively with cameras from this level and have produced commercial images for major clients, including billboards and movie posters. If you're serious about photography and looking for a place to start, research the cameras in this level.

- ✔ **The professional level:** This level offers a few options that are very specific and appeal to photographers who know exactly what they want based on their photography style. Professional cameras generally are $3,500, but they can easily cost you $7,000.

 These cameras aren't necessary for beginners, but they can be beneficial to a photographer who shoots for specific clients and needs the highest quality available. If you shoot sports events and need the fastest camera on the market, or if you're an artist and want to produce the largest prints with the highest quality, this level of camera may be for you.

Before purchasing your camera, research to see what's available. Choose a specific brand and look at the different cameras that the company offers. Pay attention to what features are available in certain price ranges. When you find the price range that works best for your needs, compare the different brands that offer something at that price. Also read online reviews that other photographers have written and compare each brand to find out which will serve you and your photography style best.

Looking for a lens to suit your needs

After you find your camera body, you need at least one lens. Determine which focal length would best suit you and whether you need a zoom lens or a fixed lens. (I describe each of these lenses in the earlier section "Making the All-Important Lens Choice.")

A great general-use lens for beginners is a 28mm–135mm zoom lens. You can acquire more lenses over time, but if you can have only one lens right now, make it one that has a good range of focal lengths.

Each camera body is designed to work with lenses made from the same company, and you generally can't mix and match. For instance, Canon lenses aren't compatible with Nikon cameras (and vice versa). However, some companies make lenses that are compatible with those two brands. If you do the research and find out which lenses work with your camera, you may be able to save some cash. I recommend reading reviews from other photographers before buying anything, however.

Selecting memory cards

Sure, a camera body and lens are important if you want to take photos, but unless you have something to store those digital photos on, you can only pretend to shoot. You need memory cards to record your images and download them to your computer. The size and shape of the card varies depending on the make of your camera. Check your owner's manual to be sure you purchase the proper card.

Memory cards come with different storage sizes and different speeds. Most photographers don't need to buy the biggest, fastest, and most expensive cards. I recommend starting out with a few 4 gigabyte (GB) cards that have a rating of at least 30 megabytes per second.

Having four 4GB cards as opposed to one 16GB card enables you to store images in multiple areas rather than putting all your eggs in one basket. Imagine shooting all day and then realizing that the one card that contains all your images is lost or broken.

Getting the right external flash

Sometimes the light you have in a scene isn't adequate for getting the exposure you want for your image. In this case, you need to have some sort of artificial light, such as an external flash or strobe. (You can find more information about lighting in Chapter 10.)

Your camera brand makes external flashes that are designed to work specifically with your camera. When you connect the flash to the camera, the two products communicate and automatically expose images. The camera adjusts its exposure settings and tells the flash how much light to produce in order for the scene to be properly exposed. This flash process is referred to as *through-the-lens exposure analysis,* or TTL. You can find out how to set your flash to TTL by reading the flash owner's manual.

TTL creates a simple shooting experience in which you don't have to worry about setting the intensity of your flash, but it only works when the camera and the flash are made by the same company. Don't try to mount a Nikon flash on a Canon body and expect the two to sync with TTL features.

Trying a tripod

Tripods are essential for taking images with slow shutter speeds and for leveling your camera to ensure a proper perspective in nature and architecture photography. (Chapter 8 tells you more about perspective.) I bring a tripod on every shoot whether I plan to use it or not. It's nice to have it when you need it.

You can find tripods in different weights and sizes. The most important factor to consider when purchasing a tripod is what you plan to use it for. Consider the following:

- ✔ If you are a travel or nature photographer and go on long hikes with your gear, you want a tripod that's lightweight and compact.

- ✔ If you shoot architecture, you want a tripod that has a great deal of extension in the legs; architecture photographers commonly shoot from high angles for exterior shots. For this type of photography, a tripod that reaches at least 10 feet is essential (and so is bringing a step stool along with it).

- ✔ A studio photographer would be best suited with a heavy tripod that's as large and sturdy as possible.

Look at the different tripods available and determine what qualities would best suit you and your style of photography.

Figure 3-7 shows a scene with a still subject that I photographed using a very slow shutter speed of 1 second. I took the image on the left while the camera was fixed to a tripod. The result is a sharp image. I held the camera in my hands to snap the image on the right. As you can see, the natural movement of my hands caused the scene to become blurry with motion blur.

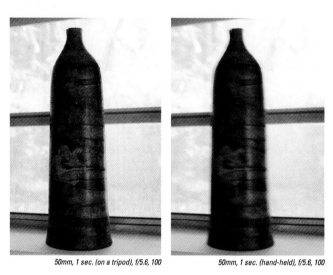

50mm, 1 sec. (on a tripod), f/5.6, 100 *50mm, 1 sec. (hand-held), f/5.6, 100*

Figure 3-7: Placing your camera on a tripod enables you to use slow shutter speeds and maintain sharpness in a still scene.

Part II
Elements of
Photographic Design

The 5th Wave · By Rich Tennant

"I read that you should always divide your pictures into thirds, but I can't for the life of me see how that improves them."

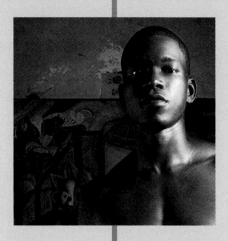

In this part . . .

Photographic composition involves many layers and ideas, and in this part of the book you find out about the elements that go into any composition. I introduce you to the fundamentals that lead you toward amazing photographs, and I also tell you about the rules of composition that decades of photographic talent have honed. (You do yourself a service in learning them, but don't think you can't break them.) Finally, I round out the part with a helpful chapter on using color in your compositions.

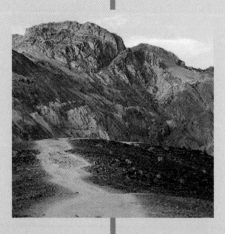

Introducing the Elements of Photographic Design

· ·

In This Chapter

▷ Determining what your points of interest are in a scene

▷ Understanding lines in composition

▷ Differentiating between shape and form

▷ Working with texture to increase scale and depth

▷ Exploring the patterns you can include in your compositions

· ·

*P*hotographic composition is a combination of everything in an image. Depending on how you compose a photograph, you may represent each separate element in your frame as what it literally is or as the basic lines, shapes, forms, and textures it includes. For instance, you can include in your composition a sofa that's obviously viewed as a sofa, or you can break it down to its shapes and lines or the colors and textures it contains.

In order to purposefully create compositions that have a clear message and that are visually impressive and influential, you need to understand the basic elements of design and what each is capable of. Understanding basic design helps you make compositional decisions that improve the way your photography looks and reads.

As a starting point, consider a stick figure: A stick figure with its arms angled upward seems happier than a stick figure with its arms angled downward. Even without any literal expressions or details, the message of joy is conveyed through lines and shapes. If a stick figure was standing at the beginning of two lines that gradually got closer until they finally connected at a point, you could get the idea that the stick

figure was standing on a road and had a distance to travel. The lines and shapes in your scene create the foundation of your message. The relationships they have with each other make up the basis of your composition.

In this chapter, I examine the basic elements of design, such as points, lines, shapes, textures, and patterns. I show you how to use them in your photographic compositions to maximize the aesthetic and descriptive value of your images.

Grasping the Point about Points

The most basic design element is known as a *point,* which is any spot or area where something exists in a photograph. A simple way to look at it is as a *point of interest.* Your eyes are drawn to the points in a photograph.

For instance, a white frame with a single red dot is a composition with one point, the red dot. If the frame had a second red dot, it too would represent a point in the composition. If you then added two intersecting lines in the frame, the area in which they intersected would represent a point.

Your subject can exist at a point if it's fairly small in your frame, but a large subject would most likely have multiple points of interest. In a close-up of a person's face, for example, her eyes, nose, and mouth are all points of interest.

The *rule of thirds,* which I discuss in Chapter 5, helps you determine where to position the key points of interest in your frame to give them the most visual impact. Figure 4-1 illustrates how the rule of thirds highlights the four strongest points in your frame, which are depicted as the larger dots. These stronger points are called *primary points.* The smaller dots represent the supporting elements, called *secondary points.*

Figure 4-1: A graph highlighting the four strongest points and the secondary points of interest in a frame.

Some photographers refer to the four main points in a composition as the *golden points.* Viewers naturally consider anything on these points important, so use those points wisely. Sometimes filling one or more of your strongest points with *negative space* (blank space that doesn't contain any point of interest) strengthens the other points compositionally.

Each element in Figure 4-2 has a particular size and position in the frame, which determines its importance and role in the message. Check out the graphed version of the image to see how each element relates to the others.

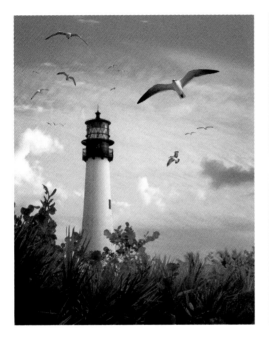

50mm, 1/250 sec., f/11, 100

Figure 4-2: A photographic composition with various elements and a breakdown of how important each point is and its role in the composition.

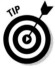 Because Americans read from left to right, an American audience would most likely be drawn to the points on the left side of your frame. Even so, you determine the strongest point in your image by how you position the elements in your frame. In Chapter 1, I tell you that the area with the most contrast will most likely be the first place a viewer looks in your frame. So, if you place that high-contrast area on one of your golden points, it most likely will be the strongest point in your image.

Anything can occupy a golden or secondary point and act as a point of interest. For example, consider the following:

✔ Intersecting lines create a point at the area where they cross.

✔ Lines that meet at a point and don't intersect can create a vanishing point, like railroad tracks going off into the horizon.

✔ Any area of high contrast draws attention and so constitutes a point.

✔ Small shapes and forms can create points. An oak tree on top of a hill in the distance, the moon in the sky, freckles on a person's skin, or a bird on a wire could each represent a point.

Following Lines, Real and Imagined

You use lines in a composition to lead a viewer from one point of interest in an image to another. These lines often are literal, such as a telephone pole and the wires attached to it or the shadows the pole and wires create. An element that has the visual impact of a line or is made up of lines generally is considered a line as far as design goes.

However, you also can use *implied lines,* which aren't as easy to spot as literal lines but are equally important for creating excellent compositions. An implied line can be created by the edge of a shape, the joining of two edges (like where the wall meets the floor), the direction a person is looking or pointing, or directional light. If something causes you to follow a linear path through the scene, consider it an implied line.

Figure 4-3 shows an image with a strong sense of lines. If not for the lines in this scene, I wouldn't have even taken my camera out of the bag. This image includes a few different design elements, but notice how the lines have the strongest visual impact. They work together to guide your eyes through the frame so you explore all the different details.

The telephone pole and the wires coming from it represent literal lines. The pole itself has the strongest presence in the scene, so it's the first thing to draw your eyes in. It does so because it makes up the point of highest contrast, is positioned along the left third of the frame, and is the largest element in the scene from this vantage point. The pole leads your eyes up to the wires, and they lead you into the vanishing point on the horizon.

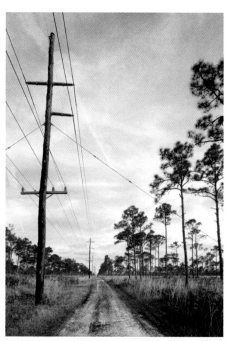

24mm, 1/250 sec., f/14, 400

Figure 4-3: It's easy to see how lines lead your eyes through the frame in this image.

If you start to pay attention to the implied lines in the scene, you notice that everything leads your eyes to that same vanishing point, including the following: The tree line (or the line created by the tops of the trees), the lines created where the road meets the brush, the textures in the dirt road, and the texture and patterns created by the clouds in the sky. (I tell you more about the last effect in the later section "Considering Pattern Types.")

In fact, Figure 4-3 tells a story by using lines. Everything points out how distant the road is. Only trees, telephone poles, brush, sky, and the dirt road appear in this image. The message would be quite different if the frame included a house or a person walking along the road. This image, in its most basic sense, is about the relationship of lines and distance. As you explore the frame, you're constantly led back (by lines) to the area that represents the farthest distance.

In the following sections, I explain how to effectively use and position the different types of literal lines, and then I give you further guidance on seeing and including implied lines in your compositions.

Looking at literal lines

The queen is the strongest piece in chess because she can move vertically, horizontally, and diagonally, which gives her access to the whole board. A strong photographic composition with lines guides viewers to points of interest in various ways as well.

You can use different types of lines to strengthen an image's message. People subconsciously make associations with lines based on whether they're vertical, horizontal, straight, curvy, diagonal, soft, edgy, or three-dimensional. In order to use lines as a design tool to create great compositions that get a clear message across, you need to understand what each type of line signals to viewers. Start by thinking about the common elements that a particular type of line reminds you of. The upcoming sections give you some examples of what message certain types of lines can portray.

Strong and sturdy: Vertical lines

The way viewers interpret a vertical line depends on the subject or element in question, but in general a vertical line appears strong, dignified, and sturdy.

Skyscrapers, for example, stand erect in a vertical line and represent height, strength, dignity, formality, and sturdiness. A person who stands with good posture represents those same characteristics; on the other hand, a person who slouches conveys a message of laziness, weakness, or informality.

The pole in Figure 4-3 leans slightly to the right, which keeps it from appearing sturdy. Had the pole been perfectly perpendicular to the ground, it would have seemed more permanent and less rickety.

Calm and expansive: Horizontal lines

Horizontal lines give a sense of calm and repose (like a person napping). They also can represent expansiveness and mass. A building that's wider than it is tall seems anchored, for example. The most common horizontal line, of course, is the horizon, which makes me think of gravity.

Consider your subject matter when determining how it will be represented as a horizontal line. A person lying in a grassy field will seem more relaxed than a person standing in a grassy field. A tabletop provides an area for items to rest, and people standing in a line offer a formal horizontal sequence for you to look at (much like the letters in this sentence). If vertical lines are dignified, horizontal lines are relaxed.

Lively and interesting: Diagonal lines

Diagonal lines can give a sense of energy. When something is in the process of falling over, it's diagonal; a person running is diagonal; and a palm tree blowing in the winds during a Miami hurricane is diagonal. Some may consider diagonal lines to be less formal than vertical and horizontal lines, but in that sense you could say that a diagonal line is more interesting.

Diagonals work well to connect areas within your image; combining them with other types of lines makes for a more dynamic composition as well. You also can achieve three-dimensionality in an image by using diagonal lines. For instance, if you were at the beach and pointing your camera straight out at the horizon, your image would have a horizontal shoreline and horizon and wouldn't offer a three-dimensional sense. If you pointed your camera up or down the shoreline, however, it would become diagonal and would gradually move closer to the horizontal horizon, giving the illusion of distance and depth, or three-dimensionality.

Graceful and depth-producing: Curvy lines

Curved lines appear graceful, beautiful, sensual, fun, and organic. The shape of a woman's body, the idea of a winding country road in the mountains, and a river cutting through the forest all are idealized as being curvy. The most sought out type of lines in photography are those that have an *S curve*. This type of line is named as such because it looks like an S — it curves out to one direction and then comes back in the other.

Curvy lines (particularly S curves) can add a great deal of interest to your compositions. Use them to create graceful and sexy compositions or to add depth to an image. Like diagonal lines, curvy lines can stretch into the distance toward a vanishing point. Figure 4-4 shows you how curvy lines work to draw your eyes to where the dirt road gets lost in the mountains.

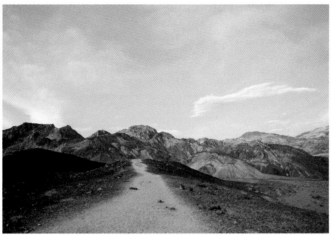

24mm, 1/50 sec., f/5, 50

Figure 4-4: Curvy lines can be used to give a sense of depth.

Tracking implied lines

Certain recognizable actions or ideas in an image can create invisible lines. These are referred to as *implied lines* because you can't see them but you follow them anyway.

If a human subject in an image is looking at a specific area in the scene, for example, viewers look at that area to see what the subject is looking at. Compositionally speaking, a subject's line of sight can work as an invisible line to guide your eyes to another area of the image. You can combine implied lines with literal lines for even more dynamics in a composition. And keep in mind that implied lines can carry the same qualities as literal lines with regard to being horizontal, vertical, diagonal, and curvy.

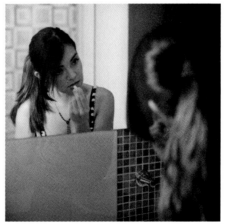

50mm, 1/30 sec., f/2.5, 400

Figure 4-5: Line of sight being used as an implied compositional line.

Figure 4-5 represents an image with implied lines. The eye contact that the woman is making with herself in the mirror helps keep viewers looking back and forth between her and her reflection.

Motion is another type of implied line. You follow the direction in which a subject is moving as if to see where it's going. And if two points of interest are lined up with each other across the frame and nothing but negative space stands between them, you most likely cut across the image in a straight line from one to the other, creating an implied line. These are good techniques to use when a scene doesn't provide any useful lines in the literal sense.

Bringing More to the Mix with Shape and Form

When lines connect to seal off a specific area in a composition, they create shapes and forms. One line that goes around in a loop creates a circle, and three lines that intersect create a triangle. Refer to Figure 4-3, for instance, and notice the following combinations of lines that create different shapes:

- The lines that make up the road form a triangle as they move into the distance.
- The horizon line combined with the frame's edges and the area where the brush meets the road outline diamond shapes.
- The trees make triangles, and so do the wires.
- The sky takes on a similar shape to the diamonds in the foreground created by the brush.

Shapes and forms work together with lines to say even more about a particular scene. Understanding what shapes and forms convey in your message and being able to differentiate the two is necessary to create beautiful and descriptive compositions.

In the following sections, I explain the differences between shape and form and show you how to highlight each in your compositions.

Distinguishing between shape and form

In photographic composition, shape and form are related but separate. Elements can have similar shapes but different forms. The shape of a racquetball is similar to that of an orange, for example, but the two are very different in form. The racquetball is perfectly spherical, while the orange has natural flaws in its shape. Also, the texture of an orange is rougher than that of a racquetball. You would approach each differently in terms of composition based on what you wanted to reveal about them.

To distinguish between the two, here's what you need to know:

✔ **An element's *shape* is represented by its outline.** A shape is two-dimensional and takes up a specific amount of your frame's space. A human silhouette is a recognizable shape, as is that of a tree or a chair.

✔ **In photography, *form* is the three-dimensional representation of a shape.** Your images are two-dimensional, but they can give the feeling of three-dimensionality by revealing a sense of space.

In Figure 4-6, a circle sits on the left side of the composition. It only takes up space on the surface of the frame. The element on the right has the same shape as the element on the left but is a sphere. It takes up space inside the frame, which you see because of light and shadow.

Figure 4-6: The element on the left is a shape and the element on the right is a form.

The following sections tell you more about shape and form and when you want to use each.

Examining shape

Understanding how shapes fit into a frame and relate to other shapes is an important step in photographic design. The way you position shapes and show how they compare with one another creates their relationship in a composition.

Look at the couple in Figure 4-7. The shapes of their bodies come together to create a new shape that's recognizable and visually pleasing. The compositional element of shape alone creates the message in this image. If you had no other details to interpret, you would still get the idea that this image is about a couple in love.

Here are some guidelines to keep in mind when considering how to portray shapes in your compositions:

✔ **Represent the shape of your subject in the best possible way.** Your goal should be to make your subject as recognizable as you can. For instance, a human silhouette is more clearly recognizable when viewers can make out the shape of the head and limbs. And appropriate separation between certain body parts helps tell the story. A person who's running ideally has one leg in front and the other behind; the same goes for the arms. The runner's knees and elbows are bent and the body leans on a forward diagonal. A person who's dancing may have her arms above her head and her hip would swing out to one side.

50mm, 1/1000 sec., f/2.8, 100

Figure 4-7: Shapes and their relationships to each other lay the foundation for a photo's message.

✔ **Choose an appropriate angle.** The angle from which you shoot determines how your image reveals the shape of a subject. A silhouette of a cat that's photographed from the front or side view and from a very low angle is more descriptive than one photographed from a high angle behind the cat.

✔ **Consider your subject's shape and how it fits into the shape of your frame.** A person, for example, is made up of organic shapes (natural and curvy), and the frame of your shot is geometric (uniform and not often found in nature). This contrast creates an interesting relationship when you execute it properly.

Look at how the silhouette in Figure 4-8 fits in the frame. The black area represents the organic shapes of the person; the white area represents the geometric shape of the frame combined with the organic shape of the subject. The white area around the subject has just as much visual importance as the area that represents the subject.

✔ **Create a sense of balance and flow around the subject.** You can do so by leaving some space around the edges of the frame and by creating interesting shapes. If the subject in Figure 4-8 was standing straight up with no accented curves in her posture and was positioned dead center in the frame, the results would be far less attractive than the final image you see.

Getting the scoop on form

An element's two-dimensional shape is defined by how much of the frame's space it takes up and in what manner. (See the preceding section for more on shape.) Its form, on the other hand, is defined by how much space it takes up inside the space of the frame.

Forms work together with lines and shapes to convey meaning in a composition. Because a form includes more detail than the other two compositional elements, it conveys a message in a more literal sense.

Figure 4-7 tells the story of a loving couple through shape and form. Squint your eyes when viewing it and notice how the pose of the couple creates a recognizable shape that you know as two people embracing. Form reveals the more literal narrative qualities, such as facial expressions, detailed hand gestures, the type of clothing people have on, and so on.

How you reveal form in an image depends on how you position the lines and shapes of your scene, but it also depends on lighting and shadows. Chapter 10 explains different types of lighting and how to work with different subject matter (or different forms).

Figure 4-8: The placement of a shape in a frame combined with the nature of the shape is important to a photo's message.

Emphasizing shape or form in a composition

Depending on what you want your photo to say, you may choose to emphasize either shape or form in a composition. Each emphasis requires different treatment. Here's the lowdown on both:

- ✔ **Emphasizing shape:** When you want to give a universal message that represents a recognizable idea or feeling, you usually do so with shapes rather than forms.

 You can emphasize shape as opposed to form by shooting in a backlit scenario, such as the one in Figure 4-7 where the sun is directly behind the subjects. Backlighting creates a silhouette, which draws attention to the shape of a subject but doesn't reveal form. Use this lighting technique when the shape of your subject is more important to your message than the literal details in its form. For instance, a random person fishing off the edge of a pier during sunset could be silhouetted to give the timeless sense of what's happening. The lack of detail enables viewers to envision themselves in the person's place.

✔ **Emphasizing form:** If the details of your subject are important to your message, you'll more likely emphasize form over shape in your composition. Say, for example, the man fishing off the pier at sunset is your father. In that case, you could create a great image of him by changing your point of view so he's lit from the side by the sun rather than from behind. This angle reveals details in his face and clothing, causing the image to become sentimental. Understanding perspective (Chapter 8) and lighting (Chapter 10) helps you emphasize form in an image.

Adding Scale or Depth with Texture

Texture is an important element in images, and it can play several roles. It can inform viewers of what they're looking at, offer a sense of scale and distance, and add depth. If you include the peeling bark of a birch tree, for example, nobody's going to look at your image and think the subject is a car. By including the tree's lines, shapes, and forms, viewers know without doubt that they're looking at a tree.

Trees that appear in the distance within an image create the texture of the landscape. Viewers don't get a sense of the textures of the individual trees, but they get the sense of trees *as* texture. This technique gives viewers the sense of scale: Because trees are big, viewers know that the more trees shown in the image, the bigger the space being represented must be. If your vantage point looks over the tops of the trees, you can see rows of them as they go back into the distance. This angle gives the sense of depth in a composition.

The following are some examples of how you may use the texture of something to convey a certain message:

✔ **The texture of a person's skin can give you an idea of how old the person is, or what kind of life he's had.** Someone who has worked hard all his life doing manual labor outdoors has rougher skin than someone who was pampered and didn't have to spend so much time exposed to the sun.

✔ **The texture of a subject can represent the selling point of that item.** For instance, a frosty mug of beer wouldn't look nearly as refreshing if sweat beads weren't dotting the surface of the glass. Similarly, if you were looking at images of carpet, you wouldn't be able to differentiate them if you couldn't get a sense of their textures.

The best way to reveal texture in an image is to light it from the side. Doing so puts a highlight on one side of the elements that make up the texture and a shadow on the other throughout the surface, giving a three-dimensional sense to the texture itself. (For more on lighting see Chapter 10.)

In Figure 4-9, I used sidelighting to bring out the texture in the brick. I took this image for a brick manufacturer that needs to provide its clients with images that clearly represent the specific qualities of its products. Revealing texture gives the clients a sense of what makes this brick texturally different from another brick with the same shape and color.

135mm, 2 sec., f/11, 200

Figure 4-9: Sidelighting helps to reveal texture in an image.

Considering Pattern Types

Photographers seem to be drawn to patterns, both natural and manmade. Patterns are interesting to look at, so it makes sense that they work well in photographic compositions. In fact, patterns can help you do any of the following: reinforce your message, draw a viewer's eye to certain elements in your scene, and add visual interest.

Most importantly, however, including patterns in your compositions is an easy way to keep a viewer in your frame for longer periods of time. You can lead a viewer to your subject by positioning it at the end of a pattern or in the line of one. Picture a car driving around the bend on a winding road. The yellow dotted lines create a pattern that leads your eyes from the foreground, around the bend, and right to the car.

The key to using patterns successfully in your compositions is to know one when you see it, to know which type of pattern it is, and to figure out how it relates to your message. I show you several of the different types of patterns you're likely to use in the following sections.

Adding interest with sequence patterns

You can find a *sequence pattern* — a pattern in which one element follows another — just about anywhere. The windows on the outside of a building can create a pattern, as can the railroad tracks, or the ripples in a lake after you throw a stone in it, which is exactly what I did to add interest to the

composition in Figure 4-10. The scene alone was interesting enough to photograph, but I still felt that it could use something else to make people want to look at it — and continue to look at it. Without the sequence of ripples in the water, this lagoon would be bordering on boring.

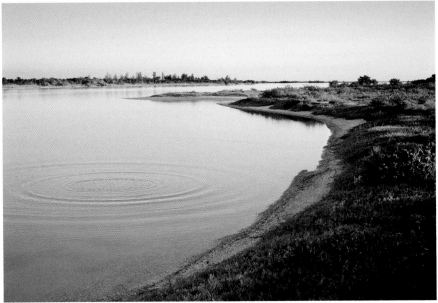

50mm, 1/160 sec., f/8, 100

Figure 4-10: Using a pattern to add interest to your composition.

Look for basic sequence patterns in reflections, butterflies, brick walls, ripples in the sand and water, and on flowers, plants, and trees (to name only a few). Elements that repeat naturally draw the eye and people's attention. Viewers often tend to follow the pattern to see whether it keeps going or to compare one side to the other as if looking for differences.

Leading your viewer by using repetition

Repetition can suggest a pattern even when no real pattern exists. Five men lined up with surfboards standing in the sand right next to one another can suggest a pattern. The men and boards can be of varying shapes and sizes and colors. This situation doesn't technically show a pattern, but you get the sense that it does, and your eyes are drawn to it.

Repeating elements also help drive home your message. For instance, if you see one sailor walking down the street in Times Square, you may assume he's on leave and is visiting the city. On the other hand, if the streets are filled with sailors, you probably can assume that a parade or other special occasion is taking place.

Notice the use of repetition in Figure 4-11. The chopsticks act as leading lines to direct your eyes to the main subject — the repeating sushi rolls. (I explain more about using lines in the earlier section "Following Lines, Real and Imagined.") The repeating shapes of the sushi rolls draw your eyes around the frame and back to the starting point, which in turn leads your eyes back into the image. In this image, repetition works as a leading element and as a descriptive element. It shows how many pieces are served with this particular menu item.

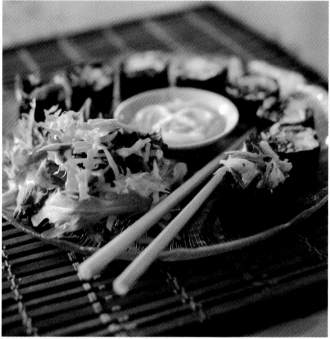

50mm, 1/100 sec., f/2.5, 400

Figure 4-11: Repetition is used to guide your eyes through the frame and inform you about the subject.

Breaking patterns to grab attention

One way to capture attention even more strongly than a pattern itself is to show a break in a pattern. Technically, a break in a pattern could be considered a flaw, and flaws stick out visually like sore thumbs. However, you can use this attention to your advantage; Figure 4-12 proves it. Which window draws your eyes the most?

In the figure, the windows with no lights create the pattern. The one window with the lights on stands out as being different from the rest. If you take advantage of the situation and incorporate your subject in the broken area of the pattern, your subject will stand out for sure.

Sometimes the flaw in the pattern can work alone as your subject. For instance, a row of trees in which one has been chopped down could provide a message of taking only what's needed. A row of tree stumps with only one tree standing would provide a message of greed and abuse.

Figure 4-12: A break in the pattern can grab your attention more strongly than the pattern itself.

5

Arranging Visual Elements in a Frame According to the "Rules"

In This Chapter

▸ Understanding the different areas of an image

▸ Aiming for a more pleasing composition with the rule of thirds

▸ Making the most out of the space in your frame

▸ Deciding between simple and chaotic compositions

▸ Creating balance in a composition to keep a viewer's attention longer

*R*ookie photographers often instinctually place a subject dead center in a frame, but doing so rarely produces a great-looking photograph. So, as a photographer, one of the first things you need to recognize is that keeping your subject out of the center creates better compositions. In the world of visual arts, thousands of years of practice show that artists rarely obtain the ideal image of a subject by placing it in the center of a frame.

Think about it this way: If you placed a person's face directly in the center of your frame, you have just as much space above the head (referred to as *headroom*) as you do below the head. The person has an entire body below her head and nothing above it. So why waste the space above the person's head by showing nothing but the sky or your backdrop when you could eliminate that space and show more of the person's body?

As a photographer, you choose what to shoot and how to position that subject in your frame. The "rules" — okay, they're more like guidelines — I pose in this chapter get you started in the right direction; understanding them is the first step toward improving the way you take pictures.

Looking at Foreground, Background, and the Space Between

A typical scene is made up of these three different areas:

- ✔ **The foreground:** This area contains elements that are the closest to the camera.

- ✔ **The background:** This area is made up of anything that's the farthest from the camera or that's behind the subject itself.

- ✔ **The midground:** This is the space between the foreground and background.

You can compose an image that contains just a foreground and a background, but including a foreground, midground, and background in your compositions can maximize the illusion of depth. The separate areas work together to give the sense of space.

In most cases, your subject can exist in the foreground or the midground. Exceptional situations enable you to photograph your subject in the background (such as mountains or a storm on the horizon as your subject), but these cases are rare.

Because the foreground is the most prevalent to the viewer, placing your subject there is an easy way to make it stand out in your image. This position, which is closest to your camera, maximizes the size of your subject in relation to the other elements in your scene, causing it to seem important to a viewer. In this situation, the subject makes up the foreground and everything else is considered the background. However, to create a composition that's more dynamic and contains more depth, photographers often place the subject in the midground with supporting elements in the foreground and background.

When your subject occupies the midground, you can use foreground elements to lead a viewer into the scene. Supporting foreground elements often are blurry when compared to the subject because they're outside the range of your plane of focus, which determines what's sharp and what's blurred. (For information on focus, check out Chapter 7.)

Figure 5-1 shows an image composed to have a foreground, midground, and background. The tree on the left side of the frame and the brush on the ground make up the foreground in this scene. They give you a sense of what the environment is like and lead your eyes to the subject in the midground, which is the house with the two dummies. The subject is the main focus of the image and is supported by the foreground and the background. The

mountains and the sky make up the background in this image. They work with the foreground to create the illusion of depth, which causes your eyes to wander around the image, exploring the different areas and gathering information about the subject. The combination of the foreground, midground, and background tells a lot about where this shack is located and how sparse the human population is there.

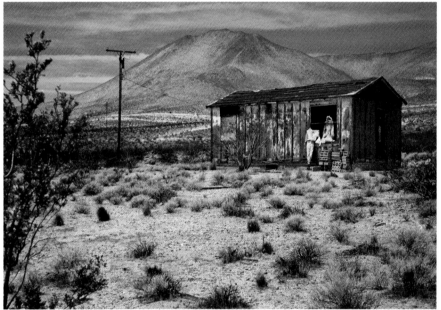

60mm, 1/400 sec., f/10, 100

Figure 5-1: The foreground, midground, and background in this image give a sense of depth.

Enlivening Your Images with the Rule of Thirds

The most common composition guideline is the *rule of thirds,* which refers to the photographic technique of dividing your frame into thirds horizontally and vertically to determine which areas have the most aesthetic quality. By placing key elements on a frame's thirds, you can create compositions that are easy to look at and can break the habit of placing your subject in the center. Getting your subject out of the frame's center produces more interesting, dynamic results. In the following sections, I show you how to take advantage of the rule of thirds to take the best photos possible.

Your subject consists of whatever seems most important to you in any scene. If you're having a difficult time identifying your subject, ask yourself why you're taking the picture in the first place. Are you creating a landscape that highlights the river curving off into the distance? If so, the river is your subject. If you're taking a person's portrait, the person is clearly the subject. You may have multiple subjects in one scene. In that case, you can use the rule of thirds to prioritize each subject.

Dividing your frame to conquer composition

To use the rule of thirds, imagine four lines (two vertical and two horizontal — picture a tic-tac-toe board) dividing your frame into nine equal boxes, as in Figure 5-2. These lines determine the sweet spots for positioning your scene's key elements, such as your subject.

View the image in Figure 5-2 to get an idea of how photographers typically use a frame's thirds. Notice how the woman's eyes are lined up along the top third of the frame and the horizon in the background is lined up along the bottom third. Plus, the woman's eyes are lined up with the left third of the frame rather than being centered.

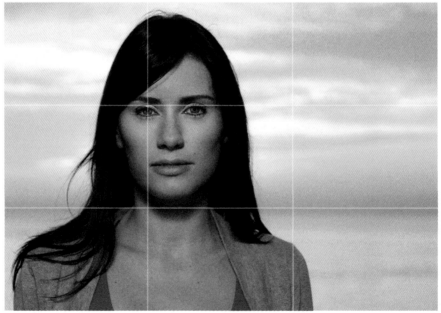

50mm, 1/125 sec., f/4.5, 50

Figure 5-2: The rule of thirds in action.

The areas where the horizontal and vertical lines of thirds intersect — called *golden points* — are known to have the highest visual impact. (You can read more about golden points in Chapter 4.) Placing a key element in one of these areas makes it one of the strongest visual elements in the frame. As you can see in Figure 5-2, the woman's eyes are placed near the intersection in the upper left-hand corner.

Don't get too obsessed with the positioning of your elements on the thirds. Placement doesn't have to be exact to be effective. Cutting your frame into thirds gives you an idea of where the most visually pleasing areas are, but it doesn't create a definite rule of where to place your elements. If your subject is a little to the left or right of one of the thirds, it's still going to get the attention it deserves. Think of the rule of thirds as a guide rather than a rule.

As you gain experience, the rule of thirds becomes so embedded in your brain that you stop noticing it's there. At this point, you automatically place the key elements on the thirds of your frame.

Using the thirds to their fullest

When taking a photo, you'll most likely want to place your subject in the area of most importance. You do so by placing it at a point where two of the thirds intersect in the frame. (See the earlier section "Dividing your frame to conquer composition" for more information on these golden points.)

For those who speak English, the left side of the frame has more visual impact than the right side because English reads from left to right. So placing your subject on the left third gives it the most compositional importance for English-speaking viewers. In cultures where text reads from right to left, the inverse is true.

Because a frame includes four points of intersection among the thirds, you have options when considering where to place particular elements in your frame.

Certain elements in composition (including your subject) almost always are placed on one of the thirds because of their naturally striking visual impact. Here are some common elements that are positioned on the thirds:

✔ **The horizon line:** The horizon line usually stands out in an image because it cuts straight through your frame from one side to the other. Placing it along the top third emphasizes what's in the foreground; placing it along the bottom third emphasizes the sky.

Notice, for example, the difference in the two images in Figure 5-3. In the image on the left, the horizon lies on the upper third, drawing attention to the chair in the foreground and the expansiveness of the sea. The image on the right, on the other hand, emphasizes the sky and the power of the kite because the horizon is on the bottom third.

✔ **The tops of buildings, trees, and mountains:** These elements often appear along the top or bottom third in an image. You sometimes can align the horizon with the bottom third and place the top of the buildings, trees, or mountains in the top third to create a comfortable composition that accommodates both naturally strong visual elements.

✔ **Supporting elements:** Your *supporting elements* are the things in a scene that help to tell the story of the subject. When photographing a musician, for example, including his instrument in the composition clues a viewer in to who he is. Place supporting elements on or near the thirds in order to take advantage of their descriptive qualities, but don't let them compete with your subject as the main attraction.

24mm, 1/80 sec., f/5.6, 200 *135mm, 1/125 sec., f/5.6, 200*

Figure 5-3: Draw attention to your foreground by placing the horizon on the top third and to your sky by placing it on the bottom third.

The size of your subject determines where you position that subject in your frame and what you focus on when positioning it. If the subject is large in your frame, you have to determine what detail is most important and most deserving of priority placement. For example, when you photograph a person so he's large in your frame, consider placing his eyes on a third so

viewers are drawn to make eye contact when looking at the image. If the person is smaller in your frame, you can simply position his entire body on one of the thirds.

Leaving some of your golden points empty (containing no points of interest) gives more impact to the ones you do use. In Figure 5-4, for instance, the right side of the frame has more visual impact on a viewer because the left third contains no points of interest. The left side of the frame contains leading lines that walk your eyes through the frame, but they ultimately lead you back to the subject.

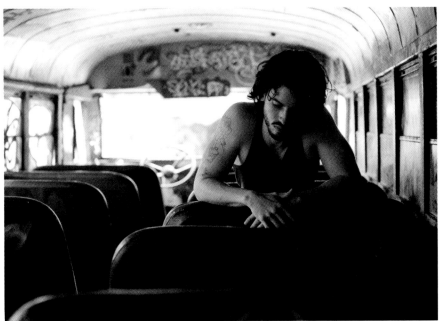

50mm, 1/125 sec., f/2.8, 400

Figure 5-4: Keeping some of your golden points free of compositional elements helps to draw more attention to the others.

Interpreting the rule of thirds to make it work for your scene

The rule of thirds is a wonderful guide for helping you get more creative with your compositions. It causes you to consider placing your subject, supporting elements, and horizon lines somewhere other than the center of your frame. However, don't think that you have to follow the rule of thirds to a T every time. If you compose images in such a formulaic way with every scenario, your photography will become predictable and possibly even boring.

Treat every scene according to its own unique circumstances. After all, certain elements change the way you compose a scene. Sometimes you can use the rule of thirds as a guide and then shift your subject (or another key element) a little to one side or the other in order to convey your message more appropriately.

The size and shape of your subject along with your intended message determine where you position the subject. Placing it closer to the center creates a more traditional and comfortable feeling. Placing it nearer the edge of your frame creates tension and suggests that you did so for a reason. Perhaps you intended to lessen the importance of the subject in comparison to the rest of the scene. You may use this composition if you were photographing a firefighter putting out a house fire. Having the firefighter toward the edge of the frame enables you to reveal the blazing house as a major part of the story.

After you find the appropriate position for your subject, also make sure that everything else in the scene has a place and fits comfortably in that place. Doing so is important to creating clear messages and images with high aesthetic quality.

Figure 5-5 shows you a composition that successfully manages many separate elements. I didn't follow the rule of thirds precisely in this figure, but I did apply the general theory.

Here's a breakdown of how I composed Figure 5-5 and why:

- ✔ **I positioned the subject between the center and the right thirds.** I placed him on the right side because of the room's setup and the lighting. The bed takes up much of the space on the left side of my frame, and the light comes from the right, casting a shadow to the left. If I had positioned my subject nearer the left third, the shadow (which creates an interesting leading line in the composition) would be lost, and he would be uncomfortably close to the bed. I moved him slightly toward the center to keep him from merging with the edge of the door on the right side of the frame.

 To avoid merging lines (see Chapter 9), I had to choose between placing my subject in front of the painting or in front of the door. I chose to block the painting with my subject so it wasn't recognizable. After all, this photo is my work of art, not the painter's.

- ✔ **I positioned the bed in the foreground to help lead viewers' eyes into the image.** This supporting element signals that the subject is in a bedroom and gives a sense of environment. The bed's coverings also have a similar texture to the curtains in the background, and repeating (or similar) elements add interest to a composition. (Chapter 4 tells you more about using patterns and repetition.)

- ✔ **I placed the horizon (where the floor meets the back wall) along the bottom third.** This placement helps create a comfortable space to work within. If a horizon line is too close to the center, it divides an image in

half in a somewhat uncomfortable manner. And having the horizon too close to the bottom edge creates an unbalanced relationship between the floor space and the wall space.

✔ **I arranged the chair in the background to balance the bed in the foreground.** Because of these strategic placements, this scene is naturally symmetrical; having something on the left requires something on the right to maintain balance.

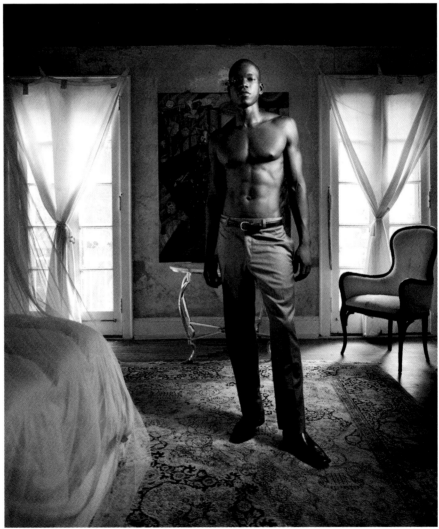

24mm, 1/25 sec., f/3.5, 500

Figure 5-5: Every element has its place in a successful composition.

✔ **I ensured that the back doors appeared at the edges of the frame in order to bring closure to the composition.** The outer edges of the doors are darker than the center areas of the doors, creating an edge that keeps viewers' eyes in the frame. In other words, including more wall space beyond the doors would have invited viewers' eyes to go out of the frame.

✔ **I left space in the foreground to bring viewers' eyes into the frame, and I included the dark section above the back wall to close out the top of the frame.** Both of these techniques help keep a viewer in the frame longer and provide descriptive details about the subject's environment. If this image was strictly about selling the pants or the model, I would crop in closer to show a clearer depiction of each. However, this particular image was created with the intentions of selling a photographic style that maximizes depth and narrative quality.

Your own judgment always trumps a general rule when choosing the best composition for an image. Keep the rules in mind but do what looks best in the end.

Taking Advantage of Space to Get Your Message Across

Your frame provides a rectangular space that's basically a blank canvas until you take off your lens cap and begin to compose a scene. You need to fill the canvas with information that's going to get your intended point across. The elements you include in your composition should fit appropriately according to their size in the frame and their relationship to the other elements.

Space refers to the two-dimensional frame you're working with and the three-dimensional relationships a scene's elements have with one another within the frame. The closer an element is to the camera, the more space it takes up in the frame. Various techniques enable you to take advantage of the space in your frame and use it to create visually compelling compositions. I explain what you need to know in the following sections.

Giving your subject more (or less) space

In order to reveal the details that are necessary for conveying your message, be sure to consider the amount of space that your subject takes up. When you want to reveal intimate details about your subject, for example, make it larger in your frame. You may use this technique to show the color of a person's eyes, the texture of a piece of fruit, and so on. If, on the other hand,

you feel that the environment surrounding the person can reveal more pertinent information to your intended message, you can back up from your subject and fit more of the scene into your frame.

Your ultimate goal is to find the best size to represent your subject while allowing adequate space to reveal any necessary supporting details in your scene. Sometimes you may want to fill your entire frame with your subject in order to show the maximum amount of detail, and other times you may reveal the subject as a tiny speck on top of a mountain.

Figure 5-6 shows two examples of the same subject in the same scene. In the image on the left, the subject is large in the frame and takes up a dominant amount of space. The image on the right shows the subject in a less-dominant position, which enables the environment to be more important and informative.

Emphasis on subject Emphasis on environment

Figure 5-6: Your subject's position in the frame changes what you reveal.

Allowing shapes room to breathe

When you compose an image, pay attention to how the shapes of your elements are being represented. When one element merges with another, which happens in the left-hand image of Figure 5-7, both shapes become less recognizable. By repositioning your camera or your subject, you can separate the elements in your frame to better illustrate them. See the image on the right, for example.

Merging elements A clear view

Figure 5-7: Show the shape of your subject and supporting elements in the best way possible.

WARNING!

In some cases, you can allow elements to merge in order to create the illusion of depth, but do so with caution. Make sure the closer elements don't block any important details in the further elements. Letting elements merge is appropriate only when it doesn't compromise the viewer's ability to see the elements as distinct objects.

For instance, in Figure 5-8, the image on the left shows two triangles side by side. This arrangement highlights their size relationship — because the gray triangle looks larger than the orange one and is on the same horizontal plane, you can assume it is in fact a larger triangle.

In the image on the right, I allowed the larger triangle to overlap the smaller one. I also positioned the smaller triangle higher in the frame than the larger one. This arrangement creates the illusion of distance. Because of the size difference and the overlapping effect, the gray triangle seems to be closer to the viewer than the orange triangle. In this version of the image, a viewer can't assume that the gray triangle is larger than the orange one, and he knows only that it's closer.

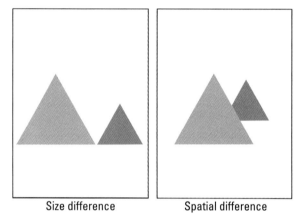

Size difference Spatial difference

Figure 5-8: Composition reveals size and spatial relationship of objects.

Staggering objects within your frame

Lining up elements throughout your frame can cause images to feel stiff and boring. However, using your space to stagger the elements keeps viewers' eyes moving from one to the other in an interesting way. Taking advantage of the space in your frame and giving viewers a reason to explore the whole scene is a good way to keep their attention for longer periods of time. Figure 5-9 shows you how staggering adds interest.

TIP

You can more easily create dynamic compositions with informal balance by using an odd number of key elements than with an even number. Perhaps this is because even numbers have a natural tendency to cause symmetry and formal balance. (Read more about the pros and cons of informal and

formal balance in Chapter 12.) You call a person who's boring a *square,* not a *pentagon.*

The left-hand image of Figure 5-9 shows a staggered composition of three elements. The lack of symmetry is natural when dealing with odd numbers. The right-hand image shows how to work with an even number of elements to throw off symmetry. Doing so adds interest in your composition and enhances the illusion of depth.

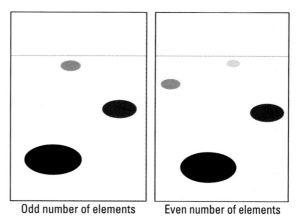

Odd number of elements Even number of elements

Figure 5-9: Staggering elements helps create interest in your compositions.

Containing lines inside your frame

When you allow a *leading line* (a compositional element that directs a viewer's attention) to go off the edge of your frame at a corner, you take the viewer out of the frame and leave yourself no space to bring her back into it. Doing so is clearly a problem because the whole point of creating a photo is to grab a viewer's attention and keep it for as long as possible.

In Figure 5-10, the image on the left uses the foreground to lead your eyes into the frame and then uses the horizon line to bring your eyes back into it where the blue curvy line goes off the edge. The space above the point where the line exits the frame enables me to use the space to keep your attention. A corner is at the edge of your frame both vertically and horizontally. As the image on the

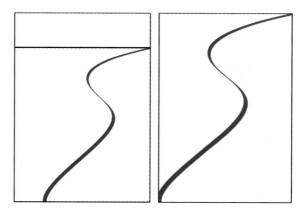

Figure 5-10: Stop lines from exiting the corners of your frame to keep a viewer's eyes from permanently exiting the frame.

right-hand side of Figure 5-10 shows, a leading line in a corner leaves you no space to work with and no way to bring the viewer back into the image.

Keeping an Image Simple or Unleashing Controlled Chaos

Your message in a photograph consists of *what* you include in a frame and *how* you include it. Anything that doesn't go with your message should be left out of your frame (check out Chapter 8 for tips on using perspective techniques to exclude certain elements). Everything that a viewer can see impacts what he takes away from an image. You can choose between the following two types of compositions (or find a happy medium), depending on your message:

- ✔ **A simple composition:** This type of composition points out exactly what you want a viewer to notice with as few distractions as possible. It includes only the supporting elements that are absolutely necessary to your message. Simplicity is a good approach if you want to make sure a viewer gets your point.

 A simple composition makes the most out of the few elements that exist in it. By having fewer distractions, you can say more about your subject (assuming the subject has some sort of descriptive qualities). Imagine, for example, that you're photographing at a concert and the singer on stage is really getting into a song. You can capture that moment with a frame that simply includes the singer on stage in the spotlight with an expression that conveys the way he feels at that moment in time. The rest of your frame is filled with darkness, drawing the maximum amount of attention on the singer.

- ✔ **A chaotic composition:** If you push the limits of how much you can fit into a single composition, you create chaos. Chaotic compositions include more elements for a viewer to look at and are most successful when everything works together to get a single point across. At first glance a scene of chaos may seem random and pointless, but further investigation shows that something specific is happening.

 A chaotic composition uses everything possible to convey a message. Picture the same moment when the singer is on stage at a concert, except this time you want to capture a different side to the story. Turn your camera toward the crowd and fill the frame with screaming, jumping fans. Now you have a frame filled with descriptive elements all working together to say the same thing; something exciting is happening. No one element takes the spotlight in a chaotic composition, but many elements reinforce a similar message.

Although each type of composition takes a very different approach, you can use either concept to create photographs with clear messages. Figure 5-11 shows an example of a simple composition in which the subject is a wake

boarder. He's caught in a moment filled with adrenaline and energy. By combining that moment with a simple composition, I focused all the energy on him. The rest of the scene is fairly peaceful. The wake boarder is the star, and this is his moment.

In Figure 5-12, I made a fairly peaceful scene appear hectic by creating a chaotic composition. Leaves floated on top of this lake. From my point of view, I could see the reflection of a tree that was above my head. To add some interest, I dropped a stone into the water to cause some disturbance. My shutter speed was slow, so the reflections in the surface of the water were blurred but the leaves sitting on top weren't. The combination of the leaves, the reflections, and the movement cause this image to appear chaotic.

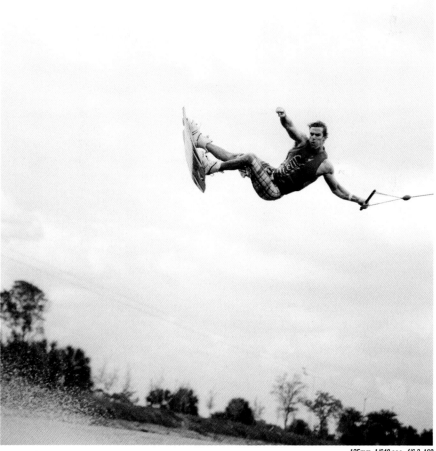

135mm, 1/640 sec., f/6.3, 160

Figure 5-11: An example of a simple composition.

Figure 5-12: An example of a chaotic composition.

Balancing Your Compositions

Balance refers to a distribution of visual elements throughout an image that lets a viewer's eyes scan the entire frame without being drawn too much to one specific area. In theory, balance is most effective when your composition has perfect *symmetry,* which is when the left and right sides and top and bottom of your frame are the same and balanced by their opposites. You're unlikely to shoot many symmetrical scenes, though, so you need to understand how to achieve balance without having symmetry.

Weight in a composition refers to the visual impact a specific area has. A balanced composition is comfortable to look at and keeps a viewer's attention. You can draw specific attention to your subject by having it stand out more visually than the other elements in a scene. However, you still want to give viewers a reason to look throughout the entire frame. Finding the right combination of weight distribution between elements is key to achieving balance.

Balance allows viewers to look at an image with an appreciation of its use of space. You don't want to place all your elements in one area; otherwise the rest of your frame will be empty and the weight of the image may appear to be lopsided. Distribute your elements throughout the space of your frame in order to create a sense of balance that's more comfortable to look at.

In the left-hand image of Figure 5-13, the frame is practically divided in half by the diagonal line that runs from the top of the image to the bottom. The left side of the frame includes nothing that makes it worth looking at. Plus, this image is heavily weighted to the right, and the elements on that right side aren't interesting enough to keep your attention for more than a few seconds. An element on the left side of the frame would cause you to move your eyes back and forth between the two sides, which would keep your interest longer.

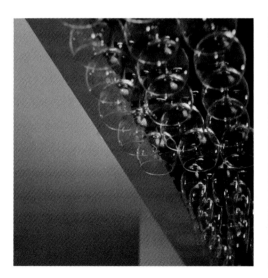

Both photos: 50mm, 1/30 sec., f/3.5, 640

Figure 5-13: Including the glasses on the left side of the frame created balance in this composition.

Aiming my camera lower and including some wine glasses that were sitting upside down on the bar corrected the balance problem occurring in the left-hand image in Figure 5-13. The right-hand image of Figure 5-13 shows this new version of the same scene composed in a more balanced and dynamic way. The wine glasses on the left side don't take up as much space in the frame as the glasses on the right, but they contain more tonal contrast, which gives them more weight in the composition. The two sides work together to create a sense of harmony that gives more purpose to the image and makes it easier to look at. For more information on achieving compositional balance see Chapter 12.

6

Paying Attention to Color in Composition

▶ Using color to control the message and feeling in a photograph

▶ Making interesting compositions in black and white

▶ Determining when to shoot for color and for black and white

C olor may be the most powerful compositional element. I make such a bold statement because color can alter a person's mood or cause a familiar sensation to occur. Fast-food operations know that red makes you hungry, for example. People also associate colors with various emotions. When a person says, "I'm seeing red," you know she's angry. And you know that someone who says he's blue is in low spirits.

When combined with other, more literal elements, color can enhance the mood or feeling you want to convey in a photograph. A scene of a family sitting by the fireplace will likely feel warm to a viewer because of the orange glow the fire casts onto the other elements.

In this chapter, I show you how color affects your images, how best to use the drama of black and white photography, and how to decide whether to shoot in color or not.

Discovering Color Basics

Color exists in almost every scenario that you may photograph, so you need to understand the basics and how color can affect your images. Most importantly, you need to realize that the light waves hitting your eyes or your camera's digital sensor create the illusion of color.

In nature, red, green, and blue waves of light combine to make every color you see. Because of their prominence, red, green, and blue are considered the *primary additive colors.* When you mix red and green waves of light, you get yellow; green and blue give you cyan; and blue and red create magenta. The color wheel in Figure 6-1 shows you how colors relate to each other and what their differences are.

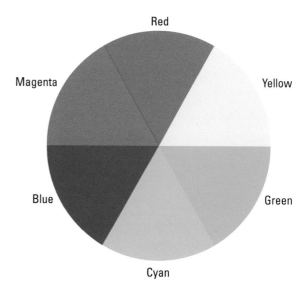

Figure 6-1: The color wheel.

Each color on the color wheel relies on the following three properties that differentiate that color from other colors:

- ✔ **Saturation:** *Saturation* refers to the purity of a color. Equal amounts of red, green, and blue create a neutral color such as white, gray, or black. The more dominant a single color is, the more saturation you have. Figure 6-2 shows the saturation levels in red.

- ✔ **Brightness:** *Brightness* describes how much light exists in a color. Lighter shades are considered brighter than darker shades of a particular color. Brightness is represented in Figure 6-2 on the vertical axis of the color grid.

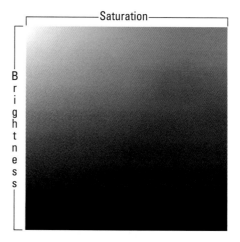

Figure 6-2: This graph represents the saturation and brightness of the red hue.

- ✔ **Hue:** *Hue* represents the combination of red, green, and blue that exists in a color. Pure red, for example, has a red hue. Red and green combined creates a yellow hue. If a color combination has more red than green, the hue is orange. Notice the image of different hues in Figure 6-3.

Figure 6-3: From left to right, each point represents a different hue.

The properties of a color determine how certain colors will react together in a composition and which colors should be used to create specific effects, feelings, and looks. The design of color in a photographic composition is its color scheme; when used properly, it can enhance the strength of your message. When you create an image, keep in mind the following characteristics that people commonly associate with various colors:

- **Red:** Excitement, drama, danger, lust, love, passion, vigor, strength, hunger, stimulation

- **Orange:** Encouragement, warmth, plenty, kindness, nearness

- **Yellow:** Comfort, joy, brightness, friendliness, knowledge, persuasion, concentration, dishonesty, betrayal, caution

- **Green:** Success, luck, nature, growth, finances, greed, jealousy, freshness, fertility, optimism

- **Blue:** Tranquility, patience, health, sadness, truth, honor, peace, freshness, wisdom, distance, authority

- **Purple:** Royalty, power, tension, wisdom, sentimentality, bravery, magic, intelligence, creativity

In the following sections, I explain how to use the color wheel to create compositions that generate a feeling. I describe the many different color schemes you can use and when you're likely to have the most success with them.

Using complementary colors for contrast

The colors that are directly across from each other on the color wheel (refer to Figure 6-1) are *complementary colors.* They're opposites, so they cause the maximum level of contrast when you use them in the same photographic composition. For instance, a red balloon sailing upward against the cyan sky would stand out to your eyes more so than a blue or green balloon would.

When a composition is made up of complementary colors, it has a *complementary color scheme.* You can use a complementary color scheme to clarify your subject or your intended message. By including only complementary colors in your composition, you eliminate distracting colors and allow viewers to concentrate on the relationship of the colors.

Using a complementary color scheme in a composition is especially effective when you want to do the following:

- ✔ Draw attention to your subject
- ✔ Create a composition that's vibrant, exciting, or powerful
- ✔ Give the sense of conflicting feelings in a scene (For example, an image of a red, sunburned tourist standing at the edge of a cool, cyan pool conveys that the day is hot and the pool is a refreshing alternative to the baking lounge chairs.)

The subject in Figure 6-4 stands out because of the level of contrast the complimentary color scheme creates. Everything in the scene is either red or neutral in color apart from the cyan dress that the model is wearing. The dress stands out drastically because of this.

Maximizing monochromatic color schemes

A *monochromatic* scene is one that contains only one hue (I explain hue earlier in the chapter). The monochromatic colors are made up of the various combinations of saturation and brightness levels within a single hue. Figure 6-3 provides a map of the colors that exist in the red hue.

Using a monochromatic color scheme can help you achieve subdued energy levels in a photograph. When a scene offers only one hue, very little color contrast exists. Elements that have a similar hue tend to naturally fit together and create a sense of harmony that seems peaceful. Figure 6-5 shows an example of a monochromatic image.

Certain situations work best with a monochromatic color scheme. Use one when you want to do any of the following:

- ✔ **Create a clean, simplistic composition:** Including more than one hue tends to distract from the subtler elements in a scene.
- ✔ **Give the feeling of a specific hue without having any possible distractions from another hue:** Colors carry specific associations (see my discussion of this earlier in the chapter). For example, a scene made up of different shades of blue could appear cool, fresh, and calming.
- ✔ **Convey the idea of elegance in a photograph:** A monochromatic design rarely seems tacky. It's clean and proves that less is more.

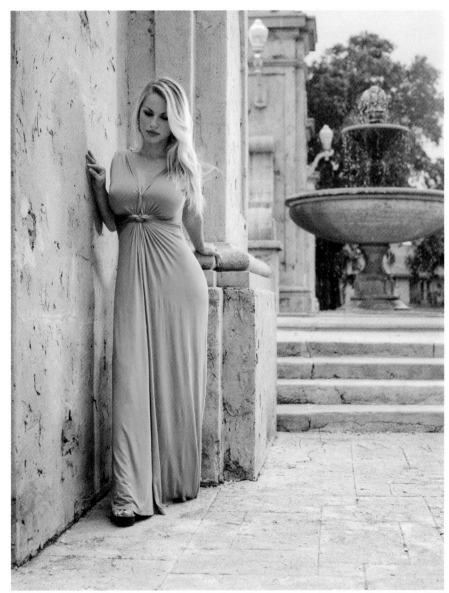

50mm, 1/160 sec., f/4, 100

Figure 6-4: Complementary colors create interest through contrast.

85mm, 1/300 sec., f/5.6, 50

Figure 6-5: Use a monochromatic color scheme to create a sense of harmony.

Creating harmony with analogous colors

Using colors that reside next to each other on the color wheel (refer to Figure 6-1) creates an *analogous color scheme.* The closer two colors are to each other on the wheel, the more similar they appear to your eyes and the smoother the transition from one to the other. Your eyes notice a dramatic difference between complementary colors, but analogous colors have a subtler impact. However, keep in mind that an analogous color scheme isn't as subtle as the monochromatic scheme that I discuss in the preceding section.

Analogous color combinations are useful when you want flexibility with your message. You can work with all warm colors, all cool colors, or a mixture of the two depending on what area of the color wheel you're using. You can create a specific mood by allowing one color to be dominant, while including its neighboring colors to invite a gradual amount of color contrast that helps to liven your image. If you aren't looking for the drama of complementary colors, but you want some color variety, choose the analogous scheme.

In Figure 6-6, I combined the analogous colors green, yellow, and cyan to create a cohesive story:

✔ **Cyan** resides in the woman's dress and in the shadow areas of the tree. It works to create a sense of coldness or mystery.

✔ **Green** works as a transition from cyan to yellow and exists on the lit areas of the tree.

✔ **Yellow** provides a subtle contrast to the cyan because it has a warm and sunny feeling. The shadows in Figure 6-6 are uninviting, but the lit area is appealing and comforting.

If I had used the complementary scheme of a bluish-cyan in the shadows and orange (which is a combination of red and yellow) in the lit area, the message would be similar but the drama would be higher.

50mm, 1/100 sec., f/4, 100

Figure 6-6: The analogous color scheme helps create subtle transitions from one color to the next.

Drawing the eye with color

Any area with high contrast in an image acts as a point of interest. Whether the contrast is caused by a drastic change in tone or in color, it draws your eyes to it. As a result, you can show a viewer where to look in a photograph

by positioning an element with a contrasting color in a specific area, like I did in Figure 6-7. The yellow raincoat in this image stands out a great deal in the otherwise blue and grey scene. In this example, your eyes are likely to fixate first on the yellow coat for a while, and then they'll be drawn back to it as you scan the rest of the frame. (Head to Chapter 10 for more on contrast.)

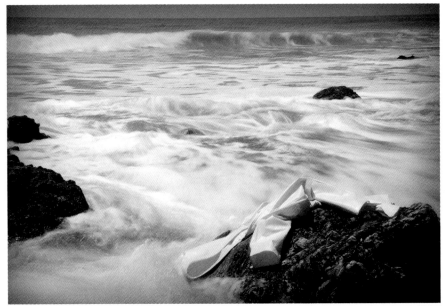

65mm, 1/4 sec., f/32, 100

Figure 6-7: A single color that stands alone in a frame will draw a viewer's attention.

In Chapter 4, I show you how to use lines and shapes to lead a viewer's eyes through a frame. You can do the same with color. You can use color as a leading element by positioning it throughout the frame in a way that gradually moves toward something of interest.

Figure 6-8 uses color as a leading element with the pink flowers, which draw your eyes toward the cyan church in the background. The flowers stand out as a contrasting color in this image and have the strongest visual presence. Because they lead toward the church window in the background, which has the most tonal contrast in the scene, the compositional strength is distributed between the two. The flowers catch your attention, and then they lead your eyes to another area of visual importance in the image.

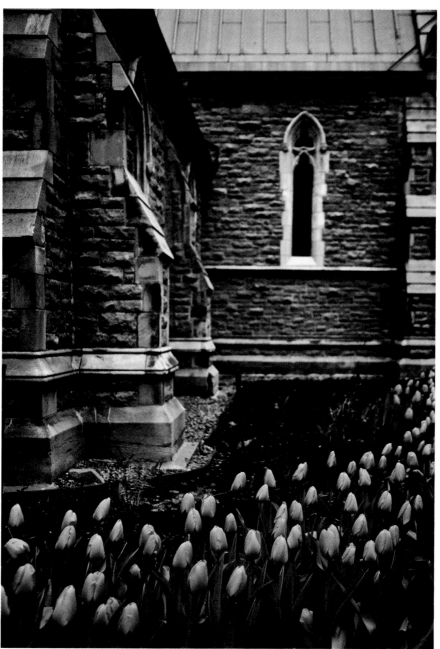

35mm, 1/60 sec., f/3.5, 500

Figure 6-8: Color as a leading element.

Shooting for Black and White

Sometimes a scene contains no significant qualities with regard to color. If you see no reason to show an image in color or feel that the colors in a scene take away from your composition rather than adding to it, shoot the scene for black and white. Doing so eliminates your concern about color while still creating a photo that's full of life.

Your digital camera can shoot in black and white mode, but usually you don't need that mode. Shooting in color and converting your image to black and white during postproduction provides the best results.

Converting your images to black and white is easier than ever, and I explain a few ways to do so in this section. However, to understand how color converts to black and white, you first need to understand how your digital sensor captures an image.

Being aware of how your digital sensor sees light

A digital camera uses an array of millions of tiny pixels to produce images. Tiny wells distributed throughout the surface of your camera's digital sensor receive light when you take a photograph, and each well represents a tiny portion of the entire image. A single well can't determine the difference between red, green, and blue light; it simply receives light and measures its intensity as a whole.

In order for a digital camera to record color information, filters over each well allow one specific wavelength of light to enter. Some wells receive red light, some green, and some blue (see the earlier section "Discovering Color Basics" for more on these primary additive colors). These wells are distributed evenly throughout the space of the sensor and determine how much of each color of light a photo records.

When you take a photograph with your digital camera, you're actually recording three separate images, called *channels*. The camera has a red, a green, and a blue channel. The combination of the three channels creates a color photograph, but the image in each channel is represented as black and white. You basically have three black and white photographs in every color image, which is important to realize when converting your images to black and white with your photo-editing software. You can benefit from these three images as follows:

- ✔ **The red channel** allows more red light (and less green or blue light) into an image. The result is darker skies and brighter tones in people's skin.

- ✔ **The green channel** also produces darker skies but not as dark as the red channel. Photographers use the green channel primarily to brighten green areas in an image, such as grass and trees.

- ✔ **The blue channel** produces bright skies in comparison to trees and skin tones. This channel shows the most flaws in a person's skin. If you want to accentuate the wrinkles and texture of someone's face, the blue channel is the one you want. Otherwise, to avoid unflattering shots, steer clear of this channel when converting portraits to black and white (which is discussed in the later section "Converting an image to black and white using the three channels").

Figure 6-9 shows you how each channel affects an image that contains elements that are predominantly red, green, and blue. The red channel emphasizes the red glow coming from inside the tent, and it shows a very dark sky. The green channel emphasizes the green grass and shows a normal representation of the sky and the light within the tent. The blue channel shows a bright sky and the darkest representation of the tent's interior.

Color representation of the channels combined Red channel

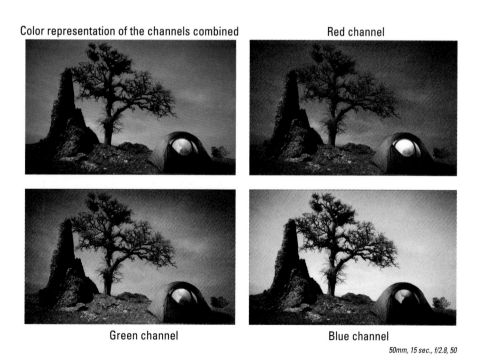

Green channel Blue channel

50mm, 15 sec., f/2.8, 50

Figure 6-9: Looking at how red, green, and blue are represented in each channel.

Exposing your photo for black and white

When you approach a scene with the intentions of photographing it for black and white, the most important thing to consider is how you'll expose it. After all, most normal situations contain too much contrast for your digital sensor to record a perfect reading. The difference in brightness in the shadows and highlights is too great for each to be exposed properly.

To solve this problem, expose for your highlights and process for your shadows. Be careful not to overexpose the highlights in your scene to the point that they have no detail, however. (Chapter 3 covers how to set your exposures and check them, using the tools provided by your camera.) If you lose the detail in your highlights, you can't bring it back in postproduction. You're more likely to be able to brighten your shadow areas in postproduction.

Your camera likely provides an exposure-warning feature that causes the image on your LCD display to flash when you've experienced a loss of detail. If you receive this warning, decrease your exposure and take another shot to ensure you have detail in your highlights. See your owner's manual to find out more about this feature.

When you expose a scene for its highlights, your original image probably will have very dark shadows. These dark shadows are fine if you feel they serve your message appropriately. However, if you want to create a black and white image that has a smooth gradation of contrast from black to white, with everything in-between, you most likely have to do some postproduction work to get it there, including brightening the shadows.

Figure 6-10 shows a tonal scale that represents the shades that make up a full-scale, black-and-white photo. When you produce an image that contains each of the shades shown, you're on par with Ansel Adams as far as creating a true black-and-white photo. The scale ranges from white without detail to black without detail. The shades in between include whites with detail (or texture), light gray, middle gray, dark gray, and blacks with detail. If you can't see the surface texture of snow in an image, you have white without detail. By having the slightest amount of texture present, you have white with detail.

Figure 6-10: A full-scale, black-and-white image contains each of these tones.

The point in trying to create full-scale black-and-white images is to avoid creating an image that's a muddy, gray mess. Contrast in an image enables viewers to better see what's happening in the scene and makes the overall image look nicer.

Keep the tonal scale from Figure 6-10 in mind when you're exposing an image. Besides representing how much detail is in an image, these tones also help you understand your camera's histogram. Chapter 3 explains how to read the histogram and how to control your exposure.

Converting an image to black and white using the three channels

Because shooting in color with your digital camera produces three black-and-white versions of an image, you really don't need to shoot in black-and-white mode. Doing so gives you less control over your final results. Instead, you can use the three channels I describe in the earlier section "Being aware of how your digital sensor sees light" to mix and match the channel percentages to create a combination that suits a specific scenario.

You can do this conversion in most photo-editing software programs. Adobe Photoshop is the most common program, so I show you how to convert with it here. Follow these steps to convert a color image to black and white while maintaining control over each element in your scene:

1. **Open your image in Photoshop so it contains all its original color data.**

 Don't convert the image to grayscale. Doing so provides a black-and-white image but eliminates the color information, making all three channels the same. Because of this loss of color information, you lose the benefits of working with these channels.

2. **From the layers palette, open a new Channel Mixer layer.**

 A window opens and enables you to make adjustments to convert your image to black and white. It contains three separate sliders that allow you to adjust the red, green, and blue channels. For more information on working with layers read Chapter 18.

3. **Click the box labeled "Monochrome."**

 The image is now black and white.

4. **Use the sliders to adjust the percentages of each channel to control how that channel affects your overall image.**

When you begin, your red and green channels are each set to 40 percent, and your blue channel is set to 20 percent. They, of course, add up to 100 percent, which represents the normal exposure for the original image you took. So, if you want to emphasize the red light in your scene, set the red channel to 100 percent and the others to 0. ***Remember:*** Finding the perfect balance between the three channels is the key to creating the perfect amount of contrast exactly where you want it in your frame.

You can create a curves layer to tweak your contrast even more. Chapter 18 gives you the scoop on using curves to adjust contrast in a scene.

Figure 6-11 shows two versions of the same image. The original was exposed properly but needed some work to reach its potential. I converted the first image straight to black and white without making any other changes. The red and green channels were set to 40 percent, and the blue was set to 20 percent.

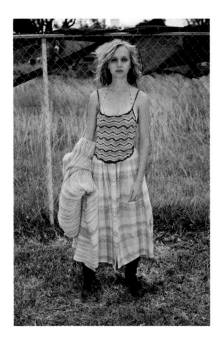

50mm, 1/125 sec., f/5, 200

Figure 6-11: Postproduction work enabled me to increase the contrast in this image and avoid a muddy composition.

I converted the second image more carefully to concentrate on specific elements. Consider the following changes:

- ✔ Bringing the red channel to 65 percent brightened the tonality of the woman's skin.

- ✔ Dialing back the green to 25 percent gave the grass more brightness. (Grass usually comes out as yellow in an image and is affected by the red channel as well as the green channel.)

- ✔ Reducing the blue channel to 10 percent minimized the texture of the woman's skin.

After I converted the image, I used the Curves Layers feature in Photoshop to further increase the contrast and make the whites and blacks in the image richer. (Check out Chapter 18 for more about using this feature.) The result is a more descriptive photograph that's more pleasing to look at.

Color or Black and White? How Your Decision Impacts Your Message

In photography, each scene is unique, and you have several options for capturing it. One major decision you have to make is whether a particular scene would be better represented in color or in black and white.

The easiest way to figure out whether to shoot in color is to look at the colors in your scene. Ask yourself whether the colors are creating any significant impact. Look for complementary color relationships. If those are absent, perhaps you see an analogous relationship or a monochromatic one that you can work with. Does any element stand out because of its color, or do the colors in the scene work well together?

If the colors in the scene don't create any interest or impact, and you decide that black and white would be most representative of your message, you should still shoot the scene in color. That way, if you download your images to your computer later and decide that the image looks good in color, you can roll with it. If not, you can convert it to black and white.

If you intend to convey a specific message, you may need to shoot in color or in black and white to accomplish that message. Each format has a different way of telling a story and can be used to achieve different effects on viewers.

Color photography is the better choice when you want to convey the following:

- ✔ **Temperature:** Warm colors give a warm feeling and cool colors do the opposite. If you were selling the idea of a cold, refreshing drink, you'd need color to enhance your message.

- ✔ **Emotion:** Different colors signify different emotions, and if your intent is to convey a specific emotion, using color (along with the other elements in your composition) strengthens your message.

- ✔ **Separation:** In black-and-white photography, you may have a difficult time creating separation between elements that are different in color but similar in tonality. Color photography gives you the ability to separate compositional elements through tonal and color differences. For example, it shows the difference between a red apple and a green apple, and black and white could make them appear the same.

- ✔ **Vibrance:** Color is vibrant and creates an image with a modern feel that most people prefer. Just like pop music sells more than the blues or jazz, color photography sells more than black and white.

You may shoot in black and white when you want to

- ✔ **Simplify the scene:** If the colors in your scene don't work well together, you can simply remove the mess of color by converting the image to black and white.

- ✔ **Create an artistic edge:** Black-and-white photography is still familiar to people as a classic art form. By converting your images, you automatically cause them to appear more artistic.

- ✔ **Provide emphasis:** A subject that doesn't rely on color may be better shown without it. If the main focus of your image reveals the shape and texture of someone's body, for example, including color in your composition may distract viewers from your message. Minimizing the elements in an image (such as color) emphasizes the ones you keep.

- ✔ **Generate drama:** By creating a great deal of contrast between your shadows and highlights, you can create a feeling of drama that's clear-cut and uninterrupted by the distraction of color.

Part III
Arranging the Key Elements to Compose a Successful Shot

In this part . . .

Great compositions tell stories, and the chapters in this part help you best tell yours. These chapters provide you with in-depth info on the key compositional elements. You find out about using focal points, making the most of perspective, and choosing backgrounds that support your story instead of taking away from it. I also tell you about light (a critical element of any composition), show you how to keep viewers' eyes in your image with framing, and give you tips for creating a harmonious image.

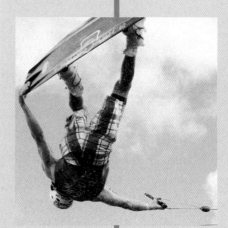

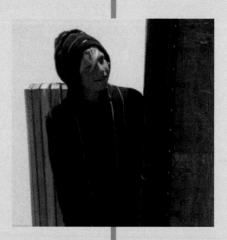

7

Using Focal Points to Tell a Story

- -

In This Chapter

▶ Determining your subject and focusing attention on it

▶ Applying selective focus

▶ Making good use of two focal points

- -

*1*n Chapter 3, I tell you how your camera and lens work together to achieve focus in an image. In this chapter, I discuss how to control what's in focus in your composition and why this control is essential. You can enhance the sense of purpose or message in your photography by literally focusing on what's important and controlling what your viewers focus on throughout the scene.

By creating primary and secondary focal points in your compositions, you can control the order and amount of time in which viewers look at the elements in a scene. You also can control your focus by eliminating distracting details that aren't relevant to your message. I tell you everything you need to know about focal points in this chapter.

Finding Your Focal Point and Helping It Take Center Stage

When you approach a scene and decide to take a photograph, some reason drives you to make that decision. That reason is most likely going to be your subject. A subject gives purpose and meaning to a photograph — it's the focus, or the star of the show. The exact point where you place your focus is your *focal point*. In most cases, your focal point is your subject or some part of your subject. Selecting a focal point provides a clear way of informing your viewers of what they're supposed to be looking at. If you were focusing on the subject when taking the photograph, your viewers will focus on it when viewing the photograph.

In Figure 7-1, the dew-covered spider web is the subject of the photo. It not only provides life to the photo, but it also tells you (because of the dew) that the scene took place in the morning and creates an interesting effect by reflecting and refracting light. (You can read more about using light to tell your story in Chapter 10.) Without the web and the dew atop it, the blades of grass wouldn't be very interesting, and I really wouldn't have had a reason to take the photograph.

100mm macro, 1/500 sec., f/2.8, 100

Figure 7-1: Morning dew settled on a web that's covering the ground amid blades of grass.

Your focal point determines how far from your camera the *focal plane* is placed. The focal plane is a flat area that's parallel to your digital sensor and intersects with your focal point. Every point that falls in line with the focal plane is sharp. For instance, if several people are standing in a straight line parallel to the camera and the camera is pointed directly at them, each person will be in focus, assuming you placed your focal point on one of them.

The further an element is from the focal plane, the more blurry it will appear in your photograph. In Figure 7-1, for example, the blades of grass become blurrier as they get further away from the spider web. You have control over how far your focus reaches in front and behind the plane of focus. The distance your focus reaches is called *depth of field* (see Chapter 3 for more).

Selecting a focal point and manipulating depth of field gives you the ability to control which details are noticed and ignored by your viewers. Focal point and depth of field are major tools used to create your message in a photograph. Having a shallow depth of field (as I do in Figure 7-1) can cause your viewers to notice your focal point more clearly. In a composition with a great depth of field, your viewer may not even know which point contains the most focus because everything appears sharp in the scene. (Refer to the later section "Controlling depth of field" for more information.)

When choosing your focal point, ask yourself, "What is the story here?" and focus on that subject. After you're in the habit of choosing your focal point without having to think too hard about it, you can consider other variables that help draw attention to your subject, which the following sections explain.

Making your focal point stand out

A successful composition appropriately reveals your subject to your viewer and sends the message you intended for the photograph. Making an element your focal point is a great first step in revealing it as the subject. Sometimes you may need to go even further in drawing attention to the subject, however. For instance, you may want to make clear that other elements in the scene are just playing supporting roles to help tell the story of the main subject. Here are some techniques (apart from making it the focal point) for making your subject stand out:

✔ **Use contrast to your advantage.** A viewer's eyes are drawn toward the highest point of contrast. If your subject is in focus and has more contrast than any other areas of the scene, it will stand out the most. Contrast is determined by how drastic the difference in tones or colors is. In Figure 7-2, the clouds in the foreground have more tonal contrast than any other elements in the frame. Chapter 10 explains more about understanding and controlling contrast.

✔ **Follow the rule of thirds.** Placing your focal point or subject away from the edges or center of the frame assures that it's more pleasing for the eyes to rest on. I explain this concept, referred to as *the rule of thirds,* in detail in Chapter 5. The subject in Figure 7-2 is positioned along the bottom third of the frame.

✔ **Eliminate competing elements.** Using a shallow depth of field helps make your focal point stand out by blurring the other elements in the scene and thus softening their details. (See the later section "Controlling depth of field" for more info.)

If an element becomes so blurry that it's no longer identifiable, it becomes negative space. *Negative space* is any area of the frame that doesn't contain any elements, details, or relevant information. Surrounding your subject with negative space helps draw attention to the subject by eliminating competing elements.

✔ **Choose your moment wisely.** Capturing a moment when something significant or recognizable is happening assures that your viewers can relate to why the photograph was created. The significant moment is known as the *decisive moment,* and it could be anything from a handshake to a revealing facial expression to the moment a salmon jumps into a grizzly's mouth.

Combine these techniques to draw the most attention to your focal point. The more ways you make your focal point stand out, the easier it will be for a viewer to identify it as the subject.

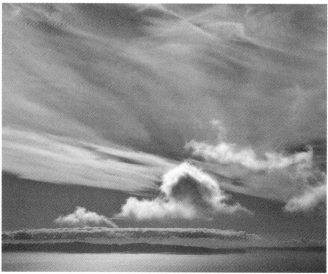

50mm, 1/2000 sec., f/7.1, 50

Figure 7-2: Using multiple techniques to draw attention to your subject helps your viewers know what to look at.

Using your camera's focus control to select your focal point

Having control over your focal point and where it's placed in a scene is one of the most important aspects of creating compelling compositions. A proper focal point is natural, and viewers may take it for granted when executed perfectly. But a poorly executed focal point stands out like a fly in Chardonnay.

Be sure that you're familiar with your camera and lenses and how the focusing controls work on them. Your digital point-and-shoot camera may or may not allow you to focus both automatically and manually. Refer to your owner's manual to find out about your focus control and how to use it. In the following sections, I provide some general information on how to use each type of control.

Going with manual focus

If you have a digital SLR with manual focus, you can focus on your focal point by rotating the focus ring on the lens until the plane of focus is positioned on the point of your choice.

Manual focus is great when you're close to your subject and can easily see the detail in your focal point. However, if your subject is fairly small in your viewfinder, determining when your focus is spot on may be difficult. You can solve this problem by switching to auto focus mode (if your camera and lens allow it) and letting modern technology take over for your eyes.

Trying out auto focus

To use auto focus with most digital SLR cameras and lenses, you place your *focusing sensor* (the rectangular graphic in the center of your viewfinder) on your desired focal point and press down the shutter release button halfway. You'll hear the lens elements shifting back and forth until focus is achieved. After the focus is set, you can press the shutter release down all the way and take the photograph.

If your auto focus sensor exists in the center of your viewfinder, and you don't want to place your subject in the center of your frame, you need to lock your focal point before composing the shot. (Centering your subject makes for a weak composition and goes against the rule of thirds; check out Chapter 5 for additional information.) Most cameras offer different options for auto focus. Refer to your owner's manual to find out which setting enables you to lock your focal point.

Here's the general idea on how to lock your focal point: Position your auto focus sensor on your subject and press down and hold the shutter release button halfway. After the shutter release button is pressed down halfway, the focal point is locked on the subject, and you can move the camera to compose the scene in the way you see fit.

Some cameras contain more than one auto focus sensor point in the viewfinder. In this case, you can scroll through the points until you get to the one that's closest to where your subject is in your composition. Still, the point may not be placed exactly on the subject, so you'll have to perform the locking technique described earlier.

Determining how much of the frame your focal point should cover

The closer your subject is to the camera lens, the more of the frame it covers. And the larger the subject becomes, the less significant the other elements in the frame become. (If you're wondering about those less significant supporting elements, flip to Chapter 9 for a complete discussion of your composition's background.)

The message you would like to convey with a photograph requires a certain balance of the significance of the subject and its supporting elements as well as the spatial relationships between them. So focusing on someone who's much closer to the lens than the other people in the scene creates a drastic separation in the importance of that person and the others. Having a more subtle separation between the subject and the other elements brings more relevance to the other elements. Check out the next two photos for examples of the two scenarios.

In Figure 7-3, the boy who's on the paddleboard is much closer to the camera than the person who's diving down into the water. It's clear that the boy is the subject and the diver is a supporting element.

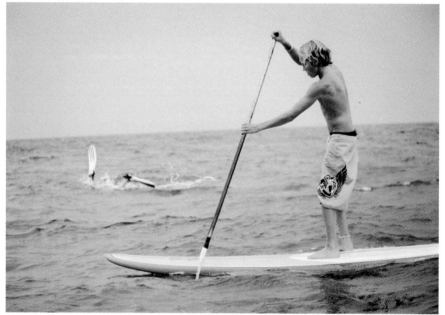

135mm, 1/640 sec., f/5.6, 200

Figure 7-3: Using a single subject and a secondary focal point.

However, in Figure 7-4, the two main elements are equidistant from the camera. Each is in focus and each provides an equal level of importance to the message. As a result, the relationship between the boy and the bird is the message. The pelican is staring at the boy, and the boy is playfully peeking from behind the piling. The photo shows a sort of standoff between the two. I represented the boy and the bird equally in the composition in order to cause the viewer to look back and forth between the two in the spirit of the standoff.

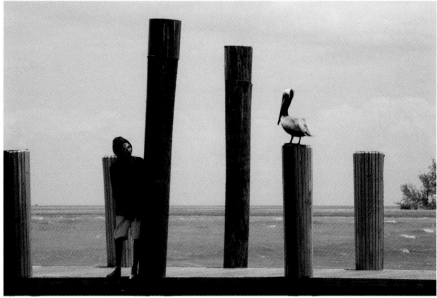

135mm, 1/400 sec., f/13, 200

Figure 7-4: Using spatial relationships to show two subjects.

Enhancing Your Message with Selective Focus

When you look at something, your eyes focus on that one point, and you technically see two of everything else in your field of view. (I tell you more about how eyesight works in Chapter 2.) To test this theory, place your finger 12 inches from your eyes and focus on it while noticing the elements behind it. Apart from your finger, you see two of everything. Typically, you won't pay any mind to the elements that you aren't focusing on. You concentrate on what's in focus, basically ignoring everything else even though you know it's there. If you scan your focus to another element, you're then ignoring the previous one. The point? Your eyes can focus on only one thing at a time.

In reality, your eyes can jump from one focal point to another, adjusting the sharpness of the elements around you. However, when you view a photograph, you can see only what the photographer lets you see. He hides and reveals things using focus. More specifically, the photographer uses selective focus to hide background and foreground elements. *Selective focus* means using a shallow depth of field and placing your focal point on something to make it

stand alone regardless of its surroundings. (See the later section "Controlling depth of field" for more info.) Photographers use selective focus to tell people exactly what to look at in a photograph.

In Figure 7-5, for example, I used selective focus to highlight the figure in the stained glass window. Nothing else in the scene really caught my eye, but I was interested in the way the figure in the glass was lit. A streetlight from outside the church was shining directly behind her and affecting her alone, giving her prominence. Through the use of selective focus, I made the subject even more prominent in the scene.

50mm, 1/80 sec., f/2.2, 400

Figure 7-5: The use of selective focus leaves no doubt as to what the subject is.

Photographers often use selective focus to reveal a specific detail. For instance, you often see it used in stock photography of an open book or a newspaper, where the technique forces viewers to read one word. The other words on the page are soft in focus and aren't as easy to read as the one that's used as the focal point.

In order to achieve selective focus on a small detail like a newspaper's text, use a macro lens (or set your point-and-shoot to macro), which enables you to get close to your subject and still achieve focus. (Turn to Chapter 3 to find out more about the macro lens.) In situations when your subject isn't so small, you can pull off selective focus by using a telephoto lens and shooting with a wide-open aperture. The upcoming section "Controlling depth of field" tells you more aperture and focal length.

Getting creative with your focal points

The way you choose your focal point can reveal a lot about your subject and its relationship to other elements in the scene. When taking a portrait of someone, it's generally nice to make their eyes the focal point. After all, it's human nature to look at people's eyes when communicating with them — the eyes are known as a "window to the soul." However, when you're trying to

tell a story, the eyes may not always be the best place to focus. Try focusing on a person's hand touching something or making a gesture.

Imagine a scene where a boy is holding flowers behind his back and a girl is in front of him trying to peek over his shoulder. When taking this photo, you can focus on her eyes to reveal the expression she's making, or you can focus on the flowers to reveal what all the fuss is about. If you have time, try it both ways. If you have even more time, focus on the calendar on the wall in the background that has one of the days circled in red, which could suggest that the viewer is seeing an anniversary celebration.

Panning is a creative technique that isolates your focal point in a way that shows motion. This technique is a great way to make your subject stand out and tell a story about motion or speed. Panning is achieved by setting your exposure to have a slow shutter speed and physically moving your lens with a subject that's in motion. If you move at the same speed and distance as the subject and in the same direction, you'll get a fairly sharp image of it while everything that wasn't moving comes out blurry.

In Figure 7-6, I used the panning technique (which I tell you even more about in Chapter 16) to isolate the man riding the motor vehicle while every other element in the frame is affected by motion blur. In this image, I set my shutter speed to 1/30 second.

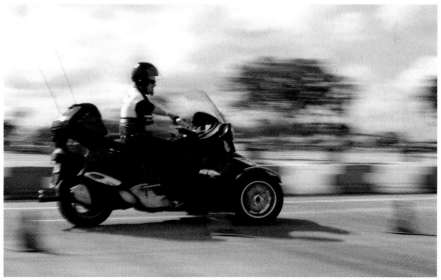

35mm, 1/30 sec., f/22, 50

Figure 7-6: Using the panning technique to focus on a point and reveal that it's in motion.

Controlling depth of field

Traditionally, photographers control depth of field using two methods: aperture and focal length. *Aperture* controls the amount of light that's let in at a given time of exposure. The more light that's let in, the less depth of field you have. In Chapter 3, I discuss how differences in focal length and your distance to the subject cause your depth of field to change due to magnification. The more magnification that occurs, the less depth of field you have in your composition.

Your focal length is determined by the size of your lens. In the 35mm digital SLR format, you have the following lens options:

- **Wide-angle lens:** Any lens that's 35mm or less is considered a wide-angle lens. The wider the lens, the more depth of field it provides at a given aperture. In other words, using a wide-angle lens provides less magnification in your scene's elements and results in greater depth of field. In fact, it's often difficult to cause your background to go soft when shooting with a wide angle lens. To do so, you must get very close to your subject and have a great distance between it and the background. Typically a wide-angle lens is used when you want to reveal details about the scene and when a large depth of field works in your favor.

 Compare Figure 7-7 to Figure 7-8 and notice how shooting with a wide-angle lens increases the amount of scene you see and the amount of detail in it. Figure 7-7 shows a wake boarder jumping off a ramp; the wide angle lens worked great to show how much distance he went after hitting the ramp and reaching his peak. A telephoto lens would have shown more detail in the wake boarder but would have eliminated the important details surrounding him. In a close-up shot, you'd have no idea how far he jumped or that he hit a ramp to get airborne.

- **Normal lens:** A 50mm lens is considered to be a normal lens. This option is neither wide, nor telephoto, and it's great for representing scenes as closely to the way you see them when taking the photograph.

- **Long lens:** Anything above 70mm starts to get into the telephoto classification. A 300mm lens is extremely telephoto while anything from 70mm to 135mm is referred to as a mild telephoto lens.

 When shooting with a long or telephoto lens, you magnify the elements in your scene. Often photographers use a long lens to draw attention solely to the subject and eliminate any distracting background details. In Figure 7-8, I used a 200mm lens (which coincidentally allowed me to stay farther from the fire, smoke, and ash) in order to focus on the fireman himself. Because the background is out of focus, it's easier to see the water drops that are coming from the fire hose in his hand.

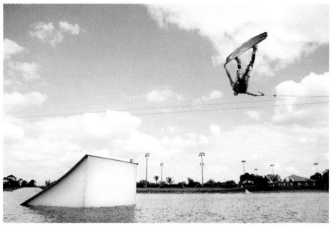

28mm, 1/640 sec., f/6.3, 160

Figure 7-7: Showing the details of the scene with a wide-angle lens.

Focal length has a major impact on depth of field, but it doesn't have to be the deciding factor on the issue. In situations when you have limited control over your camera position, you may choose your focal length based on your distance to a subject. If you have to use a long lens due to being far away, you don't necessarily have to have a shallow depth of field.

When you're forced to use a specific focal length to get the composition you want, you can control your depth of field by changing your aperture. A larger aperture (determined by a lower number, like f/4, as I explain in Chapter 3) produces a more shallow depth of field. On the contrary, a smaller aperture (represented by a higher number, like f/16) produces a greater depth of field.

Here's a list of combinations you have as options for controlling focal length and depth of field:

- ✔ To show more of the scene and have a more shallow depth of field, use a wide-angle lens opened up all the way. (Increasing the size of the lens's aperture opening is referred to as *opening up*.) This combination is a good way to tell the story about the subject's environment while still focusing mainly on the subject.

- ✔ To show less of the scene and have a greater depth of field, use a telephoto lens closed down all the way. (Decreasing the size of the lens's aperture is referred to as *stopping down*.) This combination is good for showing the most detail in your subject without losing all detail in the background.

✔ To achieve maximum depth of field, use a wide-angle lens and a small aperture opening.

✔ For the shallowest depth of field, use a long lens and a large aperture opening.

200mm, 1/160 sec., f/8, 320

Figure 7-8: Showing the details of the subject with a long lens.

Adding a Secondary Focal Point to Your Composition

Think of the elements in any scene you photograph in terms of a chain of command. Your subject or focal point is the General, and the other elements fall in rank based on how much importance you give them. These other elements are *secondary focal points,* and the amount of attention a viewer pays to them depends on the same variables that cause the viewer to pay attention to the subject.

For example, if your subject is large in the frame and is sharp, and another element is slightly smaller in the frame and is soft in focus, your viewer looks at the subject first and then moves on to the secondary focal point to see how it relates to the subject. If you add a third element that's even smaller and even more out of focus, it becomes the third object your viewer looks at.

Use *leading lines* (any line that directs the viewer's eye; see Chapter 1) to direct your viewer from one focal point to another and to ultimately lead them back to the subject itself. After all, your goal is to have people look at your photographs for as long as possible.

Figure 7-9 shows a photograph that has many elements that are all relevant to telling the story of the subject (the woman sitting on the bench). Including a light source like the campfire in your composition can cause competition with the subject, so be sure to make your subject stand out (see the earlier section "Making your focal point stand out" for ways to do this). In this case, the woman is in front of a very dark background that causes her to stand out. She's also positioned in a stronger area of the composition than the fire (you may look at the campfire first, but you'll spend more time looking at the woman). When I view the elements in this photograph, I begin at the fire, which leads me to the tent, which leads me to the woman. I then scan the picnic table, the firewood, the silhouetted trees, and the man approaching. Finally my eyes hover back to the subject.

When including secondary focal points, keep in mind your intended message. If an element seems to compete with the subject in a way that takes away from the message you're trying to convey, you may want to remove it from your composition.

Say, for example, that you're taking a portrait of someone on the beach and another person in the background is wearing a bright red hat. If the hat is the only element in the scene that has such a bold color, you may want to avoid including it in your composition. The distracting element will take away from your subject and won't necessarily add anything to the message.

24mm, 1/5 sec., f/5.6, 320

Figure 7-9: An example of a composition with secondary focal points.

Some techniques to keep in mind for removing a distracting element from your composition include the following:

- ✓ Crop it out so it isn't included in your frame. You can do so by simply rotating your camera or zooming in until the element goes outside the edge of the frame or by physically moving closer to the subject.

- ✓ Use a shallow depth of field to allow the distracting element to become blurry.

- ✓ Block it with the subject or another element by changing your position.

- ✓ Physically remove it if you have the option.

- ✓ Allow it to be in the shadows so it isn't obviously visible (assuming you have control over the light or have time to wait for the light to change).

- ✓ Take it out later in postproduction. (Check out Chapter 18 for details.)

8

Finding Your Perspective

You can take the Ansel Adams tour of Yosemite National Park and set your tripod in the same exact spot that the great photographer once did while shooting one of his classic landscapes, and odds are that your perspective will still be slightly different than his was. This variation could be because of a minor difference in the vertical or horizontal placement of the camera or because of the change in elements in the scene through time. The possibility of two photographers accidentally creating images with the same exact perspective is very unlikely.

Each photographer has a unique perspective that he can alter and adjust. Discovering your own perspective and evaluating that of others helps you take photos that look like you want them to and sets you apart from other photographers. In this chapter, I explain techniques you can use to create depth in photos, draw attention to your intended subject, tell a story with a photo, and explore less common perspectives.

Looking at Things from a New Perspective

In photography, *perspective* is where and how you place your camera in relationship to your subject and the elements of a scene. When you determine your perspective, take into account where all the elements of a scene are in relation to each other at the time you take the picture. Every

situation is different, so you must determine the level of significance to be given to your subject and the surrounding elements. Here are a few options and examples:

✔ **Placing your camera low and filling most of the frame with a particular subject usually helps to make the subject appear to be a hero of some sort.** Look at iconic images of presidents of the United States or Che Guevara to see what I mean.

✔ **Shooting from a high angle and including many elements in the frame could dull the significance of your subject and draw more attention to the other elements.** Consider the famous photograph of the man standing in front of the tanks in the protest on Tiananmen Square. In that image, the tanks are as important as the man is to telling the story.

The choices you make with regard to perspective play a major role in defining your photographic style. When a photographer develops a style, anyone familiar with that signature look can recognize the photographer's images. Style develops over time and always has room to evolve. Although you may choose to do things a certain way to maintain your look, you need to understand all your options for manipulating perspective so you're prepared for any situation you may come across.

As a photographer, you have a job to do whether you're shooting for fun, being paid to cover an event, creating an editorial fashion story, or making a fine-art masterpiece. Your job is to take photos you're pleased with. Training yourself to automatically recognize the subjects and elements in a scene, to understand their relationship to you and to each other, and to know how your decisions affect those relationships frees your mind to concentrate on other techniques like focusing and adjusting your exposure.

Understanding how perspective impacts your message

A photograph tells you something about its subject. This message can be subtle or literal or somewhere in between, but the message is going to be there. The main subject in an image has relationships with whatever other elements exist in the frame, and your job is to present a clear message based on those relationships.

Take a look at Figure 8-1 and notice the differences between the two depictions of tuna tartar. In both photographs, the tuna tartar stands out as the subject because of its focus and position in the frame; however, the message is different in each case.

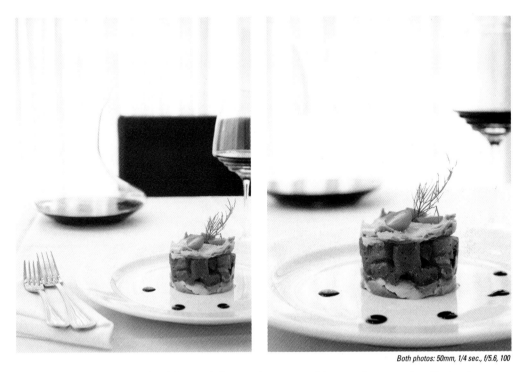

Both photos: 50mm, 1/4 sec., f/5.6, 100

Figure 8-1: Changing the angle of view and distance from your subject can have a major effect on how people read an image.

The left-hand image in Figure 8-1 tells the story of the entire setting. It's clear that the tuna dish is served in a restaurant environment and is good with red wine. The relationships it has with the other elements in the photo tell you these things. For instance, the red wine is in the background on the same table as the dish. The photo shows a setting for only one person, so the wine has to be for the person who's having the tuna. The folded white napkin and white tablecloth tell you that the dish is in a restaurant.

The image on the right tells a much different story even though I took it with the same setting just moments after the shot on the left. Because you see the dish from a lower angle and because the camera is closer to the subject, the tuna tartar looks more like a product than part of a meal. The forks, napkin, and chair are no longer in the image; all were eliminated by the change of angle. You still see the wine glass and carafe, but they're blurry because I changed the distance between the subject and camera. Because they're so far out of focus, they don't convey a strong message. Instead they provide an interestingly shaped frame around the subject along with the garnish on the plate. (The section "Moving the subject or yourself" tells you more about manipulating depth of field using distance.)

By changing the height and angle of the camera, I changed the message of the image without changing any other aspects of the photography. You can easily control your message when you understand the relationships among the objects in front of you and have the know-how to manipulate them.

Making choices about perspective

Even though it may not always feel like it, you have an infinite number of choices regarding perspective when taking pictures. Consider the following:

- ✔ **You're free to move around.** The slightest movement in any direction affects your angle relative to the subject and the other elements in a scene. Even when your ability to move is restricted, you have some options for getting the best angle possible.

- ✔ **Your focal point and depth of field play a major role in conveying your message, and a slight change can have a huge impact.** Tell your viewers what your subject is by making it the focal point, and determine how much of the scene should be in focus to support it. (See Chapter 7 for more on focal points.)

- ✔ **You choose the correct focal length to include an appropriate amount of surrounding elements.** A 28mm–135mm lens provides a flexible range; it allows you to capture wide scenes, situations that require zooming in for more detail, and everything in between.

The later section "Considering Techniques to Get the Shot" tells you more about moving around, finding your focal point and depth of field, and choosing the correct focal length.

Making decisions based on perspective eventually becomes second nature. You begin to notice every detail in your frame as you develop an eye for composition and use perspective to incorporate or eliminate elements in order to create *your* version of the story.

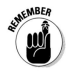

If you see something in the background that you feel has some relevance to your message about the subject, you may want to find a perspective that allows you to include that element successfully. Search for the appropriate distance and angle to approach the subject so that no other element blocks what you've found. To see more of your background, usually you raise the height of your camera so you see the details of objects directly behind your subject or foreground. This also is a way to add depth to your photography.

In landscape photography, photographers often shoot from a high angle in order to include as much detail as possible and to show how expansive a scene is. The high angle also is common in portraiture, which focuses on someone's face. Conversely, fashion photography uses a low angle to

highlight the wardrobe as the subject. Of course, these are all just common practices and are encouraged to be tweaked and personalized by each individual photographer.

I make decisions on the fly based on the situation at hand. Sometimes my portraits look like fashion images and vice versa. In the left photo of Figure 8-2, I had to have a high-enough angle to show the muddy foreground and the water on the horizon through the tall grass. In the right photo those details were lost; the low angle shows less of the environment and instead shows a subject with a background. It's all about the girl or the coat she's wearing.

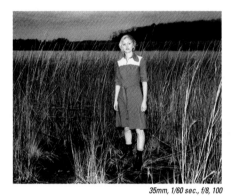 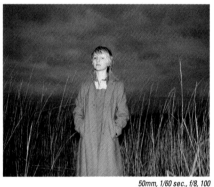

35mm, 1/60 sec., f/8, 100 *50mm, 1/60 sec., f/8, 100*

Figure 8-2: Choose a perspective that gets your message across.

Selecting perspective according to light

Photography in its most basic form is a record of light, so it's no surprise that light is the most important element in any photographic scenario. Light causes you to see what you see. The ability to manipulate light in a scene is important but not always possible. When you can work only with available light, you may find that you choose your perspective based solely on what the light is doing.

People view photographs according to a lot of subconscious rules. Knowing these rules helps you decide which perspective would best capture a potential viewer's attention. Most good compositions are designed to keep a viewer's eyes within the frame for the longest time possible. Using contrast is one way to accomplish that task. (Refer to Chapter 10 for more on controlling contrast.) Typically, eyes go immediately to the spot on the image that has the most contrast. From there they move around the image following the lines and gradients that make up the image. (To see the lines and gradients in their basic form, squint while viewing an image; check out Chapter 3.)

Figure 8-3 presents a case in which light dictates perspective based on placing the subject in the area with the most contrast. A window just out of the frame on the right side lights the subject and the scene. The wall has a semigloss quality and reflects the light from the window, creating a highlight similar to a spotlight. With the perfect perspective, the reflected light ends up behind the subject — the female model. Because she's fairly dark compared to her surroundings and was placed in front of the lightest spot in the room, she's in the exact area your eyes go to when viewing the image (though, I'm sure the bright green mask helps draw your attention to her as well). The reflection also causes a natural *vignette* (a gradual loss in brightness toward the edges of an area that draw attention to the center), which helps keep your eyes from wandering outside of the frame.

If you don't have any interesting light falling into your background, you can always position the subject in a well-lit area in front of a background that's covered in shadow.

Another way that light can dictate perspective is when a photographer includes the shadow of a subject as part of the background. If you're using available light and can't move your subject, you have to find the right perspective by moving your camera. If you want to take a picture of a tree lit by the sun, for example, you can wait for the sun to move and change *your* perspective, but the tree is staying right where it is. Of course, if the tree happens to be a bonsai, you have the option to change the relationship of the tree and wall.

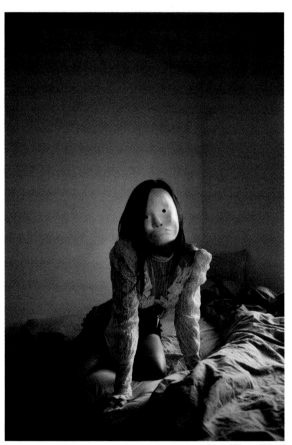

24mm, 1/20 sec., f/3.5, 800

Figure 8-3: Creative use of available light can add interest to your compositions and draw attention to your subjects.

Here are some more suggestions for using available light to create interesting compositions:

✔ Approach your subject from an angle that places your key light source to the side of your subject for a more dramatic composition.

✔ Be aware of how the light affects what's behind you if you're photographing a reflective surface like a shiny car or a person wearing sunglasses. Changing your angle could create a smoother highlight or a more appealing reflection, or it could reveal details about the environment. You control the effect of this light by moving around and viewing the changes that occur in the reflective surface.

✔ When shooting a backlit scene (a scene that has a key light source behind your subject), find an angle where the subject or an element in the scene blocks the light in order to have a normal amount of contrast in your exposure.

Making the light source visible in your frame cuts down on contrast and provides a softer overall feel. In most cases, it also causes *lens flare* (halos and geometrical-shaped areas of color and haze that are created when a light source shines directly into a lens). Lens flare can be good or bad depending on what you're shooting and what your message is supposed to be.

Considering Techniques to Get the Shot

Sometimes you have more time and control over getting a shot you're happy with, but other times you have to get the shots on the fly. In those hurry-up situations, a well-trained photographer will have an idea of what to expect and will be prepared for the decisive moment. In order to prepare yourself for these types of situations, be sure to familiarize yourself with the techniques discussed in this section and get some hands-on experience using them. Before you snap a shot, look around and notice what options you have for getting a higher angle or for getting closer.

Keep in mind the basic rules of composition as discussed in Chapter 1. If you're familiar with your camera, its settings, and how to focus it, you'll have more time to concentrate on getting the best composition. I'm usually disappointed in myself when I capture a great moment and later discover I'm not satisfied with my composition.

You often can improve your composition by making quick adjustments to your perspective. Searching for something to stand on may provide you with the extra height needed to reveal more detail in the scene, or you can kneel and shoot from a low angle. I've been known to lie down on busy sidewalks to get a shot. (Don't be too embarrassed to do these things; it's the photographers with the million eye-level images who should be embarrassed.) If your subject moves and ruins your composition, move with it to regain your desired composition. Always be aware of the elements in your frame and their relationships with each other.

In a more controlled photo shoot, you can take time to perfect your composition and should consider everything. Here are some tips for getting the shot you want:

- ✔ **Move things around as necessary, if possible.** If your subjects are smaller objects, they're (usually) moveable. While you look through the viewfinder, have an assistant or friend move things around until you have the desired composition.

- ✔ **Move your camera if the subject isn't movable.** If you're shooting buildings or mountains (or other large immovable structures), move the camera until you're satisfied with the composition. Many architectural photographers bring a ladder to their shoots in order to achieve maximum depth and to have more control over their perspective.

- ✔ **Try holding the camera instead of using a tripod.** For instance, when photographing people, I prefer to hold the camera in my hands. The tripod offers you a fixed perspective, but it also requires you to rely on directing the model in order to achieve the right composition. If you don't need a fixed perspective, try holding the camera so you can move around to tweak the composition instead of asking the model to move over an inch.

- ✔ **Take several photos.** When you have time, shoot from multiple perspectives to give yourself options and the chance to compare results. I often find that my second or third composition works much better than the original.

Moving the subject or yourself

A photographer's distance from the subject is as important as the subject's distance from the other elements in the frame. Keep the following tips in mind when you're deciding whether you need to move your subject or your camera:

- ✔ The closer the subject is to the background, the sharper the background appears in the photo.
- ✔ The closer you are to the subject, the softer the background appears in the photo.
- ✔ The closer a light source is to the subject, the darker the background appears (and vice versa).
- ✔ As you back away from your subject, it becomes part of the background.
- ✔ As you get closer to your subject, it becomes part of the foreground.

Experiment with factors like these in order to become familiar with the ways a shot can come together.

If you use an on-camera flash as your key light source when you photograph a person leaning against a wall, the person and the wall both will be fairly sharp and will receive the same intensity of light during the exposure. If you stay in the same spot and have the person step out half the distance between you and the wall and take another shot, the results will be different: The wall will become softer because your focus is now farther from it. The wall also will become darker. Light falls off at a certain rate as it travels through space, and in this case it would lose one stop of intensity by the time it traveled from the person to the wall. The person would be exposed properly and the wall would be one stop underexposed.

In some situations, you may prefer that your background be out of focus but exposed properly with the subject. In that case, bring the subject away from the background and rely on available light instead of an on-camera flash.

Zooming in to reveal details

A zoom lens can come in handy when you're shooting on the fly or when you can't move closer to your subject. When zooming in isn't your only option, however, you have to decide whether to zoom in or physically move in.

A major misconception in the world of photography is that the focal length of a lens can change perspective. This simply isn't true. Only *you* can change your perspective.

Try following these steps to see what I mean:

1. **Set up your camera with a subject in front of a background that includes various elements at various distances.**

 A city street is a good choice.

2. **With a zoom lens at its widest focal length, take a photo of the subject.**

3. **Without moving the camera or any elements in the frame, zoom in to the lens' longest focal length and take another photo of the subject.**

If you look at the images from Steps 2 and 3 on your computer side by side, you may appear to have two different perspectives. In reality, though, you have two different *crops*. To prove this to yourself, crop into the photo taken with the wide focal length until the crop matches that of the photo taken with the long focal length. Compare the images, and you see that the compositions are the same. The relationships of the subject and the other elements have stayed the same, so the perspective hasn't changed.

The reason photographers often believe focal length has something to do with perspective is because they typically use telephoto lenses from far away and wide angles from nearer perspectives. Focal length may cause

a photographer to change perspective, but it doesn't change perspective itself. So, if you feel that your perspective is perfect but you want more visible detail, you can zoom in. When you do so, you lose background information in two ways:

✔ You magnify your subject, making your depth of field shallower.

✔ You eliminate much of the surrounding background details.

If you want a clearer and more descriptive background, move in and use a wider angle. As you get closer to your subject, the background elements get smaller. By using a wider lens, you see more of the background and surrounding details, and your subject isn't magnified in the lens. Therefore the depth of field is greater.

Macro photography is the art of magnifying the subject as much as possible while keeping sharp focus on that subject. With this technique, however, the background becomes much less focused. As you can see in Figure 8-4, the depth of field becomes extremely shallow with this much magnification.

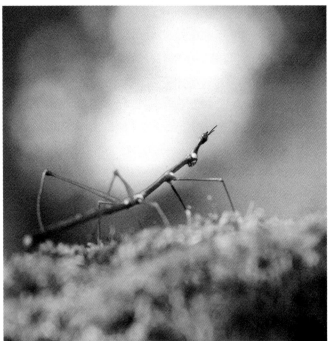

135mm (with 25mm extension tube), 1/60 sec., f/6.3, 400

Figure 8-4: Place your focus where you want it when you use a lens or perspective that magnifies your subject.

Using focal length to achieve your goals

In addition to being a tool that helps you control depth of field, focal length is useful in finding the right perspective. Having *depth* (the illusion of three-dimensional space) in your photographs is a great way to draw viewers in. ***Remember:*** Don't confuse depth with *depth of field,* which is the amount of sharp detail you have in an image. (See Chapter 7 for more details.)

Depth occurs when a viewer can sense the distance between different elements in a photograph. Wide-angle lenses enable you to incorporate more of a scene into your frame, which helps to maximize the illusion of depth. The wide angle enables you to include more physical space in the frame, so naturally it gives you the potential to create photographic depth when you combine it with a high angle. Figure 8-5 represents an example of depth in a scene created by using a wide-angle lens and a high perspective or angle.

24mm, 1/250 sec., f/11, 100

Figure 8-5: Shooting down from a high angle with a wide-angle lens can create an image with depth.

Setting the camera high on a tripod and pointing it straight out and parallel to the ground gives you a frame with a centered horizon line and a lot of sky. The *film plane* (the plane that your digital sensor exists on; see Chapter 3) is perpendicular to the ground, limiting the focus you can achieve in the shot, regardless of your aperture. In most cases you can lower the angle of the camera to eliminate some of the sky and include more of the foreground. The foreground then contains a lot of detail because it's closest to the lens. And if you choose it well, the foreground then provides purpose to your image.

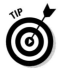

When the film plane is closer to parallel with the ground, you can achieve focus on details in more of the frame. Shooting with a vertical crop instead of a horizontal crop can increase depth even more. You lose some of the surrounding details, but you then have the ability to include even more of the foreground in the frame. A horizontal crop works great for depicting expansive areas, and a vertical crop works for creating depth.

In many cases, depth isn't the most important factor when composing an image. Consider, for example, when you take a portrait of a person's face. If you get in close to someone's face with a wide-angle lens and take a picture, your subject's nose will appear much larger in the image than it does in reality. When taking a headshot or close-up portrait in the 35mm format, choose a focal length of 70mm or higher. Doing so proportions the features of the face evenly.

Rotating Your Camera to Create Unusual Angles

Imagine you're in position with your camera, and your subject is in place. You're satisfied with the perspective as far as the relationships of the elements within the frame, but suppose you want a more interesting composition. Maybe it seems that the situation needs something different to tell the whole story, or maybe you're just bored with the traditional composition that you see through the viewfinder.

One way to take charge of this situation is to rotate your camera in order to depict the relationships of the elements in the scene in a different way. The difference can be obvious or subtle. Rather than changing the relationships of the elements to one another, you change their position in the frame, which ensures that viewers see them differently.

In the following sections, I show you different ways to rotate your camera so you can portray a scene differently without changing the relationships of the elements to one another.

Putting the subject off center

Sometimes I choose to put a subject in the center of my frame as an artistic statement or because the scene is symmetrical and I want to depict it that way. However, as a general rule, I try to center my subjects as little as possible. Centering your subject is sort of like making it the bull's-eye on a target. It can be viewed as too obvious a place to put a subject, making it aesthetically unappealing; in fact, the viewer may think you were being lazy when you took the photo. Putting the subject off center can help liven up your photo's composition.

When I suggest putting the subject off center, I'm not simply suggesting that you remove it from the center of the frame. I'm suggesting that you move the subject out of the typical place of importance or compositional strength.

When I'm shooting an event with a keynote speaker, for example, I find myself wondering how to show more of the story. Photographing a person talking to a microphone or showing a person's back while she's talking to a crowd can be boring; however, if you show a profile view of the speaker, you can include interesting details in the photos. Choose a lens wide enough to include the speaker and at least the first few rows of the audience, using a perspective where you can see facial expressions on both sides. In person, you can only view one thing at a time and would either catch the speaker's delivery or the audience's reaction, but a photograph enables you to record both of these by selecting the appropriate angle.

Many photographers would place the speaker in one of the frame's thirds (see Chapter 5). Doing so ensures that the speaker is the main subject and provides the viewer with some idea of her importance. Plus, according to the rule of thirds, this placement of the subject makes for an aesthetically pleasing composition. However, keep in mind that although this placement can be a good idea, it isn't always necessary or possible.

Assume, for example, you have the subject on the left third of a horizontal frame and a row or two of the audience on the right side of the frame. With this composition, you're saying that the speaker is the main subject and the members in the audience are just details. Chances are the space on the far left of your frame (beyond the left third) isn't filled with important details and is being wasted. Try angling your camera more to the right, placing the speaker on the far left edge. Now the audience has a stronger presence in the frame. The speaker has become less important and now has to compete with the audience for the viewer's attention. This could cause tension, irony, or harmony, depending on the interplay between the audience and the speaker. You could go from having a fairly boring image to having an image that tells the whole story.

You also may try setting the focus on one of the unexpected heroes in the audience who's having a strong reaction to the speaker's presentation. Doing so would show a different side to the story and could be more interesting than the expected shot where the speaker is sharp. Changing focus gives the slight illusion of changing perspective, but it's best known for directly telling a viewer exactly where to look in a photograph.

Another time when I often choose to place a subject on the edge of a frame is when the subject is in motion. If a surfer is riding the face of a wave in a photograph, I like to see what he's coming up against rather than seeing the water he's already covered. You could accomplish this by using the rule of thirds, but instead why not try placing the surfer on the edge of the frame? Doing so gives a moving subject space to move into the frame.

Keep two things in mind when you place a subject on the outer edges of the frame (especially when using a wide-angle lens):

- ✔ **Keep your subject in focus.** If you're using the camera's auto focus, be sure to have a thorough understanding of how it's controlled, because most cameras don't allow you to simply focus on the far edges of the frame. (Chapter 3 tells you about your camera's settings.)

- ✔ **Avoid (or be ready to correct) distortion.** When you use a wide-angle lens and place subjects on the edge of your frame, you get *barrel distortion,* which is the illusion that something is bigger in the middle than it is at the edges.

 For instance, a soda can photographed with a normal lens appears cylindrical. If you photograph the same can with a wide-angle lens, it would take the shape of a wooden barrel (having a fat center compared to the top and bottom). The closer the lens gets to the can, the more the can begins to appear that it has the shape of a barrel. Distortion becomes worse toward the edges of the frame. *Tip:* Some photo-editing programs provide filters that correct lens distortion. These programs are worth looking into if you haven't already. However, sometimes distortion can add to the aesthetic quality in a composition, so you don't need to fix it in postproduction. (See Chapter 18 for details on these programs.)

Placing the subject in the top or bottom of the frame

Having a foreground, subject, and background is a good way to create the illusion of depth in a photograph. This formula works great in doing its job, but it doesn't always have to be configured in the traditional sense; in other

words, you don't always have to put the subject in the middle. In fact, the subject could become more interesting when it fills the space of the foreground or the background. Let some other elements fill the midground, and then set up your subject to be as subtle or obvious as you like.

When you take a high angle and place your subject in the foreground or background, you take a risk similar to placing the subject at the edge of the frame. The statement is bold and works for more tense messages, but could potentially throw off the balance of your composition. You have to make sure that you draw the viewer to the subject. The viewer's eyes can wander farther from a subject at the bottom or top of the frame, so they may need extra instruction to come back. Lines that lead to the subject usually bring the viewer back to that area of interest.

Check out Figure 8-6; the lines created by the elements in the photo direct your eyes to the girl in the background. In Figure 8-7, on the other hand, the subject is in the foreground; this placement is blatant and provides an easy read.

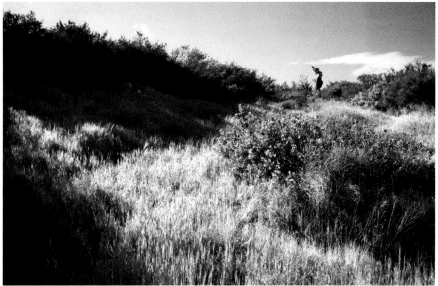

28mm, 1/200 sec., f/8, 100

Figure 8-6: A subject placed in the background.

Sometimes you place a subject in the bottom or top of a frame simply because it makes sense. If you want to emphasize the greatness of the sky or the size of a tree, for example, putting the subject in the bottom of the frame

may be wise. Cropping someone at the bottom of a frame tends to say as much or more about the environment as the subject. Or, if a flag is staked at the top of a tall mountain, you could place it at the top of the frame to show the size of the mountain compared to the flag itself and to represent the great feat of getting the flag there. Placing a subject at the top of a frame also could give it room to fall or roll down, or the arrangement may show that it has been thrown and has reached its peak.

50mm, 1/200 sec., f/2.2, 200

Figure 8-7: A subject placed in the foreground.

You have the same concerns with focus and distortion when you photograph a subject on the top and bottom of a frame as you do when photographing a subject on the outside edges. You need to be familiar with your camera's auto focus controls in order to use it on subjects that are placed outside of the sensors. And remember that if you use a wide-angle lens, any element that nears the edge of the frame will be distorted. Check out the earlier section "Putting the subject off center" for more details.

Changing your camera's orientation

When you turn your camera sideways, the orientation of the frame goes from horizontal to vertical. Deciding on the orientation is important for choosing and creating the appropriate composition in any given scenario.

Both vertical and horizontal crops have their time and place, but sometimes neither is quite right for the message you want to depict. In these cases, you may want to take a photo with a crooked orientation. For me, a horizon looks best in photographs when it's straight, but if you're going to make it crooked you may as well go all the way with it. Instead of turning your camera the full 90 degrees, try somewhere around 45 degrees — what photographers and cinematographers call the *Dutch angle*. If a clockwise rotation doesn't look so hot, give counterclockwise a shot. Take a look at my example of a Dutch angle in Figure 8-8.

Figure 8-8: Using a Dutch angle for a crooked orientation.

The Dutch angle can add visual interest to an otherwise boring composition. It can add more drama to a subject in motion, throw off a viewer's understanding of the photograph, or increase the depiction of an incline or decline. Try experimenting with this technique while using various camera angles as well. (Remember that the Dutch angle refers to your camera's orientation, but your camera angle refers to your camera's position in relation to the subject.) For instance, using a Dutch angle with a high angle and low angle will provide much different results.

9

Backgrounds:
As Important as the Subject

As a kid, I remember having my portrait taken once a year from a photographer at my school. It was quite a big deal. Maybe you remember picture day, too? A few weeks after having your picture taken, you could buy different packages. Of course, all the kids wanted the premium setup that included some absurd amount of wallet-size photos to hand out to friends.

If your parents were willing to dish out some extra cash, the photographer would hook you up with the popular bookshelf or laser backdrop. I was always stuck with the plain old blue-blur background, and now that I look back on it, this was probably a good thing. Everyone must reach a certain age when they realize that the laser background isn't only irrelevant to the portrait but it's also distracting. A viewer spends more time examining the neon glow of the straight, high-contrast lines intersecting with your head than they do with you — the subject.

A good composition creates a balance between the subject and background and enhances your message. In portrait photography, you almost never want a background that draws more attention than the subject does. The rare exception is a situation in which the background tells a great deal about the subject. In this chapter, I give you pointers on planning the perfect background for your shot, including a few examples that show backgrounds that gain more attention than your subject.

Keep the lasers in mind when you compose your images, and ask yourself whether the background is appropriate and supportive to your subject and message. In great compositions, the background is just as important as the subject and other elements in the scene.

From Great Outdoors to Crawlspace: Considering Types of Backgrounds

When I'm planning a photo shoot, the first question I ask myself is, "What would be the most appropriate setting for the subject?" Based on the subject and the purpose of the shoot, I decide right away whether I should shoot on location or in the studio.

Nine times out of ten, I choose to shoot on location. I tend to take mostly environmental portrait and fashion assignments, and shooting on location brings up new challenges with each different environment; striving to get the most out of each one keeps my creative urges alive. When I spend too much time in the studio, I start to feel like I've seen it all before. (By the way, an *environmental portrait* is one that tells who someone is by incorporating a descriptive background.)

Where you shoot depends on what type of background you're looking for. Ask yourself these questions when considering where to set up:

- **Do you want a background that provides an environment for the subject?** If so, shooting on location is your best bet. In this case, you need to determine how much information you'll include from the scene.

- **Do you want a background that provides *negative space* (areas of the frame that aren't filled with any elements of interest)?** If so, you can either shoot in the studio or find a location that enables you to position your subject in front of the open sky or a large solid wall that's monochromatic and has little texture.

- **How much space do you need and what lens will you use?** If you want to shoot with a shallow depth of field (to blur the background) and a long lens, you'll need adequate space between you and the subject. If you're shooting multiple subjects (like a group portrait), choose a location that has enough space to fit them all in. If your studio space is small, it will limit your compositional capabilities.

- **If you're going to photograph on location, do you need an area with light pedestrian traffic, and will you need to pull a permit for that location?** The city wants to make sure you have insurance if you're going to be working on public property. You have certain liabilities to consider when photographing. If someone gets hurt while on your

set, you may be responsible. When you're being paid to photograph, chances are you should have insurance and a permit to work on public property.

✔ **Are you going to create a clipping path around your subject in order to place them in front of a new background in postproduction with image-editing software?** If so, you want to separate the subject from the background as much as possible through the use of contrast and color. This pertains to shooting in the studio or on location. (A *clipping path* is an outline that isolates a subject from its surroundings so you can move it or place it into a new image. Techniques like these are discussed further in Chapter 18.)

Asking these questions helps you put yourself in situations that work to your advantage based on the photo you want or need to take. If you're shooting street photography or travel photography, you have to work with what you're given as far as subject matter and backgrounds. Using this type of photography is a great way to develop your skills in composition because you're forced to think fast and pay attention to details. Working with in-studio shoots, on the other hand, allows you to manipulate the scenes more.

In this section, you discover some of the pros and cons associated with shooting in open spaces and in tight spaces as well as how to work within each. You also find out what solid backgrounds do for your message and how to achieve different effects when using them.

If you choose to photograph on location, I recommend shooting at times during the day when the light is directional and creates interesting effects on your backgrounds and subjects. For instance, it's a good practice to shoot early in the morning and late in the afternoon. See Chapter 10 for more on ideal outdoor lighting conditions.

Working with wide-open spaces

Having space to work with is essential to compositional freedom. You may not take advantage of the entire scene by including it in your frame, but you have the option to. When you're surrounded by expansive space, the background is probably going to be far from your subject, which gives you flexibility when it comes to lens choice. You can use different focal lengths to create entirely different representations of the same scene. Consider the following, for example:

✔ **A wide-angle lens will show how expansive the space is in relation to your subject and will reveal more details in the background.** Shooting with a wide-angle lens in a wide-open space means that you can move around without changing your background too drastically. You can get as close or as far from your subject as you see fit. You control your depth of field partially by getting closer or farther from the subject.

In the left-hand image of Figure 9-1, I kept my distance from the subject in order to show the scene that she was photographing. In this image, you see that she is photographing. You also see *what* she is photographing. In the right-hand image, I got very close to the subject to make it all about her hands and the 4-x-5-view camera she's operating. In this shot, you can still see mountains in the background, but the depth of field has changed and the subject takes up the majority of the frame, lessening the importance of the background. You can't see what the subject is photographing; you can only tell that she's using the camera.

✔ **A telephoto lens will show a more intimate relationship between the subject and the background by decreasing the amount of background in the frame.** If I would have moved in on my subject in the images in Figure 9-1 by using a telephoto lens rather than physically getting closer to her, I would have lost a great portion of the mountains that were in the background. This would have made the composition even more about the hands and the camera's parts and less about the relationship of the photographer and the environment.

Handling tight spaces

Photographing in a tight space is much more limiting than working in open spaces (see the preceding section). Because the amount of space you can set between yourself, the subject, and the background is sparse, you have to rely on aperture for depth of field. (Chapters 3 and 7 provide more information on aperture and depth of field.) Depending on the size of your subject, your telephoto lens may be useless in a tight space.

I typically shoot with a 50mm lens when I have little room to work with. I feel that this lens shows things as closely as possible to the way the human eye sees them in reality, which provides a certain integrity to the photograph. Using an extremely wide-angle lens in a tight space helps you show as much of the scene as possible; however, the closer the elements in a scene are to your wide lens, the more barrel distortion you have in the image. (*Barrel distortion* refers to an object looking larger in the middle than at its edges; I discuss this type of distortion in detail in Chapter 8.)

A tight space keeps you up-close and personal with the background and forces you to examine the strong points and weaknesses in it. (In a wide-open space, your background could be so far that you don't see intimate details in it; you simply see more of it.) So, pay attention to shapes, textures, colors, and light. These elements add interest to your composition. If, for example, your background is a wall with peeling paint, use the area of the wall that has the most interesting shapes, colors, and textures as a result of the corrosion.

24mm, 1/80 sec., f/5, 50

24mm, 1/80 sec., f/5.6, 50

Figure 9-1: In wide-open spaces, you have more control of your distance to the subject than to the background.

Find a way to fit your subject into the scene comfortably, keeping in mind what I mention about intersecting and merging lines in the later section "Backgrounds that merge with your subject." The subject's shape should interact positively with the background so the tight space makes sense. Otherwise, you may end up with a composition that feels awkward or unnatural.

I was in a tight squeeze when I shot Figure 9-2, so I placed the model right up against the background and shot with my normal 50mm lens. The result was a tight crop, which works well for images used on a model comp card (a marketing tool for models to show off their features and posing abilities). Positioning the model so close to the background was beneficial because the wall's texture was interesting and worth having in focus.

Using solid backgrounds

Solid backgrounds enable you to surround your subject with negative space, which is ideal when you want to make sure your viewers concentrate on the subject and nothing else. Eliminating competing elements in the scene ensures that the subject remains the sole reason for the photograph to exist.

When you use solid backgrounds, you have fewer elements to get your message across; so every compositional decision you make will have a strong impact on your message. So you have to be creative when using solid backgrounds and make decisions based on your desired message. Here are some background elements to pay attention to:

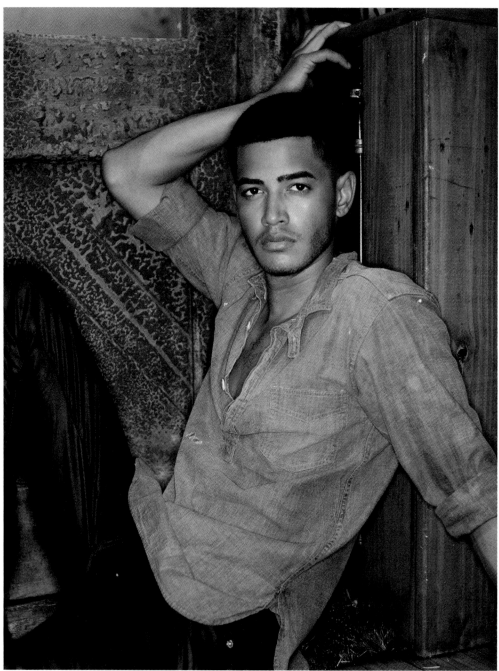

50mm, 1/125 sec., f/3.2, 50

Figure 9-2: Tight spaces often call for tight crops that reveal as much detail as possible.

- ✔ **Detail:** Because the background provides few details, each detail has a great impact on the story. If, for example, you provide an image with no details in the background, viewers won't focus attention on that background. However, if you include a shadow on the background, you've introduced a detail that tells viewers that a background exists.

- ✔ **Texture:** When shooting against a solid background, you typically want to eliminate all texture in order to keep the viewer's focus on your subject. If you don't have a smooth background available, you can have your subject step away from the background as much as possible. Because of depth of field, the farther the subject is from the background, the less detail the background shows in the photograph. (I explain depth of field in detail in Chapter 7.) In the case that you include the texture of the background, viewers will naturally consider what type of background they're looking at.

- ✔ **Color:** If the background is one solid color, the color will most likely be the strongest supporting element in the photograph. You can choose the color of your background based on what mood you want to create or on how well it complements the subject. Refer to Chapter 6 for details regarding complementary colors and how they affect a person's view of an image.

- ✔ **Subject placement and size:** Your placement of the subject in your frame and its size in relation to the negative space plays a major role in revealing the purpose of the image. A subject that appears small and is surrounded by much negative space seems less dominant and important than a subject that appears large and takes up most of the frame's space.

When you're using a solid background and want to be more creative and interactive with it, putting the subject close to or against the background will show texture and may cause the subject to cast an interesting shadow on it. Some photographers crinkle the paper backdrops in their studios and position models right in front of them. An image with this background doesn't try to conceal the photographic process. Rather, it gives you the sense that the photographer was present and that the subject was photographed in the studio. Some photographers even use wide-angle lenses to reveal the stands that are holding up the backdrop and the paint buckets and ladders in the back corner of the studio. This gives a sort of behind-the-scenes, creative twist to studio photography.

In fashion and product photography, you may sometimes want to create an environment that contains no detail whatsoever — a monotone and monochromatic environment that surrounds the subject. In studio or on location, you can create these solid, seamless backgrounds with rolls of paper that are suspended in the air and pulled down and out along the floor or table. You position your subject on the paper with enough distance from the background to ensure that it blurs and reveals no flaws in the paper. This type of shooting is great for drawing attention to your subject with absolutely no

distractions. To view examples of this type of photography, visit any online department store and browse the clothing galleries. Or take a look at some fashion catalogs.

In Figure 9-3, I show a photograph of my father shortly after he went through a successful treatment for throat cancer. He was happy to be alive and cancer-free, but at the same time he was experiencing steady discomfort and would continue to wear the tracheostomy tube in his throat for months to come. His body language and expression combined with this composition and the muted colors relay the conflict of accomplishment and uncertainty. I placed him in the bottom corner of the frame and made him relatively small in comparison to the negative space, which gives the sense of being cornered and alone. Cancer is an uncomfortable topic, so I felt that an uncomfortable composition was fitting.

50mm, 1/2000 sec., f/2.2, 1600

Figure 9-3: A balance of negative space, color, subject placement, and expression.

Recognizing Problem Backgrounds

In some situations, your background may not cooperate with your subject or your message. It may be too busy, meaning it contains too many elements that don't support your subject or message in any way. Or a subject may blend in too well with the background if it's similar in color or tone or has a similar texture or pattern as the background. These situations create compositional problems in which your viewers are distracted by the background and can't read the image in a clear manner. So, when you're trying to make your subject stand out from the background, you want to avoid situations like these.

However, sometimes you may not consider these situations to be problematic. For instance, you may find situations in which you can use a busy background or one that blends with your subject creatively to reveal a certain message. Your job is to decide when a background works with your message and when it detracts from it.

To help you get a handle on what works and what doesn't, in the following sections, I review some background problems you may experience, along with some ways to avoid or fix them.

Badly lit backgrounds

The most common issue that new photographers encounter with regard to backgrounds is too much or too little light hitting the background in comparison to how much light is hitting the subject. If you find that your subject is being lit by full, direct sunlight and your background is in complete shadow, you're going to have exposure problems (unless of course, your background has distracting elements and you want it to appear as dark as possible). In this situation, try to move your subject to an area that isn't being lit by the direct sunlight (if you can). Or, find a way to shed some light on the background. I usually carry a small, battery-powered flash in my camera bag in case I need to balance the light in a scene.

Another background problem may be that your subject is indoors but near a window through which sunlight beams into the scene. The window will be overexposed if you expose for the indoor light. To solve this problem, bounce a portable flash off a wall or the ceiling to bring up the ambient exposure inside to more closely match the outside exposure.

To operate a flash that isn't on your camera, you can sync it to your camera with a chord. However, this may not give you the reach that you require. I use a PocketWizard that transmits a signal from the camera to the flash telling it when to fire. With this system, I can place the flash far away from the

camera and still have it sync with my shutter. Finding the right flash (and setup) for your specific camera and needs requires some research. I suggest asking the folks at your local camera shop or browsing forums online to see what other photographers are doing.

To ensure that you accommodate areas being hit by bright light, consider your shot carefully before you work. Determine whether you even want to include the details in the background before getting out your flash. Sometimes, letting the background lose detail helps to bring more attention to your subject.

Distracting backgrounds

You've probably seen the ubiquitous party snapshot with some guy standing in the background staring at the camera or — even worse — posing in an absurd way. Nobody knows who the guy is, but for some reason he decided to steal the show in this group photograph. The unannounced visitor is pretty much the worst-case scenario for a distracting background. Other distractions could include the following:

- **Shapes or lines that are high in contrast or bold in color:** These elements can take attention away from your subject in some cases. To lessen the distraction when removal is impossible, use a shallow depth of field to blur them a little.

- **Harsh spots of light or shadow:** A spotlight is meant to direct attention to a specific area. If a spot in your background draws attention away from your subject, try changing your *perspective* (the relationship between your camera, the subject, and the background elements) in order to use the harsh tonality to draw attention to your subject. Or eliminate it from your frame all together. Check out Chapter 8 for more information on perspective.

- **Subjects placed directly in front of noticeable lines or straight objects:** For instance when a person is positioned directly in front of a telephone pole, it can appear that the pole is growing out of her head. By moving the subject or the camera so the telephone pole is no longer a distraction, you can fix this problem.

- **Horizon lines in the center of a frame:** The center of your frame can act like a bull's-eye when it contains strong elements. A horizon cutting through the center of a frame is more successful as a distraction than as a complimentary compositional element.

- **Photos with too many elements that are irrelevant to your subject or message:** When taking a picture of the bride and groom at a wedding, for instance, you wouldn't want to include the empty beer bottles on the table and the trash can that's just behind them. Crop in tight or change your camera angle to find the appropriate composition.

Any element in the background that causes tension and takes priority away from the subject and supporting elements in the scene is a distraction and can hijack your message. Distractions can have different levels of competing power. For instance, the annoying, background party guy creates enough tension that he actually takes over as the subject. A harsh spot of light, on the other hand, may be less of a distraction.

When you're dealing with a distracting background, try one of the following:

- ✔ **Change your perspective.** You may be able to find the perfect angle to minimize or eliminate the distractions. (See Chapter 8 for more about perspective.)

- ✔ **Use a shallow depth of field.** You may be able to use a focal length and aperture that cause the background to go out of focus and minimize the distractions. Chapter 7 tells you how to work with focal length and aperture.

- ✔ **Edit out the distractions during postproduction.** If you want to use a great depth of field and can't eliminate the distractions, you can always clean up the problem with a photo-editing program like Adobe Photoshop. I discuss techniques to do this in Chapter 18.

Backgrounds that merge with your subject

Keep an eye out for merging shapes and lines in your compositions. A *merger* — when the edges of two shapes meet at the same point — causes confusion. You usually want your subject to stand out from the background, and that doesn't happen when a background element merges with the subject.

In particular, pay attention to how the horizon line intersects with the subject and the elements in a scene. You want to avoid merging lines and awkward intersections. You don't want to let a horizon line (or any background line) merge with the top of a person's head or to pass through their eyes, neck, or knees. Basically, don't allow any joints or points of interest to have a line cutting through them.

In Figure 9-4, I provide two example photos of the same scene. In the left-hand image, the subject and background merge, making a weaker composition than in the right-hand image, where they don't merge. Notice how the subject's shape is more defined when a merger doesn't take place.

Adjust your camera position or the position of the subject to eliminate mergers. The slightest movement could make a great difference in compositional quality.

50mm, 1/200 sec., f/8, 50 *50mm, 1/125 sec., f/8, 50*

Figure 9-4: Merging elements create tension in composition rather than harmony.

Avoiding lines and shapes that merge is a good practice for compositional quality, but you don't always have to separate the subject from elements in the background. Placing your subject partially in front of an element that's behind it can create the idea of depth or three-dimensionality. In this method, the subject's shape overlaps the shape of the background element, revealing that it's closer to the camera. However, do pay careful attention to how the two shapes overlap, making sure the points of intersection aren't awkward.

Preventing and Fixing Problems

To avoid background problems, you have a few options. If you're shooting on location and making do with the background that's available, you can check and fix shots as you take them. Or, if you're going to be in the studio, you can make your own backgrounds so they fit your needs exactly. I discuss each method in the following sections.

Identifying poor backgrounds by reviewing your work as you go

If you're lucky, you catch a background problem at first glance of a scene or notice it while looking through your viewfinder. In the days of film, photographers had to catch a problem by this stage in the process or it would be exposed later when they processed the film. By then it usually was too late — the perfect shot would be missed. Fortunately, your digital camera has a viewing screen so that you can see your images immediately after shooting.

After you compose a scene, snap a shot and check your results to make sure you haven't missed any problematic background issues. When a shoot permits, I tether my camera to a laptop so I can view the images on a larger screen as I shoot them. Viewing the pictures this way allows me to see my compositions more clearly so I get the most accurate exposures and the sharpest focus.

After you determine that something about the background is hurting your composition, figure out which of these categories you're dealing with:

- ✔ **Problems that can be fixed by changing your perspective:** This category pertains to situations where a specific element is a compositional nuisance and makes up only a small portion of the background. You can crop the element out of the frame, block it with another element in the scene, or eliminate it by putting it out of focus. Or, if necessary, you can use a combination of these techniques. In Chapter 8, I discuss your options for finding the right perspective.

- ✔ **Problems that can be fixed through lighting:** With this category of problems, you have too much or too little light on the background compared to the subject. In other words, in some cases you want to hide background details (or reveal them) by changing the intensity of light on the background. In the earlier section "Badly lit backgrounds," I mention carrying a battery-operated flash that you can use to create a more intense light on the background or on the subject. When photographing outdoors, you can wait for the sun's position to change in order to achieve the light you desire, or you can use strobes to increase the light intensity where it's needed, which in turn decreases the light intensity everywhere else.

- ✔ **Problems that you can fix in postproduction:** Problems that can't be fixed with changes in perspective or lighting have to be manipulated using photo-editing software. You can clone out a distracting background element with this type of software, and you can increase the lightness and darkness in certain areas of your scene.

Fixing a problematic background while shooting can save you a lot of time in front of the computer. I also try to minimize the amount of work I do to a photo on a computer in order to maximize the quality of my images. The more alterations you make in postproduction, the more likely it is that you'll have inconsistencies as far as noise distribution and tonal and color gradations. In Chapter 18, I discuss postproduction techniques in detail.

✔ **Problems that can't be fixed and should be avoided:** If you come across a problem that would be too much work to fix in a program (and isn't fixable using changes in perspective and lighting), you should reconsider the background entirely. If you notice that the background doesn't work for your purposes, perhaps you can move to a new location. Or, if possible, consider creating your own background (as I discuss in the following section).

Creating your own backgrounds to avoid problems

You can avoid many background problems by creating your own sets or backdrops. Some types of photography demand specific backgrounds because they require consistency in order to show a coherent story of many images. Fashion, product, and portrait photography often fit this description. Consider the following reasons you may want to create sets in the studio or other indoor locations:

✔ If you're shooting for a catalog, your client may want the images to have consistent lighting and tonalities so the images look like they go together.

✔ If clouds are moving through the sky during a shoot, your lighting will keep changing, and the consistency of the background may be jeopardized.

✔ If you're shooting large products that are difficult to move and each one needs to be shot in a different room, in-studio sets are convenient, because they can be built around the large product rather than moving the product itself.

After a set is built and lit, it will remain the same for as long as you want it to. However, after you're finished with the set, you can easily change it around and create a brand-new set with whatever type of lighting you need. Building sets gives you 100 percent control over your backgrounds and enables you to focus on your subject as the priority.

Depending on your budget and the kind of photography you're involved in, building sets can be as simple as creating the illusion of one wall that's a certain color and texture or as complicated as creating a space with multiple

levels and rooms that are furnished and appear functional. A commercial studio has walls on standby, ready to be painted and brought on set as well as rolls of linoleum flooring ready to be rolled out. Windows built into the walls have backdrops outside of them with blurry images of nature depending on the season you're trying to sell. Props are brought in and the photographer composes the image so it appears to be a real room.

If you have the studio space but can't currently build elaborate sets, you can use a few tricks to build nice sets for portraits and editorial fashion photography. One idea is to purchase 4-foot-x-8-foot pieces of foam core and use them as walls. These pieces of foam are lightweight, affordable, and easy to prop up. You can spray paint them, but the best way to give them life is to attach fabric to the surface. If you cover them with fabric, you can remove that fabric and reuse the foam boards multiple times. Plus, you can find many interesting fabrics that have designs and patterns that would be difficult to achieve with spray paint.

You may want to keep your own backgrounds simple and use a shallow depth of field to minimize the amount of detail revealed. This way you can suggest a certain background exists without having to pay elaborate attention to detail in creating it.

Using Background Elements to Support Your Subject

In some cases, the background in a scene is the most descriptive or one of the most descriptive elements to support your subject. This situation can happen because of these reasons:

- ✔ The scene doesn't include many supporting elements.
- ✔ The subject itself has few descriptive qualities.
- ✔ The background reveals the location, which is important to the message.

Take advantage of a background that includes useful information. Consider, for example, the images in Figure 9-5, which show the back of a woman's head. Because you see so few details, the woman remains a mystery. These images work together to tell you that the woman is a tourist. The only reason you know that about her is because of the backgrounds. She's facing the backgrounds; in the top image she's taking in the architecture, and in the bottom image she's taking in the detailed sculpture. In this diptych, the background speaks to you, and the subject's purpose is to make you imagine yourself in her position.

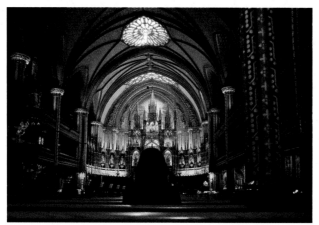

28mm, 1/15 sec., f/3.5, 1600

50mm, 1/50 sec., f/2, 400

Figure 9-5: Use the background as the sole source of information supporting the subject.

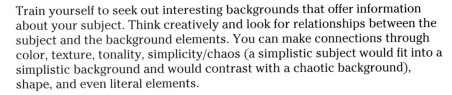

Train yourself to seek out interesting backgrounds that offer information about your subject. Think creatively and look for relationships between the subject and the background elements. You can make connections through color, texture, tonality, simplicity/chaos (a simplistic subject would fit into a simplistic background and would contrast with a chaotic background), shape, and even literal elements.

Keep the following tips in mind to effectively choose and use a background:

- ✔ **The color scheme in a background works with your subject to control the message in an image.** Each color has a different message, which typically is derived from natural senses and cultural conditions. Blue typically gives the feeling of openness or cool temperatures, but in some cases it represents depression. Orange can give the feeling of warmth and is often associated with stimulating a viewer's appetite. Green can be associated with freshness and has a calming effect in some cases. Chapter 6 has more information on colors and their meanings.

- ✔ **A background's tonality speaks greatly to the meaning of an image.** A *high-key image* is one that has light tones and gives the feeling of cleanliness, life, and energy. A *low-key image* has mostly dark tones and speaks a more mysterious, melodramatic, and quiet message.

- ✔ **Texture in a background can take on many different characteristics.** It can be smooth, rough, old, new, clean, dirty, and so on. It should be appropriate for your subject and your message.

- ✔ **A solid background with few details and elements is considered simplistic, and a background with lots of texture, lines, shapes, colors, and tones often appears chaotic.** The same goes for your subject. A chaotic subject stands out more on a simplistic background and blends in more to a chaotic background. For example, picture a floral-print sofa in front of a solid-colored wall. Then picture the same sofa in front of a wall with floral-print wallpaper. Each background could be interesting, but each represents the sofa in a different way.

- ✔ **Literal elements in the background tell you about the subject based on things you already know.** A man and woman kissing in front of an altar, for example, have just been married. An adult in front of a chalkboard that has mathematic equations on it is most likely a teacher; a child in front of the same background is most likely a student.

Figure 9-6 shows a photograph that I took while shooting for a health-food restaurant. This wheatgrass shot showed one of their menu items, which they wanted to look heroic. After all, wheatgrass is supposed to do great things for you. Putting the raw product behind the prepared shot and getting a tight perspective worked out to my advantage in a few ways. For one, it suggests

that the product is fresh. Also, it helps you to understand what the product is. If you saw just the green liquid in the shot glass, you might or might not know what it was. If you saw just the grass, you would assume it was grass, but you might not know what kind of grass. Seeing the two together lets you know exactly what you're looking at.

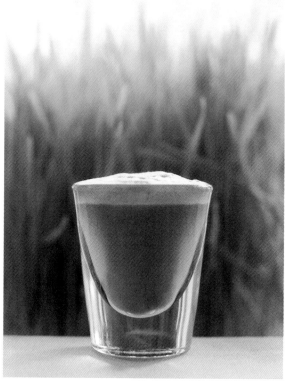

50mm, 1/50 sec., f/4, 500

Figure 9-6: When combined with the subject, this background reveals important details.

10

Using Light to Tell Your Story

*L*ight is the most important photographic element in any scene. After all, it's what makes photography possible. Even if you take the existence of light for granted, you should be aware that it dictates the message in your images just as strongly as any other element. For instance, a statue doesn't have the ability to change its expression or to move in any way, but you can use that statue to convey very different messages depending on the lighting style you use to photograph it.

This chapter shows you what light can say in an image and how to achieve the lighting you want based on what you want to say. For a more in-depth look at lighting, check out *Digital Photography Lighting For Dummies* by Dirk Fletcher (Wiley).

Recognizing Sources of Light

In just one scene, you may use many different forms of light from many different sources. An infinite number of recipes for light exist, and each controls the contrast throughout the composition of a scene. As photographer, you're the chef.

A *light source* is anything that provides light in your scene. Many different sources of light have unique value for photography. You can mix and match light sources to create limitless possibilities and create a photographic style of your own. Some common light sources include the following:

TIP

Making your flash less flashy

When shooting with a digital SLR and using a flash that's positioned on top of the camera, try not to point the flash directly into your scene if you can help it. A direct, on-camera flash can be an unflattering source of light. To avoid the direct flash, examine your surroundings to see whether you can bounce the light off of something else. If you're in a room with a low-enough ceiling, for example, point your flash upward so it directs light onto the surface of the ceiling rather than your subject. The ceiling reflects the light down toward the subject and acts as a larger source than the flash itself, spreading out the light and creating a more realistic quality. (See the section "Understanding Light

Quality and Intensity" for more information.) You can use the same technique with a nearby wall. Simply rotate the flash head to the side instead of pointing it straight at your subject. The light will spread and bounce off the wall, creating a much more pleasant effect on the subject.

Be aware of a surface's color when you're bouncing your flash off of it. This color will be reflected onto your subject along with the light. For example, a pink wall will cause a person's face to appear more pink. Bouncing light off a surface works best when you use a white wall or ceiling, because you avoid getting a shift in color.

✔ **The sun:** This is the most common light source. Because light reflects off of certain surfaces, the sun can create multiple sources of light at one time. In the upcoming section, "Modifying the quality and contrast of light," I discuss how you can control sunlight (also commonly called *natural light*) in order to achieve the lighting you prefer at any time of day.

Natural light is a *continuous light source,* meaning the light is uninterrupted. The sun provides continuous light from just before it rises to just after it sets. A *noncontinuous light source* is one that provides light for a brief moment — like the flash on a point-and-shoot camera.

✔ **Available lights:** These lights are part of the scene but aren't typically used to generate light for photography. Examples include lamps, overhead lights, candles, streetlights, and so on. These lights can be used as your main source of light, but in some cases they're dim, causing less-capable cameras to have difficulty exposing them properly.

✔ **Hot lights (designed for photography, video, or theater performances):** These are continuous light sources that usually can be *spotted* (focused more directly on one spot) or *flooded* (spread more evenly). They also can be turned up or down with a dimmer. These light sources require electricity, and they drain portable power sources quicker than strobes.

✔ **Strobes:** These are noncontinuous sources of light that produce light that lasts for just an instant at the time of exposure. Each flash or strobe of light is known as a *pop.* Strobes are professional lights that require

electricity to work. When using strobes on location outdoors, you need a portable power source like a battery pack or a generator.

✔ **Battery-powered flashes:** These are similar to strobes but are smaller, more compact, and can be used on the camera. They don't provide as much light as strobes, and they have slower recycle times between pops.

Recycle times are determined by how long the flash takes to recharge after a pop. A flash can't create another pop until it's recharged. With full batteries, a common recycle time is about 2 to 3 seconds. As your batteries are drained, the recycle times increase.

✔ **A reflector:** This is any surface or material that reflects light from another light source.

✔ **Window light:** This type of light is an indoor source that provides direct or indirect sunlight.

Understanding Light Quality and Intensity

In any light recipe that you cook up for a particular scene, the primary two ingredients are

✔ **Quality:** A light's *quality* is determined by how hard or soft it is when it falls on the elements in the scene.

✔ **Intensity:** The *intensity* of a light source depends on its relationship to the other lights in the scene. If one light is much more powerful than any other light, it stands out in the photograph and is considered high intensity.

In photography, the intensity of light is measured in *stops* because your exposure is measured in stops and can be determined by using your camera's built-in light meter. (Chapter 3 tells you all about this light meter.)

On a clear day, for example, the sun (like most uninterrupted light sources) provides a direct light that produces hard shadows. A *hard shadow* is one that's separated from the lit area with a sharp, well-defined line. The line between the shadowed and lit areas is very clear. You can think of this quality of light as *hard light;* some photographers refer to it as *harsh light.* The sun also provides an intense light producing dark shadows in areas that aren't receiving the light directly.

On the other hand, on a cloudy day the sun still acts as a light source, but it comes in contact with clouds before reaching the elements in your scene. The molecules in the atmosphere cause the sun's light to bounce around and scatter. Therefore, the light comes in at many different angles rather than

just one, producing soft shadows. The line between the lit area and the shadowed area isn't distinct. Because soft light spreads out more, it fills in the shadows somewhat, causing the light to appear less intense.

Having control of the quality and intensity of light — or at least knowing how to use the available light to your advantage — is the first step in achieving the balance that best reveals your intended message.

Considering hard light versus soft light

Because hard light provides drastic shadows, it's best known for its ability to reveal texture and make shapes appear more rigid or to have an edge. As you can imagine, this effect is great for some things and not so great for others.

For example, when the sun is low in the sky and is shining directly toward sand dunes, you have a perfect opportunity to show the ripples, sandy textures, and shapes of the dunes in your photograph, as I did in Figure 10-1. However, when you're shooting a portrait of a young woman's face, hard, directional light isn't the best choice because it reveals all the flaws and texture in her skin. Soft light is the better choice for representing beauty because it helps eliminate texture and blemishes by smoothing surfaces and softening shapes. See Figure 10-2 for an example of using soft light in a photograph.

Certain situations commonly call for hard or soft light. Here's a rundown of when you're likely to use each:

- ✔ **Hard light:** You use hard light when you want to reveal details, show texture, and create distinct lines. Use it when shooting the following:

 - Landscapes that are rigid, textured, or busy (meaning full of elements) or that contain fine details that soft light would minimize

 - Fashion or portrait photography that's meant to be *edgy* (meaning it has a sharp or biting edge and is associated with being bold or controversial)

 - Products with texture or fine details

 - Architecture that you want to appear sturdy and powerful

- ✔ **Soft light:** You use soft light when you want to minimize details and texture, reveal smooth shapes, or produce dreamlike photographs. Use it when shooting these:

 - Landscapes that are melancholy, smooth in texture, or sublime

 - Fashion or portrait images that are meant to represent beauty, purity, or a pleasant image of a person

 - Products with smooth shapes or reflective surfaces

 - Architecture that's rounded, graceful, or flowing in shape

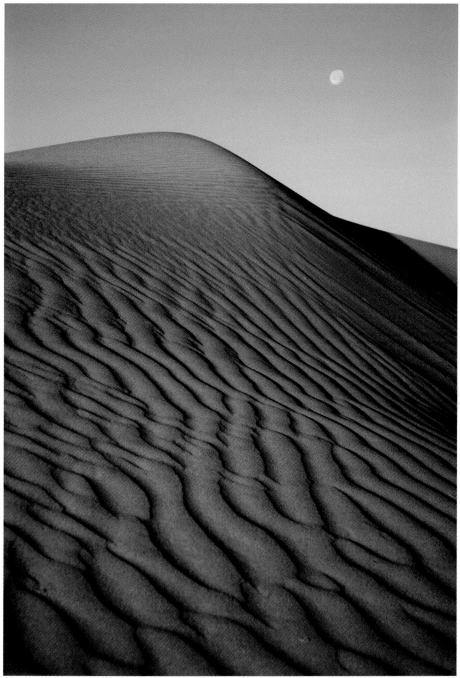

85mm, 1/200 sec., f/11, 100

Figure 10-1: Hard light reveals texture, lines, and shape in the dunes.

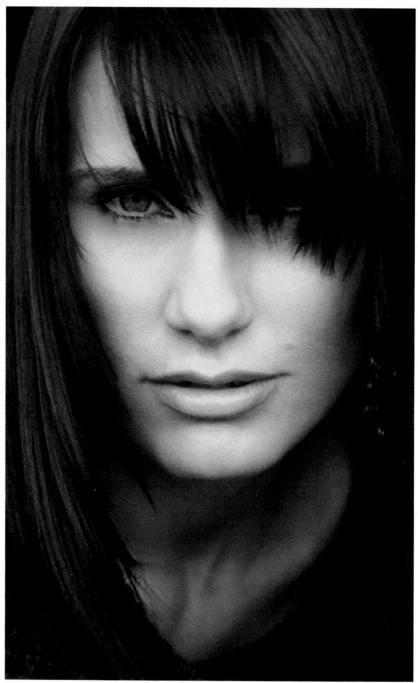

50mm, 1/160 sec., f/3.2, 50

Figure 10-2: Soft light often is used to portray images of beauty.

Keep in mind that sometimes images, especially landscapes, can have a mixture of hard and soft light. Using both helps to reveal different aspects of one scene.

Controlling your contrast

Contrast refers to how dramatic the difference is between your highlights and shadows in a photograph. If your highlights are white and your shadows are black, you have maximum contrast in the scene. If your highlights are white and your shadows are gray, you have less contrast.

You control contrast by changing the intensity of your key light in comparison to the intensity of your fill light. The *key light* is a directional light source that causes shadows to be cast in the scene. The *fill light* is an ambient light source (meaning it causes no shadows) or a light source that comes from the same direction as the camera, which minimizes the shadows it creates. The fill light gets its name by filling in the shadows created by the key light and controlling the level of contrast.

If your key light is 1 stop brighter (or more intense) than your fill light, you end up with low contrast. The shadows are only 1 stop darker than your highlights. When you shoot on a sunny day and use the sun as your key light, you most likely have a difference of 3 stops between your highlights and your shadows. This is a high-contrast situation and is about as far as you can go without losing details in your shadows. Your digital sensor has the ability to capture highlight and shadow information within a certain range. Anything outside of that range and you lose information in one of the areas, depending on your exposure settings.

Modifying the quality and contrast of light

Sometimes you may want to change the lighting on the scene you're shooting so you have harder or softer light or more or less contrast. When that happens, experiment with different combinations of light qualities and contrasts to get a feel for how they look and how you could use them for different messages. Here are some example situations to get you started:

- ✔ **Hard light mixed with high contrast** creates a bold and dramatic look. You can use high contrast to hide details and create a mysterious look.

- ✔ **Hard light mixed with low contrast** is bold but lacks drama. It can be edgy and informative at the same time.

 ✔ **Soft light mixed with high contrast** reveals shapes in a beautiful and dramatic way.

 ✔ **Soft light mixed with low contrast** produces images of beauty that reveal shapes in a soft and dreamlike way.

In the following sections, I show you how to manipulate the quality and contrast of the light you're working with and begin to create the preceding situations.

Bring a photo assistant to help you in situations when you want to manipulate light in a scene. Because of the equipment necessary to manipulate the light, an extra pair of hands makes life much easier.

Changing the quality

When photographing a scene, the natural light you have to work with may not be exactly what you want. So, you may need to either soften the light or harden it. I explain how to do both in this section.

You have the following two options for softening natural light:

 ✔ **Rely on the clouds.** If a thin layer of clouds comes between your subject and the sun, your light naturally will be diffused and will spread more gradually around your subject's features. If a thick layer of clouds rolls in, however, your light will become diffused to the point that it's difficult to tell which direction it's coming from. This severe diffusion causes what's known as *flat lighting*. This type of lighting is considered to be boring in most situations. The exception is beauty photography. Flat light works well in this type of situation because it diminishes texture.

 ✔ **Use a diffusion material.** Of course, you can't always rely on the clouds to get the lighting you want. When you want to take matters into your own hands, use a diffusion material stretched out over a frame. *Diffusion material* typically is some sort of thin white cloth that causes light to scatter when it passes through. You place the material between your subject and the sun, usually by fixing it on a stand or enlisting an assistant to hold it. The density of the material determines how much the light is diffused: the thicker the material, the softer the light's quality.

You can purchase Scrim Jims, diffusion products made specifically for photographers, at any photography retail store. The Scrim Jim has a lightweight metal frame with removable parts that make it easy to transport. When assembled, they make hollow 6-x-6-foot squares that you can cover with diffusion materials of different densities.

If you want to shoot with hard light but the sun is behind the clouds, you can use a strobe with a bare flash bulb to take the place of the sun. These strobes are a hard light source and provide a similar quality of light as the sun. They have an advantage over the sun because you can position them however you need to. (Try doing that with the sun.) Simply place the strobe on a light stand and place it where you want it.

You can modify the quality of light produced by a strobe in the same way that you can modify the quality of the sunlight. You can purchase accessories called *light modifiers* that attach to the strobe. Each accessory has a different effect on the light. Common strobe modifiers include the following:

- ✔ **Reflectors:** These are dishes that surround the back end of the flash bulb. They direct light forward into the scene rather than letting some of it spill backward away from the scene. Reflectors are ideal for creating hard, directional light.

- ✔ **Beauty dishes:** These modifiers are similar to reflectors but larger in size. They scatter light, making it less direct. They're good for creating a slightly softer light than reflectors.

- ✔ **Soft boxes:** You attach a soft box to the strobe so that a diffusion material is placed in front of the flash bulb and scatters the light. This modifier turns your hard light source into a soft light source. The soft box has a much larger surface area than the flash bulb. Soft boxes create a very soft light and vary in sizes. The larger the soft box, the softer the light.

- ✔ **Umbrellas:** Lightweight and easy to transport, umbrellas create soft light by bouncing it from a larger surface back into the scene or acting like a soft box and allowing your light to pass through its material.

The two things that determine a modifier's light quality are size and diffusion density. The larger a light source, the softer the light will be. Also, the thicker the diffusion material, the softer the light will be.

Altering the contrast

If you're shooting outdoors on a sunny day and want to use the sun as your key light but want to reduce the amount of contrast, you have many options. Here are a few:

- ✔ **Use reflective material.** This is the simplest way to reduce contrast on a sunny day. Many products are made specifically for photographers, but I use a piece of foam insulation with a shiny surface. You can buy it at any hardware store for less than $10. Have your assistant stand next to you and hold whatever reflective material you decide to use to bounce the sunlight at the subject. This technique increases the intensity of your fill light and reduces the contrast on your subject.

I used the preceding technique to take the photo in Figure 10-3. Notice the light that's being created by the direct sun, which is causing the highlight on the right edge of the subject. And take a look at the light that's being created by the reflected sunlight, which is filling in the face. Without the reflector, my subject's face would have been much darker.

✔ **Combine reflective material and diffusion material.** Photographers often use this combination to soften the sunlight on a subject (see the preceding section). The result is soft light with low contrast. You see this type of lighting in clothing catalogs like Victoria's Secret.

50mm, 1/640 sec., f/4, 100

Figure 10-3: Reducing contrast by increasing the intensity of your fill light.

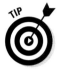

Using strobes (instead of the sun) to light your scene puts you in total control and enables you to maintain consistent lighting throughout the shoot. In the most basic situation, you have a directional key light and a fill light. You can use light modifiers to control the quality of your light, and you can control the intensity of your fill light in comparison with that of the key light to manipulate your contrast in the scene. (I discuss strobes and light modifiers in the preceding section.) Your strobes have dials, slides, or switches that allow you to increase or decrease the amount of light they produce during each pop.

The Relationship between Light Source and Subject

Light quality and intensity (which I discuss earlier in the chapter) are important ingredients when creating appropriate lighting for your photo's message. The third ingredient is the physical relationship of the light source to the subject. The position and distance of your lights in relation to your subject control many aspects of your achieved look and how you represent the subject.

In this section, I examine how the distance and position (or lighting pattern) of a light source can affect the quality of light it provides and change the way you see a subject. I also provide some information to help you add a third light source and experiment with breaking the traditional lighting patterns for creativity.

Seeing how distance makes a difference

A larger light source creates softer light. Luckily, if you can't increase the size of your light source, you can simply move it closer to your subject. Doing so softens the light by increasing its surface area in relation to the subject.

On a similar note, the closer a light source is to a subject, the more intense the light becomes. So, if you want to keep the same level of contrast you had before moving the light, you may need to reduce the intensity of the light after moving it.

On the other hand, the farther a light source is from the subject, the harder the light will be. Consider the sun as a light source. If it were really close to you, it would be large enough to send light from many different angles and would cover you with a soft light quality (but, unfortunately, its nearness

would cause all sorts of tragedy as well). But, because the sun is really far away, it's small in comparison to you on earth and provides light only from a specific angle. Therefore, because of its distance, the sun provides hard light.

Imagine that you're working with strobes and using a soft box to soften your key light. And say you want to soften the light more, but you're already using the largest soft box you own. In this case, simply move your strobe closer to your subject. Doing so gives you a softer quality of light but also a more intense light. (See the earlier section "Understanding Light Quality and Intensity" for more about these photography tools and techniques.)

Positioning your light source to create lighting patterns

The position of your light source is an important factor in getting the lighting of your scene the way you want it. The angle at which a directional key light source hits your subject determines the lighting pattern that's created. A *lighting pattern* is an effect created with highlights and shadows based on the angle of the light to the subject.

The lighting patterns I discuss in this section have been developed to optimize the way you photograph human subjects, but keep in mind that these styles of lighting can be applied to other subjects as well. You can read more about portraiture in Chapter 13.

A person's face is made up of familiar shapes that are affected by light in certain ways when approached from different angles. Each face is unique and needs to be treated slightly different from the next, but certain lighting patterns show a face in its most appealing way. For example, you can use a lighting pattern to slim a wide face, widen a slim face, increase or decrease the appearance of a face's features, or decrease the appearance of the skin's texture.

Here are the four major lighting patterns, which I show you in Figure 10-4:

✔ **The paramount:** This pattern provides a minimal amount of direction, which decreases the level of shadows and minimizes texture in the skin. The key light comes from the direction of the camera but at a higher angle, causing a small shadow under the nose and on the neck under the chin. You can see these shadows in the top left image of Figure 10-4. By putting the shadow under the chin, you help separate the face from the neck (which is especially good for photographing people with weak chins or neck fat that you don't want to highlight). The paramount pattern highlights the entire width of the face, so it's ideal for widening a slim face; however, as a result, it's not ideal for someone who already has a wide face.

✔ **The loop:** This pattern is achieved by rotating the key light away from the camera to the left or right of the subject until the shadow from the nose falls off to one side rather than down. This pattern's light is more directional than the paramount's, and it highlights one side of the face slightly more than the other. For instance, note the shadow on the right side of the woman's face in the top right image. The loop pattern is good for slimming the face while also maintaining most of the benefits of the paramount. Notice that skin texture is revealed more in the loop pattern than in the paramount.

✔ **The Rembrandt:** This pattern was named after the famous painter and was a pattern he commonly used. You achieve the pattern by rotating the key light even farther from the camera than you did for the Loop pattern. The shadow from the nose should connect with the shadow from the far side of the face. (*Tip:* You may have to tweak the height of the light source to get the shadows and highlights to appear where you want them.) This pattern leaves a highlighted area shaped like an upside-down triangle on the shadow side of the face. See what I mean in the bottom left image of Figure 10-4.

A Rembrandt, which has a more dramatic feel than the paramount or the loop, is great for slimming the face. Notice how the Rembrandt causes the face to appear much slimmer than the paramount and loop, even when the face is shot from the same angle as it was throughout Figure 10-4. Keep in mind that this pattern also tends to reveal the skin's texture. You also can use it to draw attention to the eyes.

✔ **The Split:** This lighting pattern is the most dramatic of the four. You achieve it by rotating the light farther away from the camera until it's almost directly to one side of the subject's face. This pattern is the most slimming of the four and puts one side of the face completely in shadow. Because it's a sidelight, the texture of the skin is revealed more than any of the other patterns. See the bottom right image of the figure for an example of the split.

Except for the paramount, each of these lighting patterns has two different versions, assuming you're not taking a mug shot and your subject's face is posed at an angle to the camera. These different versions are referred to as broad and short lighting. A *broad lighting* pattern occurs when the key light highlights the side of the subject's face that's closest to the camera. A *short lighting* pattern highlights the side of the subject's face that's farthest from the camera. Broad lighting typically is used to reveal more of the face, and it works well on people with slim faces. Short lighting reveals less of the face, so it's ideal for creating a slimming effect. In Figure 10-5, I show you a broad Rembrandt and a short Rembrandt.

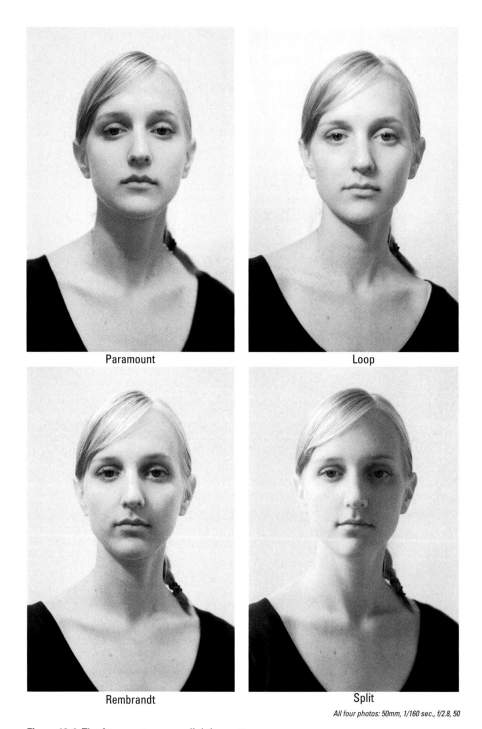

Paramount

Loop

Rembrandt

Split

All four photos: 50mm, 1/160 sec., f/2.8, 50

Figure 10-4: The four most common lighting patterns.

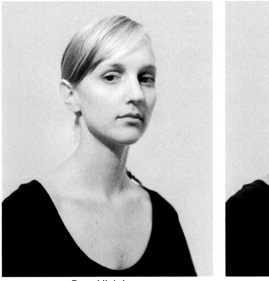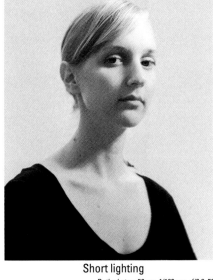

Broad lighting Short lighting

Both photos: 50mm, 1/160 sec., f/2.8, 50

Figure 10-5: Broad versus short lighting using the Rembrandt pattern.

Adding a third light source

After you have a good grasp of the ways that key light and fill light work together to create light with a specific quality, level of contrast, and direction, you can consider including a third light source.

Here are some ways to use a third light:

- **To highlight the edge of a subject:** Most photographers use a third source to create a *rim light* (also called a *kicker*), which is a light from behind that puts a thin highlight on the edge of the subject. The rim light was originally designed to separate the subject from the background, and it does just that when the background is darker than the subject or similar in tone to the subject. A rim light that's used when the background is lighter than the subject will cause the subject to blend into the background a little. This use of light could have a slimming effect.

 Figure 10-6 shows you a portrait shot using three lights: a key light, a fill light, and a rim light. Notice the highlight caused on the right edge of the subject's hair and jacket. This helps to separate him from the background and to add more visual interest to the image. (See Chapter 13 for more on portraiture.)

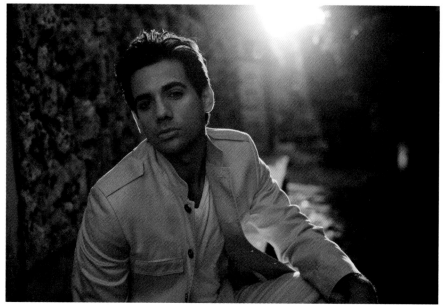

50mm, 1/250 sec., f/3.2, 100

Figure 10-6: A rim light helps to separate the subject from the background.

- ✔ **To highlight the subject's hair:** This use of a third light is known as a *hair light*. It works well to reveal color and texture in the hair and also helps to separate the subject from the background.

- ✔ **To light a background:** In addition to lighting your subject, you may sometimes want to use a third light to light your background, especially if you're shooting in the studio. To do so, set up a separate light behind the subject and out of your frame. Direct it toward the background. Decide whether you want a background that's evenly lit or one that has a gradation. The closer you place the light to the background, the more focused the light will be in the area that it's pointing toward. The farther the light is from the background, the more even your light will be.

By placing the light fairly close to the background, you can create a spotlight behind your subject. This spotlight helps keep a viewer's eyes in the frame by causing the composition's edges to be darker than its center. You determine the intensity of your background light based on the tone of your background and how it relates to the tone of your subject. A subject that's naturally darker, or is wearing dark clothing, stands out more from a lighter background, and a lighter subject stands out more from a darker background.

Breaking the patterns and creating your own look

The lighting patterns I discuss earlier in the chapter (see "Positioning your light source to create lighting patterns") are great for making people look good in photos and often are used by professional photographers for formal portraits. This formal lighting works well when you're taking headshots for business marketing, and you often see it in fashion photography as well.

Most people in the industry are familiar with these traditional lighting patterns. When I look at a photograph in which the shadow from the subject's nose meets the shadow from the far side of his face, I say to myself, "Oh, so she went with the Rembrandt." When a photographer creates an image that has a unique lighting style, I see it and ask myself, "How did she do that?"

Each situation is unique, and it should come across that way in a photograph. So it pays to find new ways to light people and objects. Try moving the lights around and adding or subtracting the number of light sources in the scene. Combine natural, available, and artificial lighting in one photograph. For example, if a lamp is on and a window provides light, take advantage of both of the sources. Whatever you do, never limit yourself to the four traditional lighting patterns.

Use your own judgment and experiment with lighting. Whenever you see a photograph with lighting that you find appealing, study it and try to figure out how the photographer achieved it. Then try to re-create it for yourself.

Figure 10-7 doesn't use a specific lighting pattern on the subject's face. The light simply reveals the shapes of his features, including his high cheekbones and strong jaw.

To achieve this lighting, I chose the sun (which was slightly diffused by a thin layer of clouds) as my key light. It acted as a mix between a key light and a kicker, or rim light (which I discuss in the earlier section "Adding a third light source"). The light was positioned behind the subject just enough to avoid causing a shadow on the far side of the subject's nose. Because of the light's soft quality, it smoothly wrapped around the side of his face.

My fill light was created by an assistant who was holding a reflector and standing just to the left of the camera. (Refer to the earlier section "Changing the quality" for more on reflectors.) This reflector put the highlight in the subject's eyes and balanced the intensity of the key light so it wasn't overbearing. By placing the fill light just slightly to the left of the camera, I created the illusion that the light was gradually wrapping around the subject's face going from highlight to shadow with a smooth gradation.

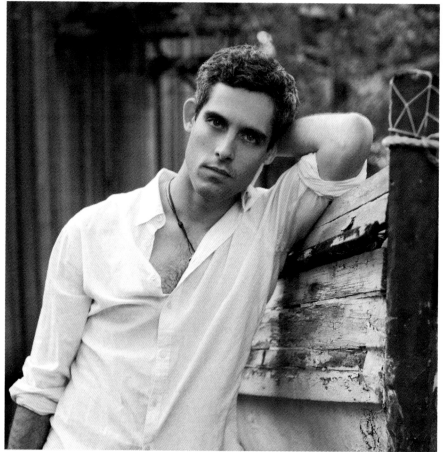

50mm, 1/500 sec., f/2.8, 50

Figure 10-7: Beautiful light doesn't have to provide a traditional lighting pattern.

Manipulating the Direction of Natural Light

Whether you're shooting on a bright sunny day with clear skies or one with heavy cloud coverage, the sun is your source of light in a naturally lit scene. Even at night, the sun provides light by reflecting off of the moon. It even provides natural light indoors by shining in through the windows and reflecting off of walls, ceiling, and floors.

Using natural light gives you less control over the sources of light and means that you have to work with what you're given. In the earlier section

"Understanding Light Quality and Intensity," I explain the ways to control the quality and intensity of a naturally lit scene. In this section, however, I focus on how to achieve your desired direction of light when shooting with natural light so you can control your lighting patterns and the amount of texture that's revealed in a subject or scene.

Any light source that you include in a scene but isn't provided by the sun and isn't placed there by you is known as an *available light source*. These sources could be lamps, streetlights, or any other manmade light. In this section, I concentrate only on natural lighting, but most of the rules that apply to natural light also apply to available light, assuming you don't have the ability to reposition them or control their intensity.

Giving yourself the time of day

Time of day has everything to do with the direction of the sun in relation to a particular scene. So become familiar with the sun and its patterns. The sun is the main light source used in outdoor photography, and it doesn't change its ways for anyone. The time of year and your location on the planet determine exactly how the sun will move through the sky throughout the day.

Dusk and dawn

The time just before the sun rises and just after the sun sets (known as dusk and dawn) often provides amazing light for photographing. The sky is colorful at dusk and dawn, and the light that occurs during these time periods is soft and has a directional quality that isn't as intense as direct sunlight. The light, which has a soft quality with low contrast, makes for dreamy results.

Dusk and dawn are great times for capturing photographs of objects with *specular surfaces* (surfaces that reflect light like a mirror). It used to be popular to photograph cars during dusk or dawn so they would be evenly lit and wouldn't have any hot spots from the sun's reflections. I enjoy shooting landscapes and portraits during this time.

Sunrise and sunset

The day begins and ends with the sun in a low position, which is ideal for creating compositions with sidelight. *Sidelight* refers to light that comes across your scene from the side, creating highlights and shadows that reveal texture. The light at sunrise and sunset doesn't last long, and as the sun makes its way up over the horizon, its effect on the scene changes drastically.

In portraits, sunrise and sunset are just right for using the split lighting pattern (check out the earlier section "Positioning your light source to create lighting patterns"). In landscape photography, these times are ideal for creating compositions with long shadows and for revealing texture in a scene.

When I travel to a new location, I always wake up before sunrise at least once so I can explore the city, town, or scenery during this inspirational time of day.

Figure 10-8 shows a sidelit landscape that I shot in Death Valley at sunrise. Notice how the light causes the texture of the dunes to be revealed and how it only affects certain areas of the scene. The foreground area is on a slope that faces west. Because the sun is so low in the sky, only the parts of the dunes that are facing the east receive light. As the sun gets higher, everything gets filled in with light, eliminating the early morning intricacies.

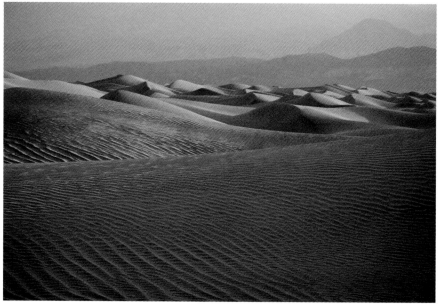

135mm, 1/125 sec., f/8, 100

Figure 10-8: As the sun creeps over the horizon, you can watch the light enter the scene.

Morning and evening sunlight

When the sun is between 15 and 45 degrees in the sky (which indicates morning and evening), it's still low enough to reveal texture and shape. If it's positioned slightly (or directly) behind the scene, it works as an excellent backlight. A backlit scene is great for emphasizing depth because texture is revealed from front to back rather than side to side.

During these morning and evening times, you can create loop and Rembrandt lighting patterns in portraits. (Refer to the earlier section "Positioning your light source to create lighting patterns" for more on these patterns.) This also is a great time to shoot landscapes and city scenes.

In Figure 10-9, I was able to emphasize texture and depth by shooting the scene with the sun behind it and about 30 degrees in the sky. Notice how the texture in the sand is revealed from front to back, showing separation that gives you an idea of how far the beach extends into the background.

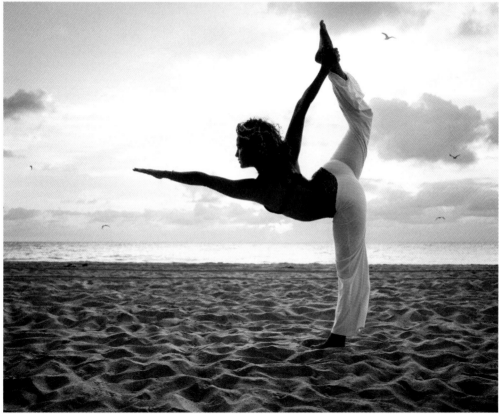

24mm, 1/250 sec., f/3.5, 100

Figure 10-9: Backlighting a scene helps to reveal depth in a textured surface.

Midday sunlight

During the times when the sun is at 45 degrees, you can achieve the paramount lighting pattern (see the earlier section "Positioning your light source to create lighting patterns") in portraits; however, after the sun goes much higher than that, you don't want to use it as a direct key light. When the sun is high in the sky, it casts shadows over the eye sockets that are referred to as *raccoon eyes*.

When photographing people in the middle of the day, I suggest that you look for shade. The shade provides a more even light. When your subject is in the shade, you can have an assistant bounce in some sunlight with a reflector (see "Modifying the quality and contrast of light," earlier in this chapter, for details about reflectors). Doing so enables you to choose what light direction works best with your subject and composition.

You usually won't get good results when photographing landscapes during the middle of the day when the sun is high. If you don't have a choice to wait around for better light, experiment and make the best of every situation. It's possible — just not likely — to get beautiful results in the middle of the day. In fact, sometimes you get your best and most creative results at those times when you normally wouldn't even take your camera out of its bag. So don't let yourself get too caught up in the rules and common practices.

Appreciating different results in different seasons

The sun's elevation is drastically different in the summer months than it is in the winter months, so factor this in when determining what time to arrive on a specific location. After all, the direction of light and how it affects your scenes depends on the sun's elevation. In downtown metropolitan areas and in the valleys of mountains, you lose your direct sunlight much quicker than you do in flat areas — especially in the dead of winter. Arrive earlier than you normally would to these types of locations in order to capture the sunlight before it creeps behind the buildings or mountains.

The quality of light in a specific region also may be different throughout the year due to changing weather patterns. In San Francisco, for example, the summer is filled with hazy days causing direct sunlight and distant visibility to become severely limited.

Pay attention to the seasonal patterns in your home region and create a log of the pros and cons for shooting at certain times of the year. When you plan a trip, do some research to find out what time of year best suits photographing in your desired destination.

Setting Light in Motion

Most photographs are captured in a fraction of a second. Quick shutter speeds eliminate motion as much as possible to give you the sharpest, clearest image. When you leave your shutter open for extended periods of

time, anything moving in the frame starts to blur or streak; if the source of light moves, the light in your scene changes throughout the course of the exposure.

Some common subjects to photograph with long exposures are waterfalls, flowing creeks, rivers, and windy sand dunes. When you capture light in motion, you let go of the desire to achieve technical perfection and instead create something that's more surreal than real.

To shoot with a long exposure during the day, set your camera to its lowest ISO rating and use the smallest aperture setting available. (See Chapter 3 to get the details on ISO and aperture.) If these settings don't slow down your exposure enough to achieve the amount of motion you want, use a *neutral density filter* in front of your lens. This filter is made of glass and is neutral in color. Its purpose is to decrease the amount of light entering the lens without changing the colors in a scene. You can buy these filters in a variety of densities, or you can purchase a variable density filter that enables you to choose between a variety of densities on a single filter. The darker the filter, the more light it blocks out.

Nighttime also provides a great opportunity to experiment with photographing motion. The light reflected off the moon isn't nearly as intense as direct sunlight, so you can leave your shutter open for long periods of time, capturing drastic lengths of motion. Flowing water begins to lose texture when photographed for long periods of time. A one-minute exposure can cause the ocean to appear as calm as a lake on a windless day. I exposed Figure 10-10 for 8 seconds, which caused the ocean to become smooth while maintaining some of its detail.

On nights with a full moon, I tend to include the moon in my composition or to use the moonlight to expose my scene. When the moon is just a sliver in the sky, I like to go far away from the city lights into the wilderness and use a wide-angle lens to compose a scene that has a great deal of sky in it. With such a small intensity of light in the scene, you can leave the shutter open for hours and capture the illusion of the stars moving through the sky. Of course it's the earth that's rotating, but your camera is grounded here and records the stars as moving. This phenomenon is referred to as *star trails*.

Base your nighttime composition around the position of the North Star because that's the only star that remains in the same spot throughout the night. The other stars circle around it, creating a neat effect in a photograph. Also, make sure your camera battery is fully charged before starting your exposure; otherwise you may run out of juice before the exposure is complete. (Check out Chapter 14 for more info on photographing nature.)

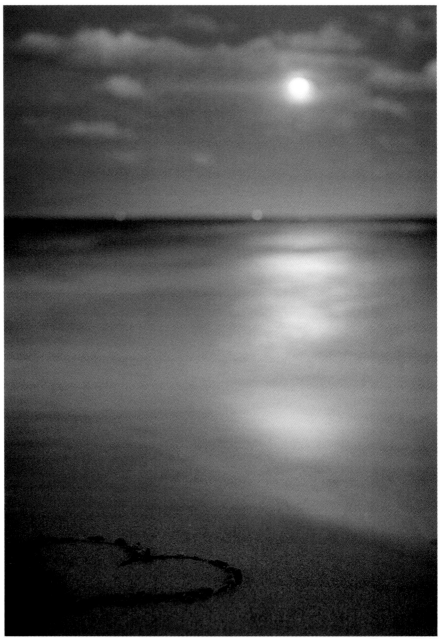

50mm, 8 sec., f/2.5, 100

Figure 10-10: Photographing a scene at night makes capturing light in motion easy.

Accounting for the Color of Light

The impact of color in your scene comes not just from the color of the elements in it but also from the color of light in it. Each light source you use in a scene has a dominant color. Light burns at a specific Kelvin temperature, and that temperature determines the color of the light. The term *red-hot,* for example, refers to something that's burning at the Kelvin temperature of the color red. Warm colors are created from lower temperatures (like 1000K candle light), and cool colors are created from higher temperatures (like 9000K open shade).

Here's how lights commonly used in photography fall into the Kelvin scale:

- 1000K = candlelight
- 3200K = household tungsten lighting/photographic hot lights
- 5000K = typical flash bulb used in photographic strobes
- 5500K–6000K = direct sunlight
- 7500K = overcast sky
- 9000K = open shade (subject is in shadows that are exposed to the blue sky)

Your digital camera's sensor reacts differently to each of these light temperatures, which is why the camera has a separate setting to shoot in each one of them. You access your camera's color balance through the shooting menu. Refer to your owner's manual to find out how your specific camera enables you to choose the color balance.

When preparing to take a photo, evaluate the lighting in your scene and determine which setting will provide the most appropriate results. For instance, when you're indoors and regular household lights are lighting your scene, set the camera's color balance to tungsten. When you're outdoors, shooting in cloudy conditions, set the color balance to the overcast setting.

The way you see things in the direct sunlight is what you use as the standard for how things should look. And your camera does the same. Your *white balance* is the setting on your camera that determines how your sensor will react to the color of light. Consider the following examples:

- If you shoot under tungsten lighting and set your white balance to tungsten, the camera compensates for the orange light by making it bluer. This compensation makes the light appear to have the color temperature of daylight instead of tungsten light.

✔ If you shoot in the daylight and set your white balance to tungsten, the image will come out extremely blue. This can be used as a creative technique to produce images with a cool, blue tone.

✔ When shooting in the open shade with the appropriate color balance, the camera will compensate for the cooler light and make it appear normal.

✔ If you shoot in the daylight with your color balance set to open shade, the camera will compensate by making the image warmer. Because your scene was normal to begin with, the result will be an image that's very warm.

✔ If the sun is out and you want to create the warm feeling of sunset but it's only 3 p.m., simply set your color balance to the overcast setting. The result will be a warm image. If you want to make it even warmer, set the color balance to the open shade setting.

✔ On an overcast day, you can set your color balance to the sunlight setting in order to create a photograph that has a cooler tone.

Photographers used to place color filters in front of the lens to achieve all these results, but with digital cameras you can control the color balance with the camera's settings and don't have to purchase expensive filters.

Do some tests with the different color balance settings on your camera in different lighting scenarios and figure out which scenarios cause effects that you find interesting. You can control the color of your photographs with photo-editing software as well. I show you how to do so in Chapter 18.

11

Adding Interest through Framing and Formatting

*W*hen you put a photograph in a picture frame, you send potential viewers a clear message. If a frame could speak, it would say, "Hey, look in here." A frame shows viewers exactly where to look and then keeps their eyes inside its borders. You can get that same effect by composing your images so that elements within it surround your subject and ensure that the viewers' eyes go directly where you want them (and then stay there). To make that frame effective, you have to study your scene, determine your subject and which elements successfully frame it, and then compose the image accordingly.

An interesting composition is one that fulfills two jobs: It provides a framed image that's aesthetically pleasing, and it tells a story based on the relationships of the elements included in the frame. Ideally, a composition is interesting enough to keep a viewer's attention for more than just a few seconds. When viewers can explore compositional elements that fit perfectly in your frame and interact with each other in a harmonious way, they're likely to be captivated by your image.

In this chapter, I help you gain and keep your viewers' attention by guiding you in an exploration with compositional framing techniques. I also provide information on determining whether a horizontal or vertical format would best suit your subject and message in a particular scene.

Making the Most of Framing

Your *frame* is the entire rectangle that contains your scene. Within it you may create an additional *compositional frame* — certain elements that surround the subject. Serving as the outer rim of your composition, a compositional frame keeps viewers' eyes from leaving the image and directs them to the scene's important components. You can make a compositional frame from almost anything, as I highlight throughout this section.

Photographers commonly use trees to frame a subject. Tree limbs bend and twist into dynamic shapes that seal off the edges of your frame. Often, photographers will pay particular attention to trees when shooting exteriors of buildings and structures. I've seen everything from small cottages to the Eiffel Tower framed by trees. In Figure 11-1, I used trees in the background as a compositional frame to surround my subject.

50mm, 1/200 sec., f/2.2, 200

Figure 11-1: A basic example of a compositional frame.

A successful compositional frame pulls a lot of weight in an image, working to make it richer, more intriguing, and worth lingering over. It also provides viewers a sense of environment. Here are some things you want to do when creating a compositional frame:

✔ **Find the right perspective.** Perspective is the most important element when creating a successful compositional frame. Consider a tree in comparison to the Eiffel Tower, for example. If you're far away from the tree itself, the Eiffel Tower dwarfs the tree. From that perspective, the tree serves as a foreground element and can't frame the structure. But if you move your camera very close to the tree, it appears taller than the Eiffel Tower. This perspective enables you to compositionally frame your very large subject; it also gives depth to your composition by highlighting

distance between elements within the image. When scanning a scene for the best perspective, move forward and backward to search out elements that you can use to frame it.

✔ **Use the appropriate depth of field.** *Depth of field* controls how much of your scene is in focus. If your compositional frame provides information that's essential to your message, you may want to keep it sharp enough to reveal some of its details. If your compositional frame works only to frame the image, you'll likely want to let it go blurry so it doesn't draw any unnecessary attention but provides a realistic sense of depth. Chapter 7 goes into more detail about depth of field.

✔ **Avoid merging shapes and lines.** *Mergers* are shapes and lines that intersect in awkward ways. If a compositional frame merges with your image's subject, make sure it doesn't affect the shape or appearance of the subject. For example, you probably don't want to block a person's face with a tree branch when taking her portrait. I discuss mergers further in Chapter 9.

In the following sections, I explain how the compositional frame can provide a sense of three-dimensional space in your images, how to get creative when including compositional frames, and why a viewer will look at an image longer when this technique is used successfully.

Giving your image a sense of depth

Visual depth causes the appearance of three-dimensionality and gives viewers a more enjoyable visual journey through an image. The simplest way to add depth to your composition is to include elements in the foreground.

An object in the foreground appears larger than those things that are farther away. If you position a foreground element in the center or on a third (refer to Chapter 5 for more about thirds) of your frame, the element takes up a great deal of attention, and viewers most likely see it as the subject. On the other hand, positioning foreground elements at the edges of a frame ensures that they work as compositional framing tools instead of stealing the show from your subject.

In Figure 11-2, I positioned the rocks in the foreground at the front edge and left and right sides of the frame. They don't come into the frame enough to compete with the waterfall, which is the subject. Instead, they work to lead viewers to the waterfall. They serve a double purpose by showing the environment around the waterfall and leading viewers' eyes to the subject.

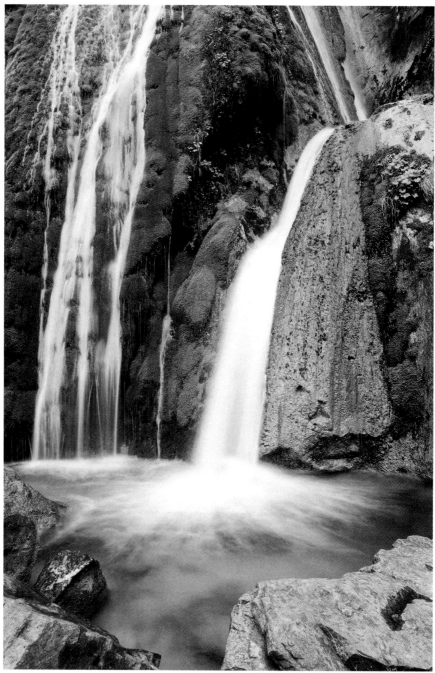

28mm, 1.3 sec., f/22, 100

Figure 11-2: Foreground elements can be used to lead viewers and keep them from exiting the bottom of the frame.

A shallow depth of field can enhance the sense of distance in your image. (Chapter 7 tells you more about depth of field.) Your eyes can focus on only one distance at a time. The closer two objects are, the more likely you can see them both clearly without switching back and forth between one and the other. So, when you focus on something distant, the object right near you becomes a vague blur in your peripheral vision.

When you compose an image with an element in the foreground as a compositional framing element, make it appear blurry; doing so gives the sense of depth based on how you would see the scene in real life. To cause the blur to happen, shoot with a shallow depth of field, which can be achieved by using a large aperture.

Adding interest by getting creative with your compositional frame

A compositional frame doesn't have to be as obvious as a tree or rock in the foreground. You can use anything to frame an image — any object, shadow, or reflection — and it can be in front of or behind your subject. Be as creative as you can with your frames. Look for shapes, tones, colors, and forms in a scene that seem to create a border for your subject, and allow them to become part of the scene rather than just existing at the edges. Also try to incorporate a compositional frame into the image subtly.

Sometimes a compositional element that frames an image serves only one purpose — to be a frame. This isn't true in Figure 11-3, which has many compositional ideas happening at once. It has a frame that's also quite possibly the subject of the image. You could say that the birds or the sunrise are the subject, but you could just as easily say that the pier stands as the subject as well. The pier works together with the dark sand in the foreground to frame the image, and it also extends into the stronger areas of the image as if it were the subject. Patterns are created with the pier and its reflection. Where the dried up sand washes the pattern away, the sun is positioned to make that point important in the composition. The existence of the pattern on the right side of the frame is balanced by the absence of it on the left side.

Keeping a viewer in the frame

A compositional frame helps keep a viewer from exiting your image and moving on to something else. Imagine that Figure 11-3 included space above the pier for your eyes to wander. This extra space surely would take you away from all that's happening beneath the pier.

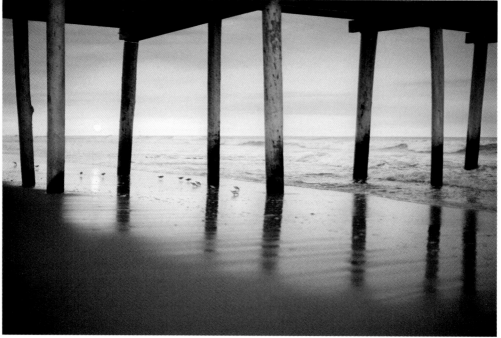

50mm, 1/60 sec., f/3.5, 100

Figure 11-3: The compositional frame in this image also is one of the strongest elements in the composition.

To successfully keep a viewer's attention through the use of a compositional frame, you need to seal off the edges of your image with elements that exist in the scene in a natural way that doesn't seem too obvious or forced. Your compositional frame should work in a way that presents the subject and the key elements of your image to a viewer. Most compositional frames are created with elements that are dark in tonality. An image with dark edges and a bright center invites viewers to look at what's in the center.

A compositional frame needs to add more interest to a scene by providing a unique and creative way of seeing it. Never allow it to distract from the subject or the scene. If you're using foreground elements to frame your scene, be sure not to block any important elements or details with the compositional frame. Choose a camera angle that reveals everything that's necessary to convey your message.

The image in Figure 11-4 combines multiple elements to create a compositional frame; the elements work together because they share a dark tone. The dark elements surrounding the subject make the lighter areas seem more inviting, providing a porthole for you to peer into. The dark subject (the bonsai tree) easily stands out against the light background, which

immediately draws your eyes in. As you look around the image, the pier and its pilings do their best to keep you from exiting by sealing the perimeter. In fact, the sunlit driftwood occupies the only area along the edge that invites your eyes to leave. This spot stands out and is right at the edge, which can be danger- ous compositionally. In this case, though, the driftwood works with the pattern underneath the pier to bring you back into the image. Notice how the sunlight on the piece of wood creates two light areas separated by a dark strip. This pattern looks a lot like the underside of the pier; the similar- ities cause you to subconsciously compare the two, bringing you back into the scene for another look.

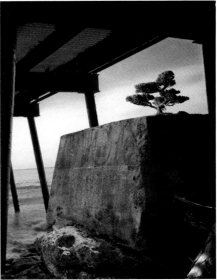

24mm, 1 sec., f/16, 50

Figure 11-4: Compositional frames are designed to keep your eyes in the image.

Choosing between the Horizontal and Vertical Formats

If you're using a camera with a square format (or you intend to create an image that will be presented in a circle format or any other shape than the typical rectangle that's created by most digital SLR cameras), you don't have to worry about whether your images should be composed vertically or hori- zontally. However, because most cameras do produce images that have one long side and one shorter side, this decision has to be made more times than not. Digital point-and-shoot and SLR cameras, for instance, use a rectangular sensor that, unless you turn the camera from its natural upright position, is wider than it is tall. Many people forget that they can turn the camera, so they end up with a lot of horizontal images.

Always consider which format is most appropriate compositionally for a particular scene; doing so can sometimes determine how successfully your message comes across in an image. Until you get comfortable with vertical and horizontal formats, shoot scenes in both so you can later compare the two. Note what you like and dislike about each, and then determine why one works better than another in a specific situation.

Three different elements — the message, the subject, and the environment — can affect which format you choose for your image. I discuss each in the following sections.

Understanding how your message influences which format to use

Your message relies on the format of your image in the same way that it relies on any of the other compositional techniques in this book. Visual changes occur when switching from a horizontal to a vertical format. Sometimes an image works much better as one or the other, and sometimes both formats seem to work equally well.

Here are some questions to ask that help determine which format best suits a scene you're photographing:

- ✔ **How is your subject going to fit into your frame?** If you have a vertical subject, a vertical frame maximizes how much space that subject can take up in the frame. The same goes for a horizontal subject and a horizontal frame. Because people are vertical when they're standing or sitting upright, a majority of portraits are taken with the vertical format.

- ✔ **How are the elements in the scene arranged?** Your subject may be vertical but the supporting elements are spread out along a horizontal area. You need to determine what's important to your message and how you can best fit it into your frame.

In Figure 11-5, both formats work well to display the scene, but they both affect the image's message in different ways. The vertical format in this case allowed me to give more of the frame's space to the subject than the horizontal format did. That's because the subject is vertical. Having the woman appear larger in the vertical frame caused the image to convey details about her and the dress she's modeling, with a moderate emphasis on the environment that surrounds her. Vertical images almost always are used in fashion and portrait photography unless the scene includes multiple subjects. In that case, a horizontal image may be required to fit everyone in.

Notice how the horizontal image in Figure 11-5 has less emphasis on the person and the dress and includes more detail in the environment. The trees to the left of the frame, which don't show up in the vertical composition, make the image less about the woman and more about the environment. Each composition works well in a different way: The vertical image may work on a magazine cover, in a catalog, or in a look book; the horizontal image is appropriate for a fashion editorial across a two-page spread.

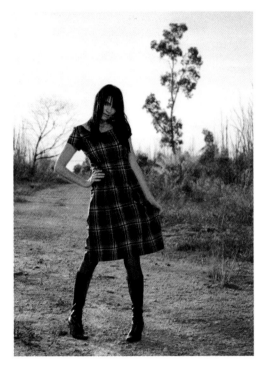

Both photos: 50mm, 1/200 sec., f/5.6, 50

Figure 11-5: Vertical and horizontal image comparison with a human subject.

Figure 11-6 shows two examples of a Miami cityscape image. In most cases, you would shoot a skyline in the horizontal format because of the natural horizontal layout of the scene. In this case, however, the late-evening sun and the city lights illuminate a colorful and cloudy sky. The sky is more interesting than the skyline itself, so the vertical composition is more effective for this scene. The vertical image gives a more complete composition of the light in the sky while providing a good representation of the downtown buildings.

Figure 11-7 shows an example in which the message is completely lost when the format is off. In the vertical version you get a basic idea of the building's architecture, and you get a small glimpse of the theater-style letter board. However, these details provide an unclear representation of who the man is. The horizontal image, on the other hand, reveals that the man is sitting on a playhouse. You can use this information to assume that he's an entertainer. The idea behind this image was to use photo-editing software to enter the man's name into the marquee as if the playhouse were presenting him.

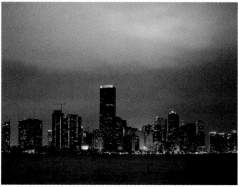

Both photos: 70mm, 8 sec., f/16, 100

Figure 11-6: Vertical and horizontal image comparison for a cityscape.

I could have changed my perspective in Figure 11-7 in order to create a composition that fit both the subject and the marquee into a vertical frame; however, I wouldn't have been able to achieve the lighting effect that I got in this image from the new camera angle that would have been required. (For more on perspective, flip to Chapter 8.)

Determining format based on the subject

When the subject itself is the most important aspect of an image's message, you'll most likely format the image according to what works best for showing off the subject. As a general rule, a vertical subject works best in a vertical frame, and a horizontal subject works best in a horizontal frame. After all, distributing the space around the subject in a more balanced way is easier when the frame's orientation is similar to the subject's. The subject can take up more space in a frame that shares the same orientation.

Both photos: 28mm, 1/1000 sec., f/4, 100

Figure 11-7: Vertical and horizontal image comparison for an environmental portrait.

If your subject is a winding river, for example, you'll most likely choose a format based on which way the river runs through your scene. If you're looking up or down the river, you probably want to shoot vertically to capture the distance that the river stretches. If you're looking at the river from the side, shoot horizontally to fit as much of it as you can into your composition.

General rules are great to follow most of the time, but they don't work all the time. When photographing a person's portrait, you generally use a vertical format because people are taller than they are wide. Remember that, but also consider other variables that may affect the way you format a particular scene. If a person is sitting or lying down, a horizontal frame may be more suitable. And someone who's in motion may require some room in front of him in the frame to provide active space in the composition. (Chapter 16 tells you more about active space.) In this case, it may not be possible to provide enough space with a vertical frame.

In Figure 11-8, I chose a vertical format because I was shooting a vertical subject. The background isn't important to the message, so I minimized it. The shapes and lines of the subject fit nicely into a vertical frame; a horizontal frame would have provided only more gray background.

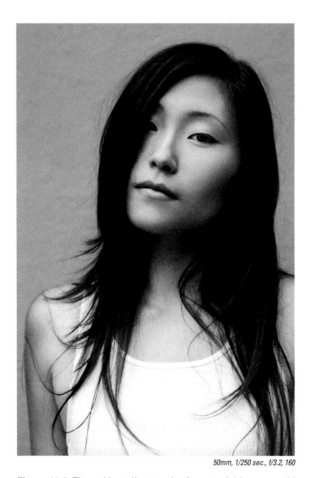

50mm, 1/250 sec., f/3.2, 160

Figure 11-8: The subject dictates the format of this composition.

Letting the environment dictate format

Sometimes the environment surrounding your subject is as important to telling the story as the subject itself. In that case, you include in your frame all the scene's elements that are relevant to your intended message. If, for

example, you're photographing a doctor who developed a robot that can perform surgery, you may want to choose a format that provides enough space to include her and her creation. The robot would be equally important to telling the story as the doctor.

Opting for the square format

The square format was made popular in the days of film, when photographers used to shoot with medium-format cameras. Today, digital cameras produce large files, so you can easily crop into an image to create the square format with any camera. When doing so, remember to compose your scenes accordingly. Focus on what's in the center of your frame, keeping in mind that you'll crop out anything outside the square.

The basic rules of composition (see Chapter 5) apply in the same ways to the square format as to the rectangle. You can break the square into thirds to locate areas of compositional strength, frame a subject, and lead viewers into the image and around it using leading lines

and shapes. Photographers often use a square image to bring a sense of harmony between the subject and its environment. The square offers benefits from both the vertical and horizontal formats without going in either direction all the way.

In this figure, I chose the square format in order to fit the length of my subject's body in the frame without losing details in the foreground and background. A horizontal format would have either included unnecessary space on the edges of my frame or cropped into the foreground and background. A vertical format would have been difficult to fit my horizontal subject into without adding too much foreground and background.

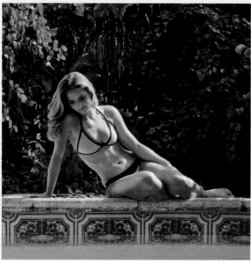

50mm, 1/160 sec., f/6.3, 50

If the elements of interest in an environment are spread out in a horizontal or vertical manner, you can easily determine the best format for composing the image — regardless of what your subject is. If you compose an image vertically and notice that a bunch of empty, unnecessary space exists at the top of your frame, you may be able to use a horizontal format instead.

Figure 11-9 gives an example of an image in which the environment, not the subject, dictates the format of the frame. The full moon acts as the subject in this image. The moon is fairly small in the frame and is neither a vertical nor a horizontal subject, so I could have used a horizontal or vertical format. Instead, the skyscrapers and the lights on the metro rail determined how I formatted this composition.

The horizontal format of Figure 11-9 enabled me to show more of the buildings and to fit the lit area of the metro rail into my frame. I could have achieved great results by shooting this scene vertically, but the subject wouldn't be affected by the change as much as the environment would be.

50mm, 1/30 sec., f/1.2, 200

Figure 11-9: The environment, not the subject, determined the format of this image.

12

Exploring Other Compositional Ideas

*E*very photograph is unique and represents a special moment in time. The composition of a photo is part of what makes it unique. However, you won't apply all the compositional rules all the time (in fact, doing so isn't possible), and what works for one scenario may not work for another.

Think of compositional rules and techniques as tools, and be sure you know which tool is right for each job. Your intended message of a particular scene determines which techniques work best. Sometimes you photograph a scene that presents its elements in a nice, clear way, and you don't have to think very hard about how to compose the frame. Other times you have to examine a scene more deeply to reveal what's special about it. If at first glance nothing jumps out at you as the subject or as having much meaning, use the techniques discussed in this chapter to draw something out of it.

Creating Harmony with Balance and a Sense of Scale

Television keeps a viewer's attention by providing a continuously changing image. You're always seeing something new (apart from the fact that much of the content on television is reruns), so you likely spend more time looking

at a single screen than you do a single photograph. Similarly, most people flip through magazines quickly, giving the average photo just a few seconds of their time. A photograph is only one image, so people feel they can get the message right away and move on.

Your job as a photographer is to catch the attention of viewers before they have a chance to flip the page or move on to another image. Creating compositions in which the elements are balanced throughout the frame and the message is informative is a great way of doing so. Viewers can't help but notice harmony within the frame of an image. When the elements in a photograph are balanced, they show viewers how to see the image and hold their eyes within the frame. Plus, having a sense of scale provides viewers with information that's necessary to understanding the size and distance relationships of elements within the frame.

In this section, I discuss the compositional weight of elements and how you can affect that weight. I also describe how to include a sense of scale in your compositions and the benefits of doing so.

Keeping the elements balanced and properly weighted

When arranging the furniture in a room, would you ever choose to place everything on just one side? Sure, you may do it to create a dance floor for a party, but for everyday living, you probably arrange the furniture in a way that gives it balance.

Balance isn't absolutely necessary, but it's natural and can work wonders for your photographic composition. An unbalanced composition in a photograph may give your viewers an uneasy feeling when they look at it — a good thing only when you do it intentionally. Generally, you want people to enjoy looking at your images, and you have many options for achieving this mission through balance. Each element has a certain visual impact in your frame known as its *weight*. How you distribute the elements based on their varying weights determines the balance of your composition.

In photographic composition, weight refers to the amount of impact an element has in comparison to the other elements in the scene. A larger element has more weight than a smaller element; an area with more contrast has more weight than an area with less contrast; and a more colorful element has more weight than a duller element.

Making compositional elements mimic one another with symmetry

When you use symmetry in a composition, you aim for an even distribution of weight, which may mean size, shape, tone, color, and so on. With symmetry, for every element you place on one side of the frame, place something of similar weight directly across on the opposite side.

By creating balance with symmetry, you give viewers a subconscious desire to move their eyes back and forth through the frame. A composition divided up into equally weighted sections gives viewers more to look at than a composition that only has one point of interest.

You don't have to achieve perfect symmetry to have balance. Your goal is simply to create a composition in which your points of interest aren't all crammed into one area, but are spread evenly throughout the frame.

In Figure 12-1, I positioned the *vanishing point* (the area at which the pier disappears into the distance) of the pier in the center and a large piling on the right side of the frame. The piling carries a lot of weight, so I balanced it out in order to make the left side of the frame equal in visual impact. Placing my subject opposite the piling helped to achieve a type of symmetrical balance in this composition.

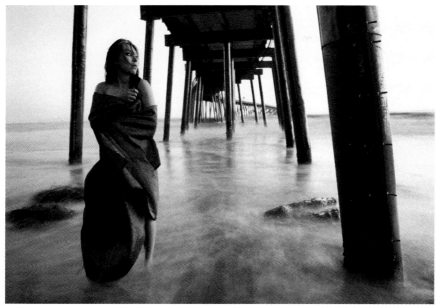

24mm, 1/4 sec., f/5.6, 50

Figure 12-1: Balance achieved through symmetry.

Even though it's an option, symmetry isn't often used in photographic composition because it can be considered stiff or boring. Instead, usually you compose a scene asymmetrically. This technique, which I describe in the next section, is known as *informal balance*. Creating balance with asymmetrical elements is slightly more complex.

Informal balance: Producing natural balance without symmetrical elements

To create informal balance, you distribute the weight of a scene's elements without using symmetry. The elements don't mimic each other's shapes, sizes, colors, or placement in the frame. However, they're still placed strategically to keep your viewers' eyes moving from one element to another, covering the entire area of the composition.

Figure 12-2 provides an example of informal balance. Notice how the image has no symmetrical qualities. The green car is close to the camera and has elements of contrast and color, which help to make it stand out as the subject. The neon lights of the buildings draw your attention to the upper-left side of the frame and then lead your eyes into the background where a car's headlights grab your attention. Although the green car is the main focus of this scene, the composition provides interest throughout the scene.

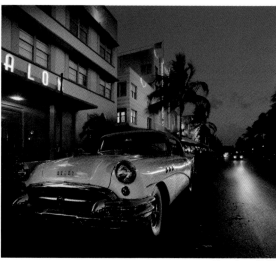

24mm, 2 sec., f/8, 200

Figure 12-2: Informal balance achieved with contrast and color.

Creating a composition in which the subject has the most weight is okay, but if you want to give your viewers something to move on to, share some of the weight with other elements in the scene. Have the weight gradually decrease in the order that you would like your viewers to move through the frame. You could do so by having slightly less contrast from one element to the next or by having the size of each element gradually get smaller.

Controlling balance with color

Color works great for controlling the balance in a composition. Each color has an opposite (refer to the color wheel provided in Chapter 6) and a certain

weight, so be sure to position the elements of your scene with color in mind. Here are some specific suggestions:

✔ Spread the color throughout the scene instead of having all the strong elements of color stuffed together in one area.

✔ Use an element of color to balance out an element of size, shape, or tone.

✔ Balance color with the absence of color. If one small red dot appears in an otherwise neutral frame, the color stands out (has weight). It also will be balanced by the vast amount of the frame that's lacking color.

Refer to Figure 12-2, and note that the blue sky and orange street on the right side of the frame contrast with each other as complimentary colors. Check out Chapter 6 for more information regarding color in your composition.

Trying out negative space

An area in your composition that contains no points of interest — no clearly represented element but space itself — is referred to as *negative space.* You can use negative space to balance your composition; in fact, it's fun to experiment with. The more negative space you provide, the more the message becomes about the negative space itself. The less you provide, the more the message becomes about the subject.

A strong subject positioned in the bottom left corner of a frame surrounded by nothing but blank space would appear to be unbalanced. However, if you find the right amount of negative space with which to surround that subject, you can achieve compositional balance.

Each situation is different and requires you to judge how much negative space is necessary in a particular scene. You can determine how much negative space you need to balance out your subject by looking at how heavily weighted your subject is and where it's positioned in your frame.

Figure 12-3 shows how the appropriate amount of negative space can provide balance in a photograph. This example shows how much negative space was required in this scenario to make the image equally about the subject and the negative space.

Including a sense of scale

Your literal understanding of certain elements affects the way you perceive balance and weight. When a person looks small in a scene, you can assume he was far away from the camera at the time of the exposure. If one person is small and another is much larger, you know that distance lies between the two of them in relation to the camera.

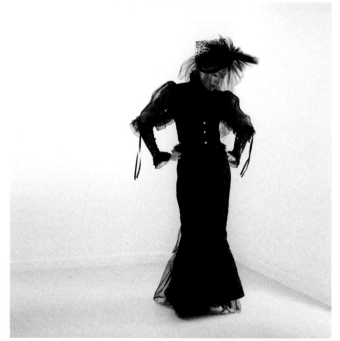

50mm, 1/60 sec., f/2, 500

Figure 12-3: Too much or too little negative space could ruin the balance in a photograph, but the right amount gets the job done.

You can make these assumptions because you're familiar with the size of people and can use that familiarity to assume things about an image. Objects, on the other hand, are trickier. If I stick a miniature umbrella (like the ones used to garnish drinks) in the sand and photograph the scene from above, you may assume that it was a beach shot taken from high in the air, perhaps in a helicopter. But, if I placed an empty glass with half-melted ice cubes next to the umbrella, you would know that it was a miniature from the cocktail someone just finished.

When it comes to representing an element's size, some situations require further explanation to get the message across. The viewer needs some element in the scene that has a known value of size (like a person) in order to reveal the size of the other elements. Including that element in your scene gives the composition a sense of *scale*.

Providing a sense of scale usually is relevant when size matters to your message. A sense of scale is a great way to capture a viewer's attention through the lure of amazement. It's also a great way to tell a story about your subject or the environment in your scene.

For example, a small figure amidst a busy city with towering buildings and traffic jams could send a message about being unremarkable or about being a necessary part of the system, depending on the compositional techniques used to create the message. A small climber on a huge rock face surrounded by wilderness is brave and adventuresome. One small figure at the far end of an expansive room highlights the size of the room and could send a message of being alone or of lacking an identity.

The redwoods in Northern California are one of my favorite things to explore and photograph. These trees are amazing and massive. Relating that size to a viewer is difficult unless you include an element that can be compared to the trees. In the left-hand image of Figure 12-4, I photographed the trees among themselves, so they appear to be fairly normal in size. In the image on the right side, however, I included a person in the scene to show just how massive the trees actually are.

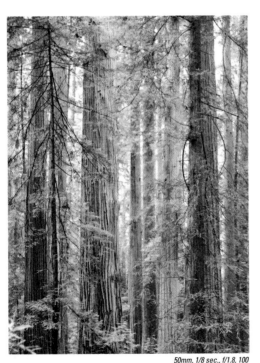

50mm, 1/8 sec., f/1.8, 100

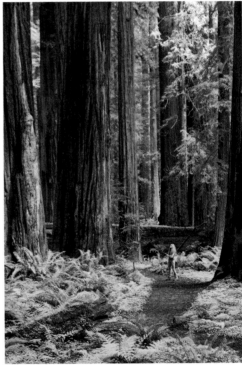

50mm, 1/15 sec., f/2.2, 100

Figure 12-4: Redwood trees photographed with and without a sense of scale.

Using Rhythm and Repetition of Elements

Elements that are identical or similar in shape, texture, line, color, tone, or size provide an excellent opportunity to create interesting and compelling compositions through rhythm and repetition. The *rhythm* in a composition is a combination of balance and repetition (see the earlier section "Creating Harmony with Balance and a Sense of Scale" for more on balance). *Repetition* is the technique of using elements that are the same as or similar to one another. As elements repeat, or mimic one another, they tend to create patterns, which are easily recognized by viewers. The way you use repetition in your composition determines the composition's rhythm.

When you put a mirror image, or two elements of similar look and size, in a composition, the viewer's eyes jump back and forth to compare the two and to look for similarities and differences. When you put elements of similar look but varying sizes in a composition, the viewer's eyes follow one to the other based on their individual weight in the composition.

In Figure 12-5, each line and shape gradually decreases in weight as you move toward the center of the frame, creating a pattern. This photo doesn't actually contain a mirror image, but the left and right sides of the frame are so similar that you're compelled to investigate it for yourself. Because of the repetition, the image has a straightforward rhythm. The symmetry causes you to bounce back and forth while

50mm, 1/60 sec., f/1.2, 500

Figure 12-5: A composition showing symmetry and the vanishing pattern, which are two styles of repetition.

the leading lines and repeating shapes cause you to be drawn into the image toward the vanishing point where a man is walking through the massive tunnel. (I discuss vanishing point in the earlier section "Making compositional elements mimic one another with symmetry.") Even with such a small and unclear subject, this composition does everything in its power to draw you toward that subject and to keep your eyes from wandering off the edge of the frame.

Patterns don't have to be as blatantly symmetrical as the example shown in Figure 12-5. Any similarity or relationship in shape, texture, line, color, or size can create repetition in a composition.

For example, in Figure 12-6, sea gulls fly through the air in no particular order. However, they each take on a somewhat similar shape created by three lines meeting at a center point. The gradual differences in size represent distance, and the scattered order of the flock represents a pattern of randomness or free will. Certain sections of the pattern create shapes similar to that of an individual seagull. The holes in the sand create another pattern in this composition. They're scattered randomly and create a sort of reflection (or symmetry) to the birds in the sky. The rhythm in this photo represents freedom and space, and it generally flows in a way that leads your eyes through the frame from left to right. The direction of this composition is much less blatant than that of Figure 12-5.

24mm, 1/160 sec., f/8, 50

Figure 12-6: Suggested symmetry through similar patterns.

Pulling harmony out of chaos

Soldiers marching to a cadence are in rhythm with each other, so if you photograph an advancing platoon you capture a moment when 40 or so men and women are in sync and each is mimicking the others. This repetition creates an obvious pattern.

People in a busy public area, however, are unlikely to be in perfect sync with one another. Each has an individual destination and purpose. Some people may be in cars and others are on bicycles. Still others are walking, jogging, standing, sitting, eating, reading, and so on. In this type of scene, where everything seems to be on its own program, you may consider the situation to be in chaos. But, if you pay closer attention, I guarantee that you can find repetition and patterns.

For example, if two (or even better, three) men are wearing hats of similar styles, you have repetition. A child holding a red balloon could produce repetition with a red traffic light and a woman wearing the same shade of red on her lips. Maybe the texture of a dog's fur is similar to the texture of a person's coat.

After you notice a pattern or repetition, the key to getting the shot is finding the right perspective to reveal the similarities in the composition. Your perspective is a combination of your relationship to the elements and their relationships to each other. I discuss perspective in detail in Chapter 8.

Shooting simple compositions

A simple design provides a clean composition with a minimal number of graphic elements. When it's successful, a simple composition provides a strong message and a complex theme using only the elements that are absolutely necessary for that specific message. With this type of composition, everything in the frame is necessary.

In a simple design, repeating elements can provide a great amount of aesthetic value. Their rhythm can reveal itself to viewers with a minimal amount of distractions, and this means you can include subtle patterns that are more likely to be noticed.

The composition in Figure 12-7 is clean and contains a minimal number of compositional elements. The obvious message is that this is a pretty photograph of the moon reflecting on the ocean at nighttime. With further examination of this image, however, you begin to notice that there's much more to the story.

Figure 12-7 looks like a simple photo at first, but many relationships take place in the composition, and some are subtler than others. The moon is mimicked in a mutated way by its elongated and warped reflection in the water. The seashells in the foreground mimic the stars in the sky — they have wet surfaces, which reflect tiny highlights similar to the stars. The fall of night helps to minimize details that are revealed, making the details that are revealed more powerful. In addition to being a pretty photo of the moon reflecting over the ocean, this image could be viewed as a story about light and patterns in nature. Additional elements in this photo would take away from the current message and decrease the simplicity of the composition.

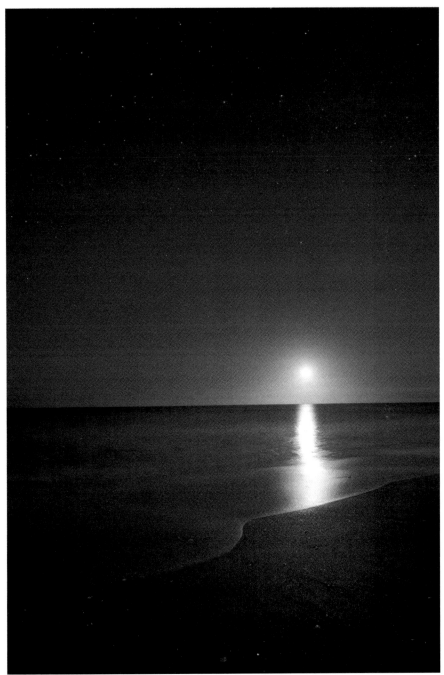

24mm, 8 sec., f/3.5, 1600

Figure 12-7: Minimizing the amount of elements helps to emphasize the ones that are included.

Reinforcing your subject or intended message with repeating elements

Sometimes you face situations where a strong competing element creates confusion about your subject or intended message. In this case, you need to find ways to direct attention back to your subject.

Including a repeating element that mimics or mirrors your subject is a great way to assure a viewer as to exactly what the photo's subject is. When shooting Figure 12-8, for example, I was excited to have the moon positioned above the pool house. However, I also was aware that the moon would compete directly with the woman (the subject) standing in the doorway. Luckily, I could include the woman's reflection in the pool as a repeating element, which causes you to examine her figure more than if no reflection were present. This composition helps to establish the woman as the subject and the moon as a supporting element rather than the other way around. This is partially due to rhythm, because the woman's presence is seen twice and the moon only once. As a result, you'll notice her more often when scanning the image.

Conversely, you can isolate your subject by making it the only element that isn't repeated in a pattern. When the subject breaks the pattern, it stands out from the elements that are alike. An office building with many windows that all look the same is more interesting when just one of the lights is

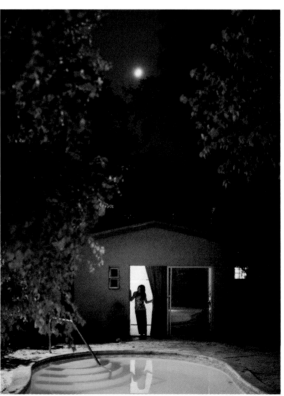

50mm, 1/40 sec., f/1.2, 3200

Figure 12-8: A repeating element helps draw attention to that which it repeats.

not on. That window stands out as the subject by breaking the repetition. Or imagine a line of men wearing white T-shirts; if one man wears a pink T-shirt, he becomes the subject. (And the message becomes "This guy doesn't know how to separate laundry.")

Creative Ways to Break the Rules or Cheat the System

Creating successful compositions by following the rules and going with tried-and-true practices is rewarding and guarantees that your photos will at least be nice to look at. However, you'll likely become bored with creating appropriate compositions — doing so may make you feel unoriginal. In these situations, let go of the rules and experiment with some new ideas. In this section, I cover some of the techniques and practices that I've tried when searching for something different.

You don't have to break every compositional rule in one photo. And you should have a purpose for breaking the rules you choose to break. There's a thin line between creating a new message and destroying an existing one. Knowing the difference is vital to breaking the rules successfully.

Experimenting with the tilt-shift lens

One of my absolute favorite tools in my camera bag is the *tilt-shift lens,* which enables me to

- ✔ Create multiple points of focus when using a shallow depth of field
- ✔ Maintain sharpness throughout vast areas both in the foreground and background
- ✔ Raise, lower, and shift my composition without moving the camera at all
- ✔ Stitch together multiple images to form seamless panoramic compositions

A tilt-shift lens's design makes these things possible. The lens is divided into two parts that work together to direct light toward the digital sensor. The front part of the lens can tilt, swing, shift, rise, and fall in relation to the back part and the camera's digital sensor.

Understanding how the tilt-shift lens works is the first step toward creating unique compositions with it. The lens is equipped with an axis that allows the front element to tilt up and down or swing from side to side while the

back element remains in its original position. Where the lens meets the camera body, a slide allows the lens to move up, down, and side to side.

Each of the different movements the front elements of the lens can make affects how the composition is changed. I explain each movement's effects in the following sections.

Tilt

Tilt represents the lens's ability to rotate up and down on a horizontal axis. This movement causes your plane of focus to rotate in the same manner. (For more information on plane of focus, head to Chapter 7.) With a normal lens, your plane of focus is parallel to your digital sensor. So, if your camera is level to the ground, your plane of focus is perpendicular to the ground and goes from side to side in your frame from the ground to the sky.

On a tilt-shift lens, when you tilt the front part of your lens toward the ground, your camera remains level but your focal plane rotates in the same way as the lens. So, instead of having a focal plane that's standing straight up, you have one that's angled from the foreground toward the background. The more you tilt the lens, the more horizontal the plane of focus will become.

This type of plane of focus helps to achieve the illusion of having a great depth of field and is great for shooting wide landscapes with interesting details in the foreground and in the background. (Check out Chapter 7 for more on depth of field.)

Swing

Swing is much like tilt (discussed in the preceding section) except that the front element of the tilt-shift lens rotates from side to side rather than up and down. Your plane of focus behaves in the same way as the direction of the lens movement. When you swing the lens to the right, your plane of focus stays vertical and rotates clockwise through the scene. Instead of having a plane of focus that goes from side to side in your frame, you now have one that goes through at an angle.

With this in mind, you can achieve focus on both a subject that's close to the camera and one that's farther from the camera as long as they're both positioned on the angle of the plane of focus. Having a shallow depth of field in this scenario lets you put the two elements in focus while everything else in the frame goes blurry. This technique is the same as selective focus (see Chapter 7), but you have two sharp points of focus at different distances from the camera. In reality your eyes can't focus on two things at two different distances, so this type of composition is unnatural and really gets a viewer's attention. Figure 12-9 shows an image with two points of sharp focus achieved by using this technique.

Shift

Shift is the technique in which you slide the lens from side to side at the point where the tilt-shift lens meets the camera body. This shift causes the lens to capture light from a different perspective than the one you see from your point of view. If you shift it to the right, your composition shifts to the right (and vice versa). I refer to this technique as *false perspective.*

You can use false perspective in a number of ways, including the following:

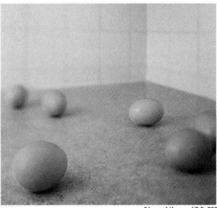

24mm, 1/4 sec., f/3.5, 200

Figure 12-9: Two sharp points of focus created by the swing function on a tilt-shift lens.

✔ **To move the subject from the center of the frame without changing its shape:** Some subjects require you to photograph them from straight on, in which case the camera is level, parallel, and lined up exactly with the center of the subject. You photograph something in this way to show the true shape of the subject without making one side appear larger than the other. In this scenario your subject rests in the exact center of your frame. Shifting your lens to the left or the right moves the subject out of the center of the frame without affecting its shape.

✔ **To create panoramic compositions:** This is the application of shift that I use most often. To create these compositions, set your camera on a tripod directed at the center of the scene and then shift your lens all the way to the left. Expose an image and then shift the camera back to the center to take another exposure. Then shift the lens all the way to the right and take a third exposure. Finally, you can use your photo-editing software to line up the three images (as layers in one single file) at the points where they overlap, resulting in a panoramic composition of the scene. See the manual for your photo-editing software to find out how to auto-align your layers.

Rise and fall

Rise and fall is similar to shift (which is discussed in the preceding section), but it instead refers to the tilt-shift lens sliding up and down at the point where it meets the camera body. Rise and fall is most commonly associated with architectural and interior photography. Sliding the lens up or down can help you achieve the composition you desire without distorting the shape of your subject.

In Figure 12-10, I show two examples of a similar composition of a building. The camera's physical position was the same in each, but in the photo on the left I had to angle the camera upward to get the whole building in my frame. Doing so caused the building to be bigger at the bottom (where it's closest to my digital sensor) and to get thinner toward the top (where it's angled farthest from the digital sensor). In the photo on the right, I raised the lens upward instead of angling the whole camera. By doing so, my digital sensor remained parallel to the building and allowed me to avoid distorting its shape.

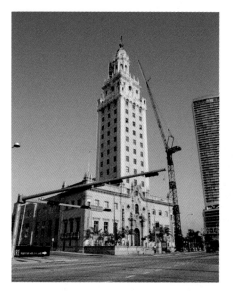 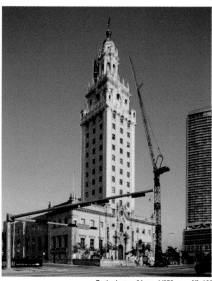

Both photos: 24mm, 1/250 sec., f/8, 100

Figure 12-10: Raising a tilt-shift lens helps achieve the illusion of a higher perspective without having to change your camera position.

Taking multiple digital exposures

With film cameras you can use one piece of film for multiple exposures. You do this by taking various shots without advancing the film; this technique used to be one of the most creative in photography. But ever since photographers started to become familiar with digital photography and photo-editing software, the art of double exposure became less relevant.

Some digital cameras don't allow you to take multiple exposures on a single frame. You take an image and the next time you release the shutter, another image is created. Instead of taking multiple exposures, you now have the

ability to put multiple images together in your editing software. (Chapter 18 tells you more about photo-editing techniques.) Creating this type of image in postproduction gives you more control over the final result and has brought on results that could never have been captured on film. Even so, it's still fun to experiment with true multiple exposures. In this section, I reveal a technique that allows you to achieve multiple digital exposures in camera much as you would have with film.

Sometimes you achieve the best results when you allow yourself to be surprised. Shooting multiple exposures with the technique discussed in this section can cause you to lose some technical control. Don't look at this loss of control as a bad thing though. If you're surprised by the results, perhaps your viewers will be as well. Like Robert Frost once said, "No surprise in the writer, no surprise in the reader."

To achieve multiple digital exposures in camera, you need to expose for a few seconds on one area and then quickly rotate the camera to another area to expose for a few seconds. Doing so creates one image with two compositions combined. It sounds tricky, but if you use the following guidelines when you create your exposures, you'll be just fine:

- ✔ **Create a situation in which you can have at least a six-second exposure, which is the minimum for creating a digital double exposure.** The longer your shutter is open, the more exposures you can include in your composition.

- ✔ **Use a neutral density filter when creating these long exposures.** If you want to shoot a photo in a situation that doesn't provide a low-light setting (such as at dusk or dawn), a filter can help. A filter that reduces your exposure by at least 10 stops is ideal. This way you can shoot during a bright, sunny day at an aperture setting of f/16 using an ISO of 100 and have an eight-second exposure. (Chapter 3 provides more information on ISO and aperture.)

- ✔ **Plan out your shot.** To get multiple images on one digital frame, you have to move your camera during the exposure from one composition to the other. It's important that you know how you need to move the camera to get the shots you want without any excessive movements. Observe your scene and choose a starting point and any other points where you'll be composing. Practice the movements a few times beforehand so you have them down by the time you start shooting.

 A tripod helps you move the camera quickly. Moving the camera slowly from one area to the next causes you to have streaks from the transition. To avoid these streaks, plan out the shot before starting the exposure and move quickly between exposures.

> ✔ **Be sure to fix the camera on your exposure's subject for about two seconds.** Because you have created a situation where little light is entering your lens, quick movements don't affect your exposure. The camera has to be fixed on something for about two seconds to record anything noticeable. However, keep in mind that anything in motion will be affected with motion blur because you're using a long exposure.
>
> If you want one exposure to be more prevalent than the other, keep the camera pointed in that area for a longer portion of the total exposure than the other. Bright elements show more dominantly over darker elements.

Crafting soft, dream-like compositions

When you think of photography, you probably think about images that are in focus. A blurry photo is considered a failed attempt and is discarded as useless. It doesn't represent the subject in an ideal way. People don't want to look at blurry images; doing so makes them feel like something's wrong with their eyesight. However, a certain quality in a blurry image is worth exploring.

As I discuss experimenting with images that don't have a focal point, I refer to blurry as "soft" because it sounds better and seems appropriate for the mood you create by not having sharp focus. A soft image is subtle and provides a sense of secrecy. The finer details aren't yours to know, so you focus on the other details in the image instead.

When you create a composition with no sharp focus, keep in mind that you'll still have a focal point or a main subject. The subject's story is going to be told through lines, shapes, and colors, but you lose the elements of texture, fine lines, and literal details. Basically you show the subject's essence, so make sure it's interesting. Throwing any old composition out of focus and calling it art usually is a mistake and won't receive positive reviews.

Because you have fewer elements to work with in a soft composition, you have to pay extra careful attention to the ones you do have. Here are the elements to consider:

> ✔ **Lines:** Your lines are softened but will still work as leading guides, telling a viewer where to look in the composition. Finer lines may be lost, which simplifies the composition and draws more attention to the bolder lines. Make sure your lines don't take away from your composition in any way.
>
> ✔ **Shapes:** Your shapes contain less detail and become very basic. However, they play a major role in your photo. If the shapes aren't interesting, you have no reason to create this kind of image. Smoother shapes work better in soft compositions than rigid shapes.

✔ **Colors:** Colors work as the strongest element in soft compositions. Because color appeals to people, it's used in abstract art, interior design, and fashion to create compositions. If you can create an interesting composition of color, you don't need sharp focus to tell a story.

Reinforce your subject as the focal point in a soft composition by keeping in mind elements like contrast, compositional placement, and size. Just because you don't have the subject in focus doesn't mean you can't cause people to concentrate on it as the subject.

In Figure 12-11, I chose not to focus on anything in order to create a soft composition. The shapes in the composition are beautiful, the subject is recognizable even without detail, and the softness helps give a dream-like sense. I used color, contrast, and leading lines to reveal my subject as the focal point.

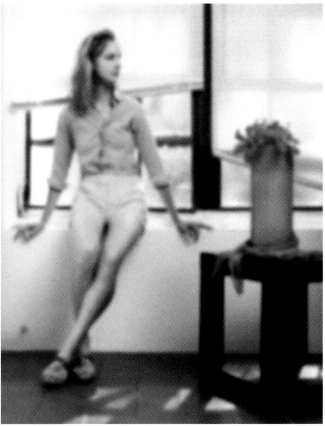

50mm, 1/125 sec., f/2.5, 50

Figure 12-11: Soft compositions provide more feeling and less detail about a subject.

Making a digital pinhole camera

Back when I developed images in the darkroom, I would sometimes spend long periods of time waiting for images to fix and dry. One way that I used to pass some of the time was to create a pinhole camera from a box. A *pinhole camera* is a simple light-proof camera that has no lens. A small hole serves as the aperture. These cameras are used mainly for fun and are based on the designs of the first cameras ever invented. Images created with a pinhole camera are soft in focus and have dark edges. These images are known as *vignettes,* and they serve mainly artistic and personal purposes and provide somewhat unpredictable results.

I don't make pinhole cameras anymore because I don't have a darkroom. However, I discovered that I could create a pinhole camera out of my digital camera, and I have been having fun with it ever since. To make a pinhole camera out of your digital camera, simply poke a tiny pinhole right in the center of the body cap to your digital SLR (the body cap is the piece that covers the camera body when you don't have a lens in place). You can keep a piece of tape over the hole whenever it isn't in use.

Now you can put your camera out just like the boxes I used to create. When you open the shutter, light from the pinhole exposes onto the digital sensor. With the convenience of digital photography, you can see your results instantly after the shot is complete rather than having to wait for the images to develop.

Part IV

Composition in Action

The 5th Wave — By Rich Tennant

@RICHTENNANT

WILDLIFE SAFARI

"Add some interest to the shot by putting the partridge in the foreground."

In this part . . .

Composing a portrait is much different from composing a shot of a skyscraper or mountain. So, in this part of the book, I take you through the special considerations of shooting a range of common subjects. You find out about the complexities of photographing people and the unique concerns that arise when you're shooting in nature. I tell you about how to effectively compose still-life photos as well as photos of moving subjects, like trains or your kid playing soccer. And if artsy photos and composites are your thing, I show you how to create those, too. Finally, I delve into the subject of enhancing your compositions by using photo-editing software in postproduction.

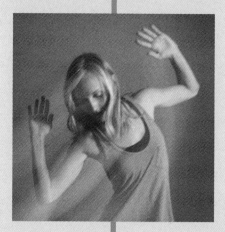

Showing People in Their Best Light

*P*eople may be the most common photographic subject in the world. After all, people are the ones controlling the cameras, and a certain level of vanity is and always will be associated with photography. Folks enjoy seeing themselves in pictures; it gives them an opportunity to see what they look like to other people. However, nobody enjoys seeing a photograph in which they look bad. Some go as far as to say they don't like having their picture taken, but usually that means they feel that the results will be bad. How wrong! Anyone can look beautiful or handsome in a portrait.

On the other hand, some people relish their time in front of a camera. I've had friends who handed off their cameras at every area of interest so I could take a picture of them. When you look through those photos, you notice not only that these people are in every picture, but that they also pose the same way every time. They're trying to look good for the camera. The problem is that they're not the ones looking through the viewfinder.

As a photographer of people, your job is to direct them so they look their best. (You do this in part by choosing the right perspective, which I talk about in Chapter 8.) This mission is especially true in portrait and fashion photography. So, in this chapter, I guide you in your quest by showing you the best ways to capture candid and posed portraits of individuals and groups. I also include a section on fashion photography.

Showing a Person's Essence in Portraits

Unless you work for the DMV or the police department, you're probably looking to draw something out of your subjects when taking their portraits. A successful portrait can reveal so many different things. For example, it can uncover a certain aspect of a person's personality or tell viewers what the person does for a living. It also can express a difficult time someone is experiencing or create an iconic representation of them. An iconic portrait typically represents a recognizable person during a recognizable time period. (Think Marilyn Monroe with her dress swirling up around her as she stands over a sidewalk grate.) The image itself becomes symbolic of what that person and others like them stood for.

Whether your subjects are recognizable by the masses or just by their close friends and family, the folks who know them can appreciate portraits that make their loved ones look great and reveal something about them. To an extent, making people look good is a matter of taste and individual scenarios. But you can apply some general rules that tend to work most of the time. I explain these rules and some ways to enhance your portraits in the following sections.

Portraiture is the art of showing the likeness of a person. In a portrait shoot, your subject wants to look good because he cares what people think about him. That portrait represents who he is, and the message relayed in the photograph says a lot about him.

Capturing genuine expressions

The most basic way to show the essence of a subject is to capture a genuine expression from the person — something that gives insight to what they think or how they feel. If you simply tell a subject to "Say cheese," you probably won't capture a real smile. Chances are your subject will be forcing it, and that will be obvious in the photos. The worst thing you can do is to force a reaction out of your subjects. And sometimes people aren't smiley; they may be more comfortable revealing a different expression. Some people are more comfortable in front of the camera than others, so each individual has to be approached differently. To capture a genuine expression, you need to engage your subjects and earn their trust.

I can't tell you the best way to get a real expression from your subjects, but I can tell you what works for me (most of the time). I like to take a few pictures that are meant to warm up the subject. After those are finished, I lower the camera and bring up something off-topic that my subject can share her opinion about — like a really good taco stand I discovered or a story from the news. This gives her something to concentrate on besides the camera. If she talks enough, I'll most likely see a part of her true personality that's worth bringing out in the portrait. Then I direct her toward revealing that trait when I begin shooting again.

Choosing your angle and your lens

Unlike fashion photography (which I describe later in this chapter), portraits often are taken from a higher angle. This angle helps to define the shape of someone's jaw line and to separate it from the neck. It also creates a view in which the eyes are more dominant than any other facial feature. When a subject looks up at your camera, he's putting a slight effort into it. This effort could come across as if he's engaging the camera or the viewers. Plus, looking down at someone could be more comfortable for a viewer compared to looking up at him. People usually associate looking up with authority figures, which can make folks uncomfortable.

The camera angle also minimizes each subject's different physical concerns. If someone has ears that stick out, for example, you may want to photograph him from a sideward angle so you don't highlight that feature. Similarly, if a subject's nose is big compared to the size of his head, you probably won't photograph him at a profile angle.

The angles for photographing people consist of the following:

- **The mug shot:** With this angle, you photograph straight on to the face from the front. Avoid using a mug shot angle for people who have wide faces, big ears, or very asymmetrical features.

- **The profile:** With this angle, you photograph straight on to the face from the side. Don't use the profile angle for people who have big noses or weak chins.

- **The 3/4:** With this angle, you approach the face from an angle somewhere in between mug and profile. The 3/4 angle is most commonly used because it's less formal than the mug and profile, and it generally works best for most faces.

You can combine each of these angles with higher or lower angles and variations of head tilts to find the best angle for each particular face.

Much like the angle you shoot from, the lens that you choose also impacts the way your subjects look. A wide-angle lens causes facial features to appear

larger than they actually are, and a telephoto lens helps to compress the appearance of features. As a result, someone with small facial features may prefer the way he looks when photographed with a wide lens, and someone with large features may prefer to be photographed with a long lens. For more about how your lens choice affects your subjects, refer to Chapter 3.

Adding interest by integrating your subject's hands into the photo

Hands say a lot about a person. People use their hands to gesture and support themselves, to hide things, and to comfort others. So, incorporating a subject's hands into a portrait can add interest to your composition. When shooting on the streets or in public, I tend to observe what people are doing with their hands. When someone makes a significant gesture, I take my photo.

When you ask your subject to do something specific with her hands, be careful not to create an awkward or discomforting position with them. When the hands support too much weight, certain signs of stress appear. For instance, a hand pressed firmly against the face causes skin to bunch and turn red. Similarly, a hand pressed firmly against the ground while someone supports her upper body weight in the sitting position makes the shoulders rise and appear stressed. So, when posing someone, ask her to place her hands in the way you want without using her hands for full support. Sometimes faking an action comes across more pleasantly than the real thing.

In the left-hand image of Figure 13-1, I had the woman rest her head on her hand without using her hand to fully support her head's weight. If she had put her head's full weight on her hand, her skin and left eye would have been stretched back, and her face and hand would have become blushed because of the skin-to-skin contact. In the right-hand image, the woman's hands are pressed together firmly enough to bring a certain level of tension to the portrait but not so much that they begin to look overstressed.

Taking advantage of a person's surroundings

An *environmental portrait* tells a person's story by using surrounding elements, like a house, workplace, or laboratory (to name just a few). These portraits are great for revealing what someone does for a living or a hobby. They're also effective for showing what era or location the person lives in. One of the greatest photographers to shoot environmental portraits was photojournalist Sabastião Salgado. He was a successful photographic storyteller, and his work can provide you with inspiration.

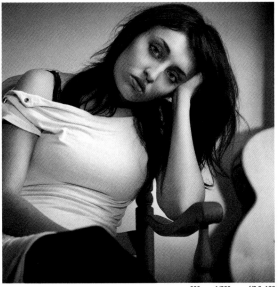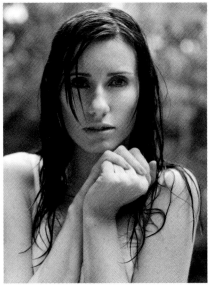

<div align="center">200mm, 1/200 sec., f/3.2, 100 50mm, 1/80 sec., f/2.5, 100</div>

Figure 13-1: Incorporating the hands in a pose helps to bring confidence to the subject and creates interesting shapes.

The environmental portrait presents a compositional challenge because you must create harmony between the subject and his environment. By including supporting elements in the portrait, you risk taking too much attention away from your subject.

To make sure your subject gets the viewer's attention, take note of the following compositional elements before you shoot:

- **The highest point of contrast in your composition:** This area draws in viewers' eyes first, so place your subject on or near this point to assure she gets the most attention in the scene.

- **The relationship between the size of your subject and the other elements in the scene:** If you want to make your subject dominant in the scene, make her the largest element. If you feel that the piano she plays defines who she is better than she does, make that the biggest element in the scene.

- **The effect of color on your composition:** Choose a color scheme that fits your subject's persona. For more on color schemes, check out Chapter 6.

- **The place where your compositional lines are leading your eyes:** Make sure you use the compositional lines in your scene to direct your viewers' eyes to your subject. Read more on this topic in Chapter 4.

Chapter 7 provides more information and techniques to focus the main attention on your subject.

In Figure 13-2, I placed the woman in front of the bright open doorway so the shape of her body would stand out as the most dominant shape in the image. The environment tells you that she's a surfer and that she lives in a tropical area, but it doesn't take away from her as the subject.

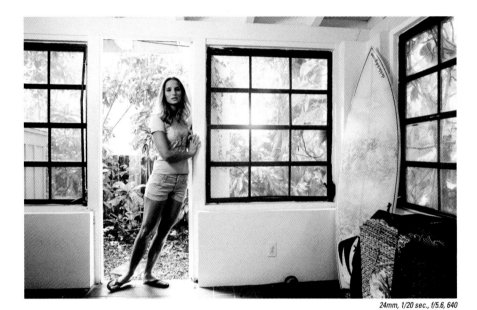

24mm, 1/20 sec., f/5.6, 640

Figure 13-2: Using the environment to support the subject.

Getting Great Results from Both Candid and Posed Portraits

Photographers typically take two types of portraits of people: posed and candid. In a *posed portrait,* which is the more traditional of the two, your subject is engaging the camera, and it's clear he's aware that his photograph is being captured. A *candid portrait* represents a moment where the subject wasn't engaging the camera but rather living his life in a natural sense. You can get candid shots by taking photos when no one knows it, or by posing your subjects to suggest a candid moment. I provide information on both types of portraits in the following sections.

Making a case for candids

The easiest way to capture a moment of genuine emotion is to photograph your subject when she has no idea that you're taking her picture. This method has its ups and downs and isn't applicable to most photographic situations. It's most useful in photojournalism, party and event photography, and perhaps in some lifestyle photography. It's difficult to use candid methods for commercial photography because the results aren't guaranteed — you have to rely too much on random occurrences.

To get a candid portrait of someone, you either have to be really good at blending into your surroundings, or you have to get the shot before the subject notices your presence. You often get only one shot. That's because if you get one shot of the subject and then he becomes wise to you for the second shot, you'll most likely notice that the facial expression in the first photograph looks sincere and the second one looks forced.

Here are some things to keep in mind when attempting a candid shot:

✔ **Make sure your exposure settings are correct for your scene before trying to photograph (and risk being seen by the subject).** Take a few test shots in an area to see how your lighting is before going in for the true shots.

✔ **Get your subject in focus on the first try.** An image that's genuine, expressive, beautifully composed but not in focus is a big disappointment. If you're using autofocus, ensure that your focal point is locked in on your subject by pressing your shutter release button halfway with the subject in the center of your frame. Then (keeping your shutter release button pressed halfway) compose your image and take the shot. For more on using your equipment, check out Chapter 3 (and, of course, your owner's manual).

✔ **Wait for the decisive moment.** In other words, don't rush. If you're going to get only one shot, try to capture a moment you'll be happy with. For instance, if you rush and take the picture while your subject is blinking, she'll probably notice your presence by the time you press the shutter a second time. And then you'll be left with a photograph you're unhappy with.

✔ **Choose your perspective wisely.** Make sure you have a perspective that shows the subject in a way that pertains to your intended message. When shooting candids, you may want to rely on your zoom lens for getting closer to a subject (rather than physically moving closer). Doing so may help you to stay unnoticed. Also be aware of your surroundings when moving into position. You may find descriptive, supporting elements surrounding your subject that would work to enhance your photo's message. Chapter 8 provides more information on perspective and composition.

Taking control with posed shots

Although candid photography provides interesting results, it isn't a reliable way to achieve professional portraits. Setting up your shot lets you take control of your lighting, allows you to choose your background, and provides a scenario in which you can direct your subject.

A portrait that you set up doesn't have to give you stiff, traditional results. You can get those results if you want them, but think of a posed portrait as one in which your subject is fully aware of the fact that you're taking his photograph. The two of you are working together to create something worth photographing.

The combination of your background, lighting, scene, subject, and composition determine your message and whether you get a good shot. So keep each of these elements in mind as you're planning your portrait. Here's some explanation for each:

- ✔ **Background:** Setting up a great portrait depends on choosing a good background or environment. Notice your surroundings and be aware of colors, shapes, lines, patterns, and textures. Redheads, for example, look great in front of blue or green backgrounds. And a busy subject looks best in front of a simple background or environment. Check out Chapter 9 for more on choosing a background.

- ✔ **Lighting:** Typically I use light to determine where I place my subject. If you want soft light, for a baby portrait for example, keep your subject out of the direct sun. And if you want hard light, position him directly in the sun. The direction from which the light falls is important, too. For instance, curly hair glows when it's backlit by the sun, and direct side light from the sunrise looks amazing on cowboys. You may have to rotate your subject or yourself to get the lighting you desire. See Chapter 10 for more details about lighting.

- ✔ **Scene:** Choose a scene that best suits your subject and your intended message. If you're going for a light, airy feel, don't shoot in a dark and dank abandoned building. The possibilities for pairing people and scenes are infinite. You may take a lawyer's headshots in an urban, downtown area, and a bikini model's headshots may be best photographed on the beach.

- ✔ **Subject:** In order to get the most from your subject, you need to direct him. Find a way to inspire him to be excited about the photograph, or just let him be who he naturally is. If you involve your subjects in the creative process, you help them care about it as much as you do. Also, instead of having someone sit still in a pose for several shots, encourage him to switch positions in between each one. Doing so keeps him from getting bored or tense. It also gives you more options to choose from. By taking numerous images, you ensure that you have a great one. After all, the more you have to choose from, the more likely you are to find one that you and the subject both like.

 ✔ **Composition:** Composition is the combination of all the points discussed in this list and how they relate to one another. Your composition determines what in the scene is included in your frame and how. For instance, how you pose your subject determines how he fits into the background and how the lighting looks on him. His pose also says something about who he is.

In Figure 13-3, I captured an informal moment while still posing the scene and the shot. I maintained control of my lighting and placed my subject in front of the background of my choice.

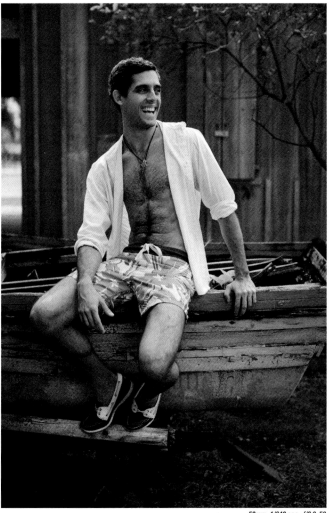

50mm, 1/640 sec., f/2.8, 50

Figure 13-3: Setting up for a portrait is one way to guarantee a suitable shot.

Photographing People Together: Showing Connections

Photographing more than one person at a time is a different challenge from photographing an individual. Single subjects in a portrait create their own messages, which in turn become a photograph's message. In a group shot, each subject creates his or her own message while contributing to the photograph's message as a whole. If one person in the group has a contradictory expression compared to everyone else, that person changes the message of the whole photo.

A good photographer creates a cohesive message within the group. To produce this cohesive message, you have to make sure everyone is on the same page. So, in this section, I help you make compositions that show relationships between multiple subjects and show you how to make everyone in the group look good in the photo.

Overcoming the technical challenges of photographing groups

Along with the natural tendency for people to act rowdy in groups, you face some technical issues when photographing more than one subject at a time. Keep the following points in mind when you prepare to take a shot that has more than one subject:

- ✔ **Your depth of field determines how much of your scene is in focus.** (Turn to Chapter 7 to read more about depth of field.) You can place your focal point on only one subject at a time. If another subject is farther from the camera than your focal point, that person won't be in focus. You can use a small aperture to increase your depth of field when photographing more than one person at a time; keeping your subjects fairly close to one another also distributes the focus more evenly.

 At times you may want to use a shallow depth of field and create a distance between subjects in order to let one or more subjects fall out of focus. This technique can create an artistic effect and can be useful in creating a specific message. However, it will portray the subject that's sharp much more strongly than the others. And in most cases, you want to keep everybody in the frame as sharp as possible.

- ✔ **Pay attention to how the light affects each individual.** Sometimes one person casts unwanted shadows onto another person. In that case, you need to reposition the subjects or the light source so the light can

clearly reach each of them. Using the paramount or loop lighting patterns (see Chapter 10) is a good start. Having the light out in front of your subjects keeps it from casting shadows on people's faces. This is true because you won't usually place one person's face in front of another's but rather to the side of it.

✔ **Use a variety of patterns when gathering people for the photo.** Lining people up side by side is a great way to ensure that your focus is distributed evenly, but compositionally it's not the most interesting way to pose people. By breaking up the pattern and allowing for some variation in shapes, sizes, and lines, you can make interesting photos that people enjoy looking at. Try to make the various subjects create different shapes instead of having them stand in the same pose; you want the different shapes to work together to create a flowing composition.

Composing portraits of couples

Romantic couples make for a common photographic scenario, so photographers who can master the traditional poses and portray couples in new and unique ways will always be in demand. The advantage of photographing two people who love each other is that they provide comfort for one another while interacting during the shoot. Having one lean on the other for support or telling them to look into each other's eyes rather than at the camera helps to get more realistic and sincere expressions.

To me, photographing couples is all about creating a single shape out of the two individuals. This represents them as one. Ways to do this include the following:

✔ **Place the taller of the two slightly behind the other.** This arrangement helps to bring the couple together without blocking any key areas like the face.

✔ **Vary the heights of similar-sized couples.** If both people are the same height, have one seated or kneeling while the other stands. Or ask one to lie down while the other sits. This way you can vary their heights and create a more interesting shape of the pair.

✔ **Ask the two to embrace.** Having the couple position their arms around each other suggests some sort of comfortable flow of energy between the two. Areas where the two come into contact with each other help to bring their shapes together as one.

In Figure 13-4, I positioned the couple so that each person's energy was directed toward the other. Their individual shapes work together in a complimentary way to create one shape. This makes it look as if they belong together.

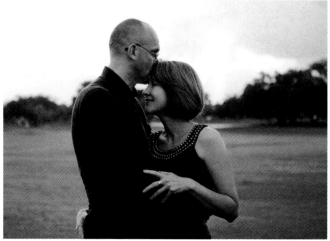

50mm, 1/640 sec., f/2.8, 100

Figure 13-4: Flowing lines and shapes between two subjects.

Setting up group portraits

A group portrait is similar to a portrait of a couple except you don't usually have the romantic aspect to work with. Posing people in groups is usually more formal, and getting everyone's attention is more challenging than with a single subject or a couple.

Here are some tips for creating an interesting composition in a group portrait:

✓ **Stagger people in a way that gets them out of a straight line.** Doing so gives each subject in the group her own unique space. People standing in a straight line look as though they were instructed to do so, making the image look much too formal. A slightly less organized group looks as though it came together naturally.

✓ **Keep your subjects fairly close to one another.** They're more likely to be a similar distance from the camera that way, helping to keep everyone in focus.

✓ **Use a V-shaped pose to avoid a group that spreads out too wide in a straight line.** To create this setup, have each person face the camera at a slight angle and position people slightly in front of or behind each other.

✔ **Work with levels.** Positioning someone directly in front of another person only works if your subjects are on different height levels. For example, you can position part of a group on the floor in front of the rest of the group sitting on a sofa. If more people are in your group, you can ask them to stand behind the people on the sofa for an added height level. By having multiple rows of people on different levels, you keep the group contained to a smaller area.

✔ **Make sure each person in the group has her own place in the scene.** More specifically, pay attention to how each individual is placed in front of the background. In Chapter 8, I discuss finding a perspective in which your subject fits appropriately into the background and can be clearly seen.

In Figure 13-5, each person in the photograph has his or her own space in the frame and is placed comfortably in front of the background.

✔ **Pay attention to how the subjects interact with each other and the supporting elements of the scene.** Nobody's face should ever intersect with anyone else's, and each person should be represented in a clear and pleasant fashion. The shape of each person's head should be clearly identifiable. Also be sure to avoid merging lines, which I discuss in Chapter 9.

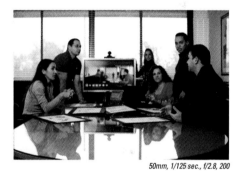

50mm, 1/125 sec., f/2.8, 200

Figure 13-5: Good composition applies to everyone in a group photograph.

Fabulous Darling, You're Gorgeous: Shooting Fashion Photography

In fashion photography, the main goal is to sell clothing, so you have to make the wardrobe look great. But, of course, that effort would be in vain if the model didn't look so hot. When you're shooting fashion, your client wants the model to look good in the photographs because that model represents what the wardrobe is supposed to look like on the people who are viewing the images. If the model looks bad, viewers may make a negative association to the clothing.

Going beyond the ordinary snapshot: Conceptual photography

Portraiture and fashion photography aren't the only reasons you may photograph people. For a school project, for example, a teacher had my class photograph a portrait of a loved one. The catch was that the person couldn't be in the shot. The goal was to show the essence of a person without showing that person. By placing objects in the scene and creating a mood through light, tonality, color, and perspective, we were expected to reveal the essence of someone. If you reverse that scenario, a person also can be used to reveal the essence of something else.

This type of photography is referred to as *conceptual photography*. It's the art of creating a deeper meaning in an image by using symbolism. It's fun to create, but you run the risk of looking like the pretentious artist type by assuming that people want to read into your images beyond their initial aesthetic and literal qualities. Plus some conceptual photographs are more literal and easier to understand than others. To be successful in producing conceptual imagery, you may want to research Sigmund Freud's book *The Interpretation of Dreams* to gain a thorough understanding of symbolism. Whatever you do, remember what great composition is, even when you're including symbolism in your images. Photographers often get so caught up in the concept of their work that they tend to forget about creating images that look amazing.

Fashion photographers often shoot from a low angle in relation to the subject. Doing so emphasizes the clothing and emulates the look of the runway. But when you shoot from a low angle, you invite viewers to look up the model's nostrils and under her chin. Fashion photographers often direct a model to put her chin down to eliminate this problem. Most models are thin and have strong chins, so when they put their chins down their face maintains an appealing shape. However, each subject is different. So if you're not pleased with the way someone looks from a low angle with her chin down, she won't be either. In that case, find a different angle that better suits your model.

The message in fashion photography usually depends on the wardrobe and the intended market. You use different lighting styles, locations, and concepts based on what you're shooting. A clothing line that's designed to be sold in surf shops to teenage girls most likely will have natural, soft light that makes the models look beautiful, and your location and concept could represent a carefree environment. You may want to capture candid moments of your models laughing and holding hands or rolling in the sand. On the contrary, you'd likely photograph a line of elegant evening attire with dramatic lighting in the studio or in a ritzy hotel. (See Chapter 10 for more on lighting.)

In fashion photography, you can shoot clean portrait-like images of models, or you can opt for action-lifestyle images. Either way, you're selling the clothes. One method sells them by putting them on display, and the other method sells them by showing how they make someone feel. Both methods work and can be justified in most scenarios. As long as the photography and the compositions are great, the images work.

Figures 13-6 and 13-7 show two examples of fashion photography. One shows clothing that's designed for a special occasion (referred to as *high fashion*). The other shows casual, everyday clothing that's supposed to emulate a recognizable moment in viewers' lives. This type of photography is called *lifestyle fashion*. In Figure 13-6, I photographed the model wearing an elegant blue dress. The dress itself is more of a work of art than a functional piece, so I composed the image as if she were presenting the dress to viewers.

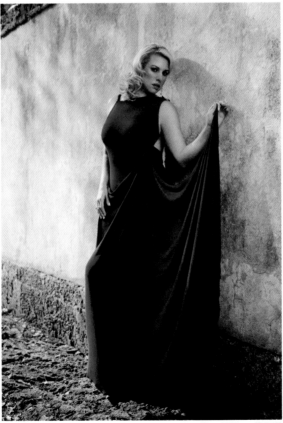

50mm, 1/500 sec., f/3.5, 100

Figure 13-6: This dress is artistic and dramatic, so the photograph was composed to be artistic and dramatic as well.

When you shoot high-fashion pieces (like the blue dress in Figure 13-6) you can create compositions that are all about the clothes. Have your model pose in dramatic ways to emphasize the wardrobe. Unlike lifestyle fashion, high fashion usually is detached from real life, so drama is appropriate and expected.

I created Figure 13-7 to highlight functional, everyday attire. I photographed the model in a more casual and realistic composition based on my message to highlight a recognizable moment in everyday life. His pose is natural and his expression is inviting. The lighting is less dramatic and the background is commonplace. You're more likely to see someone sitting like this in real life than to see someone posing like the model in Figure 13-6.

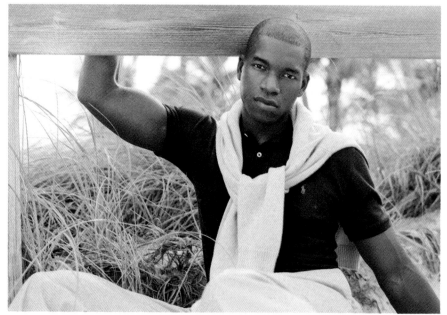

28mm, 1/160 sec., f/6.3, 200

Figure 13-7: This wardrobe is designed for everyday living and is represented in a casual composition.

14

In Nature: Landscapes and Wildlife

Nature provides settings that offer limitless opportunities for creating beautiful, peaceful, meaningful, sublime, surreal, or tragic photographs. Putting yourself in situations that are relevant to the photo you want to capture assures that you're there when the moon rises over the mountains, the forest fills with morning mist, the storm begins to form in the distance, or the eggs hatch and the baby turtles begin to race toward the sea.

The natural world offers all these wonderful photo opportunities, but it also provides some special challenges that you must consider to get the photo you seek. For example, you must understand composition in context of a natural setting. You also need to consider how to best capture a photo of an awesome, yet dangerous creature (or one that's harmless but skittish around humans). Finally, lighting can be an issue in certain settings, such as in a shadowy forest or on a sunny beach or desert. In the following sections, I offer tips to help you with all these challenges.

If you want to get great images of nature, spend some time in it. The perfect vantage point won't come and find you, and the eagle won't pose for you if it senses your eagerness to capture its image. Patience is a virtue that enables you to be presented with nature's beauty rather than having to search for it or force it. By spending time in an area and exploring its diversity, you'll start to notice things that you couldn't see if just passing through. You'll also get to see how the area is affected by the sun and weather at different times during the day. After you've been still for a while and the wildlife has grown to accept your presence, perhaps animals will get nearer to you and provide you with the chance to get some great images.

Recognizing Compositional Elements in Nature

The natural world consists of relationships between elements. The elements consist of things like the sky, mountains, fields, meadows, water sources, rocks, trees, brush, flowers, beaches, and of course, living creatures. These natural compositional elements vary greatly in size, causing photographers to think about focusing on elements both big and small.

The basic rules of composition help you make the most of any situation with any elements. These guidelines help you determine where to place your subject in the frame and how to work with the lines and elements in a scene in order to captivate a viewer. The rules also help you decide where you should position yourself to achieve the best vantage point. After you study the rules and put them to use, everything starts to become second nature. (Chapter 5 provides plenty more information on the compositional rules.)

Creating the appropriate composition depends on what's in front of you and how you want to show it. If you know what does and doesn't look good, you can make wise decisions based on how you feel a scene could best be represented. In this section, I tell you about the three most common types of scenes in nature photography.

Expansive landscapes: Basking in your surroundings

Expansive landscapes are those that cover large areas. They show the big picture, revealing the type of environment that you're photographing and the elements that exist in it. Figure 14-1 represents an expansive landscape scene.

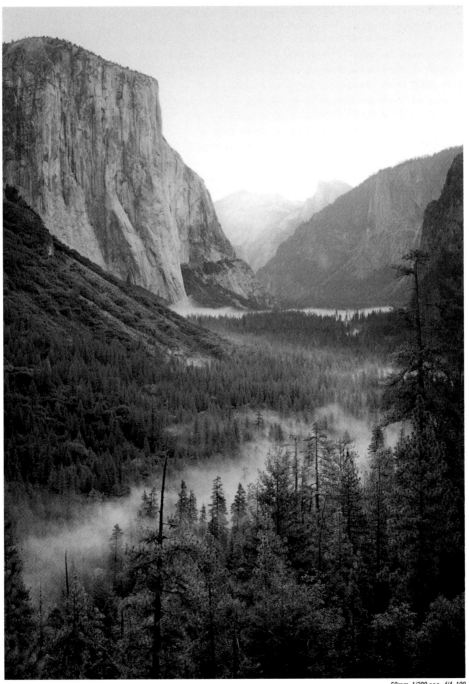

50mm, 1/200 sec., f/4, 100

Figure 14-1: An expansive landscape shows a large area.

When you hike to the top of a mountain, a certain sense of accomplishment inevitably runs through your blood. To capture the feeling you get from this achievement, find the best spot to photograph the view from the mountain you've tackled. This view is a perfect example of an expansive landscape. And taking that picture is sort of like receiving a trophy for the hard work you put in to get there. With this expansive photo, you want to show as much of the scene as possible in order to emulate the experience you're having by being surrounded by open space and being able to see far into the distance. Being on top of a mountain also allows you to see over smaller mountains, causing a layering effect that provides depth in your compositions.

Some elements that may intrigue you to shoot expansive landscapes include mountains, rivers, wide-open spaces (salt flats, meadows, dunes, rolling farm fields, and so on), tropical beaches, and arrangements of trees.

When composing a landscape, try to find a perspective that shows the scene as you want it to be seen. (Chapter 8 explains perspective in greater detail.) Your perspective determines how much depth your composition has and the physical relationships between each element. Consider shooting landscapes in the early morning or late afternoon. The lighting tends to be more directional at these times, so colors seem to be enhanced. (See Chapter 10 for more information on lighting.)

Narrowing in on intimate landscapes

Intimate landscapes cover specific details in an environment. Instead of including the entire area in the frame, an intimate landscape composition focuses on a specific element, revealing the details in it. You still get an idea of what the environment is, but you don't get the big picture as you do in an expansive landscape shot. If an expansive landscape were compared to a photo of the New York City skyline, an intimate landscape could be compared to a photo of your favorite store in the Italian Market. Figure 14-2 shows an intimate landscape.

You'll be most successful shooting intimate landscapes when you notice a specific detail that's strong enough to give meaning to an image without needing the whole environment to tell the story. For example, a rock in a stream could cause the flowing water to create an interesting pattern as it pushes past it. Or you may notice that the light is reflecting on the surface of a tree or a rock in a way that has narrative qualities.

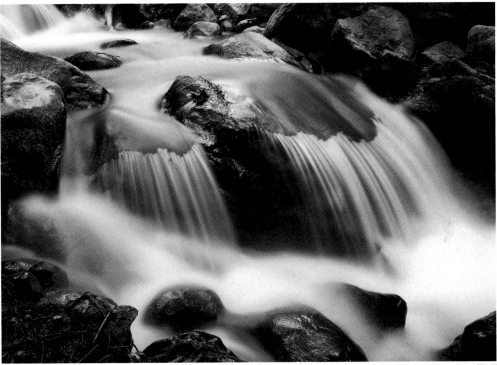

28mm, 15 sec., f/22, 50

Figure 14-2: An intimate landscape highlights a revealing detail, such as reflections on a rushing waterfall.

In Figure 14-2, the light was shining on the water in a way that highlighted the difference between the direct sunlight and the blue sky. Had I shot the photo with a wider lens and included more of the environment, it would have become more difficult to see what was happening in the reflections.

Keep the quality of light in mind whenever you're photographing intimate scenes outdoors. While direct sunlight works well to reveal as much detail as possible in expansive landscapes, it may create too much contrast in a more intimate scene. Similarly, if your shadows are much darker than your high-lights in an intimate scene, you may lose valuable details in your exposure. Be aware of the weather forecasts and make the most out of any situation. Chapter 10 tells you more about working with sunlight.

Master and protégé: Ansel Adams and John Sexton

One of the masters of landscape composition in photography was Ansel Adams (1902–1984). The work he did in Yosemite National Park is amazing and basically set the standard for landscape photographers to reach for. Through his images, he covered the big picture by capturing the landmarks that everyone knows today. As far as expansive landscapes are concerned, Yosemite belongs to Ansel Adams. In fact, many professional photographers would never think to place an image of El Capitan in their portfolios because it would only cause viewers to think of Adams when looking at it.

However, another great photographer by the name of John Sexton photographed Yosemite National Park in a way that was equally amazing and unique. The two photographers worked and studied together, and you clearly can see that Sexton (the younger of the two) learned a lot about composition in his time with Adams.

Because the big-picture images had already been created to perfection by Adams, Sexton chose to take a more intimate approach to Yosemite's natural beauty. He concentrated on the subtle relationships among individual rocks, streams, and trees. By creating striking compositions and shooting during times with appropriate lighting, Sexton produced images that were respected and not associated with the work of Adams. You can see John Sexton's work in his book *Recollections: Three Decades of Photography* (Ventana). And you can view the images created by Ansel Adams in Yosemite at www.anseladams.com.

Exploring fine detail through macro photography

Macro photography uses a macro lens, which allows you to get very close to your subjects and still achieve sharp focus, to capture intimate scenes in nature on a very small scale. (Flip to Chapter 3 for more on macro lenses.) Insects on a log, tiny flowers, spiders and their webs, and grains of sand are some of the elements that may be best represented through a macro lens. By using this type of lens, you can photograph an ant so that it's fairly large in your frame, revealing details and textures that otherwise would be unnoticeable. Figure 14-3 shows the fine details of a leaf's texture and biological design.

Keep the following points in mind when shooting macro photography:

✔ **Increasing magnification decreases depth of field.** As a result, images taken with a macro lens often have a very shallow depth of field. (Chapter 7 explains depth of field in more detail.) If you want your composition to show more sharp detail by increasing your depth of field, shoot with a small aperture, such as f/16.

The smaller your aperture, the longer your exposure. Because of this long exposure, the slightest movement has a great effect on the sharpness of your image. As a result, you should use a tripod when shooting with a macro lens.

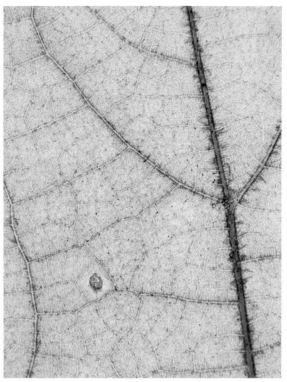

50mm (with 25mm extension tube), 1/60 sec., f/11, 100

Figure 14-3: Macro photography shows the fine detail of small subjects by enabling you to achieve focus at close distances.

✔ **When you get extremely close to a small subject, you may block the available light.** If you do, rotate to a position where you aren't in the way of the light source. If you can't rotate your position appropriately, a small, battery-powered flash off-camera and to the side of your subject produces a nice quality of light in most cases. Some photographers use a small *ring flash,* which covers the rim of your lens and provides a flat, ambient light.

If you want to keep the light as natural as possible, bring a collapsible reflector into the field. This type of reflector can be used to bounce sunlight toward your subject, or it can block the wind from causing your subject to sway.

✔ **Macro photography can be misleading regarding the size of your subject or the other elements in your photo.** Providing something with an easily recognizable size in the composition gives your viewers a sense of scale and helps reveal the true size of the other elements. For more on scale, check out Chapter 12.

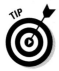

Even if you don't own a macro lens, you can shoot macro photography with your 50mm lens if the need arises. To do so, attach an *extension tube* to your normal lens; this tube allows you to get closer to your subjects and still achieve sharp focus. An extension tube connects to the back of your lens and then to your camera body. It extends the distance between the glass in your lens and your digital sensor. The closer you get to a subject, the farther your focus gets from the backside of the lens. By adding distance from the lens to the digital sensor, you enable yourself to move in closer to your subjects. Keep in mind that when you use an extension tube, light has to travel farther to reach the sensor, which affects your exposure. You can compensate by opening up your aperture or slowing down your shutter speed.

Capturing Wildlife

Photographing wildlife is exciting, but it requires patience and skill. You gain a certain level of satisfaction from simply seeing an animal in the wild; but, having the photo to prove it is like having a trophy. Photographing wildlife is sort of like a nonviolent form of hunting. Knowing where to see animals in their natural element is the first skill you need to acquire; getting the shot is the second. I explain both in the following sections.

Finding animals to photograph

If you want to take photos of wildlife, you first have to figure out where to go to see the animals you're interested in. You have several options:

✔ **Go out into the wild and explore.** This option is probably the most exciting and respectable way to photograph wildlife, but, depending on the subject of your photo, it also can be the most dangerous and least likely to provide results.

Always be cautious of wildlife, and put your safety ahead of capturing the shot. Getting too close to a potentially violent creature is never a good idea. Also, don't taunt or bother wildlife to gain a reaction either. It's your duty to respect and preserve wildlife and your relationship with it. Maintain your distance for its sake as well as yours.

✔ **Sign up for a tour or a safari.** These group activities are designed for photographers and enable you to capture images of animals without putting yourself in harm's way. They're great for guaranteeing that you see the animals you want to see and ensuring a safe journey.

✔ **Contact a local exotic-pet handler.** This option is helpful if you don't have the time, money, or expertise to go exploring in the wild or to go on an expensive tour. These companies usually allow you to photograph the animals in their care for a reasonable rental fee. Some even come to your location and provide unique and interesting insects, lizards, snakes, and various sizes of fuzzy creatures. You may have to shop around to find the specific animals you want.

The tarantula in Figure 14-4 was photographed in a class that I attended. This particular spider is very aggressive and contains venom. So, of course, I was more comfortable encountering it with knowledgeable handlers in the area as opposed to finding it on my own in the wild.

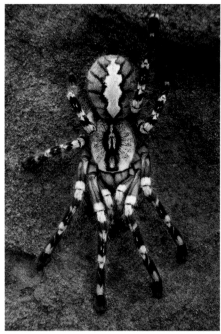

135mm, 1/80 sec., f/5.6, 400

Figure 14-4: A tarantula photographed during a wildlife photography class.

✔ **Visit the zoo.** If you can't get into the wild and haven't found a handler who has the animal you want to photograph, consider the zoo. Choose a day fewer people are visiting. The middle of the week and early in the morning are your best bets for finding the freedom and space to work with. Large crowds can make it difficult for you to get the compositions you desire. By cropping in close and using a shallow depth of field, you usually can create compositions that are believable as being taken in the wild.

Don't try to literally pass off your images from the zoo as being captured in the wild. Nobody likes to be lied to, and this includes stock photo agencies, magazine editors, and friends and family.

Getting the best-composed shot

When composing an image, consider wild animals as you would any other photographic subject. To make great images of wildlife, make sure that you

✔ **Seek out interesting moments.** Scenes showing a mother interacting with her young or two animals engaged in a turf battle always provide great compositional material. Even a moment where an animal makes eye contact with your camera can be great. Pay attention to the animals rather than photographing them randomly; you'll better enjoy your personal experience, and you'll capture the most interesting moment.

✔ **Look for great lighting.** The best way to increase your chances of great light when photographing wildlife (because it's wild and somewhat unpredictable) is to go out during the best hours of the day. The best hours are during the beginning or end of the day. On bright, sunny days, perhaps you can use the middle of the day to take a nap or a long lunch. (Head to Chapter 10 for more information on lighting.)

✔ **Find supporting elements that say something about the subject.** A shot of a cheetah is cool, but a cheetah in a tree is even cooler. This says something about how the cheetah lives its life. An eagle landing by a nest suggests that it has offspring. A photo of a lone wolf tells a different story than one that shows a wolf backed by its pack.

✔ **Use the key elements of design.** Regardless of the subject, you should always apply the elements of design. Think about how your subject fits into your frame and how you're composing the other elements that surround it. Draw the viewer to the subject by incorporating leading lines and paying attention to contrast in your scene. You can read more about design principles in Chapter 4.

✔ **Make your subject stand out as the focal point.** Get your subject in focus to ensure that your image has the highest quality. It would be confusing to a viewer if a twig in the background was in focus but the lion's face was blurry. To discover how to work the focus features on your camera, refer to Chapter 3.

To get the best composition possible when photographing lions, tigers, and bears (and other dangerous animals), bring a telephoto lens. By zooming in on your subject with a long lens, you can give the illusion that the image was taken up close and personal without having to risk your life.

Figure 14-5 was taken at about 100 feet from the buck in the scene. I used a long lens to get as tight a crop as possible. As I began to move in for a closer shot, he made it very clear that I was going to have to fight for the territory. I packed up and left, knowing that no photograph is worth getting in a tussle with a male elk.

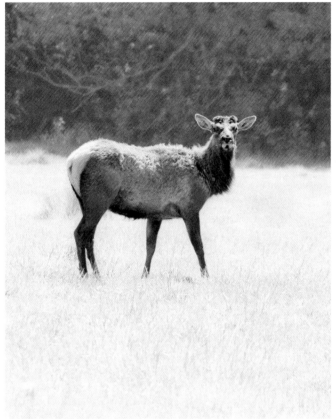

300mm, 1/320 sec., f/8, 320

Figure 14-5: Photograph wildlife without overstepping your bounds.

Developing a Respect for Nature's Elements

Nature is one of the most common and fun subjects to photograph. It's also potentially the most dangerous for you and for your equipment. Before embarking on a journey through nature, be prepared with the necessary tools and information regarding your specific destination. The Internet is

filled with valuable information, making researching an area easier than ever. Some things to look out for include:

- ✓ **Water:** In nature, you develop a love/hate relationship with water. You love water because it makes for a great photographic element, and you need it to survive. It's refreshing to drink and to swim in or to rinse yourself with. All in all, staying relatively close to a fresh water source is a good idea when you're out in nature. However, you may start to hate water when it begins to rain and you're out in the middle of nowhere, when the tide comes in to drench all your camera gear, or when you slip while crossing a stream.

Keep an eye on the weather before going out, and know what you're up against. Bring a poncho or some strong plastic bags to protect yourself and your gear in case it rains. If you're shooting on the beach, find out the times for high tide and low tide. And before setting your camera on a tripod along the ocean's edge, make sure the tide is going out and not coming in. When hiking in the woods, wear shoes that have decent traction. Falling on slippery rocks can get you seriously hurt and can damage your equipment.

- ✓ **The sun:** If you go out in the summer, the sun is going to be in the sky for long periods of time. So, as mom always says, bring sunscreen! I do most of my photographing in the morning, late afternoon, and at night. Doing so allows me to use the time during the middle of the day (which is when the sun does its worst damage) to rest in the shade, go for a swim, or explore new territories. Besides messing up your skin, the sun can provide not-so-flattering results as far as lighting your scenes during the middle of the day.

Keep in mind that without the sun, navigating an area will be much more difficult. If you're not completely familiar with your surroundings, and you're away from camp as the sun is going down, be sure to give yourself enough time to get back before it gets too dark. And always be prepared with a flashlight! When shooting night scenes, it's wise to set up camp near where you'll be placing your camera.

- ✓ **Location:** Always know where you are and how to get to where you're going. As a precaution, keep a compass packed with your camera gear. If you don't know how to navigate with a compass, research it. If GPS is more your style, nowadays you can get a system for fairly cheap. However, if you're relying on GPS to keep you from getting lost, be sure not to run out of battery power. Otherwise, it will act only as dead weight you have to carry.

- ✓ **Local wildlife:** Know what's out in the wilderness with you. You need to know whether an animal is a threat or not. Pay attention to which snakes are common in the area, and what to do if you encounter any large animals. If you're camping out, be sure to wash any dishes before going to sleep at night. And hoist your food up in the air to help keep wild animals from getting into it throughout the night. Also, keeping the food at a good distance from your campsite helps keep bears and mountain lions at a safe distance from you.

Never go out into the wilderness alone. If you get injured or lost, you probably won't be able to get help.

Photographing the Forest

The forest is familiar, mysterious, expressive, and secretive all at the same time. You can reveal the secrets of the forest or keep them hidden depending on when and how you photograph it. Spending time in the forest is the only way to develop an appreciation for its beauty. In the following sections, I provide pointers to help you succeed when taking photos in a forest setting. (If you're shooting another location, like the beach or the mountains, follow the tips I give you earlier in this chapter.)

Determining what you want to photograph

If you're well equipped while you're in the forest, you can almost always find something right in front of you that's worthy of photographing. If the grandiose scene doesn't appeal to you, perhaps you'll notice something happening on the intimate level, such as insects, spider webs, or wild mushrooms. (Check out the earlier section "Recognizing Compositional Elements in Nature" for more on expansive and intimate compositions.) Seek a nuance of personality in a tree or rock. Pay attention to patterns and textures. Notice what the lines in a scene are doing — where and how they lead your eyes.

Factoring in light when in the forest

The most important factor in photographing a scene in the forest is light. Direct sunlight entering through the trees in the forest creates very high contrast. The shadows aren't filled in by the sky's ambient glow. Areas being hit by the sun are much brighter than areas in deep shadow, and your digital sensor isn't capable of exposing both of these areas properly at one time.

You can create mysterious compositions by using the high contrast to your advantage, however. Be sure to include some interesting elements of composition in your frame. Give purpose or meaning to the image; otherwise, it comes across as a poorly executed snapshot of the forest in a bad lighting scenario. When shooting a high-contrast scene in the forest, you most likely rely on lines and shapes to tell your story. Remember to avoid merging lines, especially in the trees (see Chapter 9 for more information). Find a perspective that separates each tree as much as possible. Doing so provides a clear and descriptive view.

Soft, diffused light is the best for getting images of the forest with the most detail. Because the forest itself is already high in contrast, you don't need an intense key light to add any more. A little directional light is nice, though. The ideal scenario is when a thin layer of clouds is blocking the sunlight, softening it just enough to tone down the contrast.

Figure 14-6 shows an example of a forest scene photographed on a partially cloudy day with the sun being diffused by a thin layer. Notice how you can see detail throughout the entire scene. The scene shows no blown-out highlights or shadow areas that are too dark to see. The forest's natural level of contrast is enough to work well in this lighting condition.

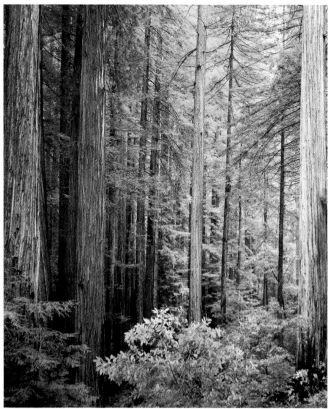

28mm, 1/30 sec., f/3.5, 100

Figure 14-6: A forest photographed in cloudy conditions to reveal an ideal amount of detail.

Find ways to make your subject stand out when shooting in this condition. Here's how:

- ✔ Shoot from a perspective that gives a clear view of your subject with no merging background elements. Head to Chapter 8 for more information on perspective.

- ✔ Use a shallow depth of field to eliminate the impact of competing elements. Chapter 7 provides detail on using depth of field.

- ✔ Give closure to your image by paying attention to the edges of your frame. The elements around the edges are equally important to your message as the subject. The forest is continuous, but your photo shows one portion of it for a reason. If the edge of your frame leads viewers away from the subject, they won't feel the need to go back to it. For this reason, avoid letting lines go off the edge of your frame. Refer to Chapter 11 for more information on framing a composition.

Taking advantage of night in the forest

In the forest, the most interesting light occurs just before, during, and right after sunrise and sunset. The easiest way to be ready for that light is to set up camp overnight. Doing so allows you to shoot until after sunset and not have to hike out in the dark (which can be dangerous). By camping out, you also can wake up in the morning before sunrise and be ready to shoot.

The best part of camping in the forest is that you get to shoot at night. You'll likely find that some of your most interesting images are ones that were taken in the dark. Sometimes I set up my composition while some light is still available, and then I leave the camera in place on the tripod for later.

Here are some tips to consider when shooting at night:

- ✔ **Test your shutter speed.** With a full moon, you can get decent exposures of most scenes with a 15- to 30-second shutter speed. On darker nights you may want to shoot on *bulb* (the camera setting that enables you to keep the shutter open for extended periods of time) and do some test shots to find out how long to leave the shutter open.

- ✔ **Purchase a cable release for your shutter.** This cable enables you to leave the shutter open without having to touch the camera during the exposure. Not touching the camera during exposure is important so you don't introduce blurriness. When the shutter is open for a long time, every movement, including the natural shaking of your hands, will be shown as blurriness or motion.

✔ **Take advantage of the campfire.** The light provided by your campfire sometimes adds an interesting quality to your nighttime images. The night's light is cool in temperature, and the fire's light is warm. (Flip to Chapter 10 for more on color temperatures in light.) In other words, the moonlight provides a bluish color to the scene, and the fire produces an orange glow on the elements that are affected by it. Color temperature is good for adding some color contrast to your composition. The trees closest to the fire will have a warm glow, and the elements farther away will remain cool and blue.

✔ **Use your flashlight to paint light into the scene.** With the shutter open, shine the light on your subject or supporting elements and move it around as if you were painting with it.

In Figure 14-7, I used a 15-second exposure to capture the sky and the stars. While the shutter was open, I used my flashlight to paint light onto the limestone in the foreground to brighten it and reveal it as the subject.

✔ **Shoot at night near a river, stream, ocean, or lake.** These bodies of water can provide amazing results. The motion of the water causes a smoothing effect on your final image and causes interesting things to happen to reflections.

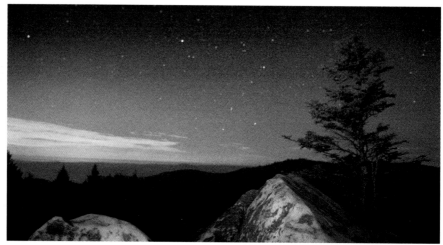

24mm, 15 sec., f/5, 3200

Figure 14-7: Painting with light when capturing a nighttime image in the forest.

Shooting Still-Life Photography

*P*hotographing objects (rather than people) comes with particular joys and challenges. One of the joys of photographing still-life objects and architecture is that you're working with subjects that don't move. You can concentrate solely on your composition and lighting without having to worry about directing your subject or having it become bored.

But objects also require you to get all the details just right. Good composition and good lighting always are important in photography, but they're especially important when you photograph subjects that aren't alive. Living subjects can bring more to your message through expression and body language. Objects don't have that quality, so your message relies completely on what you're photographing and how you photograph it.

In this chapter, you find information on how to create beautiful photographs of fine art and commercial still-life subjects as well as flowers both in the studio and in their natural locations. I also cover the art of architectural and interior photography, including tips for getting the perfect composition and lighting your scenes.

Making Everyday Objects Interesting

Still-life photography, or the portrayal of an inanimate subject matter, can be created for artistic or commercial purposes. Although the objects can be similar in the two styles, the message usually is much different.

For example, a pair of soccer cleats hanging from a rusty nail in your grandfather's shed could make a great fine-art subject. Dramatic lighting on the weathered cleats set in the rustic environment would create a sense of nostalgia. Product photography, on the other hand, wouldn't show old cleats. A new pair of cleats hanging in the locker room would be more likely to show that the cleats are used by someone on a team.

In the following sections, I provide pointers on shooting both fine art and commercial product photos.

Seeing objects as fine art

Fine art is fun because you can show objects for what they really are, or you can fabricate their relevance in any way you choose. Either way, a fine-art photograph is your personal work, and you can say whatever you want in it. Nostalgia works particularly well in fine art because it speaks to the human condition. Things fall apart or change through time. There's something romantic about photographs that reveal this aspect of life.

Consider, for instance, the example of the old cleats from earlier in the chapter. Adding a deflated soccer ball to that scene would reinforce the idea that the footwear hadn't been used for a while. At one time the cleats and ball worked together, but now they just sit in the shed. When photographed together, however, they tell the story of what used to be — and that's their new purpose.

Such a dramatic theme requires dramatic light and a dramatic composition. Dramatic light is directional and high in contrast. (Check out Chapter 10 for more details about lighting.) A dramatic composition in the case of the cleats and soccer ball in the shed reveals the textures of the objects in the scene. By cropping in fairly tightly, you maximize the detail in the cleats, the soccer ball, and the shed to most effectively tell the specific story of those objects.

A wider crop includes more of the environment and concentrates less on the soccer-related items. This kind of composition tells more about the cleat owner's life as a whole. Maybe it shows some heavily used tools, telling viewers he was handy, and some old military medals, showing that he survived a war.

Everything in your frame adds to or detracts from your message. So think about what you want to say and compose your image accordingly.

The first time I set out to take pictures for art's sake, I took photos of my feet, my girlfriend's feet, railroad tracks, some tombstones in a graveyard, and the tire swing in Figure 15-1, which I like to think of as my first photograph. This image includes only a few elements, so they each have a great impact on the message. The tire swing is the subject, and you know this because it's placed on the frame's bottom third in a dominant compositional position (for more on placing elements in a scene, take a look at Chapter 5). The tire also makes up the area of the frame with the most contrast and is my focal point. The wooden beams behind the swing give you a sense of what's holding the swing in midair. The lines created by the wooden beams mimic the lines created by the tire's chains. This mimicry causes viewers to look back and forth between the two elements, comparing their similarities and differences. (I discuss the use of repeating elements in Chapter 12.) The leaves on the ground help to give a sense of the environment with regard to the time of year and the types of trees present. Anyone who grew up in the northeastern part of the United States would subconsciously be aware that this scene took place in autumn. The background is made up of a tree line, but no fences or buildings are present. This park is most likely not in an urban environment.

70mm, 1/400 sec., f/5.6, 100

Figure 15-1: A fine-art photo of an ordinary object.

Selling objects with photography

Commercial product photography is all about making the subject look its best. No matter the message, the product always looks perfect. One of the biggest fabrications in everyday life is the way companies show their products in relation to how they really are. Have you ever gotten a deluxe burger that looked the same as the one in the photograph on the menu board? I know I haven't.

The two main ways to glorify a product are lighting and product enhancement — tricks of the trade that cause products to look ideal. I discuss these in the following sections.

Lighting your product

The way you light a shiny soda can is going to be different from the way you light a dull but highly textured basketball. You use different lighting techniques to make different products look great.

REMEMBER

Chapter 10 gives you the details about lighting, but here are some of the ways you apply those principles in product photography:

- ✔ Directional, soft light reveals the shape of opaque objects and is ideal for rounded objects.

- ✔ Directional, hard light reveals the texture of opaque objects.

- ✔ High contrast conveys power, drama, high energy, mystery, and masculinity.

- ✔ Low contrast conveys beauty, sincerity, calmness, smoothness, and dreamlike states.

- ✔ A reflective surface is like a mirror, and you light it differently from opaque surfaces. Lighting the surface of a reflective object isn't as effective as actually lighting what's being reflected. For instance, to better see your face in a mirror you light your face, not the mirror itself. Place white or black pieces of foam core around your subject to add or take away light in the reflection.

In Figure 15-2, I created the highlight running down the left side of the glass bottle by placing a large piece of white foam core just to the left of the frame. The white surface reflects light from the key light source (a strobe that was bounced onto the ceiling just behind the camera), and its reflection shows in the surface of the glass bottle. I also used an available light that was directly above the martini glass, which helped to light the liquid without affecting too much of the bottle's surface.

In Figure 15-3, the product has a plastic wrapper. The client wanted to show the product inside the plastic without glare and reflection, so I positioned my lights in a way that eliminated distracting highlights. This way you can see clearly through the packaging. Sidelighting was used to show texture in the product and provide a low level of contrast to keep the image from being overdramatic.

50mm, 1/60 sec., f/3.2, 400

Figure 15-2: Lighting your scene according to a subject's reflective characteristics.

Enhancing your product

Viewers have certain expectations from the products they see in photographs, and certainly clients care deeply about the way you present their products. As a result, it's often necessary to enhance products when photographing them.

The following list shows a few of the ways you can show off products to their best advantage in photographs:

75mm, 8 sec., f/20, 50

Figure 15-3: Minimizing the visibility of reflections by properly positioning the scene's lights.

- ✔ **Steam clothing and linens to ensure they're wrinkle-free.** Also, use pins to make clothes fit a model or mannequin perfectly and to make curtains fall to the perfect length.

- ✔ **Mix glycerin and water in a 50/50 ratio to create a substance that makes perfect sweat beads on the outside of bottles and glasses.** You can buy glycerin in the first-aid aisle of most drug stores. Apply the mixture to the bottle or glass with a spray bottle; for larger drops use a syringe.

- ✔ **Experiment with fire to make foods look more appealing.** For instance, a torch gives the perfect level of char to a steak and browns the edges of baked goods. You can use an electric charcoal starter or metal skewers heated over an open flame to apply grill marks.

- ✔ **Place the hands of a clock or watch on the ten and the two so the time reads 10:10.** This position generally looks good on most watches and is an old-school trick that many photographers use. Of course, if you're shooting a watch with a face that has other smaller dials or graphics, you want to place the hands in a way that doesn't block those extra items.

- ✔ **Add some texture bubbles to the back edge of a cup of coffee.** You can do so by applying a mixture of the drink and some detergent to the surface with an eyedropper.

- ✔ **Enhance milk's color and texture, which come out looking yellowish and translucent in photos, with glue.** If you're shooting a glass of milk, use white glue instead.

Because representing a product at its best is critical in commercial images, photographers often use photo-editing software to remove flaws and to enhance contrast and color saturation. You can find out more about digital enhancement in Chapter 18.

Photographing Flowers in Studio and in Nature

Flowers probably are the most common still-life subjects for artistic photography. They act as recognizable, everyday subjects that can be shown in extraordinary ways. Flowers make for such common photographic subjects because they're beautiful and designed to attract. They're also easily accessible and somewhat compliant.

Images of flowers have been created for many years in drawings, paintings, and photographs; they're most successful when paired with the appropriate light, environment, and composition. Achieving these requirements depends on whether you're shooting in studio or out in nature itself. So, I discuss each scenario in the following sections.

Some flowers are fairly small, so no matter where you're shooting — indoors or out — using a macro lens may be your best bet to create a composition that magnifies the flower enough to reveal maximum detail. I cover macro lenses further in Chapter 3.

Producing images in the studio

When you photograph flowers in a studio, you don't have to worry about wind or overly bright sunshine, but you do have to create a background for the flower. If your shot consists of just a flower and a background (as it likely will in studio), the background has a major impact on your message. So be sure to choose a background that's appropriate for the flower you're shooting and for the mood you're trying to create. Of course, you should use your best creative judgment for your situation, but here are some general pointers for choosing a background:

- ✔ A smooth and even-toned background helps create a simple composition in which the flower is the main focal point.

- ✔ A textured and high-contrast background is more chaotic and competes with the flower for attention.

- ✔ Setting a bright flower against a dark background causes it to stand out. Similarly, a dark flower stands out more on a bright background. Placing a flower in front of a background with a similar tonality shows the flower in a subtler way.

Figure 15-4 depicts the same flower in front of two different backgrounds. Each has a much different feel and produces a different message. The white background causes you to look only at the flower and maximizes the emphasis on the rose's shape. The green, textured background is more similar to one you'd see in nature. Flowers naturally stand out from the color green (perhaps so bees and birds can see them from far away). The background competes slightly with the rose in a complimentary way and gives you more to look at than just the flower. The shape of the rose isn't as identifiable in this image as it is in the one with the white background.

After you choose an in-studio background for your flower, you also have to consider your lighting. Fortunately, when shooting in the studio, you have complete control over your lighting. You can manipulate its direction, quality, intensity, and the number of sources of light that are used. Most often, flowers are shot with a soft key light source. I shot the roses in Figure 15-4 using window light. The sun wasn't shining directly in the window, so the quality of light was very soft.

Both photos: 50mm, 1/15 sec., f/13, 400

Figure 15-4: A background alone can change your message when photographing flowers.

Here are some guidelines to keep in mind as you consider your lighting:

✔ Soft light is used for representing beauty, and most people associate flowers with being beautiful. It also accentuates the rounded shapes of buds and petals. The larger the window, the softer the light will be.

✔ A directional light coming from one side or the other helps to reveal the texture of the flower's petals, buds, stems, and leaves.

✔ Shooting with high contrast will produce a dramatic representation of the flower, and shooting with low contrast will produce a subdued representation.

For more details about lighting, head to Chapter 10.

Capturing flowers in their natural environments

Photographing flower subjects in the studio gives you control over the wind and the lighting, but shooting them outdoors enables you to capture their images in a realistic and natural setting. Taking photos of your flower subjects in their most natural settings requires you to consider both background and lighting and also perspective.

Most flowers are naturally designed to stand out from their surroundings. Notice, for example, how well the flowers in Figure 15-5 pop because of their color. A flower's prominence in a scene makes it fairly easy to choose a perspective that enables you to capture great images without having to manipulate the background too much.

Consider the following when finding your perspective for an effective flower image:

✔ **Angles:** Shoot from an angle that shows the flower clearly. Avoid positioning it in front of background elements that are a similar color or that interfere with the perceived shape of the flower. As I explain in Chapter 9, you want to avoid merging lines and shapes.

✔ **Depth of field:** If you're stuck with a busy background, using a shallow depth of field can help to make the flower stand out.

✔ **Grouping:** If you're shooting multiple flowers, remember that multiples usually look better compositionally when grouped in odd numbers.

50mm with a 25mm extension tube (for shooting macro), 1/125 sec., f/10, 100

Figure 15-5: Flowers naturally stand out from their environments.

> ✔ **Lighting:** The direction of your lighting (combined with the elements discussed in the first bullet point) should determine how you approach a flower. A sidelit scenario helps to reveal texture in a flower. Some flowers have thin petals that are semitransparent. A backlit scenario can cause them to glow, such as in the example shown in Figure 15-5.

Flowers can be unruly in a breeze; they sway easily and can make focusing and exposing with slower shutter speeds difficult (movement in slow shutter speeds causes blurring in your photo). However, if you block or eliminate the wind through the use of a collapsible reflector (as I discuss in Chapter 14) or shoot on a calm day, you should have an easy time working with flowers.

Cooking Up Beautiful Food Photos

Food is a frequently chosen subject for still-life photography. You may find yourself composing images of food for a number of reasons. The most common food images are for product photography, *lifestyle photography* (images that sell the feelings associated with a product rather than just the product itself), and fine-art photography. The tricks discussed in this section are useful for all types of food photography.

In product photography, food is treated in the same manner as any other subject: It's idealized and made to look immaculate. In the earlier section "Enhancing your product," I list some methods of making products look their best. If you're working on a commercial assignment, a professional food stylist is likely to be on set. A stylist handles the food preparation and does all the tricks necessary to get the look the client is going for. So, you're responsible for (and free to focus on) lighting and composing a beautiful photograph of the final product.

Here are some tricks I've discovered for getting great images while photographing food:

> ✔ **Light your subject from the back.** Many times foods are grouped on a plate and the various items merge with each other. Backlighting food helps to separate the shapes of different items on the platter and helps to reveal texture.

> Even though backlighting is important, be sure to fill in your scene from the front as well to bring out the details in the shadow areas. To do so, use a reflective material to bounce light in from the key light source. (Chapter 10 provides further information on lighting.)

✔ **Keep angle in mind.** Of course, you can shoot from any angle you want, but you should understand what the angle says about the subject. Consider these guidelines:

- A high angle shows food as viewers are used to seeing it in reality when seated at a table, so the angle looks natural in photographs.

- A low angle gives the perspective as if the viewer is looking up at the subject. This angle isn't a natural one for someone to see food from in real life, and it often causes the subject to appear as a hero of sorts.

- A bird's-eye view of food is interesting when you have various shapes to work with, and it gives viewers the sense that they're directly over the food, as if they were about to dig in to it.

Figure 15-6 shows the same scene photographed with a traditional high angle and with a bird's-eye view.

✔ **Get close to your subject.** Doing so helps you draw more attention to it and show the textures, juices, and smaller ingredients.

✔ **Choose a background that has appropriate colors for your specific subject.** Similar colors work well to make the subject fit in, and opposite colors make the subject stand out. In Figure 15-6, the subject fits into the scene because of the similarity in colors. This similarity makes it seem like it belongs there. If you have distracting background details in your composition (and you can't choose another background), use a shallow depth of field to eliminate them.

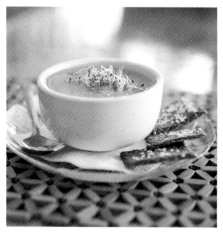 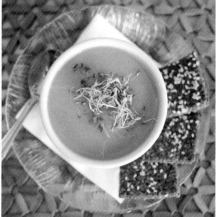

Both photos: 50mm, 1/80 sec., f/2.2, 400

Figure 15-6: Two angles of the same food item.

You can combine these and other compositional elements to achieve the look you want. The photo in Figure 15-7, for example, uses many different elements. A shallow depth of field eliminates the details from outside the window in the background, and the low angle makes the dessert look like a piece of art rather than just something you eat. The close perspective also reveals the dessert's texture. The plant in the background gives a sense of environment, but it isn't distracting because of the shallow depth of field. The glass of juice in the background acts as a complimentary color to the garnish on top of the dessert, and the backlighting highlights the texture and shapes of the dessert while separating it from the background.

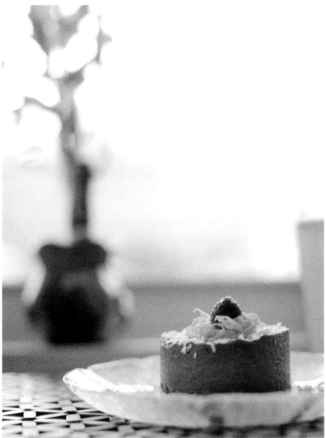

50mm, 1/80 sec., f/2.5, 400

Figure 15-7: Multiple compositional elements combine to create one message.

Working with Architectural and Interior Photography

Like photography, architecture is an art form that uses composition to create works that are functional and aesthetically pleasing. The spaces created by architects and interior designers affect your mood while you're in them. They manipulate the way you feel, and it happens in such a subtle way that you likely won't notice it. Consider the outside of a building as the cover of a book and the interior spaces as the content inside that book. Each building is a story, and an architectural photographer's job is to document that story in the best way possible.

When photographing a building, think about the architect who designed it and why she did things the way she did. And when shooting interiors for a hotel, restaurant, condo, or home, pay attention to how the décor works with the architecture to provide a complete mood in your image. All the design work in architectural and interior photography has already been done and is laid out in front of you. You just have to know it when you see it and be able to capture it appropriately on your digital sensor.

Often you have to tweak the layout of a room's design to accommodate for the specific camera angle you've chosen. Some furniture may have to be moved to better reveal details that are behind it, and some angles and placements of furniture may have to be cheated a bit in order to better suit your composition. Look through the viewfinder while your assistant moves the elements based on your instructions. If you're shooting in a privately owned property, be respectful of the owner's concerns about moving furniture, and involve them in the creative process by showing them the results of your styling on the camera's display screen.

I provide you with some guidance on photographing both exteriors and interiors in the following sections. The images used in this section are courtesy of Craig Denis, a photographer and friend of mine who specializes in architectural and interior photography.

In Chapter 12, I explain how you can raise and lower the lens element of a tilt-shift lens to correct distortion caused by high and low perspectives. These lenses are great for shooting architecture and interiors, but if you don't have one, you can correct distortion with your photo-editing software. I discuss postproduction techniques in Chapter 18.

Crafting images of building exteriors

To get great compositions of building exteriors, you first need to determine the best time of day to photograph. After all, sometimes the lighting is the most interesting part about the exterior of a building. Because your subject is large and can't be moved or repositioned, you have to shoot when the sun is in the appropriate area for your desired lighting. Take some time before your shoot to figure this out. Go to the location in the morning and in the afternoon to see which looks best. Also, check to see whether the building looks best at night.

If you're going to photograph a building at night, start shooting just after the sun goes down and continue shooting until it gets dark. Sooner or later, you'll hit the specific time during which the ambient light that's fading from the day and the building's lights expose properly together. Think of the ambient light as your fill light and the building's lights as your key light. (Check out Chapter 10 for more on these types of light.) Because you can't control the ambient light, you have to be in the right place at the right time, and the best method to make sure you get the shot is to continually take test shots as the light fades.

After determining your lighting, you're ready to focus on the composition. Composing your shot is all about perspective (refer to Chapter 8). Buildings provide interesting lines and shapes, so their immediate surroundings can and should work to enhance those lines and shapes. In many cases, you want to photograph buildings from a high angle. You can do so by bringing a ladder or by shooting from the roof or a high window in a neighboring building. High angles provide a sense of how the building fits into its surroundings and show its landscape, which also is a part of the overall story. A low angle most likely emphasizes how tall a structure is, but it doesn't provide the optimum amount of detail.

Balance, as a compositional quality, ensures that your viewers can comfortably view the entire frame of your composition without getting stuck in one area that's weighted too heavily. By paying attention to the shape of the building and how it fits into a rectangular frame, you can determine how much space to leave around the building and which surrounding elements to include in your composition. Make sure that the building you're shooting is large enough in the frame that viewers know it's the subject. However, also leave enough space around its edges so that viewers have some supporting elements to explore or negative space to guide their eyes around the edge of the subject. Chapter 12 provides more information on balance and space.

Figure 15-8 shows the exterior of a house in which the structure is framed by the trees surrounding it. This composition helps keep your eyes in the frame and coming back to the house itself. The columns are highlighted by the use of exterior lights and the soft light available at dusk.

Taking a look inside: Composing interior shots

Composing an interior image usually is about giving a sense of space. With these types of images, typically you shoot with a slightly higher angle, which enables you to see over the elements of the room and creates depth and space. Balance also is important. Balance is created when the various elements in a room are positioned in your frame to lead a viewer through the space without getting stuck in one area that's *overweighted* (containing a dominant amount of detail in comparison to the other areas in the frame). The key is to spread the love.

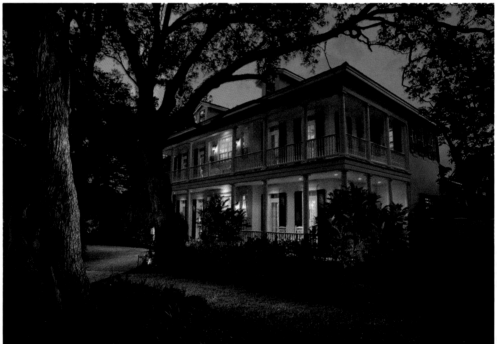

24mm, 1/4 sec., f/8, 100

Photo courtesy of Craig Denis

Figure 15-8: An exterior image of a house and its landscape.

Here are three excellent ways to add to the sense of space in an interior photo:

✔ **Create an interesting foreground, and then lead your viewers through the space in a way that gives them a sense of the architecture and the design.** The shapes created by the space itself — furniture, rugs, fixtures, and accessories — can be used to achieve this interesting foreground, or starting point. Then you can lead the viewer's eye into the frame to an area that counters the starting point. Finally, have that area lead to another point of interest and create a flow, which ultimately leads back to the starting point.

In Figure 15-9, Craig Denis used the shape of the bar to lead viewers into the image to an area where guests can lounge. Just above that part of the composition is a shape on the ceiling that mimics that of the bar. This brings your eyes over to the right side of the frame where you can get an idea of the texture of the chairs that are shown on the left side of the frame. In the end, your eyes are brought back to the bar and ideally it leads you back into the image again.

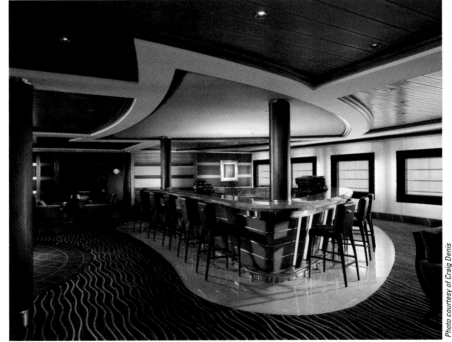

Photo courtesy of Craig Denis

24mm, 2 sec., f/11, 100

Figure 15-9: An example of leading viewers from the foreground into the image.

✔ **Light your scene to suggest depth.** You can light the farthest elements more than the nearer elements to create the sense of depth. Viewers will notice the foreground elements and continuously go to the brighter elements as their eyes move through the scene's space.

✔ **Include multiple areas in one composition.** By looking through the main area of interest and into another area beyond it, you get the sense that there's more to the story. For example, say you're shooting the master bedroom of a high-end condominium. By opening the bathroom door and choosing a perspective that shows the room in a pleasant way and reveals the bathroom's whirlpool, you're showing viewers that the people who sleep in this room have style and a private, luxury bath.

Lighting is just as important as composition. Lighting interiors can be simple or complex depending on the space and your desired look. To achieve a natural look, shoot during the day and let as much daylight in through the windows as possible. Using a single strobe at a low setting and bouncing it off the ceiling helps to fill in shadow areas and lower the overall contrast. (Chapter 10 provides more on the different types of lights.) This is a minimalist approach and provides good clean results — assuming, of course, you have a decent amount and quality of window light to work with.

16

Capturing (Or Stopping) Motion through Photography

*W*hen most people think of photography, they think of a process that provides a still, motionless image. But you also can use photography to convey motion, and knowing how to handle moving subjects to achieve the results you want opens up new avenues for your photography. Because your digital sensor has a much stronger reaction to light than its film predecessors, your subjects don't have to have to sit still and wait for the camera to (slowly) capture an image. Shooting at 1/250 second is fast enough to freeze most normal amounts of motion, and most cameras even have the ability to shoot at speeds much faster than that.

Freezing motion and creating sharp images seem to be the most technically correct ways to photograph, but many types of subjects move in a lot of interesting ways. Deciding how to photograph each subject is up to you, and part of that decision is choosing when to eliminate and capture the appearance of motion in your compositions. For example, if you want movement to be a key element in your message and the identity of your subject isn't necessary, adding motion blur could be the way to go. A random businessman walking down the city street in the rain could become even more anonymous with motion blur. The rain would be blurred as well and its visual impact may be increased.

If you're ready to show motion in your photos, you need to know how to successfully capture it so you get the exact look you want in your image. In this chapter, I provide you with all the information you need.

Following Compositional Principles When a Subject Isn't Stationary

A subject in motion may cause you to become apprehensive and concerned about your technical performance while shooting an image. And when you become too concerned with technical issues, it's difficult to pay proper attention to your subject and surroundings. But don't worry. Knowing how to use your equipment is the best way to be prepared to achieve great results and make the most out of any situation. (Chapter 3 provides some details to help you discover your equipment.)

The basic rules of composition (see Chapter 5) apply to moving subjects just as they do to stationary subjects. However, trying to capture or convey motion does bring some new challenges. Perhaps the three main elements to think about when shooting moving subjects are getting the subjects in focus, placing them in your frame in the most appropriate way, and determining whether to freeze the motion or to show it. I explain each of these elements in the following sections.

Focusing on moving subjects

Focus is one of the most important compositional elements, and whether you can get a moving subject in focus depends on the methods you use. With a digital SLR, you can either focus manually or you can take advantage of the camera's ability to autofocus.

If you're familiar with focusing manually, and you're confident in your skills, you may succeed using that method. But beware. Using manual focus for moving subjects is risky because there's a lot of room for human error. When you focus manually, you need to take your time and ensure that your focus is exactly where you want it to be. However, by the time you get the focus right on a subject in motion, you may have already missed the shot.

So, taking advantage of autofocus enables you to spend less time thinking of focus and more time concentrating on other aspects of composition and exposure. Consider the two types of autofocus:

- ✔ **One-shot autofocus:** You use *one-shot* autofocus primarily for still subjects. However, you can use this setting while shooting subjects in motion by predetermining where your subject will be, locking the focus on that area by holding the shutter release button down halfway, and then waiting for the subject to enter the area of your focal plane to take the picture. (For more information on focus, see Chapters 3 and 7.)

Sometimes I use one-shot autofocus when I shoot fashion images. I ask a model to step into a specific area, lock my focus on that area, and then ask him to back up and walk toward me. I take the shot when he reaches the area of focus. This way I get a natural walk from him and achieve sharp focus.

✔ **Continuous autofocus:** When photographers shoot subjects in motion, they usually use a setting designed to track movement and automatically adjust focus accordingly. Nikon refers to this setting as *continuous*, and Canon refers to it as *AI Servo*. (Read your owner's manual to find out which autofocus settings your camera has and exactly how to use them.)

Continuous focus allows you to focus directly on a moving subject by leading it. *Leading* a moving target refers to aiming ahead of it in order to make up for the distance it will travel. The continuous focus setting causes your camera to focus ahead of your subject based on how fast the subject is moving. Leading is best for shooting unpredictable subjects that are likely to be moving.

Composing subjects in motion

Most often, photographers compose images of moving subjects based on the direction in which they're moving. The general rule is to provide more space in front of the subject than behind it. This space in front is referred to as *active space*. It gives the subject room to move into the frame and gives viewers a sense of where the subject is going.

Figure 16-1 shows an example of active space in a composition. You may often follow this example, but remember that each situation is unique and should be photographed accordingly. Look for what's most interesting in telling the story of your subject. Perhaps where the subject came from is more interesting than where it's going. For instance, a rally car kicking up a trail of dust behind it could create interesting lines and shapes.

Because action is part of the message when photographing a subject in motion, be on the lookout for compositional elements that help give the sense of movement. Here are some elements that can help you:

✔ **Lines:** Lines are a great tool for emphasizing and hinting at movement. They lead people's eyes in certain directions. Try to compose your scenes so the compositional lines assist in moving a viewer's eyes in the direction of the suggested motion.

✔ **Supporting elements:** These elements help tell the story of why a subject is in motion or where it's going. If, for example, a runner is giving it everything she has, you may find it helpful to show the finish line that's motivating her. Or you can reveal the runner behind her who's causing her to push it.

✔ **Image format:** Whether your composition should have a vertical or horizontal format is an important decision to make. If the subject is moving in a horizontal direction, a horizontal format may work best. If it's moving vertically through the scene (as a space shuttle might), a vertical format may tell the story better. For more on horizontal and vertical formatting, check out Chapter 11.

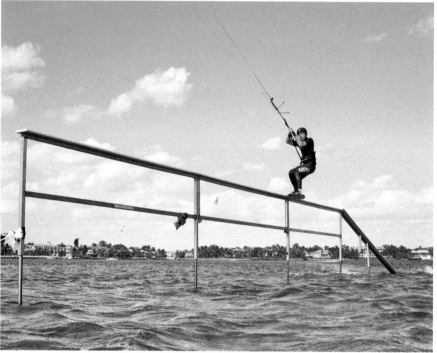

28mm, 1/640 sec., f/11, 320

Figure 16-1: The space provided in front of the subject shows the extreme length of the rail he's attempting to slide across.

Deciding whether to freeze or show motion

When you're photographing a subject in motion, you have the option to freeze or show the motion. Each situation is different, so you have to decide which way to go. I describe the methods in the following sections.

Producing sharp detail by freezing motion

When you want the maximum amount of clear and sharp detail in your photographs, you want to freeze motion as much as possible. Some situations where you may want to freeze motion completely include the following:

✔ Your subject has made impact with a liquid and created a splash, and you want to capture the effect.

✔ The details in your subject (which is moving) and background need to be clear for your message to be effective.

✔ A water drop is falling from a leaky faucet, a rock face, or a melting icicle.

✔ You're photographing an explosion or a bullet passing through something.

You freeze motion primarily by shooting with a fast shutter speed. The quicker your subject is moving, the more you should speed up your exposure time. An exposure time of 1/250 second is a good starting point for freezing motion in most cases, and it's the maximum speed in which most cameras can still sync with a flash. So, if you're shooting with a flash, you shouldn't go any faster than this unless your camera is capable. (Refer to your owner's manual to find out the max sync speed of your camera.) If you're shooting with available light, you don't have to worry about sync speeds, and you can shoot as fast as your camera allows.

Keep in mind that your shutter speed also controls your exposure (in combination with your aperture and ISO, which I cover in Chapter 3). So, if your exposure setting is 1/250 second at f/11 with an ISO of 200 and you speed up your exposure from 1/250 to 1/500 second, you need to open the aperture 1 stop to f/8 or raise the ISO 1 stop to 400 in order to compensate for the 1 stop loss of light. When the aperture is opened up all the way and using the maximum ISO, you'll be limited as to how fast you can shoot while maintaining a proper exposure. The brighter a scene, the less you have to worry about this dilemma.

Freezing the motion caused the drama in Figure 16-2. This image shows that the kite surfer just did a trick at a high speed with a lot of power behind it. The spray helps to suggest movement.

Showing motion blur

Motion blur occurs when your shutter speed is too slow to freeze the motion of your subject. As a result, your image doesn't have sharp focus and may include some streaking. Sometimes motion blur ruins the outcome of a photo, but you also can use it to tell the story of a subject in motion more effectively. The relationship between your subject and your shutter speed determines how much motion blur you have in your image.

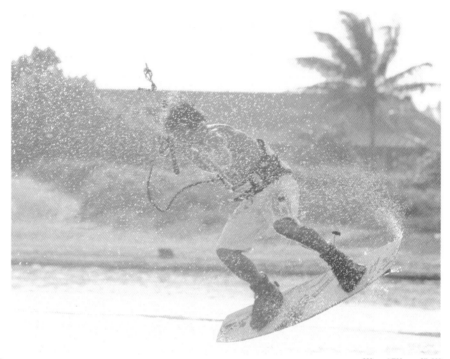

200mm, 1/500 sec., f/8, 320

Figure 16-2: Capturing the moment by freezing time.

Results vary when it comes to motion blur. The more practice you have, the more reliably you can predict the results. You can slightly blur a person walking down the street with a 1/30-second shutter speed. Depending on how fast or slow the person is moving, however, this technique could cause results that appear out of focus rather than blurred by motion. In order to emphasize the motion in his walk, a 1/15-second shutter speed may work better.

The slower your shutter speed, the less identifiable the subject and the stronger the emphasis on the motion that's happening. A car going 35 mph down the street may start to streak at 1/60 second.

In the following sections, I discuss capturing motion in light (fireworks, headlights, and so on) with long exposures. I show you how to create an effect that captures detail in your subject while causing the environment around it to streak with motion. I also explain how to combine the techniques of freezing motion and motion blur in one image.

Streaking lights

One interesting way to use motion blur is to shoot long exposures at night in order to capture moving lights. In Chapter 10, for example, I discuss the

technique of setting your camera on a tripod for long periods of time to photograph star trails. This technique also works with cars passing through your scene. Composing a frame of a winding road with the city or mountains in the background provides a great opportunity to practice with this method. Take some practice shots to make sure you have the correct exposure and an effective composition. When a car is about to enter the scene, start your exposure.

You want the car to enter and exit the scene during the time of the exposure. Doing so gives the sense that the car passed through the scene. If your exposure stopped before the car exited the scene, it would seem as though the car stopped in your image. Plan your shutter speed accordingly.

In Figure 16-3, I photographed a night scene in downtown Miami to demonstrate the effect of moving cars and long exposures. I got this shot just after rush hour on a Friday, when many cars were passing through the scene. The heavy traffic gives the impression that the city is busy and full of life. I chose a perspective that caused the streaks from the car lights to lead you into the frame toward the heart of the city. A lot is going on in this image, and my intention was to give a sense of the potential energy the bicycle has. It's still on the sidewalk in the photograph, but it could tempt a viewer to imagine riding it alongside all the streaking cars in the street toward the downtown area.

Fireworks, lightning, fire dancers, and ravers dancing with glow sticks all offer further opportunities for capturing streaking light. You also can create your own streaking-light scene by asking someone to hold a light source like a flashlight and draw. Figure 16-4 shows you an example of this technique, which is called *drawing with light*.

To expose properly for a photo showing a person drawing with light, shoot in an area that's very dark (the darker the better). Doing so ensures that the motion of the person drawing isn't detected by your camera's sensor. Use a long shutter speed to give the person enough time to draw out what you have planned. By lighting your subject and scene with a flash or strobes, you can freeze one moment during the exposure. In this case, the flash fired at the beginning of the exposure, and the remaining time in the exposure was used to draw with the flashlight.

Panning

Usually motion blur arises from elements in motion, not from anything that's still. So, because your camera is still, only moving things streak. *Panning,* or tracking your subject with your camera while using a slow shutter speed, enables you to show your moving subject in a clear way while the background and elements around it are affected by motion blur. The goal is to move your camera in the same direction as your subject and at the same speed for the duration of the exposure. If you get it right, your subject is mostly sharp and identifiable but surrounded by a mass of streaks that represent motion. For an example of panning, refer to Chapter 7.

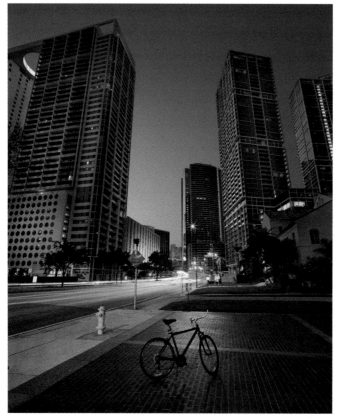

24mm, 15 sec., f/11, 400

Figure 16-3: Streaking car lights in Miami at night show a way to use motion blur.

The longer your shutter speed, the more drastic the streaks in your image will be. Longer shutter speeds mean that you need to be more accurate when you track your subject, however.

Combining flash with motion blur

Because your flash provides light for such a brief instant, it tends to freeze motion in photographs. This makes for an interesting tool when combined with a slow shutter speed. Mixing flash with available light is a common technique; it requires that you balance the intensity of the two light sources to achieve the contrast you desire.

Sometimes your flash acts as the key light and sometimes it acts as a fill light. When using your flash to freeze motion during long exposures, the flash is your key light and creates a clear image of your subject that's frozen in time. The available light causes motion blur. Because the flash lasts only an instant

and your shutter is open longer, the exposure continues to take place while the subject is moving. The result is a clear image of the subject with motion streaks behind it suggesting movement. You get the best of both worlds. (For more information on lighting, refer to Chapter 10.)

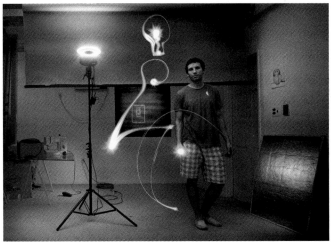

24mm, 15 sec., f/5.6, 200

Figure 16-4: Drawing with light during a long exposure is a good way to have some creative fun with friends.

When using this technique, understanding how your camera works is important. The flash can sync with your shutter in the following two ways:

- ✔ **At the very beginning of the exposure (when the shutter curtain first opens):** This sync setting, called the *front curtain sync,* isn't appropriate for combining with motion blur. If your subject is running across your frame, the flash lights her, and the motion blur occurs in the direction she's running. She then looks like she's running backward in the photograph.

- ✔ **At the end of the exposure:** Most cameras allow you to set the flash to sync with the end of the exposure just as the shutter curtain is closing. (This setting is called the *rear curtain sync setting.*) The blur is then captured first; when the subject is at her final point in the exposure, the flash captures the clear image of her. The result is an image of someone running with motion blur behind her.

Check your camera's owner's manual to find out what sync options you have.

Figure 16-5 shows examples of using the rear curtain sync setting combined with a slow shutter speed, a flash, and a moving subject. Forward motion is emphasized and a clearer depiction of the subject is created.

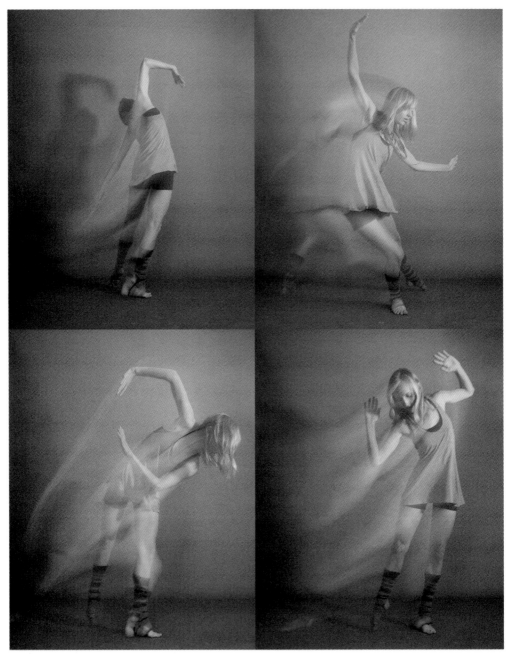

All photos: 50mm, 1/30 sec., f/8, 200

Figure 16-5: The rear curtain sync setting provides a creative motion blur that more clearly shows the subject.

Up for the Challenge: Photographing Subjects Constantly on the Move

Life doesn't always stand still for you to get the photograph you desire. In many instances, you'll be faced with subjects that are in constant motion. Being prepared and knowing what you want and how to get it are necessary skills for creating great compositions in these scenarios.

In the following sections, I discuss capturing great images of children at play, successfully photographing the family pet, and getting the shot during sporting events.

Taking successful images of children

Kids rarely stand still, so photographing them can be a challenge. However, the cool thing about children who are playing or engrossed in something is the possibility that they won't even notice you're taking their picture. Even if they are aware of it, chances are they won't pay much mind to it — that is, as long as you don't interfere with what they're doing.

When you photograph children playing or otherwise in motion, you have to be able to capture images as you see them, and you can't ask children to stand still for too long. In fact, you may even get more realistic images if you don't interfere with their natural actions at all. As a result, you need to be prepared to act fast. The more practice you have with your equipment, the better you can predict its results in different circumstances.

Here are the main things to consider when photographing children:

- **Have fun with it.** Kids sense when you're taking something too seriously, and it could ruin their mood. You don't want to create a lawless scenario and allow things to get too carried away, but it's wise to keep things interesting enough to avoid temper tantrums.

- **Vary your angle.** Get low angles so that some of your images are on the same level as the children. Doing so brings your viewers into the heart of the action. Also, try getting up high for a different perspective. A bird's-eye view could be an interesting take on children at play. Too many images from your own eye level start to become boring. For more on perspective and camera angles, head to Chapter 8.

- **Remain conscious of how your composition looks overall.** As you're photographing children, things will be happening quickly. However,

that's no excuse to have a pole sticking out of a kid's head, or to have your subject constantly positioned in the center of the frame. For a refresher on arranging visual elements in a frame, see Chapter 5.

✔ **Make sure your focus is clear.** Use a method of focusing that you're comfortable with and that allows you to achieve sharp focus on your pint-sized moving subjects. In the earlier section "Focusing on moving subjects," I suggest continuous focus as the best automatic setting for shooting moving subjects.

✔ **Look for interactions between the children, or expressions created with their hands.** Children reveal their emotions more freely than most adults, even when they're shy.

✔ **Switch back and forth between freezing the motion and allowing for motion blur.** Most of the time people want clear photos of their kids, but sometimes an image with motion blur tells the story better and is appreciated.

Catching shots of the family pet

Photographing your pets is similar to photographing children at play. They tend not to hold poses for very long, and they have short attention spans. So many of the techniques discussed in the previous section apply. For instance, getting down low (on the same level as the animal) is a great way of showing a perspective that's more personal and reveals more specific details. And taking multiple images gives you more options to choose from. This way it's more likely that you'll find an image that exudes the personality of your pet.

Animals tend to give sincere facial expressions 100 percent of the time. All you have to do is choose a location with scenery that speaks to your pet's personality and has nice lighting. (For more information on lighting, head to Chapter 10.)

Animals may not do what you tell them all the time, but unlike humans, they act natural even when the camera is out. Watching and waiting for the right moment is one method for getting great images of your pets. You can't ask them to redo something cute that has already come and gone though, so don't hesitate to take the shot. If you see a great moment, grab it. Then, if your composition isn't perfect, you can always tweak the crop and exposure in postproduction. (I discuss photo-editing software in Chapter 18.)

The image in Figure 16-6 is a snapshot that captured a fleeting moment. This type of shot shows the personalities of the dogs and can be enjoyed for a lifetime.

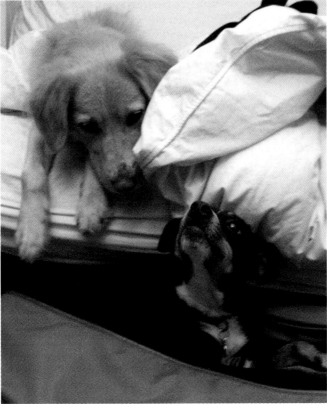

50mm, 1/8 sec., f/2.8, 800

Figure 16-6: Unlike humans, animals act natural even when the camera is out.

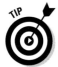

If your animal is well trained and you can get him to sit still for portraits, you should have a fairly easy time getting great images of him. After you have the animal's attention, take a few shots and reward him for being a good boy.

Tackling sporting events

Photographers line up on the sidelines of professional and college sports venues with giant lenses to record the events as they unfold. The images captured from those sidelines are as real as it gets (without getting into war photography, of course). Players are filled with adrenaline and are living in the moment unaware of and unfazed by the cameras. Picture-perfect moments

are happening left and right, but if you don't have the appropriate equipment and skills, you'll miss everything.

Details, such as sweat getting knocked off one player's face when another player hits him, are important in sports photography. And you can't capture them unless you have a long, fast lens. By long, I mean telephoto. The closer your lens gets you to the action, the better. And a fast lens has a large maximum aperture, which allows you to shoot with faster shutter speeds. Shooting with a slow shutter speed usually is unacceptable in sports photography — unless it's a race and you're panning to show speed to show motion. (I discuss panning earlier in the chapter.)

Don't be tricked into buying a telephoto lens that isn't fast. Doing so would be a waste of money. The typical max aperture for a fast telephoto lens is f/2.8.

Telephoto lenses are naturally slower than normal and wide lenses. Because more distance exists from the front of the lens to the digital sensor, the light's intensity weakens on the journey. So, to make a long lens faster, a large amount of quality glass is required to let more light in. The more light that comes in, the more intense it will be by the time it reaches the sensor. And the more glass a lens has, the more expensive it will be.

If you find yourself in need of a fast telephoto lens but unable to afford one, you can rent one. It's better to rent a good lens than to buy a cheap one. Cheap telephoto lenses provide soft images that are useless in a photographer's portfolio.

In the following sections, I discuss some ways to get the best sports photos possible — assuming you've picked up the proper equipment.

Getting the shot

If you're at a sporting event and have the right lens for the job, your first task is to determine how much available light you have to work with and to choose the best exposure settings for your subject. You most likely want to be able to freeze motion, so you should try to shoot at 1/250 second or faster.

Opening your aperture all the way and using a high ISO enables you to have the quickest shutter speed possible. Just keep in mind that opening up the aperture on a telephoto lens gives you a very shallow depth of field. And using an ISO that's extremely high causes your images to have a lot of *digital noise* (the equivalent to film grain, but less attractive). Figure out what's most

important to capturing your subject in the best way possible, and then set your exposure based on that. (See Chapter 3 for more on exposure.)

As a sports photographer, you document events that you can't change or affect. But, you can control your composition. What you choose to include or exclude from your frame determines how viewers understand and read the image. Familiarity with the sport you're photographing helps you compose interesting and informative images. Be prepared for climactic moments so you don't miss the shot, and look for less obvious moments of relevance, too. Capturing facial expressions and reactions of players and coaches is sometimes more interesting than the action in the game.

 Vertical crops work well to maximize the size of individuals in a frame, and they're also good for headshots. Horizontals sometimes are better for showing the action.

Some sporting events are easier to move around at than others, but when possible you should try to change your position and cover some different areas. Doing so allows you to capture multiple angles and types of shots. Think creatively when choosing where to shoot. For example, a marathon could be covered in many different (and equally interesting) ways:

- ✔ Arial shots show the mass of people and the amount of space they take up.

- ✔ Side shots are best for capturing movement and action.

- ✔ Shooting from directly in front of the runners is great for creating a sense of power in the mass of runners. The best way to get this shot is to position yourself at a turn. This way the runners run straight toward you and turn before reaching you rather than running you over.

Minimizing unwanted motion blur

When shooting subjects in motion, you want to minimize motion blur in order to achieve sharp, high-quality photographs. If you've ever held a 400mm lens, you know that it packs some weight — and holding a long, heavy lens steady while photographing is a challenge. Getting the shot without having motion blur is difficult when you're shaking the camera *and* your subject is moving. Some lenses come equipped with an image stabilization function that's supposed to keep your shaky hands from affecting the shot. Even so, the only recommended way to hold a long lens in hand is if your shutter

speed is a higher number than the lens. For instance, a 400mm lens shouldn't be held in hand unless the shutter speed is 1/500 second or faster.

The best way to get sharp images is to put your camera on a tripod or monopod. A tripod is more stable than a monopod, but it's less efficient for moving around quickly. So, if you're going to be staying in one spot most of the time, a tripod would be ideal; if you have to be mobile, stick with the monopod. (Refer to the earlier section "Deciding whether to freeze or show motion" for information on eliminating motion blur.)

17

Artsy Photos: Fine Art, Composite Pictures, and Abstracts

*N*o black-and-white areas or defined lines separate artistic photography from commercial, scientific, and journalistic forms of photography. Any photograph can be considered art. For example, a microscopic image of the elements that make up a chemical can be used for scientific purposes but also can be used as an abstract piece of art (most people won't recognize what they see in the image anyway). Similarly, a journalistic piece can provide a message about the hardships of Cuban citizens, and an artistic piece can provide the same message. Commercial photography and artistic photography both usually are created to provide aesthetic pleasure. So how can you tell the difference?

Art photographs are those that are produced directly in accordance with the creative ideas of the photographer. Art typically has a personal message. It doesn't have to be truthful, politically correct, meaningful, relevant, representational, or clear in its message — but, of course, it can be. The thing about art photography is that you just know it when you see it. In this chapter, I discuss different art forms in photography and help stimulate your creative thought process.

Classifying Photography as Fine Art

Fine art essentially is visual art that has been created for aesthetic purposes. The quality of fine art is determined by its beauty and expressiveness. In photography, some common subjects for fine art include people, nature and landscapes, flowers, and still-life subjects. (See Chapters 13, 14, and 15 for more about photographing these subjects.)

Commercial photography often tries to sell an idea, a sense, or an emotion in order to sell a product or the reputation of a person. Fine art also sells ideas, senses, and emotions but without trying to sell the specific product or person. It's more universal and open for interpretation. The message is sold to you simply to make you experience it. An artist likes to get a reaction from viewers and doesn't need a reason or a product to support his message. An example of a fine art message could be that the human form is powerful and sensitive at the same time.

The first step to creating fine art is finding subject matter that's interesting to you. If it catches your eye in real life, you should be able to compose a beautiful image of it as fine art. Also important is composition. Successful composition in fine art photography has a sense of poetry: The shapes, lines, tones, and lighting work together to provide an image that needs no explanation. Viewers easily can feel something when looking at a well-composed image; it will cause viewers to study it longer and get a better understanding of its intended message.

Figure 17-1 shows a photograph of a common scene from the side of a mountain. The purpose of this image is to give viewers something nice to look at. It provides a warm and comforting sentiment that most people can relate to.

When creating art you don't always have to go out of your way to be completely original. Taking a common theme and executing it extremely well can sometimes provide the most satisfaction to the artist and the viewer. As Henry John Heinz, the founder of Heinz Ketchup, said, "To do a common thing uncommonly well brings success."

If you do an image search online for fine art photography, you'll come across many examples of dramatic and ultraexpressive portraits, studies of the human figure, sublime landscapes, patterns in nature, still-life images of flowers, images of strangers in public areas, and scenes of weathered and abandoned structures. Anything you're interested in can be the subject of a fine art photograph.

In the following sections, I provide information on how to light your subject in a fine art photo and how to make the best of any scene or situation.

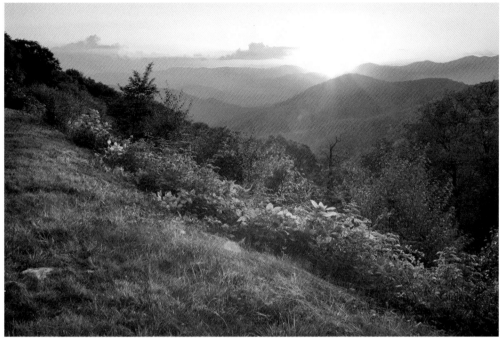

28mm, 1/10 sec., f/11, 50

Figure 17-1: The sunset may be the most common artistic theme but not without good reason.

Lighting your subject

When deciding how to light a subject in fine art, consider what's most important to the particular subject's essence. Shape, form, and texture should determine the direction and quality of light you use. (For more about lighting, see Chapter 10.) Here are a few points to keep in mind:

- Soft light coming from the side helps accentuate a subject's form.
- Hard light coming from the side helps accentuate texture.
- Light coming from the front minimizes the amount of form and texture a photograph reveals.
- Backlighting your subject helps to maximize the emphasis on a subject's shape by creating a silhouette.

The desired dramatic impact you want determines how much contrast you make in your composition. For example, you'll most likely photograph a subject that's beautiful and surreal with very little contrast. Doing so helps to

create a dreamlike essence. Conversely, you'll likely photograph a mysterious and dramatic subject with very high contrast so you reveal only the details that you want viewers to see.

Figure 17-2 shows a surfer in a tropical environment. The subject is lit in a way that makes him stand out from the other elements in the scene, but his face is hidden by shadow. This shadow is created by the direction and intensity of the key light. The soft quality of the light helps create a melancholy mood, and the high contrast creates mystery. The purpose of this image isn't to show the man's identity like a portrait would but to look pleasing and to convey a message, idea, or feeling.

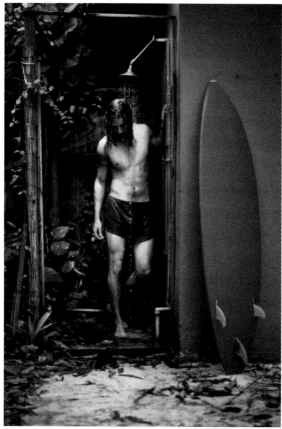

50mm, 1/5000 sec., f/1.2, 3200

Figure 17-2: Fine art often can conceal specific details (like the face) and reveal an idea rather than an identity.

Making the best of your situation

Have you ever shown up somewhere and had your friends tell you the scene or situation was better the last time they were there? Like when surfers say, "You should have been here last week when the waves were overhead!" As a photographer, know that what happened last week doesn't matter. You're here now and have to make the best out of what you have. A surfer may be bummed when the waves are puny, but if he's smart he'll find another way to entertain himself. Similarly, a good artist can find aesthetic qualities in any situation.

Being present and paying attention to your surroundings ensures that you capture great moments as they happen. Many beautiful fine art images have been created on the spot and without planning. A surprise for you is a surprise for your viewers. If you see something that inspires you to create a work of art but you feel that the lighting isn't ideal or that some element is missing or not quite right at the moment, come back to it with an open mind. Use the spontaneous inspiration to plan a perfected image.

If the weather isn't right or the time of day isn't ideal for shooting the beautiful landscape that surrounds you, pay attention to the details instead. Perhaps you're focused on the wrong things, so you're missing something that's happening right before your eyes. Rather than creating only premeditated artwork, open your mind to let in ideas as you experience them. By doing so, you eliminate your desire to copy works that you have seen from other artists and ensure that you make something that's yours.

When photographing the tree in Figure 17-3, I was slightly discouraged at first. It was the middle of the day and the sun was high in the sky. As a result, I figured it was an uninteresting time to photograph. (I prefer to shoot landscapes early in the morning and late in the afternoon.) Regardless, I liked the way the scene looked and couldn't stick around for the light to change, so I set up my camera for the shot. As I was shooting, the clouds rolled in to create a great, wave-like shape. Because the sun was up high in the sky and was lighting my scene, I was able to capture an image with very dark skies. All of the sudden I was extremely happy with the composition I had in front of me. Things just sort of worked out to my advantage.

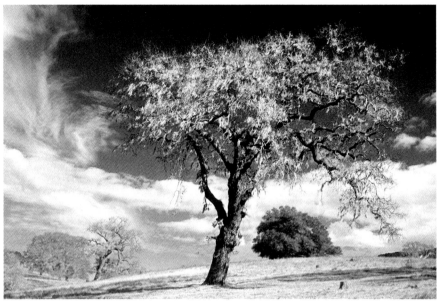

35mm, 1/800 sec., f/5.6, 200

Figure 17-3: Being present where you are is the first step to being able to make something out of any situation.

Composing Abstract Photos

Abstract art is a 20th-century style that uses nonrepresentational lines, colors, and shapes to convey a message. The subject and elements always are unrecognizable. If you can identify the subject of a photo as a person, or a flower, or any physical being, the work doesn't fall in the abstract category. Likely abstract themes consist of emotions, ideas, time, movement, and space.

Abstract art is possibly the most challenging art form to create successfully. You really have to be able to see beyond the physical. Because your subject isn't something people can literally relate to, they rely on your compositional elements to get your message.

Because compositional elements are so vital to an effective abstract piece, in this section, I discuss those elements you need to keep in mind as you're setting up for a photo.

Keeping the effects of color in mind

People relate different emotions to different colors. A photograph that's simply of the color red gives a different feeling than one that's blue. (Refer to Chapter 6 for some ideas on which emotions are related to which colors.) Different combinations of colors in one frame also affect your message differently. As a result, you need to carefully consider these effects when you compose an abstract photograph.

For example, viewers may see a composition in which the left side of the frame is red and the right side is blue as a conflict or opposition. And if one color takes up more space than the other, the story starts to change. Likewise, two different shades of red in the frame sends a different message than the photograph of red and blue. Just two colors in one frame can create an infinite number of feelings or ideas.

Using shapes and lines to create meaning

Adding shapes and lines to your composition increases the number of ways a viewer may interpret the meaning of an abstract photograph. The thickness of a line or the size of a shape compared to another creates relationships of space and distance. Although shapes and lines in abstract works are nonrepresentational in a literal sense, they can and do represent things in a nonliteral sense. For instance, a line in the shape of a smile probably gives the sense of happiness. And a shape that's fading off to one side and followed by streaks gives a sense of motion.

Playing with tonality

Separations in *tone* — or lightness and darkness — provide the idea of space in abstract works. The gradual differences between lightness and darkness either make something seem closer or farther away, depending on how the viewer perceives the entire piece of work. In Figure 17-4, for example, the farthest point seems to be represented by the lightest area.

Tonality combined with size and placement is the key to three-dimensional compositions. A subject that takes up more space than another and is placed lower in the frame will appear to be closer. By making that subject lighter in tonality, you increase this effect.

50mm, 1/250 sec., f/1.2, 50

Figure 17-4: Tonality is the main element in this abstract photograph.

Compositions that range from very dark tones to very light tones are high in contrast and come across as being dramatic or tense. Having a less drastic change in tonality decreases this effect.

Putting it all together

Abstract compositions can be simple or complex, but they're successful only when they convey a message. When the unrecognizable elements in your frame come together to represent something familiar based on your composition of them, you have created a work of art. You can set out to look for abstract themes in the things that surround you, or you can simply start taking pictures that are out of focus and hope for results.

Here are some pointers to get started:

- ✔ **Get very close to your subjects to help eliminate their identities.** A microscopic view of a person's skin doesn't look anything like the way you see it normally. You can use macro photography techniques to achieve this effect. For more on macro photography, refer to Chapter 14.

- ✔ **Experiment with your camera and shoot familiar objects in unfamiliar ways.** Focus on the shapes and textures of things rather than what they actually are.

- ✔ **Photograph the shadows created by some common subjects and think of ways to alter their shapes.** The shadow of a person, for example, can become warped when it falls on the edge of a rock wall that's jagged and warped itself.

Pay attention to the colors, lines, shapes, and tones in your scene, and consider how they work together to convey a message. If something in your frame doesn't support what you're trying to say, perhaps you can eliminate it from the scene. Move your subject or change your camera angle to alter your composition until things fall into place. Refer to Chapter 5 for information on the placement of elements in a frame.

Combining Multiple Shots to Create a Single Photo

Combining multiple images into one is a great way to get more creative with your photography. It gives you the option to include more elements in a photograph than what's available in a single scene. For example, you could create an image that shows the sun and the moon at one time. Your ability to control your message is maximized with this technique.

Photo-editing software has taken the idea of multiple exposures and collages to a level of perfection that gives you 100 percent control. Taking two separate images and placing them together in postproduction provides far more precise results than trying to do so in camera.

In this section, you discover the concept of creating multiple exposure look-alikes and collages. See Chapter 18 for further details on postproduction improvements and techniques.

Mimicking a made-up scene with multiple exposures

Sometimes a single scene doesn't provide enough information for your photograph's intended message. Perhaps you like the subject but would prefer a background that was more supportive of the way you perceive that subject. To provide such a background, photographers often use multiple images and composite one on top of the other during postproduction.

When you create a multiple exposure on film, the separate images stand out based on how they were exposed in comparison with each other. The process is technical and requires proper planning — or luck. When creating multiple exposures in digital photography, however, you can simply shoot each

image as its own photograph and then combine them with photo- editing software. Combining photos with computer software gives you more control over how much visual impact each photograph has in your final image. It also enables you to position everything with precise detail.

When combining images, think of the final image as a puzzle. The elements of each image combine to create one composition and one message. Fit the various elements into your frame according to the rules and ideas that I discuss in Chapter 5 and throughout this book. If you want to know more about the technical process of exposure, check out *Digital Photography Exposure For Dummies* by Jim Doty (Wiley).

Some concepts that photographers commonly apply when combining multiple images include the following:

- ✔ **Ghosted images of people:** *Ghosted images* are those that show a subject that's fading or transparent. You can achieve this technique through motion blur (see Chapter 16) or through the use of multiple exposures. By overlaying an image on top of another (one with the person and one without), you can achieve the ghosted effect. This technique is useful in messages that pertain to the memory of someone or the essence of their presence.

- ✔ **Action sequences:** Popular in sports photography, *action sequences* result from a still camera taking images rapidly while a subject completes any action as it moves through the scene. You may use an action sequence to show a skater doing a trick on her skateboard, for example. The photos are then combined to create one image that shows the entire sequence from beginning to end.

You need a camera that shoots very fast in order to capture a fast-moving subject in this way. Ten frames per second usually gives you enough frames to work with, but anything less than that may not be quick enough to provide a complete sequence. After all, if the action only lasts for a second and your camera can only shoot three frames per second, you'll only have three images to use in the final image. And that number of images wouldn't be very descriptive as to what happened in the one second.

- ✔ **Busy images that reveal chaos as a message:** This technique is used when there's more to the story than can be captured with one photograph and when you want to cram as much information as possible into one frame. For instance, combining multiple images of scenes in Manhattan at night would convey the idea that it's a busy place — the city that never sleeps. By combining the neon signs of various bars

around town, you would convey the message that you can find a lot of places to get a drink in the city.

✔ **Suggestive backgrounds or supported elements:** If your subject is not supported sufficiently by its environment, you can add details by creating a multiple exposure, like the example in Figure 17-5.

I came across the bird in Figure 17-5 in my backyard one morning. It was lying on a piece of wood and seemed so peaceful, as if it randomly fell out of the sky in the middle of a pleasant thought. I didn't want to move the bird to a different location, but the wood bench it was positioned on was too harsh to tell its story alone. By compositing an image of the sky onto the scene of the bird, I was able to give a sense of the bird's more natural environment, which contrasts with the wood. Without the sky, this image would be a literal depiction of a bird that has fallen onto a hard, wooden surface. With the inclusion of the sky, this image is more of a tribute to the life of the bird.

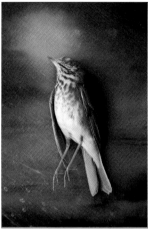

Photo of bird on wood: 70mm, 1/30 sec., f/5, 100
Photo of sky: 70mm, 1/500 sec., f/5, 100

Figure 17-5: Composite images help to say more about a subject by including multiple descriptive backgrounds.

Creating collages

Before digital photography, if you wanted to make a collage you had to cut out images from your photographs and paste them onto a board to create a compilation that conveyed your message. The collage could showcase your childhood, your summer at camp, your trip to Arizona, fashion, or whatever. However, with the advent of digital photography and photo-editing software, you no longer need scissors or paste to create a collage. Even better, you don't have to destroy any photographs. Plus, you can alter the sizes of different elements in the collage very easily. Chapter 18 gives you the technical details you need to use computer software in this way.

You can approach composing a collage from various angles. You can either create a clean composition that has a clear purpose, or you can create one with many different messages. I explain each approach in the following sections.

Producing a clean, one-message composition

To create a clean composition that conveys only one message, you place the important elements in areas of strong compositional relevance based on the rule of thirds (see Chapter 5 for details). You choose to include elements because they have a clear purpose and work together to provide a cohesive message.

For example, you may create such a collage as a flyer to advertise an event or show, as pop art (like Andy Warhol's popular reproductions of Marilyn Monroe), or for a model's comp card. A *comp card*, which is used to obtain modeling work, is a compilation of photographs that shows the model's talents and attributes. Figure 17-6 shows a comp card that I designed.

Height: 6'
Weight: 155 lbs
Shoe: 9.5
Chest: 41"
Waist: 30"
Inseam: 32"
Eye Color: hazel
Hair Color: Grey

Diego Alberto

Top photo: 50mm, 1/125 sec., f/2.8, 200
Bottom left photo: 50mm, 1/200 sec., f/4, 50
Bottom right photo: 50mm, 1/125 sec., f/4, 100

Figure 17-6: The back of a model's comp card.

Crafting a multimessage composition

Another type of collage is one that's chaotic and serves the purpose of many messages at once. You would most likely find this type of collage on the wall of a high school student or in someone's scrapbook. The design can be free and doesn't have to follow any rules of composition. However, if you're experienced with creating good compositions, you most likely apply certain design principles to this type of image without even thinking about it.

When putting together chaotic compositions, arrange the elements so they fit together and have a sense of flow. Try to make a balance between the various elements in your collage based on the ideas discussed in Chapter 12 on creating harmony out of chaos.

Mixing digital techniques and film cameras to get creative results

One of my favorite ways to create artistic photography is with old or cheap film cameras. Many photographers use photo-editing software to create the looks that are produced naturally with these cameras.

One interesting camera I use is an old Brownie camera made by Kodak. It takes 120 medium-format films and provides images that look as though they were taken decades ago — and you don't even have to digitally alter them. When you get the film from this type of camera developed, ask for the negatives to be scanned onto a disc. This way you can open the files on your computer and make minor digital adjustments, but you don't have to go out of your way to make them look as if they're vintage. The camera naturally takes care of that for you.

Consider the example in this photo. The contrast levels were digitally adjusted but other than that, the image got its look and feel from the camera.

Another camera I'm fond of using to create artsy images is the Holga. These are considered toy cameras because they're made from plastic and are inexpensive. The Holga takes 120 medium-format films and is known for having light leaks and producing unpredictable results. But don't let those so-called problems stop you from experimenting.

Try using a camera that's unpredictable. You may find it to be therapeutic to take photographs that aren't guaranteed to produce any specific quality of results. As a professional photographer, I spend so much time worrying about the technical aspects that I enjoy myself more when I'm not concerned with them.

Focal length unknown, 1/50–1/125 sec., aperture unknown, 400

In this photo, I put together a collage of some portraits taken with my Holga. I used Photoshop to create the collage, but the effects in the images were created by the light leaks from the Holga.

(continued)

(continued)

All photos: 60mm, 1/125 sec., f/8, 400

18

Improving Composition through Postproduction Editing

In This Chapter
▶ Fixing composition imperfections digitally

▶ Editing to make your subject stand out

Sometimes the images you compose have problems that you can't fix by changing your perspective or futzing with lighting. Maybe a power line runs through your shot but adds nothing to your message and isn't necessary for your composition. You obviously can't take down a power line in the real world, so you have to take it out digitally in postproduction.

Photo-editing software, such as Adobe Photoshop, Google Picasa, GIMP, and Corel Digital Studio 2010, provides photographers with limitless abilities to manipulate images. This chapter shows you how to use this type of software to enhance your compositions by eliminating unwanted elements, cropping, perfecting your perspective, drawing attention to your subject, and optimizing balance and harmony. I focus specifically on Photoshop, but many of the other available software programs provide similar features with different names. Check your program's manual for more specific information. To get more detailed information on Photoshop, you also can check out any of the books in the *Photoshop For Dummies* series (Wiley). You also may find it helpful to consult *Digital Photography For Dummies,* 6th Edition, by Julie Adair King and Serge Timacheff (Wiley).

Try not to rely too heavily on retouching. It can be time consuming. As a general rule, always create the best image possible while shooting, and never intentionally leave yourself something to digitally fix unless you have no other choice. Sometimes taking care of a compositional issue while shooting can save you hours of time at your computer.

 Whatever photo-editing software you use, experiment with it! One of the beauties of this technology is discovering your own favorite way to achieve an effect. You'll find many ways to perform the tasks in Photoshop and other software programs. This chapter simply gives you a few ideas that help you focus on the things that typically need to be fixed in postproduction.

Cleaning Up Your Composition

When you shoot a scene, you probably concentrate on many things at once. You figure out what your subject is, make sure it's in focus, determine how to fit it into the scene in relation to the other elements, make yourself aware of how light affects the entire scene, pay attention to the compositional rules (see Chapter 5), and ensure that you use your equipment correctly. Whew. Even with all that attention to detail, however, chances are high that you'll still create some photographs that can use a little help looking their best compositionally. So, in the following sections, I show you the tools you can use to edit out flaws and other unwanted elements and how to change your perspective.

 It's a smart move to make a duplicate of your background layer before making any changes to your image. Changes made to the duplicate layer won't affect the original image. Doing so enables you to go back if you make a mistake; it also gives you the option to compare the original with the new version of your image.

Removing unwanted elements and flaws

The first and most basic function of most photo-editing software programs is getting rid of unwanted blemishes, flaws, and distracting elements in a photograph. To use this function, generally scan your frame for anything that takes attention away from the subject. If something is distracting and serves no purpose in your message, get rid of it or blend it further into the background.

When working on images in Photoshop, you have the following tools in your editing arsenal: the Clone stamp, the Healing brush, and the Dodge and Burn tools. Other advanced programs sometimes have similar capabilities with different names. See your program's owner's manual for details. In the upcoming sections, I show you how to use the Photoshop tools to remove elements you'd prefer not to have in your shot.

 No matter what tool you use to retouch a person's face, remember to keep it real. Leave enough detail in the skin so the person doesn't end up looking like a cartoon or a mannequin.

If you're a photojournalist, your images are expected to be truthful. Don't get caught compromising the integrity of news photographs by removing unwanted elements in postproduction. It's okay to remove dust and scratches and to make color corrections, but don't change the truth in the scene by altering the reality of it.

Duplicating pixels with the Clone stamp

The *Clone stamp* enables you to copy pixels from one area of an image and duplicate them in another area of the image. To use this tool, you simply select the area you want to copy by dragging your cursor to it and holding the Option key (on a Mac) or the Alt key (on a PC) while clicking on it. After you select the area, you drag the cursor and click to paint the new pixels over the area where you want them. Photoshop allows you to change the size of the Clone stamp so you can work on small or large areas.

Some things to keep in mind when using the Clone stamp include the following:

- ✔ **Pay attention to texture.** You don't want viewers to notice that you cloned something out of an image. Even though everyone knows photo-editing programs exist and are used frequently, people still like to believe that what they see is real.

 When cloning over something, use a source area that has a similar texture as the area you're retouching. If you want to clone a pimple off someone's face, for example, duplicate pixels from skin that's as close as possible to the problem area. The forehead, cheeks, nose, and neck all have different textures.

- ✔ **Keep focus in mind.** If the area you want to fix is in sharp focus, select pixels from another area with similar texture that's also in sharp focus (and vice versa). A blurry area doesn't blend in well when surrounded by sharpness.

- ✔ **Avoid creating patterns.** Because you duplicate areas when cloning, you need to mix up your source points enough that you don't create a pattern. To do so, select a source point that's similar to the area you want to clone and begin to make your changes. Before cloning the entire area, occasionally select a new source point that's also similar to the area you're changing but is different than your original source point. Doing so helps create a new, original area rather than simply duplicating the one from your initial source point.

 A journalist was busted once for cloning extra smoke into a photograph of a hostile environment. He wanted it to look more dramatic than it actually was. People knew what he did because the smoke had easily identifiable patterns.

To see how you can use the Clone stamp to your advantage, compare the two shots in Figure 18-1. The top image has a cleaner composition. My client wanted this photograph to seem as if it had been taken in someone's home. Using the Clone stamp, I made the following changes to the original picture (bottom) in order to give the message of the image center stage:

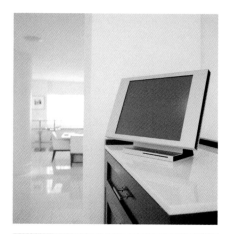

24mm, 1/30 sec., f/3.2, 320

✔ **Removed spots on the ceiling that had been caused by light fixtures:** The spots weren't recognizable in the image and distracted the viewer's eye from the monitor, which is the subject of the image.

✔ **Took out the dark reflection in the computer monitor:** This reflection showed up in the image as a flaw in the screen, so taking it out was important to eliminate distraction.

✔ **Scrubbed out the writing on the wall behind the monitor:** The writing on the wall gave away our location as an art gallery instead of a house, which is where the client wanted to portray the photo as being taken.

Figure 18-1: If something in your frame is distracting and unnecessary, you can remove it to create a cleaner composition.

Using the Healing brush to blend the tonality of duplicated pixels

Similar to the Clone stamp, the *Healing brush* uses a source point to copy pixels and duplicate them in a separate area. However, the Healing brush also blends the tonality of the resulting pixels with their immediate surroundings. This tool is useful when you need to make a change in an area with varying shapes and tonalities. With the Healing brush, you can choose a source point that's much brighter and darker than the area you want to retouch. As long as the textures are similar, your results will be fine.

In Figure 18-2, I removed the model's tattoos by using the Healing brush.
I chose to use this brush rather than the Clone stamp due to its ability to
blend the tonality of changes with their surroundings. The Clone stamp pro-
vides literal duplications and would have been more difficult to work with in
this instance.

I selected areas of skin that were ink free and then painted over the tattooed
areas. Also, I cloned out the cloud merging with the model's head in the back-
ground. (Read more about merging background elements in Chapter 9.)

50mm, 1/1000 sec., f/3.5, 50

Figure 18-2: Tattoos removed from a model with the Healing brush.

Amending exposure with the Dodge and Burn tools

The terms *dodge* and *burn* are borrowed from the darkroom, where light is
directed through a negative and onto a piece of photo paper to create a print.
Dodging is the art of lightening an area on a print by blocking it from the light
for a time period during the exposure. *Burning* is the art of allowing light to
affect one area for a longer period of time than the rest of the image in order
to darken it.

Similarly, the Dodge and Burn tools in a photo-editing software program such as Photoshop come in handy when you want to brighten or darken specific areas in an image without affecting the entire thing. For instance, you may want to brighten a person's face but keep the background dark in order to make the face stand out more.

Use the *Dodge tool* when you want to lighten something in comparison to its immediate surroundings. For instance, if a person has dark bags under his eyes, you can lighten them and cause them to be less apparent in the photograph. Similarly, tracing wrinkles with the Dodge tool can reduce their appearance. Also, blotchy areas in an otherwise smooth surface can be smoothed out.

In Photoshop, you can use the Dodge tool as if it were a brush. Be sure to select the brush size that works best for the area you're working on. A smaller brush, for example, can help control the effects when working on a tinier area. You also can *feather* the brush, which means that you soften its edges so it doesn't create defined lines.

The *Burn tool* is similar to the Dodge tool, but it darkens areas instead of lightening them. If the problem area you want to fix is too light compared to its immediate surroundings, use the Burn tool to make gradual changes until you reach the desired effect. The Burn tool often comes in handy when you want to darken a distracting background element or darken the edges of your frame just a bit to draw viewer's eyes to the center.

You can control how strong the Dodge or Burn tool's effect is in the Exposure drop box. The higher the percentage, the more quickly the tool lightens or darkens an area. I never set either to anything above 3 percent; these tools work best when used gradually. Make your corrections in small amounts until you achieve the result you want. A dodge or burn stroke that's too strong looks obvious to viewers.

You'll usually combine dodging and burning to smooth out the appearance of shapes and textures. By darkening the edges of a shape and lightening the middle, you create more dimensionality. By lightening dark spots and darkening light spots, you smooth out the texture of a surface. Notice, for example, the subtle differences in the man's face in Figure 18-3. The top image appears much smoother and draws you into his eyes better than the bottom image.

Dodging and burning can affect the color of an area as well as the tonality. Sometimes, after making changes, you may notice that the colors aren't quite right. One simple way to avoid this problem is to create a duplicate layer of your image and set the blending mode to *luminosity*. Doing so creates a layer that affects only the tonality of your image. It doesn't affect color at all. Here's how you do it:

50mm, 1/250 sec., f/4, 50

Figure 18-3: Dodge and burn to smooth textures and emphasize shape.

1. **Open your Layers palette.**

2. **Right click on your image's background layer and select Duplicate Layer.**

 You now have a background layer and a background copy layer.

3. **Set the background copy layer to *luminosity.***

 You now can dodge and burn on this new layer to lighten and darken areas while preserving the natural colors.

Changing your perspective

Sometimes the shot you want means you have to act fast, such as when you shoot a moving subject or have little time to get a shot. When photographing celebrities, for example, you have only minutes to get the perfect shot (they won't wait around forever while you fiddle with your camera). Because you can't take the time to perfect your perspective (including your crop and camera angle), you'll likely let small discrepancies into your frame with the idea that you can fix them in postproduction. (To read more about perspective, head to Chapter 8.)

The most common ways to change perspective when editing your photos is to straighten and crop, fix distortion, and resize and reposition elements. I describe each in the following sections. As I show in these sections, you can use Photoshop to edit images in this way, but other advanced programs also often have similar features. Check the program's owner's manual for guidance on each.

Straightening and cropping

To straighten your images, open them in Photoshop and follow these steps:

1. **Select Filters at the top of your screen.**

2. **Click on Distort and then select Lens Correction.**

 The Lens Correction Filter provides a grid on top of your image so you can determine whether your horizontal and vertical lines are straight. It also enables you to rotate the image with precision. Use your horizon line or the edge of a building (or any straight edge that's naturally vertical or horizontal) to determine whether your image is straight or needs to be adjusted.

3. **Align your image.**

You can rotate the dial by clicking and dragging it, or you can type in specific degrees in the box to the right of the dial.

4. **When you have everything lined up the way you want it, click OK to exit the filter screen.**

After you've straightened and rotated your image, you can then move on to cropping it using the *Crop tool*. Select the tool from your tools palette and click and drag it over your image. You can always change the size and shape of the crop and create the perfect composition for your image. Just click on a corner of the crop and drag it up, down, left, right, or diagonally.

In Figure 18-4, I gave myself extra room on the edges of my frame while photographing Alejandra Pinzón on the set of *El Hotel South Beach, Caliente!* Because I didn't have more than a few minutes to get a shot, I focused on my lighting and the model's expression. I was less concerned with the edges of my frame. Leaving some extra space to work with allowed me to decide later what the final crop would be. (Having too much is always better than not having enough.) I also rotated the image just enough to make the subject and the background straighter.

 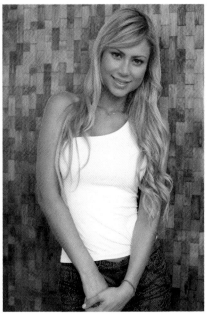

50mm, 1/160 sec., f/3.5, 100

Figure 18-4: Straightening and cropping for an ideal composition.

Fixing distortion

In the preceding section, I show you how to use the Lens Correction Filter to straighten and crop your photos. Here, I explain its use to correct distortion in your images.

What's the deal with distortion, you say? Well, sometimes buildings are distorted when you shoot from a low perspective and angle your camera up at them. They appear to be falling backward in the frame. (Refer to Chapter 15 for more details.) The same type of distortion happens when you shoot from a high angle down at a subject; the top half of the subject appears much larger than the bottom half. This angle can cause people's legs to look small in comparison to their upper bodies. Wide-angle lenses cause barrel distortion as well (see Chapter 8). You can use the Lens Correction filter to compensate for all these types of distortion.

Here's how to get the perfect perspective in the various situations:

- ✔ **When shooting at high or low angles:** The *Vertical Perspective* tool enables you to correct for distortion that happens from these angles. By sliding the cursor to the left or right, you cause your entire image to move away from you at the top or bottom. This helps to make buildings stand up straight or to even the proportion of a subject's top and bottom halves.

- ✔ **When shooting from an angle to the side of something:** In this case, the side that you took the picture from appears much bigger in your image. This effect is similar to the one in the preceding bullet; but, in this case, it's on a horizontal axis rather than a vertical one. You correct this distortion by using the *Horizontal Perspective* slider. As you slide the cursor to the left, your image twists in that direction, causing the right side of your frame to appear smaller in relation to the left. The opposite happens if you slide your cursor to the right.

- ✔ **When shooting with a wide-angle lens:** To remove barrel distortion caused by wide-angle lenses, use the *Remove Distortion* tool. This tool is controlled by a slider that allows you to choose the amount of compensation by sliding the cursor to the left or the right.

Resizing and repositioning elements

Imagine that you took a photograph and then, when you looked at it on the computer, decided that the composition would make more sense for your message if the subject were bigger in the frame.

One way to make this happen would be to crop into the image so the overall frame is smaller in comparison to the subject. However, doing so would cut

out a lot of background information, and you probably included everything in the frame for a reason. In order to increase the size of your subject without cropping into the image, follow these steps:

1. **Select your subject (or whatever you want to change).**

 A selection is represented by a borderline (sometimes referred to as *marching ants*) in the same shape as whatever you select. It dictates which pixels are affected when you make a change. In other words, any pixels inside the borderline are affected, and anything outside the selection remains the same.

 You can make a selection using many different techniques, and each is based on what you're making a selection of. The Lasso tool, for example, enables you to trace something by clicking and dragging the mouse around its edges. This is a basic way to make a selection. For more tools and methods you can use when making selections, refer to *Digital Photography For Dummies* or any of the books in the *Photoshop For Dummies* series (all published by Wiley).

2. **Choose the Free Transform tool from the Edit drop box.**

 This tool puts a box around your selection; the box has corners that you can drag.

3. **Move the corners in and out to decrease and increase the size of your subject.**

 If you drag the box out to the side, the width of your subject increases. If you drag it to the top, your subject's height increases. In order to increase the size of something while maintaining its correct proportions, hold down the Shift key on your keyboard while dragging a corner. Doing so changes the selection the same amount both vertically and horizontally.

Besides size, Photoshop also gives you complete control over the position of your subject (or other important elements). While your subject is selected, choose the Move tool from your tools palette. This tool allows you to move a selection around your frame by clicking on it and dragging it. If you move something in a frame, though, don't forget that you need to fill the space the move leaves.

When you move elements in your image, always work on a duplicated layer so you have a copy of the original underneath it. This way you can move your subject on the top layer and Clone stamp the original one so it complements the new layer with the repositioned subject. I discuss both duplicate layers and the Clone stamp earlier in this chapter.

Editing Your Images to Draw the Viewer to Your Subject

In Part III of this book, I discuss various ways to make your subject stand out in a composition — from making sure it's the element with the most tonal contrast to blurring out the background with a shallow depth of field, thereby placing the subject in a position of value in your frame. Sometimes the situation or your equipment limits you and prevents you from achieving your desired composition in camera, though. In these situations, you can use photo-editing software to draw more attention to your subject.

In this section, I discuss how to use Photoshop to amend your scene's contrast, enhance the light, and sharpen your image. However, keep in mind that other advanced programs often offer similar features. Refer to your program's owner's manual for more information.

Adjusting contrast in the scene using Curves Layers

You can't always place your subject in the area with the most contrast in a scene. Perhaps you're photographing a man with a gray jacket who's positioned in front of a gray wall in a room with black and white furniture. The black and white furniture contrasts against the gray background more than the subject — the man in the gray jacket.

You can fix this issue in postproduction with the Photoshop tool called *Curves Layers.* It allows you to make precise changes in tonality to specific areas of an image. When using Curves Layers, you have several options for fixing the contrast issue in the preceding example. Here are three options you may consider:

- You can lighten or darken the furniture to bring it closer to the tone of the background.
- You can lighten or darken the background in the areas near the furniture to achieve the same affect.
- You can make changes to the subject himself.
- You can use a combination of all three of these options to maximize the effect of your changes.

Try to make your changes appear as natural as possible. Adding contrast at high levels in postproduction can cause the quality of your image to deteriorate. Use your artistic judgment to know the difference between enhancing an image and taking things too far.

When working with a Curves Layer, you'll notice a white box called a *Layer Mask*. It's attached to the Curves Layer in your layers palette, and it determines what is affected (white shaded areas) and what isn't affected (black shaded areas).

Follow these steps to use a Curves Layer and its mask to adjust the contrast in specific areas of your frame:

1. **Create a Curves Layer.**

 You create a Curves Layer by clicking on Layer, clicking New Adjustment Layer, and then finally clicking Curves.

2. **Use the Curves Layer to lighten or darken the tones in your image as you see fit.**

 Play around with the curve, and notice how it affects your image's tones. Your middle tones are affected by the midsection of the curve, highlights by the top of the curve, and shadows by the bottom of the curve. As you raise a certain area on the curve, those tones are brightened. As you lower a certain area, those tones are darkened.

3. **Shade in your Layer Mask according to how you want the image to be affected.**

 You can click on the mask at any time and paint over your image with the Brush tool that's set to white or black. This controls how the Curve Layer's adjustment affects your image based on your brush strokes. You can make an adjustment in your Curves Layer and then paint it into the exact areas you want it to affect.

Figure 18-5 shows an image that needed adjustments in contrast in order to draw viewers to the subject. I also include its edited version. Notice how muddy the original image looks without the contrast. In the newer version, the subject's white shirt and black tie stand out as having the highest contrast, whereas in the original image the building in the background had the most contrast against the white sky. This newer version of the image helps to draw your eyes to the subject rather than the building in the background.

Enhancing an image's light

If you end up with a photograph that's underexposed or has bad lighting, don't worry! You can enhance the image digitally with your photo-editing software. I prefer these methods in Photoshop for doing so:

✔ **Use multiple Curves Layers, and then dodge and burn your way to an image with beautiful shapes and tones.** This method gives you the most control over the final outcome, but it's also a time-consuming task. I provide more information on Curves Layers and dodging and burning earlier in this chapter.

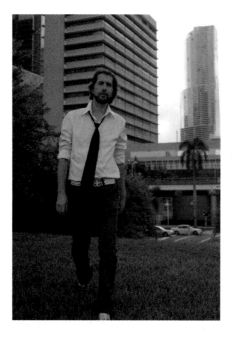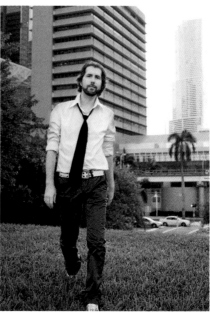

50mm, 1/1000 sec., f/4, 200

Figure 18-5: Adjusting contrast to draw viewers' eyes to the subject.

✔ **Experiment with the Shadows/Highlights tool.** If you don't have the time to spend on getting into specific detail in an image and you want to make quick adjustments, you may want to use this tool. It enables you to adjust the brightness of your highlights and shadows and to control the contrast in your midtones by using sliders. Simply position the slider in the area that makes your image look the best.

Keep in mind that the adjustments you make with this tool are generic and may work better for some images than for others. If you play with the tool for a while and don't get the results you want, you may want to make more specific adjustments with Curves Layers.

Never make adjustments directly to your background layer. This layer should be preserved in its original form in case you decide that you want to go back and start over again. Instead, create a duplicate layer to work on.

Sharpening your photos

Sometimes a photo you have taken turns out to have some focus problems after reviewing it on the computer. Certain areas may be blurrier than you'd like. Fortunately, you often can rely on photo-editing software to improve your image.

Digital editing gives you the ability to sharpen images, but don't let that stop you from achieving sharp focus on your subject or selecting the appropriate depth of field (see Chapter 7) when you shoot. The tools in your editing program work best when applied to high-quality images. The sharpening tool should be used to tweak sharpness for optimization but not to salvage an image that was completely out of focus to begin with. Too much sharpening becomes apparent to viewers as shown in Figure 18-6.

In order to sharpen an image, a program like Photoshop adds more contrast to what it perceives as edges. Wherever contrast already exists, a *sharpening filter* adds more by creating a thin strip of highlight on the darker side and a thin strip of shadow on the brighter side. This causes edges to become more apparent, and when used in the right amount, the filter gives the appearance of sharp focus.

You have a few different sharpening filters to choose from if you're using Photoshop. To find out about the differences among them, check out one of the books in the *Photoshop For Dummies* series (Wiley). When it comes to actually enhancing focus in a photograph, the filters basically all do the same thing but give you different amounts of control.

I suggest the filter referred to as the *Unsharp Mask.* This sharpening filter gives you an ideal amount of control and makes it simple to apply sharpness to the areas you want sharpened without affecting those you don't want sharpened. Here's how you use it:

1. **Duplicate your working layer, and then create a Layer Mask for your new layer.**

 Doing so enables you to make changes and then use the Layer Mask to determine what areas of your image are affected. (I discuss the Layer Mask more in the earlier section "Adjusting contrast in the scene using Curves Layers.")

2. **Go to Filters and select Sharpen. Click on Unsharp Mask to open the filter.**

 A window with a preview box and three sliders appears.

3. **Use the sliders to control the amount of sharpness to be applied, the radius of pixels that are affected, and the *threshold* (which determines which pixels shouldn't be affected within the selected radius).**

4. **After you've sharpened your image, use the Layer Mask to paint over the areas you don't want sharpened. To do so use a black brush.**

 These options enable you to sharpen images that are a little soft overall or to sharpen details that are slightly blurry without affecting the details that already are sharp (or that you want to remain soft).

For example, if you meant to focus on your subject's eyes but the person moved slightly when you were taking the shot, the focus may be on her nose or ears. Select a radius that's big enough to sharpen the eyes that are fairly soft and, on your Layer Mask, paint over the nose and ears with black. This will ensure that your subject's eyes are sharpened but the nose and ears are not.

Experiment with the filter to see what happens when you create different combinations with the Unsharp Mask's three sliders. The preview window gives you instant visual proof of how your image will be affected.

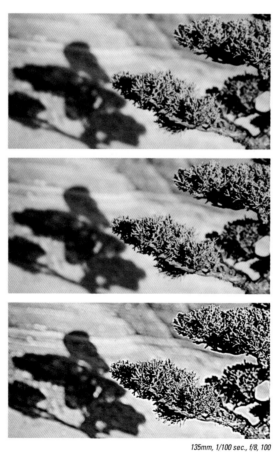

135mm, 1/100 sec., f/8, 100

Figure 18-6: The effects of not sharpening, sharpening correctly, and oversharpening.

Part V
The Part of Tens

The 5th Wave — By Rich Tennant

"And how many times has this happened to you? You land in a nice secluded spot, get out to take a picture, and a couple of yahoos in a pickup truck wander into the frame?"

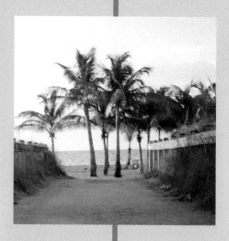

In this part . . .

Here in this traditional *For Dummies* part, you get quick bits of information that help you take your compositional skills even further. These chapters give you ten composition-focused projects to hone your technical skills and ten ideas for finding photographic inspiration. Finally, I show you ten compositions from a single scene; see how many different looks you can get from one location.

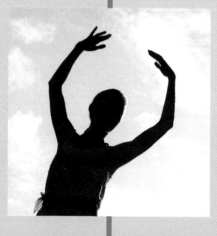

Ten Ways to Improve Composition

*E*ven more than natural talent and a good eye, experience is what makes photographers great. Using the information you discover in this book will help you create beautiful and meaningful compositions. And the more time you spend composing images and analyzing your results, the more likely you are to capture amazing images wherever you go. To help you gain the experience and practice you need, I include ten projects in this chapter. They provide a nice overview of the most important photography concepts. So, if you find yourself having a difficult time coming up with ideas or inspiration, refer to this chapter and give yourself some homework.

Reveal Contrast with Complementary Colors

Contrast is important in compositions because it draws a viewer's eyes to specific areas of a frame. You can use *complementary colors* (those that are on opposite sides of the color wheel) to create contrast and show viewers exactly where to look in your images. The color wheel in Chapter 6 can help you recognize which colors, when used together, provide the most contrast.

Here are examples of complementary color schemes: yellow and blue, red and cyan, and green and magenta. Allow yourself to concentrate only on these combinations and to seek them out when you're photographing. Notice the person holding the red balloon that's floating up in the cyan sky or the magenta flowers in their green bed. Or take a portrait

of your blonde friend wearing his blue hat. Spend the day looking for complementary colors to shoot. You can even create a photo essay on complementary colors.

Explore different ways of using contrasting colors in your compositions. Try filling the frame with just two complementary colors, and then try positioning them somewhere specific in your frame to draw the attention of viewers to that area. Make one color more dominant in the frame than the other or split the presence of each in half.

Harmonize with Monochromatic Colors

The subtlest approach to photographic composition (with regard to color) is the *monochromatic color scheme* — a design that incorporates colors from a single hue, or one area of the color wheel. You can use the various shades of red, green, or yellow, and so on. Each color has specific moods or associations attached to it, so by creating a monochromatic design, you can emphasize those moods or associations in your image. (See Chapter 6 for more details on color and the related terms.)

This color scheme may be challenging to find at first, but with a little practice and creativity you can make it happen. For example, look for a light green plant in a dark green pot in front of an even darker green wall. People often wear monochromatic outfits, and you can sometimes find this color scheme in stacks of fruit or in the décor of people's homes.

Make a Subtle Statement with Analogous Colors

The *analogous color scheme* (one made up of colors that exist side by side on the color wheel) is a mixture between high contrast and no contrast in color. The contrast level is somewhat subdued, and the result is a pleasant and comfortable design. Using three colors to create an analogous color composition often is helpful. Doing so provides a wide enough range in color to have some contrast but not enough to be dramatic. Refer to the color wheel in Chapter 6 to see which colors reside next to each other in the spectrum.

Try to create photographs that have a sense of flow by seeking out analogous colors in your scenes. A woman wearing a yellow hat and a cyan dress lying in a green meadow could give the same feeling as a slow love song, while a

man in a blue suit with a magenta vest in front of a red brick wall could give the same feeling as modern jazz may provide. Experiment with this type of color design and analyze your results. Mix the color combinations (making sure they exist in a row on the color wheel) to see what moods they create.

Use a Shallow Depth of Field to Tell a Story

Your *depth of field* controls how much sharp detail is revealed in a scene (see Chapter 7 for more information). A shallow depth of field is a useful tool for blurring out distracting backgrounds and pointing out exactly what you want viewers to see in an image. The key to minimizing your depth of field is using an 85mm or longer lens and using your maximum aperture. For more on lenses and aperture values, head to Chapter 3.

Focus on the element that you feel is most important to your message; it will be the only thing in the image that's sharp. Try using selective focus to highlight a person's eyes in a portrait, make one person in a crowd stand out, or give a clearer depiction of a flower in front of a busy background.

This technique is an important one because it helps you emphasize your points and drive home your messages. After you've mastered it, you can use it in conjunction with other compositional techniques to create strong conceptual images. For now, concentrate mainly on using the shallow depth of field in ways that seem to have purpose.

Shoot Until You've Exhausted the Possibilities

Any scene that you come across has the potential to provide many different beautiful photographs. Each photographer would approach the scene differently, and many of them would achieve good results. So, if you take only one image of a particular scene and feel that you have it covered, you're probably selling yourself short.

Explore an area and consider the various elements that exist in it. Use different compositional techniques, and take many shots from different perspectives. (For more on perspective, check out Chapter 8.) For example, you may do the following:

✔ Change your depth of field.

✔ Shoot a wide angle of the scene and zoom in for detail shots.

✔ Choose different elements to act as your subject.

✔ Shoot for color and for black and white.

Your first shot of a scene may not turn out to be a keeper, so taking only one isn't a good idea. You may find that you get the best shots later in the shoot when you really start to get familiar with the scene and its elements. Having options is always better than just having one version of a scene to represent it.

Choose a Background That Says Something

When composing an image, consider your subject and determine what you want to say about it. Then analyze the scene to figure out which elements in the background work best to relay your message about that subject. Look for supporting and descriptive qualities, and allow your backgrounds to be even more interesting than your subjects.

For example, if you're shooting an environmental portrait of a college math professor, position her in front of an area of the chalkboard that has a massive equation written on it rather than an area that's blank. By doing so, you allow viewers to gather that she teaches math.

Similarly, your goal may be to create a certain mood when shooting something like a perfume bottle. In this case, pay attention to the colors in your background, and position your subject in front of an area that matches the mood you're going for. Flip to Chapter 6 to find out which colors carry which mood associations.

Tackle Transparent and Reflective Elements

One of the biggest challenges for photographers is getting nice images of reflective and transparent surfaces. These elements tend to reveal off-camera details in their reflections, and they don't follow the same rules as opaque surfaces when it comes to light. The best way to master the art of photographing these elements is to practice, allowing yourself to experience what works and what doesn't.

To practice, find something that's transparent and reflective, like a wine glass, and position it next to a window that's letting in indirect light. Look through your viewfinder and notice how the light affects your subject. Pay attention to how the background is revealed through the transparent surface and how the window and any other elements are reflected in the glass. Change the angle of your camera a few times, paying attention to how everything changes in the scene and in the glass's reflection.

Also change your camera angle so the window is directly behind your glass. Expose an image and see what happens with the light and reflections. Then get between the window and the glass and see what happens. Find what direction of light works best with which camera angle. Strive to create the best representation of the glass that you can.

Treat Light as the Subject

Don't pay attention only to the physical elements in your scene; also be aware of what the light is doing. Some of the most interesting images are those that have a significant light situation. When I'm uninspired in a certain location, I pay attention to what the light is doing around me. It can spark some motivation to take a photograph. Light is what makes photography possible, after all. So why not allow it to be your subject?

For example, if direct sunlight is coming in a window and creating unique shapes in your room, take a picture. If the clouds are breaking up the way the sunlight is falling on the mountains, take the picture. The same goes for a situation in which the city buildings are reflecting sunlight onto the people waiting for the bus across the street. Or, if light cuts through some cracks in a wall or a street lamp shines a spotlight on someone, take the shot!

Incorporate a Compositional Frame

Compositional frames are elements that exist at the edges of your photo and keep viewers' eyes inside the frame. The most basic way to create one is to position your camera so you have some type of foreground element between you and your subject — maybe a window frame, some tree branches, or so on. When you compose the image, include the foreground element in the edges of your viewfinder in a way that surrounds your subject. Doing so creates a frame that persuades viewers to keep looking at the subject.

When you come across something you want to photograph, move about the scene and see whether anything can frame your subject. You'll likely have to try a few different perspectives in order to line everything up perfectly. Ideally, your compositional frame won't block the view of your subject.

Framing helps to add depth and visual interest to your images. It also provides information about the environment that your subject is in. Practice this concept a lot and you'll be very happy with the results.

Create a Composite Image

In some situations, you simply can't capture the beauty of the scene in just one image. For instance, if you're looking into the sunset, and a beautifully backlit scene is in front of you, you have to choose whether to expose for the sky details or for the details in your scene. The two are so different in brightness that exposing for one does no justice for the other.

If you come across a situation like this one, take two separate exposures (one for the sky and one for the ground elements) and put them together with photo-editing software to make one image that represents the scene in the way you remember seeing it. (See Chapter 18 for more on postproduction.)

To create a composite image, follow these steps:

1. **Set your camera on a tripod and compose your scene.**

 You'll be putting together multiple images of the same scene in postproduction, and layering them on top of each other is much easier if the camera doesn't move during the shooting process. So, that's why I suggest you use a tripod. Also keep in mind that the more intricate your horizon, the more difficult it is to put the two images together in postproduction. Trees can often be difficult to work with, so you may want to use a scene with a flat, undisturbed horizon line, like the beach, for your first attempt at this.

2. **Take the two exposures of your scene.**

 Make sure that one of the images exposes the ground elements in the best way possible and the other exposes the details in the sky correctly.

3. **Open the two images in your editing software, placing them side by side on your desktop.**

 Using the information on selection tools in Chapter 18, make a selection of the sky in the image that was exposed for the sky. Drag that selection into the other file that has the correct exposure for the ground elements. You now have a file that has detail in the sky and on the ground.

The main goal of this project is to create an image that looks realistic to your viewers. You don't want them to know that you edited the sky in from a second exposure just by looking at your image. You can apply this technique to all types of photography (not just landscape), but it's easiest to work with subjects that don't move.

Ten Tips for Finding Photographic Inspiration

When you're inspired by a certain location or subject, ideas flow through your head with ease, and you have no trouble composing great images. However, sometimes your creativity may be blocked, or you may find it difficult to see the photographic potential of a certain location or subject. But don't despair. The tips in this chapter can help start you on a journey toward inspiration. Try them all and look for others that help you.

REMEMBER

Accept your uninspired times without letting them get you down. Even the greatest photographers have experienced this frustration at times, and the trick is to acknowledge the situation and calmly figure out what you can do to break through the creative block.

Take a Walk, Take Photos, and Take Notes

Some scenes can produce amazing photographic settings at certain times of the day or in certain lighting or weather conditions. Many of these scenes probably exist right in your local

area, and you haven't noticed them yet. If you're having trouble coming up with ideas for photographing, pack your camera bag and go for a walk. Don't worry about which direction you go or what subjects you photograph. Just head out the door and get some fresh air.

While you walk, take in your surroundings: Notice the architecture, trees, people, and wildlife, and pay attention to the textures and colors of things. You don't even need to pull your camera out of its bag; simply take in the visual elements that are all around you. If you see something that's worth photographing, take a picture. If not, don't sweat it; you'll take plenty of pictures later, when you're inspired.

Pay careful attention to scenes that catch your eye, and consider why they caught your interest. For instance, you may see a wall that has great texture, colors, and lighting but needs something else to make it more than just a wall. In this case, take a quick snapshot and make yourself a note that describes what you like about the location. Write down ideas you have for shooting at the location and what you need to make it happen. Perhaps you can bring a friend to the same spot on another day and take her portrait there. You can arrange to have her dressed in colors that go with the color scheme of the location, and you can arrive at a time when the lighting is ideal for that spot.

As you walk around, take these snapshots and make these types of notes for yourself wherever you see potential in a location. Doing so gives you multiple spots to choose and build creative ideas from. Use whatever methods work for you. Keeping a notebook specifically for this purpose can be helpful. Or you may want to use your cellphone camera to take snapshots and then e-mail the photo to yourself with the notes you take.

Try Something Completely New

Maybe you're bored with the work you produce because you've been creating the same types of images for a while now. Forming habits or sticking with what you know best is human nature and usually causes this repetition.

Break out of these situations by allowing yourself to experiment with techniques you have little or no experience with. The best way to learn is by doing — and the more tricks you have up your sleeve, the better equipped you'll be to handle most photographic situations.

Here are some possibilities for trying something new:

- ✔ **Try shooting in a different environment.** If you normally shoot outdoors, try shooting indoors for a change (and vice versa).

- ✔ **Experiment with a new style of lighting.** If you're stuck in a lighting rut, practice some of the other methods of lighting you find in Chapter 10.

- ✔ **Take some shots of a new subject.** If you photograph mainly people, for example, try your hand at shooting landscapes, architecture, food, or wildlife.

- ✔ **Make an attempt at postproduction editing.** Many new photographers create portfolios in which their work consists of *straight photography,* meaning they don't use photo-editing software to enhance their images. Don't follow in their footsteps. Give editing a shot, and see whether you can be as creative in postproduction as you can when you're behind the camera. Doing so could open your eyes to a whole new world of possibilities. For more on photo-editing techniques, turn to Chapter 18.

If your new experimentations don't exactly work out, make it a learning experience. Study the photos so you can see what works and what doesn't — and what needs to change for the shot to be successful. You may be able go back and try again.

Emulate Your Favorite Shots by Other Photographers

Many photographers get their inspiration from famous images that someone else created. These images are iconic and expressive, such as the *American Gothic* painting, the cover image to Abbey Road, or the shot of Marilyn Monroe with her dress being blown up around her. You probably have your own list of images that stand out to you as inspirational. Try to re-create an inspiring image in its entirety, or take shots of the inspiring aspects of the image and create a new twist.

Do an online search for *American Gothic* to see just how many photographers have emulated it. You'll see a large variety of conceptual twists that should jump-start your own creativity.

Watch a Good Movie

Films are a great source for inspiration with regard to photographic composition. In a quality film, the directors of photography and art make camera angles, lighting, color schemes, and lens choices based on the narrative qualities they're looking for.

When watching a movie, pay attention to the main subjects' relationships to the other elements in a frame and how those relationships affect your understanding of the scene. Notice the different types of lighting during different scenes, and determine which mood is associated with which lighting type. What scenes use soft light and which ones use hard light? Is there a high level of contrast? (Chapter 10 tells you more about lighting.)

Some movie moments are depicted with wide-angle lenses and others with telephoto lenses. (You find out about lens types in Chapter 3.) Take notes on how moviemakers use different lenses to convey different messages. With an understanding of how different compositional techniques are put to use, perhaps you can find some inspiration to put those techniques into practice with your own photography.

Visit a Museum

Museums hold inspiration in its purest form. Looking at the online images of the great works of art is convenient and useful, but it's nothing like seeing the real thing. Most of the artwork displayed in museums is chosen for a reason. In most cases, the art world has recognized these pieces as having artistic qualities that could be of value to the public. So take my word for it and head out to your local museum (or do some traveling to see a museum that's new to you).

If the museum you visit offers a tour, take it and see what the curator has to say about the pieces you see. Listen to what he says about balance and scale, color, and technique. Try to notice compositional qualities in three-dimensional works of art (sculptures, installations, and so on); this different medium could inspire you to try something new when photographing.

Similarly, if you have a favorite photographer — one who inspired you to pick up a camera in the first place — you should see that photographer's work in person. Doing so is far more satisfying than seeing it in books or on the Web, and it will inspire you to continue creating your own images. To find out where you can view a specific photographers work, do an online search of their name with keywords such as "gallery exhibition" or "news."

Compile a Wall of Inspiration

When flipping through magazines, you'll likely come across images that jump out at you. Perhaps it's the lighting, the successful use of perspective, or the combination and balance of colors that gets your attention. Regardless of what draws you in, clip the page from the magazine and pin it up in your office or studio so you can see it on a regular basis.

As you post these images on your wall, you collect concepts and techniques that you find attractive to inspire you. If you simply take mental notes when you're inspired by images, chances are you'll soon forget about them. If you pin up the images where you can see them, you'll have a constant reminder.

Purchase a New Lens

Maybe you feel like all your images are starting to look the same, or maybe you want to use certain techniques but can't achieve them with your current lenses. If that's the case, look into a new lens! In most cases, a new lens is even more valuable than a new camera body; the camera's digital sensor sees only what the lens reveals to it.

Getting a new lens for your digital SLR is similar to getting a new toy as a child. Because the lens is new and different, it's interesting. You'll automatically be inspired to go out photographing.

If you can't afford to buy a new lens or aren't sure which one to get, try your local rental house. At a rental house, for a small rental fee you can try out various lenses. Doing so helps you decide which one works best for you and which one provides the most inspiration to create new images. To locate your nearest rental house, try searching the local business listings online. Or you can always ask a friend who may be in the know.

Head Out for a Nighttime Photo Shoot

Most photographers shoot during the day. If you want to create images that stand out from the norm (and you want to have a good time doing it), try shooting at night with long exposures.

Shooting at night is the same as shooting during the day except that you have much less natural light to work with. As a result, your exposures are very long. (With this in mind, be sure to bring your tripod.) Most digital SLR cameras allow you to set your shutter speed at a maximum of 30 seconds.

In some cases, this is more than enough time. However, if you notice that a night scene is underexposed at 30 seconds and your aperture is wide open and your ISO is maxed out, your only option is to increase the time of your exposure. (Chapter 3 discusses how to manage your exposure value by setting your shutter speed, aperture, and ISO.)

The setting that allows you to open your shutter for custom, extended periods of time is known as *bulb.* (Refer to your owner's manual to find out how to set your camera to bulb.) After you've set your camera to this setting, you can hold down your shutter release button for the amount of time you would like to expose a scene. With this setting, you can expose an image for as long as your batteries will allow.

Holding your finger on the camera while it's exposing a scene for a lengthy period of time isn't practical. Doing so causes motion blur because the camera shakes — and it's not very fun, either. You have two options for solving this problem:

- ✔ **Buy a shutter release cable.** This cable, which is perfect for long exposures, attaches to your camera and gives you control of the shutter without having to touch the camera. If you're going to buy a shutter release cable, be sure to research the different options available for your specific camera and read reviews written by other photographers on each product. Some shutter release cables offer various features, such as wireless capabilities and time-lapse options (as discussed in the later section "Reveal the Lapse of Time in a Scene"). Make sure you get one that has the features you want and is priced to fit your budget.

- ✔ **Use the tape and pebble system.** This is my own method of choice. With my camera set to bulb, I set up my shot and then carefully attach the lens cap to keep light from getting in once my shutter is opened. I then place a pebble over the camera's shutter release button and tightly wrap gaffer's tape around it and the camera body. The tape holds the stone in place, and my shutter remains open. To begin my exposure, I gently but quickly remove the lens cap. To finish the exposure, I simply put the lens cap back on, and then I peel off the tape to free the pebble. This method clearly is the more economical one if you don't want to purchase a shutter release cable.

It's best to avoid using duct tape or any type of tape that gets its stick from a thick adhesive. Gaffer's tape is commonly used by photographers because it doesn't leave a sticky residue after it's peeled off a surface.

Having the ability to control your shutter speed beyond 30 seconds is important for when you want to shoot at smaller apertures for more depth of field and lower ISO ratings, which I tell you about in Chapter 7.

Reveal the Lapse of Time in a Scene

One inspiring way to reveal a scene by using your camera is to create a time lapse. A *time lapse* is a sequence of images taken over a period of time. These images reveal the changes that occurred during that time in the scene. With the camera positioned on a tripod (for maximum stability), you can arrange to have an image taken once every minute or so. Changing the frequency of how often an image is taken changes the effect of your final results. Shorter durations between shots provide more gradual changes in the scene, and longer durations between shots provide more abrupt changes in the scene.

Some shutter release cables have a time-lapse setting that enables you to set the time between shots, allowing the camera and cable release to do all the work from there. If you don't have a cable release with this option, you'll have to manually time and execute your shots.

When composing an image for a time lapse, keep in mind the changes you expect to occur. If you're shooting the sunset, for example, compose your image so the sun sets in a way that looks good compositionally (check out Chapter 5 for info on arranging elements in a frame). If you're shooting the sunrise, predict where the sun will breach the horizon and compose your image based on that.

This technique can be fun to experiment with, and it's a good way to get a feel for creating video (which is sort of like a cousin of photography). Your time-lapse images can be put together using any basic video editing software. For more information of using digital video software, take a look at *Digital Video For Dummies,* 4th Edition, by Keith Underdahl (Wiley).

Join a Photography Forum

Photographers tend to have emotional connections to their own work, and these connections disable them from having a clear vision as to whether the work is technically adequate and successfully conveys a message to viewers. So, one of the most important aspects of developing your compositional skills as a photographer is having your work critiqued by people who don't know you and who can be critical and honest. Having these folks see your images and give feedback on what they got from the experience helps you figure out what works effectively and what requires a greater effort.

You can find Web sites that allow you to upload images of your own to be critiqued. Examples include the following sites: jpgmag.com, photoarts forum.com, and www.naturephotographers.net. At sites like these, you can also critique the works of others. Doing so gives you insight as to what common mistakes are made and what to avoid when composing photographs. During this process, compare your work to that of other photographers to see how yours stands out. Are you happy with the results of the comparisons? If not, figure out what makes you unhappy about the photo and how you can make changes in the future. Photographic composition is an ever-evolving skill, so don't ever be embarrassed to admit that you can do better next time.

Viewing Ten Compositions of One Scene

*B*eing a photographer is about much more than simply pointing your camera and taking a picture. You also have to make decisions regarding your photo's composition. These decisions determine how viewers see an image and how it compares to other images of a similar subject. Every composition you choose provides a unique message. To prove my point, in this chapter, I provide ten images and accompanying descriptions to show how a single subject in a scene can be photographed to reveal ten different messages.

Choosing a High Angle to Show the Scene

The height of your camera affects how a viewer sees a subject in relation to its environment. A high angle, like the one used in Figure 21-1, helps reveal information in your scene that's related to the subject. (Refer to Chapter 8 for more on choosing an angle to tell your story.)

In the figure, notice how you can see the surface of the path and the dunes and see just how far the walkway stretches before reaching the beach. I minimized the sky in this composition to maximize how much of the ground's details are shown. The subject is placed near the bottom right third in front of a shadowed area so she stands out visually and helps the leading lines created by the wood handrails lead your eyes to the beach in the background. You can clearly tell what the subject is while at the same time being invited to check out the scenery.

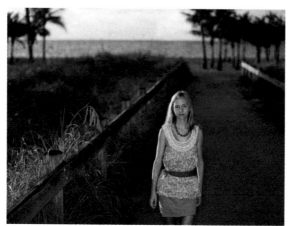

50mm, 1/200 sec., f/1.8, 50

Figure 21-1: A high angle emphasizes the environment.

Selecting a Low Angle to Emphasize the Subject

As opposed to using a high angle (which you can read about in the preceding section), using a low angle in a photographic composition helps you to put more emphasis on your subject and less on the surrounding elements. Look at Figure 21-2 to see what I mean. In this photo, I draw more attention to the model and less to the environment surrounding her. You can still get an idea of where the woman is, but this composition says more about her than her environment.

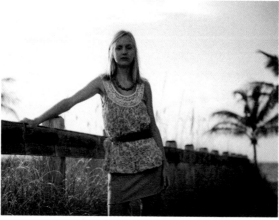

50mm, 1/200 sec., f/5.6, 400

Figure 21-2: A low angle emphasizes the subject.

Low angles are great for emphasizing height in a subject. The lower you get, the more sky you see, and the more your subjects begin to tower over your camera. You can read more on finding the right camera angle in Chapter 8.

Highlighting the Subject and the Scene with a Wide-Angle Lens

A wide-angle lens can be used to maximize how much detail you show in a scene. At the same time, when shooting with a wide angle of view, changing the distance between you and your subject can have a drastic effect on how viewers see the subject. In other words, with a wide-angle lens you can get the best of both worlds: a glimpse of the surrounding elements and information about the subject.

In Figure 21-3, for example, I revealed details in the model's face and wardrobe by standing close to her. However, you also get a good view of the scene around her. (See the following section for a shot with the same lens but different results.) You can read more about choosing the appropriate lens in Chapter 3.

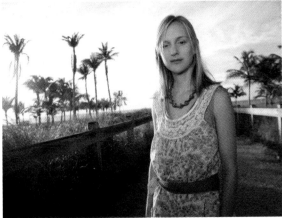

28mm, 1/100 sec., f/5.6, 400

Figure 21-3: Get close to your subject with a wide-angle lens in order to maximize detail in the environment and the subject at the same time.

Showing More Scenery with a Wide-Angle Lens

Figure 21-3 (see the preceding section) and Figure 21-4 both were photographed with the same wide-angle lens, but you can see that the subject is represented much differently in each image. Even though a wide-angle lens allows you to get similar amounts of detail in both your subject and its environment (check out the preceding section), you also can use this type of lens to get an expansive view of the scene while minimizing the presence of the subject — as I did in Figure 21-4.

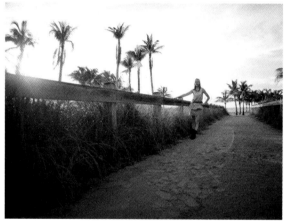

28mm, 1/200 sec., f/4, 400

Figure 21-4: To make your subject become part of the environment, place her farther into the scene when using a wide-angle lens.

Notice how Figure 21-3 and Figure 21-4 show about the same amount of the environment in the scene. You can see the palm trees, the path, and the sky in each. The main difference in Figure 21-4 is the size of the subject in the frame. By having her stand farther down the pathway, I made her seem more a part of the scene. Because she's more difficult to spot in this composition, I made sure to place her on the right third and have the leading lines of the dunes and handrail guide your eyes to her. She is, after all, still the subject.

Narrowing In on Your Subject with a Long Lens

If, for your composition, you feel that it's unnecessary to maximize the details in a scene, you can zero in on your subject and minimize the environment by using a long lens. These lenses have a narrower angle of view, so they naturally reveal a smaller portion of the environment. They also tend to create a shallower depth of field. The combination of these two factors can cause a subject to stand out from her background, making it easier for viewers to concentrate on her.

Figure 21-5 shows a more intimate view of the scene. The viewer still has enough information to get an idea of where the woman is, but this composition is more about her than the environment.

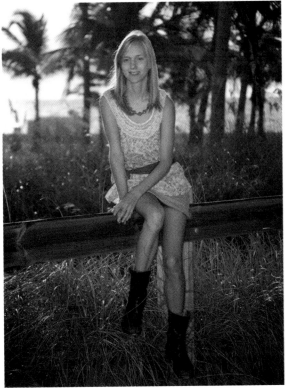

135mm, 1/200 sec., f/5.6, 400

Figure 21-5: Use a long lens to narrow your angle of view and draw more attention to your subject.

Creating an Intimate Portrait by Using a Long Lens

If you want to minimize the detail in a scene as much as possible and show a detailed, intimate image of your subject, use a long lens and move in close to her. In Figure 21-6, I used the same lens as Figure 21-5 but positioned my camera closer to the model. By doing so, I caused the background to become blurry and the model to take up most of the frame's space. This composition brings the viewer face to face with the subject.

135mm, 1/100 sec., f/5.6, 400

Figure 21-6: When using a long lens, move in close to your subject to make it all about her.

Paying Attention to the Foreground Elements in Your Scene

Photos often include a midground and background but lack a foreground. For a dynamic composition, try creating an image that contains both of these plus a foreground. Foreground elements help create the illusion of three-dimensional depth in an image. So be sure to study the foreground elements that exist in your scene and determine which ones tell the story of where you are.

In Figure 21-7 the subject is down on the beach, and the camera is up on the path. This angle includes the path in the composition without having the woman on it, which gives a sense of the environment in a not-so-literal manner.

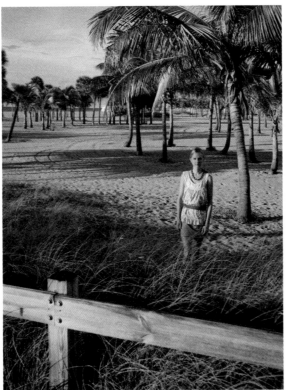

35mm, 1/200 sec., f/5, 400

Figure 21-7: Choose a vantage point that includes foreground elements for more dynamic compositions.

Giving Your Photo a Compositional Frame

Applying a compositional frame to your image helps to seal off the edges of your image and aids in drawing a viewer's eyes into the subject. (You can read more about these frames in Chapter 11.) In Figure 21-8, for example, the palm fronds at the top of the frame and the trees at the left and right edges help keep your eyes from wandering outside of the photograph. This framing also helps make the composition more interesting and descriptive.

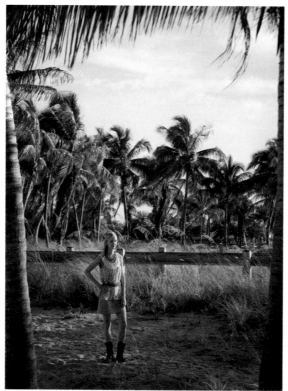

85mm, 1/200 sec., f/5, 400

Figure 21-8: Trees often can be used to frame a scene.

Finding Negative Space

If you determine that a scene isn't suitable for photographing a certain subject — perhaps because of the distracting background, foreground, or midground elements — you can always seek a vantage point that offers *negative space*. This type of space contains no descriptive details and includes things like a white sky or a blank wall. You can use negative space to get a clean portrait of your subject with no distracting or competing elements. Figure 21-9 was taken in the same location as the rest of the images from this chapter, but it offers none of the supporting evidence. For more information on negative space, head to Chapter 9.

115mm, 1/60 sec., f/5.6, 400

Figure 21-9: Draw maximum attention to your subject with the use of negative space.

Backlighting Your Subject to Emphasize Shape

Pay attention to the lighting in your scene and be aware of how it will affect your subject. For example, if your subject is backlit, as in Figure 21-10, you won't see much detail. Instead you'll get a silhouette, which is great for emphasizing shape. Often you see the backlighting technique used in sunset shots when the sun is low in the sky and the camera is pointed right at it. Anything that's between the sun and the camera appears as a silhouette.

I used a low angle in the composition of Figure 21-10 to ensure that the dark subject was against a bright background. This lighting helps to make her shape stand out rather than blending in with the other dark elements.

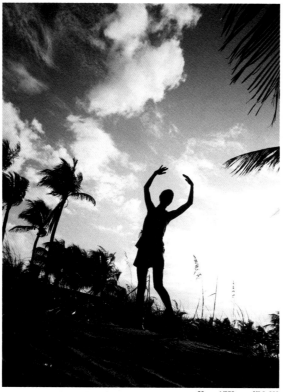

28mm, 1/250 sec., f/5.6, 200

Figure 21-10: Find a perspective in which your subject is backlit to emphasize its shape.

Index

• G •

• M •

Apple & Macs

iPad For Dummies
978-0-470-58027-1

iPhone For Dummies,
4th Edition
978-0-470-87870-5

MacBook For Dummies, 3rd
Edition
978-0-470-76918-8

Mac OS X Snow Leopard For
Dummies
978-0-470-43543-4

Business

Bookkeeping For Dummies
978-0-7645-9848-7

Job Interviews
For Dummies,
3rd Edition
978-0-470-17748-8

Resumes For Dummies,
5th Edition
978-0-470-08037-5

Starting an
Online Business
For Dummies,
6th Edition
978-0-470-60210-2

Stock Investing
For Dummies,
3rd Edition
978-0-470-40114-9

Successful
Time Management
For Dummies
978-0-470-29034-7

Computer Hardware

BlackBerry
For Dummies,
4th Edition
978-0-470-60700-8

Computers For Seniors
For Dummies,
2nd Edition
978-0-470-53483-0

PCs For Dummies, Windows
7 Edition
978-0-470-46542-4

Laptops For Dummies,
4th Edition
978-0-470-57829-2

Cooking & Entertaining

Cooking Basics
For Dummies,
3rd Edition
978-0-7645-7206-7

Wine For Dummies,
4th Edition
978-0-470-04579-4

Diet & Nutrition

Dieting For Dummies,
2nd Edition
978-0-7645-4149-0

Nutrition For Dummies,
4th Edition
978-0-471-79868-2

Weight Training
For Dummies,
3rd Edition
978-0-471-76845-6

Digital Photography

Digital SLR Cameras &
Photography For Dummies,
3rd Edition
978-0-470-46606-3

Photoshop Elements 8
For Dummies
978-0-470-52967-6

Gardening

Gardening Basics
For Dummies
978-0-470-03749-2

Organic Gardening
For Dummies,
2nd Edition
978-0-470-43067-5

Green/Sustainable

Raising Chickens
For Dummies
978-0-470-46544-8

Green Cleaning
For Dummies
978-0-470-39106-8

Health

Diabetes For Dummies,
3rd Edition
978-0-470-27086-8

Food Allergies
For Dummies
978-0-470-09584-3

Living Gluten-Free
For Dummies,
2nd Edition
978-0-470-58589-4

Hobbies/General

Chess For Dummies,
2nd Edition
978-0-7645-8404-6

Drawing
Cartoons & Comics
For Dummies
978-0-470-42683-8

Knitting For Dummies,
2nd Edition
978-0-470-28747-7

Organizing
For Dummies
978-0-7645-5300-4

Su Doku For Dummies
978-0-470-01892-7

Home Improvement

Home Maintenance
For Dummies,
2nd Edition
978-0-470-43063-7

Home Theater
For Dummies,
3rd Edition
978-0-470-41189-6

Living the
Country Lifestyle
All-in-One
For Dummies
978-0-470-43061-3

Solar Power Your Home
For Dummies,
2nd Edition
978-0-470-59678-4

Internet

Blogging For Dummies,
3rd Edition
978-0-470-61996-4

eBay For Dummies,
6th Edition
978-0-470-49741-8

Facebook For Dummies, 3rd
Edition
978-0-470-87804-0

Web Marketing
For Dummies,
2nd Edition
978-0-470-37181-7

WordPress
For Dummies,
3rd Edition
978-0-470-59274-8

Language & Foreign Language

French For Dummies
978-0-7645-5193-2

Italian Phrases
For Dummies
978-0-7645-7203-6

Spanish For Dummies,
2nd Edition
978-0-470-87855-2

Spanish For Dummies,
Audio Set
978-0-470-09585-0

Math & Science

Algebra I For Dummies,
2nd Edition
978-0-470-55964-2

Biology For Dummies,
2nd Edition
978-0-470-59875-7

Calculus For Dummies
978-0-7645-2498-1

Chemistry For Dummies
978-0-7645-5430-8

Microsoft Office

Excel 2010 For Dummies
978-0-470-48953-6

Office 2010 All-in-One
For Dummies
978-0-470-49748-7

Office 2010 For Dummies,
Book + DVD Bundle
978-0-470-62698-6

Word 2010 For Dummies
978-0-470-48772-3

Music

Guitar For Dummies,
2nd Edition
978-0-7645-9904-0

iPod & iTunes
For Dummies,
8th Edition
978-0-470-87871-2

Piano Exercises
For Dummies
978-0-470-38765-8

Parenting & Education

Parenting For Dummies,
2nd Edition
978-0-7645-5418-6

Type 1 Diabetes
For Dummies
978-0-470-17811-9

Pets

Cats For Dummies,
2nd Edition
978-0-7645-5275-5

Dog Training For Dummies,
3rd Edition
978-0-470-60029-0

Puppies For Dummies,
2nd Edition
978-0-470-03717-1

Religion & Inspiration

The Bible For Dummies
978-0-7645-5296-0

Catholicism For Dummies
978-0-7645-5391-2

Women in the Bible
For Dummies
978-0-7645-8475-6

Self-Help & Relationship

Anger Management
For Dummies
978-0-470-03715-7

Overcoming Anxiety
For Dummies,
2nd Edition
978-0-470-57441-6

Sports

Baseball
For Dummies,
3rd Edition
978-0-7645-7537-2

Basketball
For Dummies,
2nd Edition
978-0-7645-5248-9

Golf For Dummies,
3rd Edition
978-0-471-76871-5

Web Development

Web Design
All-in-One
For Dummies
978-0-470-41796-6

Web Sites
Do-It-Yourself
For Dummies,
2nd Edition
978-0-470-56520-9

Windows 7

Windows 7
For Dummies
978-0-470-49743-2

Windows 7
For Dummies,
Book + DVD Bundle
978-0-470-52398-8

Windows 7 All-in-One
For Dummies
978-0-470-48763-1

Available wherever books are sold. For more information or to order direct: U.S. customers visit www.dummies.com or call 1-877-762-2974.
U.K. customers visit www.wileyeurope.com or call (0) 1243 843291. Canadian customers visit www.wiley.ca or call 1-800-567-4797.